Contemporary Chinese Cinema and Visual Culture

Global East Asian Screen Cultures

Global East Asian Screen Cultures showcases cutting-edge scholarship on East Asian screen practices and cultures in local, regional, and global contexts. Titles in the series take "East Asia" as a focus, a nodal point interlinked with other regional screen cultures, and a method to reorient the global screen-culture cartography. The series embraces screen studies focused on geographic East Asia as well as work exploring mobility, migration, and hybridity as mediated through screen media production, textuality, and reception that traverse East Asia and its diasporas.

We welcome proposals that intersect with these areas of investigation. Please direct initial enquiries to series editors Mark Gallagher and Yiman Wang at mark.gallagher@nottingham.ac.uk and yw3@ucsc.edu.

Contemporary Chinese Cinema and Visual Culture

Envisioning the Nation

Sheldon H. Lu

BLOOMSBURY ACADEMIC

LONDON · NEW YORK · OXFORD · NEW DELHI · SYDNEY

BLOOMSBURY ACADEMIC
Bloomsbury Publishing Plc
50 Bedford Square, London, WC1B 3DP, UK
1385 Broadway, New York, NY 10018, USA
29 Earlsfort Terrace, Dublin 2, Ireland

BLOOMSBURY, BLOOMSBURY ACADEMIC and the Diana logo are trademarks of
Bloomsbury Publishing Plc

First published in Great Britain 2021
Paperback edition published in 2023

Cover design by Ben Anslow
Cover image: Nomad (*Youmu*), Qin Yufen, 2005/Art Project, Shi Du, Fangshan, Beijing.
Bamboo, silk, Aston Martin vehicle. Photo by René Staud Studios

A catalogue record for this book is available from the British Library.

A catalog record for this book is available from the Library of Congress.

ISBN: HB: 978-1-3502-3418-5
PB: 978-1-3502-5438-1
ePDF: 978-1-3502-3420-8
eBook: 978-1-3502-3419-2

Series: Global East Asian Screen Cultures

Typeset by Newgen KnowledgeWorks Pvt. Ltd., Chennai, India

To find out more about our authors and books visit www.bloomsbury.com
and sign up for our newsletters.

For Angela, Caroline, Michael

Contents

Figures

Acknowledgments

I would like to express my gratitude to Rebecca Barden, senior publisher at Bloomsbury, for her support and efficient handling of my book project; and to Mark Gallagher and Yiman Wang, editors of the book series "Global East Asian Screen Cultures," for including my book in the series. I have benefitted a great deal from two rounds of reviews of the book manuscript by three anonymous readers of Bloomsbury. As a fellow of the Davis Humanities Institute of the University of California in spring 2020, I presented this book project to other fellows at the institute. I very much appreciate their insightful comments and suggestions during our regular collective discussions. All remaining shortcomings of the book are entirely mine.

I thank my friend, curator, and art critic Huang Du in Beijing for introducing me to the Chinese art scene as he has done always. I am grateful to Wang Guofeng, Qin Yufen, Liu Xiaodong, and Wang Guangyi for providing me with images of their artworks and for permitting me and Bloomsbury to use them in this book. It has been a pleasure to work with Veidehi Hans, editorial assistant at Bloomsbury, who has shepherded the manuscript throughout the process in such a professional, helpful, and timely manner.

Portions and early versions of various chapters have appeared in a number of journals and anthologies. All the materials have been revised, updated, and expanded in this new book.

Chapter 2. "Space, Mobility, Modernity: The Figure of the Prostitute in Chinese-Language Cinema." *Asian Cinema* vol. 27, no. 1 (2016): 85–99.

Chapter 3. "Commentary: Dimensions of Hong Kong Cinema." In *A Companion to Hong Kong Cinema*, ed. Esther M. K. Cheung, Gina Marchetti, and Esther C. M. Yau, pp. 116–20. Wiley-Blackwell, 2015; "Transnational Chinese Masculinity in Film Representation." In *The Cosmopolitan Dream: Transnational Chinese Masculinities in a Global Age*, ed. Derek Hird and Geng Song, pp. 59–72. Hong Kong University Press, 2018.

Chapter 4. "Postsocialist Working Class: Male Heroes in Jia Zhangke's Films." In *Changing Chinese Masculinities: From Imperial Pillars of State to Global Real Men*, ed. Kam Louie, pp. 173–85. Hong Kong University Press, 2016.

Chapter 5. "Emerging from Underground and the Periphery: Chinese Independent Cinema at the Turn of the Twenty-First Century." In *Cinema at the Periphery*, ed. Dina Iordanova, David Martin-Jones, and Belén Vidal, pp. 104–18. Wayne State University Press, 2010.

Chapter 7. "Spatial Reconfigurations of Beijing: Transnational Architecture, Avant-Garde Art, and Local Documentary Practice." *Asian Cinema* vol. 22, no. 2 (Fall/Winter 2011): 352–63.

Chapter 8. "Artistic Interventions in Contemporary China." *China Information* vol. 29, no. 2 (2015): 282–97; Coauthor with Zhen Zhang, "Mediated Environment across Oceans and Countries." Online journal *Media + Environment* vol. 1, no. 1 (November 22, 2019).

Introduction: Refashioning the Nation in Transnational Cinema and Art

This book is a study of primarily Chinese-language cinema and partly broad visual culture from the late twentieth century through the early twenty-first century to the present time. It investigates the manners in which Chinese filmmakers and artists envision China and the world, conjure up reality, and intervene in social and cultural practices. I analyze materials mostly from mainland China and cover some films from Hong Kong and Taiwan. The kinds of works under examination include feature film, documentary film, and a variety of art forms: photography, painting, video, architecture, installation, TV drama, and performance. Occasional references to relevant literary works will also be made as they pertain to the subject matter of specific films and art works.

More specifically, I examine the ways in which the modern nation has been refashioned and reimagined by filmmakers and artists in contemporary Greater China.[1] I use the term "Greater China" as a shorthand for the geographic area encompassing mainland China, Taiwan, Hong Kong, and Macau. In my usage, Greater China is not a hegemonic structure of knowledge or a form of coercive geopolitics. Indeed, in film studies and cultural studies, a number of concepts have emerged to examine and contest cultural production and knowledge structure in this geographic area, such as "transnational cinema," "Chinese-language cinema," and "Sinophone cinema." These terms and critical approaches will be unpacked again in the following pages and throughout this book.

The nation form does not disappear in the conditions of transnationalism and globalization that have arisen since the end of the Cold War in the last decade of the previous century. In fact, the nation has found new ways to reassert itself.

The relationship among the local, the national, the transnational, and the global has been reshuffled and reconfigured in a putative borderless world. As I will demonstrate in the individual chapters, new tendencies and patterns of border-crossing as well as walling have emerged.

At the heart of my analysis is a double movement in the relationship between nation and transnationalism in the Chinese postsocialist state. By what is called "postsocialism," I mean that the Chinese economy is integrated in the global capitalist system on the one hand, and the Chinese state remains a body politic with pervasive, effective mechanisms of control and surveillance on the other hand. The nation, or "nationalism," consolidates itself by utilizing transnational resources that were previously not available; at the same time, independent filmmakers and artists also resort to transnational venues to escape the censorship and tight control of the state.[2]

China has been incorporated into a global capitalist market economy and actively participates in the international division of labor, production, and consumption. In this sense, China's mixed economy is no longer a predominantly socialist planned economy. At the same time, the country maintains its socialist governance and institutions and remains a Leninist party-state. What appears to be the largest middle class in the world is emerging from China. They have education, knowledge, property, and ideas. Not merely satisfied with obtaining sustenance and material comfort, people are eager to express themselves and be involved in the building of a civil society as individual citizens endowed with rights and responsibilities. Although China has long been a postrevolutionary society, the Communist Party still valorizes an old rhetoric and utilizes methods of governance carried over from an earlier revolutionary period when the vast majority of the population consisted of illiterate, impoverished peasants. The party regards itself as the vanguard of China's social development and positions itself as the absolute ruling power. The Chinese people are treated as the masses (*qunzhong* 群众), rather than citizens (*gongmin* 公民) in the public sphere. The masses are supposed to be in need of enlightenment, guidance, and leadership by the party.

The form of the modern nation-state often hinges upon a fraught relationship between "nation" and "state." While the state is a political, legal entity enshrined with a constitution and circumscribed by fixed geographical boundaries, the nation is a matter of heart, soul, and symbolic representation. As a community of citizens purportedly guaranteed with legal rights, the nation must be routinely imagined, reimagined, narrated, performed, and memorialized.[3] The state periodically interferes with, censors, and restricts the representation of the nation

in cultural activities such as cinema, art, and literature. It tolerates certain manners of envisioning the nation but forbids other ways of imagining the nation.

My book examines how filmmakers and visual artists confront the contractions, anomalies, dilemmas, and ironies in postsocialist China's uneven development. It proceeds along these lines of inquiry: transnational film history, the discourse of Chinese-language cinema, and world cinema studies. To show the relevance of my new study, I revisit these critical terrains. The national has managed to reinvent itself within the transnational, as it were. In the last section of the Introduction, I explore the worlding of Chinese cinema as a potentially progressive force in the midst of world cinema.

Transnational Chinese Film History

Film history has occupied a central place in the academic studies of Chinese cinema in the People's Republic of China (PRC). This has to do with the institutionalization of film studies and the dominant position of film history in the country. A key moment is the publication of *History of the Development of Chinese Film* (*Zhongguo dianying fazhanshi* 中国电影发展史) coauthored by the triumvirate Cheng Jihua 程季华, Li Shaobai 李少白, and Xing Zuwen 邢祖文 in the 1960s.[4] They are the founding fathers of academic Chinese film studies in the PRC. Their disciples trained at the Academy of Arts of China (*Zhongguo yishu yanjiuyuan* 中国艺术研究院) in Beijing have turned out to be some of the most prominent and influential film scholars in China. Writing a film history, especially, a monumental general history (*tongshi* 通史), is often regarded as a most admirable accomplishment.[5] Film historians hold a privileged position in China.

The writing and publication of *History of the Development of Chinese Film* is rooted at a specific moment. The book is in line with the orthodox ideology of the state in regard to the development of Chinese literature, art, and film. Understandably, the book tends to highlight the subject position of Chinese filmmakers and foreground the growth of Chinese cinema as an indigenous national cinema. It downplays and sometimes degrades foreign influences and international elements in the historical evolution of Chinese cinema.

In the mid-1990s, film scholars from around the world, including myself, were searching for alternative models of film studies in face of a new reality in the post-Cold War era. In 1997, I proposed the notion of "transnational Chinese film studies." This would be

a re-viewing and revisiting of the history of Chinese "national cinemas," as if to read the "prehistory" of transnational filmic discourse backwards. Such an operation has the aim of uncovering the "political unconscious" of filmic discourse—the transnational roots and condition of cinema, which any project of national cinema is bound to suppress and surmount.[6]

Numerous new inquiries in the direction of transnational film studies have been published since then.[7] Their findings have helped us better understand the contours of Chinese film history as well as the nature of world film history at large.[8] It is fruitful and even imperative to go beyond the confines of the master narrative of one single national film history, to be attentive to plural lines of narrative, to investigate film events at multiple locations. The borderlines between China and the outside world become porous.

The paradigm of transnational Chinese cinema has been further refashioned and fine-tuned in various ways in subsequent studies. Border-crossing beyond the nation-state could happen at the local, subnational, regional, and global levels. The transnational configuration of film culture can occur at numerous locations. Border-crossing can be a matter of translocality and polylocality.[9] International coproduction remains a key component of transnational cinema. In her study of Sino-French coproductions, or what she calls the "Sino-French cinema," Michelle Bloom identifies several modes of operation: "métissage, intertextuality, the makeover, translation, and imitation." This set of concepts "comprise a framework for consideration of fluid, border-crossing cinema, of which the Sino-French provides a paradigmatic case."[10]

Film was invented in France and was introduced to China.[11] As an imported new technology, Chinese cinema was a transnational phenomenon in the beginning. Films were jointly made by Chinese and foreign filmmakers. A noticeable person in the transpacific collaboration is the American entrepreneur Benjamin Brodsky (1877–1960). He worked with Chinese filmmakers in Hong Kong and Shanghai, founded a film company in as early as 1909, and played an important role in early filmmaking in China. His own hour-long documentary *A Trip through China* (1916) remains a classic and a precious document.[12]

Chinese filmmakers mastered the art of narrative feature film in the 1920s. It is important to note that most Chinese feature films made in the 1920s have bilingual intertitles: Chinese and a foreign language, such as English and French. The filmmakers have clearly the intention of exhibiting their films to international audiences. The silent feature *Romance of the Western Chamber* (*Xixiang ji* 西厢记, director Hou Yao侯曜, 1927) has French intertitles. It was

exhibited in Europe, in cities such as Paris, London, Geneva, and Berlin.[13] *The Cave of the Silken Web* (*Pansi dong* 盘丝洞, director Dan Duyu 但杜宇, 1927) was long lost in China until it was discovered in a library in Norway. The silent film is an adaptation of an episode of the Ming-dynasty novel *Journey to the West* (*Xiyou ji* 西游记). The film has Norwegian intertitles. This period of film culture across the world is regarded as the "cosmopolitan phase" by Dudley Andrew.[14]

Foreign films, especially Hollywood films, take up a big share of China's film market. The Chinese audience was exposed to films from America and other countries. American films, such as the films of D. W. Griffith, were rather popular, and they enhanced the understanding and appreciation of film art for Chinese viewers and filmmakers alike.[15] The screening of Hollywood films does not necessitate the decline of the domestic Chinese film industry. In fact, the American film industry and the Chinese film industry grow and flourish alongside each other. As Yongchun Fu argues in his book *The Early Transnational Chinese Cinema Industry*,

> Nationalism was not the central concern of the Chinese film industry in the first half of the twentieth century, although it may have served as a central concern of later Chinese film culture. The Chinese film industry prior to 1949 was driven by profits rather than nationalistic sentiments. ... The American film industry serves as constructive force in the formation of the domestic industry ... [The] existing literature advocating the concept of 'national cinema' fails to explain adequately the function of the American film industry in the making of Chinese national film industry.[16]

Figure 0.1 *Cave of the Silken Web* (*Pansi dong*). Directed by Dan Duyu. Production company: Shanghai yingxi gongsi. 1927. Long lost in China and rediscovered in Norway in the twenty-first century.

American technology, businessmen, merchants, and filmmakers are instrumental in facilitating the growth of China's film industry in the first half of the twentieth century.

The government of the Nationalist Party (*Guomindang*) in Nanjing begins to monitor and censor the screening of foreign films in China. In the name of national unity, the National government forbids Chinese films to have foreign intertitles under most circumstances. In the words of one Chinese film historian,

> Bilingual intertitles were inserted into most extant Chinese films in the 1920s and the early 1930s. During the 1930s, in order to promote the national language and prohibit excessive use of foreign languages in China, the Nationalist government repeatedly issued decrees forbidding the addition of English intertitles to prints of Chinese films intended for domestic exhibition. After these decrees, bilingual intertitles in Chinese films disappeared, and Chinese films were only translated if they were exhibited overseas, as was the case with *Song of China* (Tian lun; Fei MU, 1935), which was shown in the US.[17]

Such nationalization of film language is concomitant with the consolidation of national unity. Intertitles further lost its utility, at least for the domestic audience, with the advent of sound cinema in China and around the world. What happens in China coincides with a general trend in world cinema. Dudley Andrew names this moment as the "nationalist phase." He writes,

> Sound bolstered the cinema's nationalist turn by immediately anchoring every film to a linguistic community and its literature … Actors become familiar, fostering a feeling of familiarity and by extension the self-recognition and affiliation that comprise nationalism. This is how many cinemas managed to flourish under the shadow of Hollywood, despite the latter's incomparable resources in technology, financing, and marketing.[18]

Shanghai was the largest Chinese city in the Republican era (1911–49) and was the center of the Chinese film industry. The city was a hotbed of both cosmopolitanism and nationalism. Shanghai cinema holds an unrivaled position in Chinese film culture at the time.[19] However, Shanghai cinema is not equivalent to the entirety of Chinese cinema. Film historians have begun to look into possible alternative film histories. There are other important locales and regions of filmmaking, spectatorship, and film consumption. Such a strong sentiment toward rewriting film history is forcefully expressed by Emilie Yueh-yu Yeh. "To address this issue, we must adjust the existing binary of Communist-orthodox versus Shanghai-modern historiography by probing the cinema histories of less

familiar sites located in different sociopolitical institutions. Republican China is too large, too diverse to be shackled to just one city, no matter Shanghai's enchantment."[20] Film historians need to pry open the vital yet neglected film culture in other places beyond Shanghai, such as Hong Kong, Taipei, Guangzhou, and Chongqing.

Film culture exists at the local and subnational level in a large nation like China. There are resilient dialectal films. Cantonese-dialectal cinema from Hong Kong and Taiwan cinema (or Taiwanese-dialectal cinema) are the most well-known examples. Periodically, on and off, depending on the winds of national cultural policies and their enforcement in the PRC, local dialectal films and TV dramas thrive in the provinces and cities of China. For instance, some scholars speak of the regional flavor and cultural characteristics of western film and television in China. The "west" refers to Xi'an and Shaanxi Province 陕西.[21] There are also other vibrant cultural forces such as local Sichuan-dialectal films and TV dramas.

Be it the history of Chinese cinema or the history of Chinese-language cinema, the model of one unified national cinema may encounter difficulties in dealing with the nebulous nature and various localities of film production, circulation, and reception. Film historiography needs to employ multifarious threads of narration. A case in point is the cinema of Japanese-occupied Manchuria, or Manchukuo. The Manchurian Motion Picture Association (*Manzhou yinghua xiehui* 满洲映画协会) made numerous Chinese-language films. One of the most famous singers and stars of that era is Yamaguchi Yoshiko 山口淑子(1920–2014), or better known to the Chinese audience by her Chinese name Li Xianglan 李香兰.[22] Her parents were Japanese, but she was born and grew up in Manchuria. She starred in many films produced by the Manchurian Motion Picture Association. Her Chinese-language songs were immensely popular among the Chinese audience and are sung by people even today. But her films were made as part of Japan's propaganda campaign during the Sino-Japanese War. Sometimes she was even recruited to sing songs for wounded Japanese soldiers. At the end of war, she was arrested and was about to be prosecuted as a war criminal, a collaborator, until she proved her Japanese citizenship. She returned to Japan after the war and had an active acting, professional, and political career. She was an anti-war activist. The position of Chinese-language films from Manchuria is a problematic, thorny issue in any unilinear account of Chinese film history.

The career of Liu Na'ou (刘呐鸥, 1905–1940) also presents unique complexities to the writing of a national film history. Liu was born in Taiwan,

which was a Japanese colony. He was a filmmaker, a critic, and a writer of modernist (Japanese-influenced neosensationalist) stories in Shanghai. He was assassinated, possibly by the agents of the Nationalist Party for the reason of treason, namely collaboration with Japan. As film historians hasten to explain, Liu was a Taiwanese caught between the demands of and allegiances to both Japan and China, which were at war in the late 1930s.[23] While he was working for the China Film Company (*Zhonghua dianying gongsi* 中华电影公司), he helped Japanese filmmakers come to China to make the film *China Nights* (之那之夜; Japanese: *Shina no yoru*, director Osamu Fushimizu, 1940), starring none other than Li Xianglan.

Liu Naou's remarkable documentary *The Man Who Has a Camera* (*Chi sheyingji de ren* 持摄影机的人, 1933) was lost for a long time and was rediscovered in Taiwan in 1986. Although the film is an amateur film, it must be listed alongside other so-called "city symphony" films in the world: *Berlin: Symphony of a Great City* (*Berlin: Die Sinfonie der Großstadt*, directed by Walter Ruttmann, 1927), *Man with a Movie Camera* (*Chelovek s kino-apparatom*, directed by Dziga Vertov, 1929), and *São Paulo: A Metropolitan Symphony* (*São Paulo: sinfonia da metropole*, directed by Adalberto Kemeny and Rudolf Rex Lustig, 1929). Liu's documentary pays homage to Vertov's work by the same title. The film is "imbued with the vitality and spontaneity of amateur improvisation, playfully embracing and exploring the contingencies of the medium."[24] Such a work testifies to a thriving cosmopolitan culture in the colonial and semicolonial metropolises of the East.

The translation, circulation, and screening of foreign films have been an integral component of Chinese culture. That is also true of the PRC, although film censorship and control are more severe than in earlier period. Few Hollywood films are screened in the Mao era (1949–76). Nevertheless, according to a study, from 1949 to 1994, mainland China translated, dubbed, and screened more than one thousand films from the Soviet Bloc, Western Europe, and other countries, and these films make up one-third to one-half of the total amount of film screening and exhibition time for the audience in that period.[25]

The Cultural Revolution (1966–1976) was the most insular period in the history of the PRC. The ultraleftist policy severed cultural and economic ties from most countries in the capitalist West as well as the Socialist Bloc led by the Soviet Union. However, in the 1970s until the end of the Cultural Revolution, the Chinese audience watched more foreign films than domestic films when the Chinese film industry produced few films. People saw films from Albania, Romania, Vietnam, and North Korea that were dubbed in Chinese, and a few old

classics from the Soviet Union that was then denounced as "revisionist." As Jie Li points out, "[In] the cinematic universe, the transnational circulation of films from China's 'socialist brothers' also shared utopian models and represented class struggle, but Chinese audiences often appreciated foreign films precisely for their *differences* from the domestic fare, be it humor or pathos, romance or adventure, eroticism or exoticism."[26]

Transnationalism is not the exclusive domain of feature film. The history of China's animation film has been also an intense affair of international cross-fertilization among Chinese, American, Soviet, Japanese, and Taiwanese animators. The alleged self-closed period of socialist China turns out to be not so insular when animation develops to a higher level. Chinese animation has thrived on the transnational movements of ideas and artistic experimentations across geopolitical boundaries.[27] Animation provides a further example of the transnational forces at work in the formation of a Chinese brand of film art.

The Cold War ended in the early 1990s, and the world has entered into an accelerated new phase of globalization and transnationalism. As the borders between countries are taken down to facilitate trade, travel, business, and exchange, the role of the nation-state is attenuated at first glance. The establishment of a transnational mechanism of film production and distribution bypasses the old regulatory power of the nation-state.

Nation, Walling, Internal Globalization

So far I have attempted to unearth and emphasize the transnational dimensions in what is intuitively understood as the growth and unfolding of a resilient Chinese national cinema. Now that transnationalism is the order of the day, I would again argue against the grain in demonstrating that the nation has learned to reinvent its own images as it reinvests in new strategies of self-empowerment.

The Chinese nation is able to marshal new resources to project a more international and hence a stronger image of itself on the world stage. The transnational mode of film production has helped the filmmakers to obtain more resources and channels at their disposal in casting, location shooting, funding, and circulation beyond the confines of the isolated traditional nation-state. Globalization has created a broader space for the nation to project an even larger self-image than it could do earlier. Good examples include Chinese blockbusters, military films, and science-fiction films made in the second decade of the twenty-first century. These films have broken China's domestic box-office

records repeatedly and have indeed reignited the "imagined community" of the Chinese nation to the loud applause of an enthusiastic domestic audience. I count such films as *Wolf Warrior 2* (*Zhanlang* 战狼2, 2017), *Operation Red Sea* (*Honghai xingdong* 红海行动, 2018), and *The Wandering Earth* (*Liulang diqiu* 流浪地球, 2019). What the films show is that the Chinese people, as individuals, lone wolves, a unit, or a military group, have become active players in a vastly expanded world space in the twenty-first century. Chinese warriors and peacekeeping forces have ventured beyond Chinese territory to serve as indispensable players in international politics. Furthermore, China moves into outer space in its own science-fiction film, a genre that Hollywood, namely the film industry of the sole superpower of the world, usually excels in. Now the Chinese nation begins to churn out its own interstellar adventures and stake out a place for itself in the galaxies. A newfound confidence, a spiritual walling, or a new Great Wall, which is a traditional symbol of China's national unity and strength, is erected precisely because of the new opportunities afforded by a borderless world.

In the realm of business and capitalism, films such as *American Dreams in China* (*Zhongguo hehuo ren* 中国合伙人, 2013), directed by former Hong Kong film director-turned-mainland Chinese director Peter Ho-sun Chan (陈可辛), prove to the Chinese people that China is the land where dreams, whether Chinese dreams or American dreams, can be realized in the new century. It is unrealistic and counterproductive to go to the West to fulfill their longings. Nowadays the Chinese are equally competent entrepreneurs, capitalists, and educators. They can even beat the capitalists from the advanced West at their own game.

However, I would call this sort of cultural globalization as primarily internal globalization for the vicarious wish fulfillment of the domestic audience because these films rarely resonate outside Chinese borders and have not impressed international film viewers. Understandably, China's filmmakers are anxious to create their own truly global blockbusters. The truth of the matter is that only one particular film genre, martial art film, is able to succeed worldwide in terms of box office and audience numbers. Zhang Yimou's Hong Kong-style martial art film *Hero* (*Yingxiong* 英雄, 2002) was a breakthrough for a Chinese-language film. It did very well internationally at the box office. At the conclusion of the film, there is an image of and a short narrative about the Great Wall of China, which was in part built by the tyrannical King of Qin who later became the First Emperor of China. The film ends with a note on Chinese national unity, which might have escaped the notice of international viewers who are not familiar with

the details of Chinese history but are looking for a good martial art swordplay film (*wuxia pian* 武侠片). Interestingly enough, Zhang Yimou's expensive monster/action film *The Great Wall* (2016), an English-language coproduction between China and the United States, with a large international cast, starring Matt Damon as the lead actor, flopped at the box office and failed to achieve the purpose of becoming an international blockbuster.

China's media industry has been consolidating itself in face of the transnational flows of capital, images, and personnel. As China enters the World Trade Organization at the turn of the twenty-first century, its cultural domain is required to globalize as well by importing a fixed and growing number of foreign films, especially American films. Amidst the challenge from the influx of Hollywood blockbusters, China has created its own mammoth film conglomerate, the China Film Group Corporation (*Zhongguo dianying jituan gongsi* 中国电影集团公司), which is necessarily a state-owned enterprise. It is the largest film conglomerate in China, and for a long time it was the only company that could import foreign films. The China Film Co-Production Company is its subsidiary; it receives a good share of revenue from film coproductions with other regions and countries. This kind of media reorganization amounts to a renationalization of the Chinese film industry in the environment of transnational marketization.[28]

In pace with the globalizing self-projections in the cultural realm, China's infrastructure and physical landscape have undergone a remarkable facelift. Glitzy skylines, new airports, speed trains, sprawling highways, shopping malls, and small-looking Chinese-brand cell phones have given China an impressive new look on the surface. A seemingly user-friendly, modern China joins the rest of the world and merges with the global village.

But poor villages do exist in China. It is the independent filmmakers and artists who intensely gaze at the unsightly sites beneath the shining surfaces of the metropolises. Artistic and cultural intervention comes at the local level beneath the nation. The films and artworks reveal other facets of China, other people, other sites: migrants, laid-off workers, prostitutes, petitioners, gangsters; waste, social injustice, environmental destruction. There is a long list of marginal social groups, disenfranchised people, struggling citizens, social problems, and ecological catastrophes. Filmmakers and artists document and represent these *subjects*, both in the sense of subject matters as well as subjects/citizens who ought to speak for themselves but are deprived of a platform of expression. Such filmic and artistic intervention is often censured and tabooed by the nation-state.

China's internet regulatory mechanism, the Great Firewall of China, *fanghuo changcheng* 防火长城 in Chinese, literally "the Great Wall of fire prevention,"

blocks international websites and search engines such as Google and Facebook, and can be annoyingly user-unfriendly. The state monitors and limits citizens' access to knowledge, information, and news. This is not only frustrating for Chinese netizens but also troublesome for visitors to China. Any traveler with a Gmail account, or a university account built on Gmail, has such a difficult experience in China: the person cannot communicate through email, cannot conduct a search on Google, and cannot connect with people on Facebook. Such is the irony of a borderless world, or walling, with socialist Chinese characteristics.

Walling in the condition of transnationalism that I describe here is not exactly the same as walling understood as setting up physical barriers, barbed wires, and checkpoints along national borders in order to fortify the sovereign state.[29] In fact, the Chinese nation aggressively promotes the opening of borders between countries in order to facilitate trade, tourism, and consumption in the grand scheme of national development through a global economy. It takes great pride in what it has accomplished in these areas, as seen in newer and bigger international airports, growing numbers of outbound and inbound travelers, and the establishment of special economic zones. Walling in the Chinese instance refers to the selective, restrictive flow of information, ideas, and ideology, and much of that occurs in virtual space as well as in physical space. Globalization as such is an uneven, disjunctive globalization. While the nation may enthusiastically welcome the flow of capital, transfer of technology, and influx of tourists, consumers, and shoppers, it keeps a watchful eye on media, ideas, and certain categories of people.[30]

Therefore, walling is a cultural, intellectual, and spiritual mechanism in nation-building under the circumstances of uneven globalization at the present time. Film, art, and visual culture help forge an imagined community that was achieved in print capitalism in the nineteenth century by way of newspaper and the novel.[31] The aforementioned Chinese blockbuster films accomplish precisely this by creating and imagining sanctioned images of China inside the territory of the nation-state.

It is the public space in the transnational terrain that lends a platform to the screening of films and the exhibition of artworks outside of the constrictions of the nation-state. Here might lie the beneficial significance of cultural globalization. Filmmakers and artists are able to move their representation of reality to a broader international public sphere that the repressive nation-state is unable to police and control. In such a way, these films and artworks contribute to the establishment and functioning of a global civil society.

The transnational expansion of space has liberated individuals from the confines of the village, the community, and the nation. They become roaming subjects in the streets and cities of China and the world: whether they are migrants, businessmen, travelers, students, or sex workers. Biopolitics, namely the governance of health, life, and sexuality in the modern era in Foucauldian terms, has manifested itself in new shapes and disguises. Subjectivity, sexuality, masculinity, and femininity are continually formed and transformed as a multitude of Chinese citizens embark on journeys in search for better lives, different lifestyles, or improved material conditions of living. They try on alternative role models and unconventional behaviors outside strict traditional roles prescribed by the patriarchal state. Filmmakers and artists examine and represent such social transformations under the focus of their lenses.

The space of artistic experimentations for Chinese artists has increased dramatically since the 1990s into the twenty-first century. Visual artists have become active members of the international art community. They regularly participate in exhibitions in a variety of domestic and international galleries and museums, and their artworks have been bought and sold by art collectors. For instance, at the turn of the twenty-first century, a highly publicized exhibition, "Inside Out: New Chinese Art," was jointly held at the Asia Society in New York City and the San Francisco Museum of Art. As the directors of these two important American institutions admit, "Their work challenges our traditional perceptions about Asian art and transforms the very definition of contemporary art in an international setting." Such an exhibition is "the recognition that contemporary Chinese art has emerged as an important part of the global cultural landscape."[32] Contemporary artworks from China and the Chinese diaspora constitute an important component of a global visual culture.

In his essay "Toward a Transnational Modernity: An Overview of *Inside Out: New Chinese Art*," curator and art historian Gao Minglu writes such words about this exhibition:

> Transnational forces affecting Chinese societies have prompted contemporary artists to address the interrelated issues of marketing, materialism, and institutionalism. Chinese artists have been forced to abandon their avant-garde mythmaking and innocence—perhaps even naiveté—and pragmatically address changing relationships between the local and global, the spiritual and material, art production and producer.[33]

In the post-Cold War era of globalization, Chinese artists have learned to negotiate with and adapt to various factors and forces: artistic autonomy,

international patronage, the art market, and public spaces of exhibition. Along with filmmakers, they construct and transform the visual culture of China and the world.

In the first two decades of the twenty-first century, there are further noticeable changes in the Chinese art scene from what it was in the 1990s. This is what scholars like Meiqin Wang call a "civic turn" in Chinese art, the emergence and flourish of socially engaged art from the bottom.[34] Artists are no longer satisfied with becoming successful members of a rarefied international art club. Visual arts, installation artists, performance artists, videographers, and documentary filmmakers focus on the here and now and confront social, environmental problems at specific locales of China. These are grassroots activities that look at sights and scenes at the bottom of China's society. Given the censorship by the official of organs of the state, artists operate at the local, subnational, and then exhibit their works at transnational platforms and venues. They aim at broadening the terms and limits of art in a society and try to lead such a society in the direction of a truly civil society.

The Concept and Practice of Chinese-Language Cinema

The geographic range of most of the films and artworks in this book comes from mainland China, Hong Kong, and to a lesser extent Taiwan. The film part of this book also belongs to the larger terrain of Chinese-language cinema studies. The field of Chinese-language cinema encompasses mainland China, Taiwan, Hong Kong, Macau, and the Chinese diaspora. Chinese-language films comprise those films that use predominantly *hanyu* 汉语 and its dialects, namely the language and dialects of the Han nationality, as well as films using the languages of China's ethnic minorities such as Tibetan, Uighur, and Mongolian.

Throughout this book, I sometimes use the English phrases "Chinese-language cinema" and "Chinese cinema" interchangeably. They are actually different concepts.[35] "Chinese-language cinema" is perhaps a bit more specific, but the English term "Chinese cinema" is not clear. For example, if someone wishes to translate from English into Chinese, the translator has to decide whether "Chinese cinema" should be rendered as *Zhongguo dianying* (中国电影, "cinema of the Chinese nation") or *huayu dianying* (华语电影, "cinema of the Chinese language"). The translator needs to make the right choice by grasping the appropriate context of the text and the thought of the original writer. The embedded ambiguity, confusion, and inner tension can make our film studies difficult, problematic, and contentious. However, it is also due to such unclear

terms and ambiguous concepts that film scholars have risen to the occasion to meet the challenges. They have come up with ingenious solutions and insightful ideas and have broken new ground in research and theorization as a result.

Chinese-language film studies is necessarily an evolving discourse. Put simply, this discourse is not predicated upon the nation-state as an absolute category of analysis. It recognizes and works around the limits of grounding taxonomy such as Chinese cinema on the singularity and integrity of the nation form. I would like to briefly rehearse the history of this concept and tackle some new issues that have arisen surrounding this discourse. Once again, the nation does not disappear in the broad framework of Chinese-language cinema; rather, it is reformed and returns with the cunning of history, as it were. At the very least, the nation would not quietly exit the critical scene, but persists in the transnational, and raises new questions for filmmakers, artists, scholars, and critics.

The phrase "Chinese-language film" (*huayu dianying* 华语电影) briefly appeared in mainland Chinese newspapers in as early as the 1930s. But it was first elaborated and used by the Singaporean critic and filmmaker Yi Shui易水 in a newspaper column published in Singapore in the 1950s. Later on, he published a book under the title *Issues of Chinese-Language Film in Malaya* 马来亚化的华语电影.[36] Most film scholars were not aware of the genealogy of this term. The term was reactivated in the 1990s when filmmakers, critics, scholars, and the film industries from China, Taiwan, and Hong Kong began to interact and cooperate across the Taiwan Strait. The seemingly neutral term of Chinese-language film was accepted and adopted by people from different geopolitical backgrounds in the broad Chinese-speaking communities. The English phrase "Chinese-language film" gained currency in the academia outside of China with the publication of the anthology *Chinese-Language Film: Historiography, Poetics, Politics* in 2005.[37]

Chinese-language films have been made inside and outside the territorial nation-state. They have been produced and circulated in the Chinese diaspora since the beginning. Nanyang (Southeast Asia) is one of such places outside the Chinese nation. According to studies by Wai Siam Hee, the film *New Immigrant* (*Xin ke* 新客, approximately 1926–7) is the first Singaporean-Malayan film, produced by the Liu Bei-jin Film Company. Albeit a silent film, this film adds a significant episode to the transnational production and circulation of Chinese-language film around the world.[38]

In the 1920s–40s, Tianyi Film Company 天一电影公司, based in Shanghai, set up operations in Malaya, Singapore, and Hong Kong to distribute its

Mandarin-language films as well as Cantonese-dialect films. It also produced films in Nanyang. In the post-Second World War period, local producers and directors established a lively Chinese-language film culture, and made and circulated their films in Nanyang.[39] Moreover, contemporary Chinese-language film made by Malaysian Chinese, or what is called "*mahua* cinema" (*mahua dianying* 马华电影), is regarded as a transnational Chinese cinema.[40]

Chinese-language films are made in San Francisco throughout the twentieth century. There is a network of transpacific collaboration, exchange, and production between San Francisco and Hong Kong. The Chinese American woman director Esther Eng (伍锦霞, 1914–1970) is a good example.[41] Born and growing up in San Francisco, she made Cantonese-dialect feature films in San Francisco and Hong Kong and exhibited them in the United States, Hong Kong, and elsewhere. Eng's remarkable career has enriched the world history of women filmmaking as well as Chinese-language film history.

In mainland China, however, there are film scholars who are cautious of and hesitant in embracing the concepts of Chinese-language film and transnational Chinese film. They fear that these models might undermine the paradigm of Chinese national cinema. An intense debate on the models of film studies and the methodology of film historiography erupts among Chinese film scholars in the second decade of the twenty-first century. A few indigenous film scholars based in Beijing and Shanghai emphatically assert that the models developed from outside mainland Chinese cannot serve as the proper models of Chinese film studies; overseas Chinese film scholars operate with the hegemony and prestige of the Western academia. These native scholars think that while it is important to hold productive dialogues with overseas film scholars, it is imperative for mainland Chinese scholars to hold onto their Chinese subjectivity (*zhuti xing* 主体性) and maintain their discursive power. For them, Chinese-language film is not a viable and cogent concept. It is impossible to write a history of Chinese-language film (*huayu dinaying*). Chinese film (*Zhongguo dianying* 中国电影) is the only viable model of historiography.[42]

However, more and more mainland film scholars have come to accept, appreciate, and even promote the importance of transnational film studies and the model of Chinese-language cinema. Yet, the push and pull between a nativist force and a globalizing trend in Chinese film studies continues to play out. There is a delicate balance or imbalance between the territorial nation-state and a deterritorialized approach to film studies. For instance, the determination to assert the indigenous legacy in mainland Chinese film circles has come to expression in a new discourse, namely the creation of "a Chinese film school"

(*Zhongguo dianying xuepai* 中国电影学派), in recent years.[43] Mainland Chinese scholars attempt to establish a genealogy of a distinct Chinese film tradition from the beginning to the present moment, a "Chinese film school." This is an effort to buttress the "subjectivity" of Chinese cinema and Chinese film scholars over against the putative hegemonic loud voices from overseas academia, especially from the West, the United States.

As mentioned earlier, the emergence of the term *huayu dianying* (Chinese-language film) rose from a particular historical context and was intended to bypass the political and cultural division among China, Taiwan, and Hong Kong. *Huayu* 华语 refers the various dialects of *hanyu* 汉语, the language spoken by ethnic Han Chinese. *Hanyu* is a strict linguistic concept, while *huayu* is more a loose cultural concept. However, new questions have been raised in Chinese-language film studies that need conceptual clarifications. What term and concept can designate non-*hanyu* films that use the languages of the ethnic minorities in China, such as Tibetan, Mongolian, and Uighur? Can Tibetan- and Mongolian-language films be named *huayu dianying* (Chinese-language films)? The problem is further complicated due to the fact that such languages as Mongolian are spoken by people inside China as well as outside China, in countries like Mongolia, which is a separate sovereign nation-state.[44]

In the heyday of the socialist era in the 1950s and 1960s, there was a vibrant film genre: ethnic minority film (*shaoshu minzu dianying* 少数民族电影) or ethnic minority subject matter film (*shaoshu minzu ticai dianying* 少数民族题材电影). These films ultimately aimed at consolidating the unity of the socialist nation-state amid ethnic diversity. The fifty-six ethnicities of China belonged to one big family. Many of those films remain memorable classics of the socialist era. It should be reminded that the language of these films is *hanyu* rather than the languages of ethnic minorities. The intended audience is Han Chinese and people who understand *hanyu*.

Phurbu and Tenzin (*Xizang tiankong* 西藏天空, director Fu Dongyu 傅东育, 2014) is a historical drama film utilizing the Tibetan language. Again, consistent with the official policy, the theme of the film is about social and socialist change since the liberation of Tibet. The liberation of Tibet from serfdom remains the absolute baseline in any narrative of modern Tibetan history in mainland China. The film focuses on the evolving relationship between a young master, Tenzin, and his servant, Phurbu, over many years, from the preliberation era to the postliberation period. One another note, independent Tibetan director Pema Tseden (万玛才旦) makes thoroughly Tibetan-language films on a more personal basis.[45] His films do not fit into the mold of politically correct,

predictable films about China's minorities. His subjective, idiosyncratic ruminations on the lives of ordinary Tibetans have attracted much attention and enthusiasm from international film festivals as well as critics from around the world. His films constitute a Tibetan "minor cinema." In the words of one critic, " 'Minor' signifies the appropriation of hegemonic narratives to create new spaces of meaning and resistant polyphony ... [A] minor movement is the result of a process of *becoming minor* within the major."[46] What emerges from his films is a tentative construction of a new Tibetan subjectivity.

Chris Berry makes a useful distinction between two tendencies of new minority nationality filmmaking. One tendency extends the practices and characteristics of the previous socialist era. "The films are made primarily for Han majority audiences, often continuingly to telling developmentalist stories of Han benevolence towards the backward minorities, which also justify Han domination of non-Han regions in the name of guidance, support, and so forth."[47] In the second tendency, the filmmakers are ethnic minority filmmakers themselves who make films for audience both inside and outside China. "They are part of a wider social process of ethnic minority production of their subjectivity and culture in the era of the market economy, trade, and globalization."[48] In other words, there are different practices, emergent conditions, and new voices in the vast field of contemporary Chinese-language cinema.

In tandem with the national development strategy of One Belt One Road, China has established a Silk Road International Film Festival, whose locations alternate every other year between Xi'an, the beginning of the land route of the ancient Silk Road, and Fuzhou, the origin of the sea route of the Silk Road. Films from numerous countries along the Silk Road are screened at the festival. The CCTV station aired a thirty-episode television drama *Legend of the Silk Road* (*Sichou zhi lu chuanqi* 丝绸之路传奇, 2015) about the lives of silk garment makers in Xinjiang. Predictably, the story begins with the liberation of Xinjiang by the People's Liberation Army from the rule of the Nationalist Party (*Guomindang*) in 1950 and moves all the way to the present time in narrating the struggle, entrepreneurship, and eventual success of indigenous Uighur people to manage the silk garment industry. Uighur entrepreneurs rise above setbacks and are able to export their fine silk products to countries further down the Silk Road: Turkmenistan and Uzbekistan. Ultimately, the TV drama depicts the harmony and prosperity of China's minorities along the ancient Silk Road under the able leadership of the country.

We confront Chinese-language films inside and outside the Chinese nation, Mandarin-language films, Chinese-dialectal films, and films of the languages

of China's ethnic minorities. Where are boundaries of Chinese cinema? Where are the boundaries of Chinese-language cinema? What does *huayu* include and not include? In her radical conceptualization of the domain of Sinophone, Shu-mei Shih excludes Mandarin-language cultural productions from within China but includes those from outside the mainland or on its margins, and those of China's ethnic minorities from within China. The Sinophone defined as such is provocative and challenging.[49]

For their jointly authored book by Kuei-fen Chiu and Yingjin Zhang on documentaries from Taiwan and China, the title is "New Chinese-Language Documentaries: Ethics, Subject and Places." As they claim, their choice of the term "Chinese-language" is to keep a distance from the territorial definition of the "Sinophone." I quote their rationale at length:

> [We] believe that it is more productive than a simple gesture of denial or outrage to redirect critical attention to Chinese-language cultural productions from both mainland China and other Chinese-speaking societies. Our immediate aims are twofold: on the one hand to preserve the counter-hegemonic, decentering forces of the Sinophone by approaching visual productions inside—as well as on the margins of—mainland China as being equally disruptive and subversive as (if not more so than) their counterparts in other parts of the world, and on the other to bring into focus the intriguing, yet much under-appreciated, growth and transformation of documentary in Taiwan.[50]

The choice of material in my own book has similar aims. I look at how artists and filmmakers make visible the cracks, gaps, tragedies, and absurd comedies emerging from the processes of national development and globalization and launch critiques of the self-congratulatory aggrandizement of the ego of the nation as flaunted in Chinese blockbusters. The book scrutinizes the reconfigurations of modernity, spatiality, subjectivity, gender, sexuality, and masculinity in the development of Chinese-language cinema in Taiwan, Hong Kong, and China.

The terrain of Chinese-language cinema consists of plural histories, many lines of development, and multiple sites of formations in a long stretch from the beginning of the twentieth century to the twenty-first century. Conventional national cinema studies tilted toward the unit of the nation-state might not be up to the task. Chinese film culture is manifested at various levels: local, national, regional, transnational, diasporic, and global. The various locations of cinematic events in the mainland, Taiwan, Hong Kong, Macau, and the diaspora can all exert an impact on the formation of subjectivity. Image production, national history, cultural formation, and individual identity are in a multivalent

relationship, which can be homogeneous and mutually reinforcing as well as disjunctive, asymmetrical, and discontinuous. The tensions and differences under the masks of unity and cohesion are not sources of anxiety and trouble; they invite the spectator and the critic to rise to the occasion to explore and appreciate a rich, multifarious film culture.

The Worlding of Chinese Cinema and Art

Chinese-language cinema has been incorporated in the discourse of world cinema in international film festivals, film criticism, and university curricula. "Foreign-language film" has played a major role in America's reception and understanding of international film culture. It was a category of the Academy Awards and is now renamed "international film" by the Academy. Films from other countries offer alternative imaginaries from the usual appeal of Hollywood commercial films. Experimentation, avant-gardism, different aesthetics, social critique, unfamiliar cultural customs, and geographic distance constitute some of the attractions of world cinema. Since the mid-1980s, Chinese-language films begin to enter the purview of world cinema in the West. These films are the products of the so-called Fifth Generation and the Sixth Generation from the mainland, Taiwan New Cinema, and Hong Kong New Wave.

The pursuit of world cinema is not critical tourism around the world, nor a window shopping of famous sites, nor a sampling of fascinating cultural products from other countries. Neither is it an old Orientalist framing and taming of the other, a remote geographic location and an unfamiliar culture. One theoretical issue at this juncture is precisely the worlding of Chinese cinema amidst world cinema.

As it is properly called "motion picture," cinema is most susceptible to the pitfall of what Martin Heidegger calls "the age of world picture." In his famous essay by the same title, Heidegger writes the by now classical statement that "the fundamental event of the modern age is the conquest of the world as picture." The world is "conceived and grasped as a picture."[51] He reveals a modern system and technology of representing and positioning the world. The world is turned into an objectified world, an object, a picture in front of human beings, and a standing reserve for human appropriation.

The world that emerges from world cinema must be grasped in an appropriate way. Drawing upon Martin Heidegger's book *The Origin of the Work of Art (Der*

Ursprung des Kunstwerkes), and commenting on a painting by Van Gogh, Fredric Jameson points out that "the work of art emerges within the gap between Earth and World," or between "the meaningless materiality of the body and nature and the meaning endowment of history and the social."[52] The luminous painting of peasant shoes by Van Gogh, or a work of visual art, comes to the fore as a result of worlding by the artist. The artistic process is the transformation of one form of raw materiality into the other form of the art medium.

One term that has been frequently used in Chinese art throughout the centuries as well as in modern film criticism to describe such a process is *bizhen* 逼真, which might be translated as "zeroing in on reality," "approaching the real," "lifelike," and "verisimilar." This is the artist's asymptotic approximation of reality, the elusive yet ineluctable impulse to faithfully circumscribe the world.[53]

It should be heeded that the world that emerges from a work of art is not a precious thing devoid of the immediacy of social content. The world becomes meaningful only because of its worldliness. As Edward Said insists, texts exist in relation to a circumstantial reality, namely a worldliness. "The point is that texts are always enmeshed in circumstance, time place, and society—in short, they are in the world, and hence worldly."[54] The engagement of texts with a circumstantial reality is worldliness. Said was speaking about literary and musical texts, but his insight might apply to filmic texts as well.

It is Gayatri Spivak who fleshes out the implications of worlding in the modern era from a postcolonial vantage point. She critiques the colonialist mapping and worlding of indigenous space in imperialist cartography. The West acts as the sovereign subject and produces a narrative of the emergence of "the Third World" and "think[s] of the Third World as distant cultures, exploited but with rich intact heritages waiting to be recovered, interpreted, and curricularized in English translation."[55] One should be particularly mindful of the asymmetrical, unequal relationship in the Orientalist and colonial mapping of political formations and cultural heritages from around the world.

Chinese-language cinema's unique place in world cinema, as a result of China's special position in the world, needs to considered more carefully. China belongs to the Third World and the Global South as it shares a modern history of being a victim of imperialism and colonization in the hands of the West. Yet, China also has had a strong, persistent tradition of imperial practices and longings. Furthermore, in the twentieth and twenty-first centuries, it possesses a continuous revolutionary, Marxist-Leninist, socialist legacy. At the same time, mainland China, Taiwan, and Hong Kong have become major contenders and

front-runners in the global neoliberal regime of economic development and the formation of East Asian modernity.[56]

As succinctly put by Aihwa Ong, "worlding is the art of being global," the need to "identify the projects and practices that instantiate some vision of the world in formation."[57] Pheng Cheah emphasizes the normative and teleological nature of worlding in a theory of world literature or world cinema. He writes, "The globe is not a world ... I suggest that we should conceive of the world not only as a spatio-geographical entity but also as an ongoing dynamic process of becoming, something that possesses a historical-temporal dimension and hence is continually being made and remade."[58]

Cinema has a profound stake in envisioning the kind of world that people live in. It has a normative function. Filmmakers dream of engaging society and intervening in the public sphere. They endeavor to approach reality in ethically responsible ways as they explore film aesthetics. In regard to the symbiotic relationship between Chinese-language film studies and world film studies, Gina Marchetti points to possible directions. The task is to examine "motion pictures associated with progressive political movements, cultural critiques, and aesthetic experimentation," to engage in a "ongoing cultivation of subversive voices within commercial cinema, as renegades within film culture or as interlocutors of a distinct sensibility that offsets the status quo."[59] The purpose is to "develop a better understanding of contemporary transnational Chinese cinema within world film history," "to reposition contemporary Chinese-language film within the history of global political film culture."[60]

As a continuation of the legacy of art film and foreign-language film in international film culture, the efforts and products of directors from China, Taiwan, and Hong Kong are particularly noticeable in the pantheon of world cinema. Avant-gardism and artistic experimentation are well and alive in the belated New Waves or New Cinemas coming out of East Asia. Directors such as Hou Hsiao-hsien, a recipient of the Best Director Award at the Cannes Film Festival; Wong Kar-wai, another recipient of the Best Director Award at Cannes; and Tsai Ming-liang are among the auteurs with their own idiosyncratic styles and film aesthetics.[61] From the slow-spaced, minimalist, elliptical drama of Hou's and Tsai's works to the ostentatious, overly stylish mood of Wong's films, these visionary directors open up vignettes of the world in unique ways.

Mainland art-house director Jia Zhangke, a recipient of awards at the Cannes Film Festival and Venice Film Festival, is another important case in point. His films, such as *The World* (*Shijie* 世界, 2004), are among the most densely commented films by critics from around the world. *The World* is set in the

World Park in Beijing and describes the people and migrant workers at the park. A visitor inside the park may vicariously tour the famous landmarks of the world, such as the London Bridge, Saint Mark's Square of Venice, and the now destroyed Twin Towers of the World Trade Center of New York City. But the migrant workers trapped inside the World Park subsist and barely make ends meet on a daily basis. The film ironically reveals the jarring discrepancy between the professed benefits of globalization and the difficulties and harsh reality of ordinary workers. As such, the film *The World* (in French translation, *Le Monde*) offers a trenchant critique of neoliberalist globalization, of *mondialization*.

Underground and independent films have been pushing the boundaries of tolerance and censorship in Chinese society. They turn their gaze to the lower classes, marginal social groups, migrants, and the underprivileged. The directors focus on the daily struggles of ordinary folks in the Chinese-speaking world. Their voices, often deprived of a public platform for exhibition or forcefully silenced, attempt to broaden China's fragile public sphere with tenacity and courage.[62]

These filmmakers and visual artists, professional or amateur alike, sometimes only equipped with a video camera, bring about new social awareness from situated specific locales. They aspire to be activists responding to the ethical imperatives of art and living, and act out of a citizen's duty and right as a member of a community, a nation, and the world. Technological changes have made it possible for people to engage in the public sphere in new ways. From the urban generation to the iGeneration, from the big screen in the public theater to small screens in private settings,[63] from celluloid, to video, to computer, to iPad, to tablet, to cell phone, new modes of film production and circulation as well as new platforms of spectatorship have come into being. Filmmakers and spectators alike find new channels in fostering new spaces of public culture and social intervention.

Feature films as well as documentaries from the Chinese-speaking world have taken up the tasking of cautioning people about humanity's precarious and fragile relationship to the environment, other species, and nonhuman animals. Ecocinema constitutes an important and growing body of works in this direction.[64] Daring documentary works have come to national attention and international purview, such as *Beijing Besieged by Waste* (*Laji weicheng* 垃圾围城, Wang Jiuliang 王久良, 2011), *Plastic China* (*Suliao wangguo* 塑料王国, Wang Jiuliang, 2016), *Behemoth* (*Bei xi moshou* 悲兮魔兽, Zhao Liang 赵亮, 2015), *My Fancy High Heels* (*Wo ai gaogenxie* 我爱高跟鞋, Chao-ti Ho 贺照缇, 2010), and *Gold Underground* (*Biandi wujin* 遍地乌金,

Li Xiaofeng 黎小峰, 2012). Human beings' predatory habits toward other species along with their unchecked appropriation and depletion of the environment are both unsustainable and unethical. The documentaries confront environmental issues head-on and elicit transnational participation in a global civil society and international public culture. They remind Chinese people of their rights, obligations, and duties as citizens in what ought to be a functional civil society. At the same time, they alert people to the living environments elsewhere in an interconnected world.

Some commercial Chinese-language films also tackle environmental issues and enact the relationship between humans and other animals. Although they may cater to quick mass consumption, they deserve critical attention. The Chinese-French coproduction *Wolf Totem* (*Lang tuteng* 狼图腾, Jean-Jacques Annaud, adaptation from Jiang Rong's 姜戎 novel, 2015) is set in Inner Mongolia during the Cultural Revolution. It reflects on the conquest of nature in that period of Chinese history and examines the relationship between humans and wild animals—wolves. *The Mermaid* (*Meiren yu* 美人鱼, Stephen Chow, 2016) is a comedy coproduced by Hong Kong and China. Although this is a fantasy film, it imagines and reveals the consequences of human greed as a result of selfish real estate development on the natural habitat and endangered species, and calls for a more caring rapport among the multitude of species of the earth.

Humanity's relationship to other species is no more clearly pronounced than the outbreak of the novel coronavirus pandemic of 2020. Although the exact origin of the virus is debated and awaits the result of further investigations, such a virus is possibly transmitted from animals such as bats to human beings. One theory is that the transmission of the virus might be attributed to a wet market in Wuhan, China, that trades live animals. The outbreak of the epidemic starts in Wuhan, but the virus quickly spreads to the whole world and becomes a pandemic, thanks to the swift flow of things across national borders in the era of globalization. As if by a providential intervention, humanity is punished by nature for its carnivorous behavior.

The American film *Contagion* (Steven Soderbergh, 2011) has received renewed interest from viewers due to the coronavirus pandemic. The film depicts how a contagious virus caused a pandemic. Shortly after the protagonist Beth Emhoff (Gwyneth Paltrow) returned to the United States from a business trip to Hong Kong, she died. The mysterious virus was eventually transmitted to a large population in the United States. A horrific pandemic caused countless deaths. In a flashback at the end of the film, the disease was traced to the transmission of a virus from a bat to a pig, then to humans, and then to Beth in Macau, China.

The film is reminiscent of the SARS outbreak in 2003. However, that epidemic was mostly confined to China and its neighboring Asian countries. The world has become much more connected in 2020 than at the beginning of the twenty-first century, and contagious viruses now travel readily around the world. As people rewatch the film today, the film feels like an apocalyptic warning about the novel coronavirus outbreak.

In the time of globalization, capital, goods, and viruses move swiftly across national and geographic boundaries. To prevent the spread of diseases, social distancing within communities and new measures of walling at national borders have been established. Hence, it is even more urgent for humanity to reach out to each other and join forces across borders to fight xenophobia, racism, the exploitation of people, and the destruction of the environment. This moment is like "love in the time of cholera," as it were, borrowing the title of a novel by Gabriel García Márquez. In a pandemic, it is time to test the strength of our love of humanity and the depth of our commitment to the environment. If it is worthy of holding a spot and opening up a clearing amidst world cinema, Chinese-language cinema has to fulfill its obligations in being a progressive, caring force in a broad transnational, planetary community. As part of world cinema, it ought to have its proper functions in the time of environmental challenges, spread of viruses and diseases, and the dangerous closing of minds.

Figure 0.2 *Contagion*. Directed by Steven Soderbergh. Production companies: Participant Media, Imagination Abu Dhabi, Double Feature Films. 2011. Last shot of *Contagion* in a flashback. Beth Emhoff (Gwyneth Paltrow) shakes hands with a chef in Macau and gets infected with the virus.

The establishment and widening of a public sphere in a given country, a region, or the world should not be taken for granted, but remains to be done.

Structure of the Book

The book is divided into two parts. The four chapters of Part 1: "Nationhood, Gender, Sexuality, Masculinity in Feature Film" analyze mostly fiction films from China, Taiwan, and Hong Kong. They explore issues of space, mobility, and modernity in the time of globalization and investigate how these factors shape the construction and interrogation of national identity, subjectivity, gender, masculinity, and sexuality in feature films. A main thread of these chapters is how the image of the modern Chinese nation has been transformed, reshaped, and reconstructed in the condition of a global spatial expansion in films from China, Hong Kong, and Taiwan.

Another four chapters comprise Part 2: "Multimedia Engagements with the Local, National, and Global." In addition to feature film, these chapters look at documentary film, TV drama, photography, painting, installation, architecture, urban design, performance, as well as a small amount of literary works as needed background material. I explore the interrelations of the local, the national, the subnational, and the global as China repositions itself in the world.

Chapter 1, "Projecting the Chinese Nation on Domestic and Global Screens," analyzes screen images of China in Hollywood on the one hand and in Chinese cinema on the other. It focuses on how Hollywood blockbusters reference and incorporate Chinese elements in order to attract the Chinese audience and break into China's lucrative huge film market. The chapter also looks at how contemporary Chinese blockbusters, especially military/action films, have broken box-office records repeatedly by projecting a confident, competent image of the Chinese nation on the world stage.

Chapter 2, "Space, Mobility, Modernity: The Female Prostitute in Chinese-Language Film," is a study of the figure of the modern Chinese prostitute by examining a series of important Chinese-language films from Taiwan, China, and Hong Kong. It describes a pattern of increasing mobility on the part of the Chinese prostitute from the turn of the twentieth century to the turn of the twentieth-first century. The spatial expansion of the Chinese prostitute over a long historical time span has to do with the evolving conceptions and realities of the modern Chinese nation-state within a global capitalist system. Chinese

modernity, as embodied by the figure of the prostitute, must be understood in the specific constructions of gender, sexuality, femininity, and masculinity.

Chapter 3, "Reorientations of Hong Kong Cinema and Transformations of Masculinity," delineates main tendencies in the development of Hong Kong cinema from the eve of Hong Kong's return to mainland China to the present day. In regard to specific case studies, it further analyzes the representation of Chinese masculinity in the hands of selected Hong Kong film directors. The evolving images of masculinity in fact corroborate the general trends of Hong Kong cinema. The chapter looks at Hong Kong cinema at the local, national, regional, and global levels, and at the same time identifies new strategies of "mainlandization" and localization in Hong Kong cinema. Issues of masculinity, sexuality, and subjectivity are discussed.

Chapter 4, "Masculinity in Crisis: Male Characters in Jia Zhangke's Films," examines Jia Zhangke's portrayal of ordinary Chinese people caught in the historic yet troubled transition of China from a socialist planned economy to a capitalist market economy. Male heroes, or more accurately antiheroes, are central characters in his films. The filmic depiction of Chinese masculinity in crisis bespeaks the lack of suitable male role models and hence the need for a search of role models among a whole generation of people in contemporary China.

Chapter 5, "Peripheral, Underground, and Independent Cinema," looks at both feature films and documentaries that have been labeled as such by critics, scholars, and film festival organizers. By way of their unique style and aesthetics, such films reveal another side of China beneath the shining surface of progress and modernization. The films focus on the life and plight of marginal groups, migrants, economically dispossessed people, and politically disenfranchise folks.

Chapter 6, "Performing and Romancing the Other in Film, Television Drama, and Ballet," savors and critiques big and small tales of transnational romantic encounters. I probe a number of selected texts of film and TV soap opera, as well as some relevant ballet and literature for contextualization, on the topic of Sino-Russian romance that have been produced in the span of three decades from the 1990s to 2020. They include, in a chronological, historical sequence, the TV drama *Russian Girls in Harbin* (*Eluosi guniang zai Haerbin*, 1993), the film *Purple Sunset* (*Ziri*, 2001) directed by Feng Xiaoning, the memoir *In Memory of the Soviet Union* (*Sulian ji*, 2006) written by Wang Meng, the TV drama *My Natasha* (*Wo de Natasha*, 2012), and the film *Lost in Russia* (*Jiong ma*, 2020) directed by Xu Zheng.

Chapter 7, "Reshaping Beijing's Space: Architecture, Art, Photography, Film," examines visual representations of Beijing around the time of the 2008 Olympic

Games. It focuses on several interrelated facets of urban restructuring: the erection of new public monuments as symbols of China's globalization, modernization, and progress; cultural memory of socialist architecture as a reaction to capitalist globalization; and dislocation of local Beijing residents in old neighborhoods in order to clean up the city. The chapter analyzes the city's spatial transformations as shown in architectural design, avant-garde art, photography, and local documentary practice.

Chapter 8, "Artistic and Multimedia Interventions," aims at offering a comprehensive, kaleidoscopic examination of the many facets and types of arts in contemporary China. There is a wide range of art forms and media: film, photography, billboard, propaganda poster, graffiti, installation, and performance. There are veteran avant-garde artists, emerging talents, amateurs, and even ordinary workers. The various social phenomena brought about by China's neoliberalist developmentalism are carefully scrutinized by the artists: urban design, environmental degradation, government propaganda, grassroots social movements, urban migration, and so on. The Chinese artists skillfully tackle the consequences of urbanization, consumerism, and materialism with all the attendant exhilaration as well as destruction. They forge interesting ways to configure, represent, and imagine China through unique media.

"Conclusion: Globalization at Bay" wraps up some major themes of the book.

The territory of Chinese-language cinema is not a single straight line but is made of plural histories, multiple plots of development, and numerous sites of formations. Traditional national cinema studies anchored on the unit of the nation-state might not be adequate for a proper understanding. Chinese film culture is present at various levels: local, national, regional, transnational, diasporic, and global. The diverse locales in the mainland, Taiwan, Hong Kong, Macau, and the diaspora can each play a role in the formation of subjectivity in film. All in all, the book attempts to grasp the larger situation of cinema and art in contemporary Greater China.

Notes

1 For a discussion of the controversial notion of "Greater China," see, for example, Harry Harding, "The Concept of 'Greater China': Themes, Variations and Reservations," *The China Quarterly* no. 136 (December 1993): 660–86.

2 A portion of my book examines examples of Taiwan cinema. The "postsocialism" model does not apply in this instance. Evidently, contemporary Taiwan is not a

party-state as it was in the days of the rule of the Nationalist Party (1950s–80s). It is a democracy. Yet, Taiwan shares a common heritage culturally and linguistically with other parts of the so-called Greater Chinese area and enters into a complicated and at times contentious relationship with the mainland in the realm of culture.

3 See Benedict Anderson, *Imagined Communities: Reflections on the Origin and Spread of Nationalism* (London: Verso, 1983); Homi K. Bhabha, ed., *Nation and Narration* (London: Routledge, 1990).

4 Cheng Jihua程季华, Li Shaobai李少白, Xing Zuwen邢祖文, *Zhongguo dianying fazhan shi* 中国电影发展史 (History of the Development of Chinese Film) (Beijing: Zhongguo dianying chubanshe, 1963).

5 See, for example, Ding Yaping丁亚平, *Zhongguo dianying tongshi* 中国电影通史 (A General History of Chinese Film), 2 vols. (Beijing: Zhongguo dianying chubanshe, Wenhua yishu chubanshe, 2016).

6 Sheldon H. Lu, ed., *Transnational Chinese Cinemas: Identity, Nationhood, Gender* (Honolulu: University of Hawaii Press, 1997), p. 3. Chris Berry gives a perceptive assessment of the idea of the transnational in his essay, "Transnational Chinese Cinema Studies," in *The Chinese Cinema Book*, ed. Song Hwee Lim and Julian Ward (London: Palgrave Macmillan, 2011), pp. 9–16.

7 Chinese film studies took the lead in transnational film studies in the academia at the time, the mid- and late 1990s. Since then, countless book-length studies on Chinese-language cinema, Asian cinema, and world cinema through transnational perspectives have been published. Here are some titles on Chinese cinema and Asian cinema in chronological order. Yingjin Zhang, *Screening China: Critical Interventions, Cinematic Reconfigurations, and the Transnational Imaginary in Contemporary Chinese Cinema Studies* (Ann Arbor: Center for Chinese Studies, University of Michigan, 2002); Meaghan Morris, Siu Leung Li, and Stephen Chan Ching-kiu, eds., *Hong Kong Connections: Transnational Imagination in Action Cinema* (Hong Kong: Hong Kong University Press, 2005); Gina Marchetti, *From Tian'anmen to Times Square: Transnational China and the Chinese Diaspora on Global Screen, 1989–1997* (Philadelphia, PA: Temple University Press, 2006); Chris Berry and Mary Farquhar, *China on Screen: Cinema and Nation* (New York: Columbia University Press, 2006); Leon Hunt and Wing-Fai Leung, eds., *East Asian Cinemas: Exploring Transnational Connections on Film* (London: I.B. Tauris, 2008); Michael Baskett, *The Attractive Empire: Transnational Film Culture in Imperial Japan* (Honolulu: University of Hawaii Press, 2008); Kenneth Chan, *Remade in Hollywood: The Global Chinese Presence in Transnational Cinemas* (Hong Kong: Hong Kong University Press, 2009); Jeremy E. Taylor, *Rethinking Transnational Chinese Cinemas: The Amoy-Dialect Film Industry in Cold War Asia* (London: Routledge, 2011); Lingzhen Wang, ed., *Chinese Women's Cinema: Transnational Contexts* (New York: Columbia University, 2011); Brian

Bergen-Aurand, Mary Mazzilli, and Hee Wai-Siam, eds., *Transnational Chinese Cinema: Corporality, Desire, and the Ethics of Failure* (Piscataway, NJ: Bridge21 Publishers, 2014); Yongchun Fu, *The Early Transnational Chinese Cinema Industry* (London: Routledge, 2019); Daisy Yan Du, *Animated Encounters: Transnational Movements of Chinese Animation, 1940s–1970s* (Honolulu: University of Hawaii Press, 2019). *Jump Cut* published a special section on "China and Chinese Diaspora Films" in 1998, and Gina Marchetti wrote the introduction. See Gina Marchetti, "Introduction: Plural and Transnational," *Jump Cut* vol. 42 (1998): 68–72. See also Chris Berry and Laikwan Pang, eds., a special issue on transnational Chinese cinemas, *Journal of Chinese Cinemas* vol. 2, no. 1 (2008).

8 Below are book titles of transnational studies of the cinematic traditions of other regions and world cinema in general in chronological order. Raminder Kauer and Ajay Sinha, eds., *Bollywood: Popular Indian Cinema through a Transnational Lens* (New Delhi: Sage, 2005); Andrew Nestingen and Trevor G. Elkington, eds., *Transnational Cinema in a Global North: Nordic Cinema in Transition* (Detroit: Wayne State University Press, 2005); Elizabeth Ezra and Terry Rowden, eds., *Transnational Cinema: The Film Reader* (London and New York: Routledge, 2006); Brian McIlroy, ed., *Genre and Cinema: Ireland and Transnationalism* (London: Routledge, 2007); Nataša Durovičová and Kathleen Newman, eds., *World Cinemas, Transnational Perspectives* (London: Routledge, 2010); Manuel Palacio and Jörg Türschmann, eds., *Transnational Cinema in Europe* (Vienna: LIT, 2013); Matthias Krings and Onookome Okome, eds., *Global Nollywood: The Transnational Dimensions of an African Video Film Industry* (Bloomington: Indiana University Press, 2013); Pietari Kääpä and Tommy Gustafsson, eds., *Transnational Ecocinema: Film Culture in an Era of Ecological Transformation* (Bristol: Intellect, 2013); Katarzyna Marciniak and Bruce Bennett, eds., *Teaching Transnational Cinema: Politics and Pedagogy* (London: Routledge, 2017); Ana Cristina Mendes and John Sundholm, eds., *Transnational Cinema at the Borders: Borderscapes and the Cinematic Imaginary* (London: Routledge, 2018); Steven Rawle, *Transnational Cinema: An Introduction* (New York: Palgrave, 2018); Jaimey Fisher and Marco Abel, eds., *The Berlin School and Its Global Contexts: A Transnational Art Cinema* (Detroit: Wayne State University Press, 2018). The journal *Transnational Cinemas* (publisher Taylor & Francis) published its first issue in 2010.

9 Yingjin Zhang, *Cinema, Space, and Polylocality in a Globalization China* (Honolulu: University of Hawaii Press, 2009).

10 Michelle Bloom, *Contemporary Sino-French Cinemas: Absent Fathers, Banned Books, and Red Balloons* (Honolulu: University of Hawaii Press), p. 190.

11 Lumière films were not first introduced and screened in Shanghai, China, in 1896, as commonly thought, but mostly likely in 1897. See Sheldon Lu, "The First

Screenings of Lumière Films in China: Conjectures and New Findings," *Asian Cinema* vol. 30, no. 1 (2019): 129–35.

12 Liao Gene-Fon廖金鳳, producer; Hsieh Chia-kuen謝嘉錕, director, *Searching for Brodsky*尋找布洛斯基, documentary (Taipei: 48ers Production, 2009).

13 Kristine Harris, "*The Romance of the Western Chamber* and the Classical Subject Film in 1920s Shanghai," in *Cinema and Urban Culture in Shanghai, 1922–1943*, ed. Yingjin Zhang (Palo Alto, CA: Stanford University Press, 1999), p. 60.

14 Dudley Andrew, "Time Zones and Jet Lag: The Flows and Phases of World Cinema," in *World Cinemas, Transnational Perspectives*, ed. Nataša Ďurovičová and Kathleen Newman (London: Routledge, 2010), p. 62.

15 Chen Jianhua, "D. W. Griffith and the Rise of Chinese Cinema in the Early 1920s Shanghai," in *Oxford Handbook of Chinese Cinemas*, ed. Carlos Rogers and Eileen Cheng-yin Chow (London: Oxford University Press, 2013), pp. 23–38.

16 Fu, *Early Transnational Chinese Cinema Industry*, pp. 10, 29.

17 Hainan Jin, "Introduction: The Translation and Dissemination of Chinese Cinemas," *Journal of Chinese Cinemas* vol. 12, no. 3 (2018): 198.

18 Andrew, "Time Zones and Jet Lag," pp. 65–6.

19 For informative, insightful studies of Shanghai film culture, see Yingjin Zhang, ed., *Cinema and Urban Culture in Shanghai, 1922–1943* (Stanford, CA: Stanford University Press, 1999); Zhen Zhang, *An Amorous History of the Silver Screen: Shanghai Cinema, 1896–1937* (Chicago: University of Chicago Press, 2006).

20 Emilie Yueh-yu Yeh, "Introduction," in *Early Film Culture in Hong Kong, Taiwan, and Republican China: Kaleidoscopic Histories*, ed. Emlie Yueh-yu Yeh (Ann Arbor: University of Michigan Press, 2018), p. 2. See also Ye Yueyu (Emilie Yueh-yu Yeh) 叶月瑜，Feng Youcai冯筱才, and Liu Hui刘辉, eds., *Zouchu Shanghai: zaoqi dianying de linglei jingguan* 走出上海：早期电影的另类景观 (Get Out of Shanghai: Alternative Views of Early Cinema) (Beijing: Beijing University Press, 2016). For an analysis of the film scene in Chongqing, see Weihong Bao, *Fiery Cinema: The Emergence of an Affective Medium in China: 1915–1945* (Minneapolis: University of Minnesota Press, 2015).

21 Zhang Ali张阿利, *Shanpai dianshi ju: diyu wenhua lun*陕派电视剧：地域文化论 (Television Drama of the Shaanxi School: On Regional Culture) (Beijing: Zhongguo dianying chubanshe, 2008).

22 Chia-ning Chang, "Introduction: Yamaguchi Yoshiko in Wartime East Asia: Transnational Stardom and Its Predicaments," in Yamaguchi Yoshiko and Fujiwari Sakuya, *Fragrant Orchid: The Story of My Early Life*, translated with an introduction by Chia-ning Chang (Honolulu: University of Hawaii Press, 2015), pp. xvii–li; Jie Li, "National Cinema for a Puppet State: The Manchurian Motion Picture Association,"

in *Oxford Handbook Chinese Cinemas*, ed. Carlos Rojas and Eileen Cheng-yin Chow (Oxford: Oxford University Press), pp. 79–97.

23 Liao Gene-fon廖金鳳, producer; Liao Ching-Yao廖敬堯, director, *Treason by Birth*世紀懸案: 劉吶鷗傳奇, documentary (New Taipei City Ishine Creative Presents, no date.)

24 Ling Zhang, "Rhythmic Movement, Metaphoric Sound, and Transcultural Transmediality: Liu Na'ou and *The Man Who Has a Camera* (1933)," chapter 11, in *Early Film Culture*, ed. Emilie Yeh (Ann Arbor: University of Michigan Press, 2018), p. 283.

25 Weijia Du, "Exchanging Faces, Matching Voices: Dubbing Foreign Films in China," *Journal of Chinese Cinemas* vol. 12, no. 3 (2018): 285.

26 Jie Li, "Gained in Translation: The Reception of Foreign Cinema in Mao's China," *Journal of Chinese Cinemas* vol. 13, no. 1 (2019): 71.

27 Daisy Yan Du, *Animated Encounters: Transnational Movements of Chinese Animation, 1940s–1970s* (Honolulu: University of Hawaii Press, 2019).

28 Emilie Yueh-yu Yeh and Darrell William Davis, "Re-nationalizing China's Film Industry: Case Study on the China Film Group and Film Marketization," *Journal of Chinese Cinemas* vol. 2, no. 1 (2008): 37–51.

29 Wendy Brown, *Walled States, Waning Sovereignty* (Cambridge, MA: Zone Books, 2010).

30 These various flows are proposed by Arjun Appadurai in his influential book, *Modernity at Large: Cultural Dimensions of Globalization* (Minneapolis: University of Minnesota Press, 1996). But these flows might be manifested in different ways at different locations of the world as I try to describe here.

31 Anderson, *Imagined Communities.*

32 Vishakha N. Desai and David A. Ross, "Foreword," in *Inside Out: New Chinese Art*, ed. Gao Minglu (Berkeley: University of California Press, 1998), p. 7.

33 Gao Minglu, "Towards a Transnational Modernity: An Overview of *Inside Out: New Chinese Art*," in *Inside Out: New Chinese Art*, ed. Gao Minglu (Berkeley: University of California Press, 1998), p. 28.

34 Meiqin Wang, *Socially Engaged Art in Contemporary China: Voices from Bellow* (London: Routledge, 2019).

35 I clarify four concepts or models of film studies: Chinese national cinema, transnational Chinese cinema, Chinese-language cinema, and Sinophone cinema, in my essay "Genealogies of Four Critical Paradigms in Chinese-Language Film Studies," in *Sinophone Cinemas*, ed. Audrey Yue and Olivia Khoo (London: Palgrave Macmillan, 2014).

36 Yi Shui易水, *Malaiya hua huayu dianying wenti*馬來亞化華語電影問題 (Issues of Chinese-Language Film in Malaya) (Singapore: Nanyang, 1959).

37 Sheldon H. Lu and Emilie Yueh-yu Yeh, eds., *Chinese-Language Film: Historiography, Poetics, Politics* (Honolulu: University of Hawaii Press, 2005). See especially Sheldon H. Lu and Emilie Yueh-yu Yeh, "Introduction: Mapping the Field of Chinese Language-Cinema," in *Chinese-Language Film: Historiography, Poetics, Politics*, ed. Sheldon H. Lu and Emilie Yueh-yu Yeh (Honolulu: University of Hawaii Press, 2005), pp. 1–24.

38 Wai Siam Hee, "*New Immigrant*: On the First Locally Produced Film in Singapore and Malaya," *Journal of Chinese Cinemas* vol. 8, no. 2 (2014): 244–58.

39 Hee Wai Siam徐維賢, *Huayu dianying zai hou Malaixiya: tuqiang fengge,huayi feng yu zuozhe lun* 華語電影在後馬來西亞：土腔風格、華夷風與作者論 (Post-Malaysian Chinese-Language Film: Accented Style, Sinophone and Auteur Theory) (Xinbeishi: Lianjing, 2018).

40 Zakir Hossain Raju, "Filmic Imaginations of the Malaysian Chinese: '*Mahua* Cinema' as a Transnational Chinese Cinema," *Journal of Chinese Cinemas* vo. 2, no. 1 (2008): 67–79.

41 Louisa Wei, producer and director, *Golden Gate Girls*, feature documentary, 2014.

42 See, for instance, Li Daoxin李道新, "Chongjian zhuti xing yu chongxie dianying shi: yi Lu Xiaopeng de kuaguo dianying yanjiu yu huayu dianying lunshu wei zhongxin de fansi yu pipan" 重建主体性与重写电影史:以鲁晓鹏的跨国电影研究与华语电影论述为中心的反思与批判 (Re-building Chinese Subjectivity and Re-writing Chinese Film History: Reflections on and Critique of Sheldon Lu's Transnational Film Studies and Chinese-Language Film Discourse)，*Dangdai dianying* 当代电影 (Contemporary Film) no. 8 (2014): 53–8; Lü Xinyu 吕新雨, "Xin Zhongguo shaoshu minzu yingxiang shuxie: lishi yu zhengzhi" 新中国少数民族影像书写：历史与政治 (Writing Images of Ethnic Minorities in New China: History and Politics), *Shanghai daxue xuebao* 上海大学 学报 (Journal of Shanghai University) vol. 32, no. 5 (2015): 13–51; for a summary and review of the debate in English, see Shaoyi Sun, "Chinese-Language Film or Chinese Cinema: Review of an Ongoing Debate in the Chinese Mainland," *Journal of Chinese Cinemas* vol. 10, no. 1 (2016): 61–6.

43 See, for example, Jia Leilei贾磊磊, "Zhongguo dianying xuepai jiangou de fanxiang mingti"中国电影学派建构的反向命题 (The Antithetical Hypothesis of the Construction of a Chinese Film School), *Dianying yishu* 电影艺术 (Film Art) no. 2 (2018): 22–5.

44 Zhang Zhongnian张仲年, ed., *Menggu zu yingshi yanjiu*蒙古族影视研究 (Studies in the Film and TV of Mongolian People) (Beijing: Zhongguo dianying chubanshe, 2015). This anthology contains essays on films and TV programs made by Mongolian people or about Mongolian subjects in Mongolia as well as in the People's Republic of China. Some of the films are Mongolian-language films, and some are Mandarin-language films.

45 For an informative, insightful cluster of essays on the subject, see Kwai-Cheung Lo and Jessica Wai Yee Yeung, eds., "Special issue on the Tibetan Cinema of Pema Tseden," *Journal of Chinese Cinemas* vol. 10, no. 2 (2016): 89–165.

46 Vanessa Frangville, "Pema Tseden's *The Search*: The Making of a Minor Cinema," *Journal of Chinese Cinemas* vol. 10, no. 2 (2016): 107.

47 Chris Berry, "Pema Tseden and the Tibetan Road Movie: Space and Identity beyond the 'Minority Nationality Film,'" *Journal of Chinese Cinemas* vol. 10, no. 2 (2016): 91.

48 Ibid., p. 91.

49 Shu-mei Shih has defined and refined the notion of the Sinophone in many publications. See, for instance, her book *Visuality and Identity: Sinophone Articulations across the Pacific* (Berkeley: University of California Press, 2007).

50 Kuei-fen Chiu and Yingjin Zhang, *New Chinese-Language Documentaries: Ethics, Subject and Place* (London: Routledge, 2015), pp. 1–2.

51 Martin Heidegger, "The Age of the World Picture," in *The Question Concerning Technology and Other Essays*, ed. and trans., William Lovitt (New York: Harper Torchbooks, 1977), p. 130.

52 Fredric Jameson, *Postmodernism, or, the Cultural Logic of Late Capitalism* (Durham, NC: Duke University Press, 1991), p. 7.

53 See Victor Fan, *Cinema Approaching Reality: Locating Chinese Film Theory* (Minneapolis: University of Minnesota Press, 2015); Sheldon Lu, "Agitation or Deep Focus? Early Chinese Film History and Theory," a review essay, in *Harvard Journal of Asiatic Studies* vol. 76, no. 1 (June 2016): 197–207.

54 Edward Said, *The World, the Text, and the Critic* (Cambridge, MA: Harvard University Press, 1983), pp. 34–5.

55 Gayatri Chakravorty Spivak, "The Rani of Sirmur: An Essay in Reading the Archives," *History and Theory* vol. 24, no. 3 (October 1985): 247.

56 Sheldon Lu, "Re-visioning Global Modernity through the Prism of China," *European Review* vol. 23, no. 2 (May 2015): 210–26.

57 Aihwa Ong, "Introduction: Worlding Cities, or the Art of Being Global," in *Worlding Cities: Asian Experiments and the Art of Being Global*, ed. Ananya Roy and Aihwa Ong (West Sussex, UK: Wiley-Blackwell, 2011), p. 11.

58 Pheng Cheah, *What Is a World? On Postcolonial Literature as World Literature* (Durham, NC: Duke University Press, 2016), p. 42.

59 Gina Marchetti, *Citing China: Politics, Postmodernism, and World Cinema* (Honolulu: University of Hawaii Press, 2018), p. 21.

60 Ibid., p. 22.

61 Christopher Lupke, *The Sinophone Cinema of Hou Hsiao-hsien: Culture, Style, Voice, and Motion* (Amherst, NY: Cambria Press, 2016); Song Hwee Lim, *Tsai Ming-liang and a Cinema of Slowness* (Honolulu: University of Hawaii Press, 2014); Jean Ma, *Melancholy Drift: Marking Time in Chinese Cinema* (Hong Kong: Hong Kong University Press, 2010); Martha P. Nochimson, ed., *A Companion to Wong Kar-wai* (West Sussex, UK: Wiley-Blackwell, 2016).

62 Paul G. Pickowicz and Yingjin Zhang, eds., *From Underground to Independent: Alternative Film Culture in Contemporary China* (Lanham, MD: Rowman and Littlefield, 2006); Luke Robinson, *Independent Chinese Documentary: From the Studio to the Street* (New York: Palgrave Macmillan, 2012): Kuei-fen Chiu and Yingjin Zhang, *New Chinese-Language Documentaries: Ethics, Subject and Place* (London: Routledge, 2015); Zhang Zhen and Angela Zito, eds., *DV-Made China: Digital Subjects and Social Transformations after Independent Film* (Honolulu: University of Hawaii Press, 2015); Paul G. Pickowicz and Yingjin Zhang, eds., *Filming the Everyday: Independent Documentaries in Twenty-First Century China* (Lanham, MD: Rowman & Littlefield, 2016).

63 Zhen Zhang, ed., *The Urban Generation: Chinese Cinema and Society at the Turn of the Twenty-first Century* (Durham, NC: Duke University Press, 2007); Matthew D. Johnson, Keith B. Wagner, Kiki Tianwi Yu, and Luke Vulpiani, eds., *China's iGeneration: Cinema and Moving Image Culture for the Twenty-First Century* (London: Bloomsbury, 2014); Paola Voci, *China on Video: Smaller-Screen Realities* (New York: Routledge, 2010).

64 See Sheldon H. Lu and Jiayan Mi, eds., *Chinese Ecocinema in the Age of Environmental Challenge* (Hong Kong: Hong Kong University Press, 2009; Seattle: University of Washington Press, 2010); Sheldon H. Lu and Haomin Gong, eds., *Ecology and Chinese-Language Cinema: Reimagining a Field* (London: Routledge, 2020).

Part 1

Nationhood, Gender, Sexuality, Masculinity in Feature Film

Projecting the Chinese Nation on Domestic and Global Screens

In this chapter, I examine two sides of one phenomenon, namely, the representation of China on domestic and global screens. First, I look at the new ways for Hollywood to represent, appropriate, and incorporate China in its blockbuster films. This largely has to do with Hollywood's desire to increase its presence in the lucrative growing film market of mainland China. Second, I analyze the self-representation of China in mainland films, especially its own blockbusters. Spatial expansion and accelerated mobility have provided fresh opportunities for Chinese filmmakers to reimagine the place of the Chinese nation and its people in the contemporary world.

This chapter is organized into several sections. The first section is "Images of China on World Screens," where I mainly examine the evolving strategies of representing China in American films. The subsequent section is "Domestic and Global Projections of China's Self-Images," which reviews a sizeable number of Chinese films in the twenty-first century that render visions of China in their unique manners. The last section is "Interracial Politics and Gender Dynamics in *China Peacekeeping Forces*," which focuses on one particular film as a telling example in the reorientation of China's self-representation.

Images of China on World Screens

Chinese film studies, world cinema, and screen images of China might have been separate academic fields claiming different kinds of linguistic and scholarly expertise. "Chinese" film was an area study; world cinema belonged to a discipline—film studies; images and representations of China in different cinematic traditions came out of various area studies and disciplines, such as American studies, French studies, and European cinema.

However, such disciplinary boundaries have been blurred and crossed increasingly in an era of globalization. These areas and disciplines often overlap and become difficult to distinguish from each other. This is the result of both how films have been made and how academic disciplines have evolved. For instance, how would we categorize the "area" or national origin of a thoroughly transnational film such as *Crouching Tiger, Hidden Dragon* (*Wohu canglong* 卧虎藏龙, Ang Lee, 2000)?[1] Such films are coproductions, involve an international cast, and utilize multiple sources of funding and production.

There have been long-standing representations of China and Chinese on global screens. The framing and depiction of the other is necessary for the articulation and clarification of the self. Images of China, Chinese people, and Chinese culture are abundant in American cinema since the beginning. They are like a pendulum that swings back and forth between positive and negative portrayals of China over the years.[2]

During the Cold War, there was a steady stream of popular writings, musicals, and films about Asia and Americans' involvement in Asia. America's representation and taming of the other through the hands of writers and filmmakers since the end of the Second World War amounted to a special brand of Orientalist discourse, "Cold-War orientalism."[3] Such a discourse was in sync with the goal and reality of a US-led global integration in the economic, political, and cultural realms. The United States and the Soviet Union were competing for geopolitical influence as well as the hearts and minds of the people from around the world. Socialist mainland China was largely isolated from the capitalist West at the time.

In the post–Cold War era, there arise new opportunities for America to lead the world in the domain of popular culture. Cinema is an effective means for the United States to assert its influence and bring about a cultural, political, and economic integration. China's huge number of moviegoers provides an ideal ground for Hollywood to expand its overseas market.

Naomi Greene is among the most incisive critics of Hollywood's appropriations of Chinese motifs, materials, and stories for its own commercial gains. She comments on the commercial success and popularity of such animations as *Mulan* (1998) and *Kung Fu Panda* (2008) made in the United States:

> In *Mulan*, a legendary Chinese heroine is transformed into an American teenager; in *Kung Fu Panda*, the age-old Chinese tradition of the martial arts is emptied of weight and meaning. In both films, China itself is reduced to a

heap of motifs in which the Forbidden Palace and the Great Wall have no more meaning—and probably less—than egg rolls and chopsticks.

And what better way to tame the awakening dragon than to replace it with a cuddly panda or a diminutive creature like the pint-sized Mushu of *Mulan*?[4]

These films appear to be more interested in offering palatable images, motifs, and themes about a foreign land for popular consumption rather than providing authentic engagement with an ancient culture and a rising modern power.

Hollywood has become truly a global cinema. Its films are simultaneously released and watched in theaters all over the world. The arrival of Hollywood blockbusters (*Meiguo dapian* 美国大片) is eagerly waited for by spectators in China. New strategies are devised by film companies to bring Chinese spectators to the orbit of American film culture and make them identify with shared universal (American) values and emotions. Screen images of China have developed in new directions in the twenty-first century. Such films range from full-blown Hollywood feature films on Chinese subjects, to US-China coproductions, to films that reference and incorporate Chinese elements. A new trend in Hollywood is the making of blockbusters with an eye to export to and cash in on the huge Chinese film market. The Chinese film market has expanded tremendously, is second only to America in box-office revenue, and is poised to be the largest film market in the near future. Some American films inject a mix of Chinese elements, utilize Chinese locations, and employ a Chinese cast in order to endear and attract the Chinese audience. This has been called "Hollywood with Chinese elements" (*Zhongguo yuansu* 中国元素). As Yiman Wang points out, a major development in border-crossing film culture is "Hollywood's increasing investment in commercializing and cinematizing East Asian elements, and East Asia's active engagement with 'global Hollywood.' Other than appropriating iconic Chineseness (as illustrated in *Kung Fu Panda*), Hollywood has also taken an increasing interest in buying the remake rights of East Asian hit films and producing English versions."[5]

In regard to Hollywood remakes of East Asian films, a most famous case is Martin Scorsese's film *The Departed* (2006), which is a remake of a Hong Kong film, *Infernal Affairs* (*Wujian dao* 无间道, 2002).[6] The American remake wins several awards at the Academy Awards, including the long-awaited overdue Best Director Award for Scorsese. *Infernal Affairs* itself is a new development in the long tradition of Hong Kong action cinema. This twenty-first-century action film has little "action" in the old sense. It does not choreograph and showcase any of the intense physical, balletic gunplay in the fashion of John

Woo's action films from the 1980s and 1990s but updates an old genre in a new age of telecommunication by resorting to psychological subtlety. The Hollywood adaptation makes certain changes, from Hong Kong to Boston, from Buddhism to Catholicism, from Chinese actors to American actors, but maintains the overall storyline.

Film remakes across countries and continents are an integral component of transnational film culture. The remaking of foreign films goes both ways between China and the West. Chinese filmmakers also make adaptations of foreign films. Mainland Chinese director and actress Xu Jinglei 徐静蕾 directed and acted in a remake of a film based on the novella of Austrian author Stefan Zweig (1881–1942): *Letter from an Unknown Woman* (*Brief einer Unbekannten*).[7] This story was first translated into Chinese and published in Shanghai in the 1930s. It was adapted into a Hollywood film by Max Ophül in 1948 under the same title. Xu's 2005 remake, with the Chinese title *Yige mosheng nüren de laixin* 一个陌生女人的来信, under the postsocialist condition of Reform and Opening, adds another layer to the cross-cultural formation and recontextualization of women's images, feminine ideals, love, and purportedly bourgeois values from around the world. What appear to be escapist, conservative sentiments in one continent might turn out to be liberating, progressive forces at another location in a specific historical era.

A Hollywood film may have an American version for the American and global audiences and a slightly different Chinese version specifically for release in mainland China. These films make use of Chinese locations and employ Chinese actors or actresses. Renowned Chinese actress Li Bingbing 李冰冰 is cast as an important character, Su Yueming, in the science-fiction blockbuster *Transformers: The Age of Extinction* (2014). She plays the role of a feisty, strong woman with snappy martial art skills. Part of the film is shot in the streets of Hong Kong, and a sprinkling of the Cantonese dialect can be heard. Chinese model/actress Zhao Xi 赵茜 (aka Candice Zhao) appears for a fleeting moment in an elevator scene, posing as an iconic native girl with abundant sex appeal.

The superhero film *Iron Man 3* (2013) also has a Chinese version in order to break into the Chinese market. The Chinese version adds another four minutes with Chinese actors. Actress Fan Bingbing 范冰冰 and veteran actor Wang Xueqi 王学圻 appear in the film. Wang's role is Dr. Wu, and Fan plays the role of his assistant. Fan Bingbing is one of the most bankable female stars in the Chinese film industry. She was chosen to act in the science-fiction film *X-Men: Days of Future Past* (2014), playing the role of Blink in the film.

Figure 1.1 *Transformers 4: Age of Extinction*. Directed by Michael Bay. Production companies: Hasbro, Di Bonaventura Pictures. 2014. Chinese actress Li Bingbing stars in the film.

The two "Bingbings," literally "icy cold" princesses, are among China's hottest, most desired actresses. In these films, they exhibit strong fighting skills and resemble female actioners in earlier Hong Kong cinema, such as the supernatural/action feature *The Heroic Trio* (*Dongfang sanxia* 东方三侠, 1993) starring Maggie Cheung, Anita Mui, and Michelle Yeoh, as well as the James Bond franchise *Tomorrow Never Dies* (1997) starring Michelle Yeoh who fights alongside Pierce Brosnan. However, the intended audience this time is the vast number of the mainland Chinese audience in the twenty-first century.

Domestic and Global Projections of China's Self-Images

While Hollywood harbors its usual global ambition and steadily expands the overseas market, the mainland Chinese film industry also has its own outward-looking international strategy. China's objective is simply put: *zouxiang shijie* 走向世界, "going to the world." In the words of Chinese president Xi Jinping, Chinese cultural workers should "tell good Chinese stories" (*jiang hao Zhongguo gushi* 讲好中国故事) to the world.

Media industries both inside and outside China are facing the prospect of occupying the world's biggest market, or "playing to the world's biggest audience."[8]

Figure 1.2 *X-Men: Days of Future Past*. Directed by Bryan Singer. Production companies: Marvel Entertainment, TSG Entertainment, Bad Hat Harry Productions, The Donners' Company. 2014. Chinese actress Fan Bingbing plays the role of Blink.

China's huge population, combined with a vast diasporic population, makes up one of the largest film audiences in world. As some have predicted, China's fast-growing media industry could potentially shake the hegemony of Hollywood in the twenty-first century. Mainland Chinese filmmakers themselves have been anxious to create their own blockbusters that would be watched by world audiences in the same way that Hollywood blockbusters have been received around the world. But the truth of the matter is that only a specific genre of Chinese-language film, martial arts/action, has been able to achieve the status of global blockbusters.[9] These films are the fruits of the globalization of China's media industry in the form of coproductions with Hollywood. Noticeable examples are *Crouching Tiger, Hidden Dragon* (Ang Lee, 2000), *Kung Fu Hustle* (*Gongfu* 功夫, Stephen Chow, 2004), *Hero* (*Yingxiong* 英雄, Zhang Yimou, 2002), and to a lesser extent two other films directed by Zhang Yimou, *House of Flying Daggers* (*Shimian maifu* 十面埋伏, Zhang Yimou, 2004) and *Curse of the Golden Flower* (*Mancheng jindai huangjin jia* 满城尽带黄金甲, 2006).

Chinese filmmakers have put in tremendous efforts to project China's soft power in the world. They make coproductions to attract the attention of the international audience. Such films are often big-budget productions. They give significant roles to white Hollywood actors. Zhang Yimou's action/monster

film *The Great Wall* (Changcheng 长城, 2017, starring Hollywood actor Matt Damon) is such an example. However, this expensive Chinese-US coproduction neither reaped commercial success nor garnered critical acclaim. The box-office sales in China and globally were disappointing. The intention of impressing the world stage in a big way did not succeed.

Another way to generate a global feeling is to make blockbusters about China's international adventures and newfound strength. These are Hollywood-style Chinese action films and science-fiction films. They describe and imagine China's rise on the world stage. A series of such action/military films have been made: *Wolf Warrior* (*Zhanlang* 战狼, 2015), *Wolf Warrior 2* (*Zhanlang* 战狼 2, 2017), *Operation Mekong* (*Meigonghe xingdong* 湄公河行动, 2016), *Operation Red Sea* (*Honghai xingdong* 红海行动, 2018), and *Sky Hunter* (*Kongtian lie* 空天猎, 2017). Special Chinese task forces act inside and outside of China's borders and venture to other regions of the world: Southeast Asia, the Middle East, and Africa. These films employ an international cast from other nations with diverse ethnicities: Chinese, white, black, Asian, African, American, and European. In the films, the Chinese navy, the Chinese air force, and Chinese special task forces rescue people from the evil doings of bandits and terrorists, who are often headed by white European and American mercenaries. *Wolf Warrior 2* and *Operation Red Sea* are the highest grossing films in the mainland at the time of their domestic releases. *Operation Red Sea* is called the first Chinese navy action film. *Sky Hunter* is advertised as the "first Chinese aerial action blockbuster" in publicity. In all these films, brave Chinese soldiers fight drug lords, terrorists, and mercenaries; save Chinese nationals and foreigners from dangers; and protect people from all the world. This kind of global action films is usually seen and reserved for Hollywood films. The Chinese film industry endeavors to create its own stories of Chinese (male) heroes as the rightful saviors of the world.

Operation Red Sea is a lavish, extravagant production. This fictional film is about the evacuation of Chinese nationals by a special task force of the Chinese navy from a country in the Middle East when the country is caught in chaos, violence, and terrorism. The story is loosely based on the evacuation of Chinese nationals and other peoples from war-torn Yemen in 2015. The film is shot on location in several countries. These locations include Casablanca, Morocco's capital city Rabat, the Sahara Desert, Chinese seaport Zhanjiang, and Sanya in Hainan Island, China. Hundreds of Moroccans are enlisted as extras while shooting in Morocco. The Chinese navy lends itself to the making of the film. The film projects images of the benign humanitarian efforts of the Chinese state and the collective heroism of its military on the world stage.

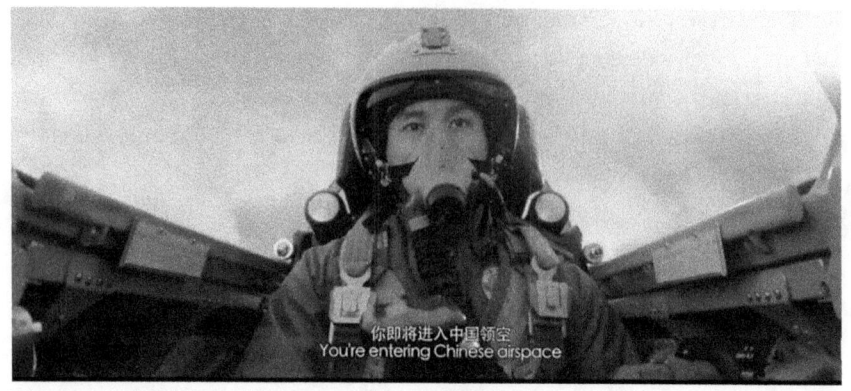

你即将进入中国领空
You're entering Chinese airspace

Figure 1.3 *Sky Hunter* (*Kongtian lie*). Directed by Li Chen. Spring Era Films. 2017. A Chinese pilot asks foreign airplanes to leave Chinese air space.

The transnational gender dynamics in the film *Sky Hunter* is noteworthy. The film showcases the skills and bravery of Chinese pilots in defending China's air space against foreign incursions. In one intriguing scene, Chinese jet fighters meet foreign planes in the air. A Chinese pilot speaks English and warns the foreigners that they have illegally entered Chinese airspace and must leave immediately. The foreign copilots of a plane are a pair of male and female officers. As they respond to the order from the Chinese male pilot, they banter about his spoken English and their own wish to study Mandarin. The female pilot, who by all appearance looks like a white American officer, makes a joke and complements the Chinese pilot: "He is kind of cute." This offhand comment on the Chinese pilot through a casual conversation between two foreign pilots in the air does seem to speak to the not-so-subtle self-aggrandizement of the ego of the Chinese military.

In these films, the Chinese military is everywhere on earth—land, sea, and air, inside and outside China. But expanding to overseas is still not enough. The next step is to venture outward further, beyond planet earth, into outer space. China produces its own action/science-fiction film, *The Wandering Earth* (*Liulang diqiu* 流浪地球, 2019), adapted from a novella by Liu Cixin 刘慈欣, who is a winner of the Hugo Science Fiction Award and other prestigious awards. Set in a future time, Chinese astronauts successfully manage to move the earth out of the solar system that was about to explode and engulf the earth, and consequently save humanity and earth from a potential disaster. The film is also one of the highest grossing films in China upon its release. Netflix has bought the right to stream the film in its platform. Once again, such a cultural product seems to parallel the interstellar, cosmic imaginations and ambitions of the Chinese nation. These

他挺可爱的
He is kind of cute.

Figure 1.4 *Sky Hunter* (*Kongtian lie*). Directed by Li Chen. Spring Era Films. 2017. A female foreign pilot jokes about the Chinese male pilot.

films, laden with large doses of male steroid, patriotism, and national pride, have been very popular with China's domestic audience and have achieved remarkable box-office success. However, they fail to win critical acclaim and popular appeal outside mainland China. The world audience does not seem to be interested in watching the global missions and adventures of China, military or otherwise.

In the grand stories about China's rescue of the world, or in the little tales about ordinary Chinese citizens' travels in the world, there is often an intriguing interracial gender dynamic at work. There involves a relationship between Chinese males, as soldiers or travelers, and foreign women, many of whom happen to be portrayed by Ukrainians working in mainland China's entertainment industry. Chinese masculinity in a multinational setting remains a central theme of these films. The film I analyze in the following is such an example.

Interracial Politics and Gender Dynamics in *China Peacekeeping Forces*

I would like to dwell on one particular film: *China Peacekeeping Forces* (aka, *Peacekeeping Force, Zhongguo lankui* 中国蓝盔, Ning Haiqiang 宁海强, 2018). I myself first watched this film on the movie menu of the inflight entertainment program of an Asian airline on a transpacific flight between San Francisco and an Asian city in 2019. I mention this personal anecdote about watching a Chinese film with a purportedly international theme in a long flight from the United States to Asia only to point out the globalizing environment of cultural entertainment across nations and continents nowadays.

The film is an action/drama film that pays homage to China's contribution to the United Nations peacekeeping missions around the world. It is released on the heels of *Wolf Warrior 2* and *Operation Red Sea*, which seem to have served as its model; but it cannot compare with them in terms of popular appeal and box-office success. As I will explain, the film is about the resurrection of national pride by way of Chinese masculinity. Ironically, to my mind, the male actors are short of the usual sort of masculine screen charisma and their acting looks unnatural and awkward in their interactions with (foreign) female characters. The film is lacking in male star power even though one real professional martial artist Yi Long 一龙 is recruited to join the cast as a warrior character.

Interestingly enough, two white foreign female characters play prominent roles. Their exotic allure stands out and steals much of the spectacle against the backdrop of African natives and uniformed Chinese male soldiers. I single out this film for detailed analysis because of its interracial politics and gender dynamics. The film weaves a meaningful tale of convoluted racial and gender relationships among black African men, white European women, and male Chinese soldiers. The specific crafting of the narrative, images, and words is not accidental; the film envisions the quintessential position of China on the contemporary world stage in the end. This is accomplished by way of a detour, by the incorporation of exotic others, namely foreign female characters, to highlight the strength of Chinese men and the nation.

The main production company of the film is the August First Film Studio, which belongs to the People's Liberation Army. But the film also employs a transnational mode of production as it recruits an international cast. It involves actors and actresses from many countries such as Ukraine, the United States, Germany, France, South Africa, Ethiopia, Zimbabwe, and Rwanda. Much of the location shooting is completed in South Sudan, Africa.

The lead female role is Lieutenant Sophie (Irina Kaptelova), an officer of an investigation team of a UN peacekeeping force. She was saved from death by a Chinese soldier, Du Feng 杜峰, in a previous United Nations mission in Lebanon. Du Feng was able to depose a bomb and protect fellow members of a UN peacekeeping force. On the other side of the fence, a prominent female character is an enigmatic lady, Dr. Annie (Daria GZ), a disguised medical doctor but actually the head of a terrorist organization in Africa.

The film opens with medium shots and long shots of violence, devastation, and carnage in war-torn East Africa. The first close-up of a person in the film is that of an innocent-looking, blonde woman wearing the white uniform of a doctor. She is Dr. Annie. She and other civilians are imprisoned in a camp. The

Figure 1.5 *China Peacekeeping Forces* (*Zhongguo lankui*). Directed by Nie Haiqiang. August First Film Studio. 2018. Lieutenant Sophie, Annie disguised as a medical doctor, and Chinese soldiers in Africa.

setting is the town of Wanzhen, where a massacre already happened. A bomb is timed to explode and kill them all. Chinese soldiers under the aegis of a UN peacekeeping force arrive at the scene on time to save them. Squad leader Chen Zhiguo deposes the bomb seconds before the timed explosion and rescues Annie and all prisoners. Yet, a follow-up explosion kills Chen Zhiguo ten seconds later. He dies as a Chinese martyr in the land of Africa.

The United Nations sends a team to investigate the event. Lieutenant Sophie on the team requests the UN commander that Chinese soldier Du Feng joins them. Sophie and Du Feng worked together previously on a UN assignment in Lebanon. Du Feng deposed a bomb and saved the lives of Sophie and others. Consequently, a special Chinese task force headed by Du Feng is dispatched to Africa and begins its operation.

The head of the local African terrorists is a person nicknamed "Nile Crocodile." However, their true boss is gradually revealed. The film audience hears the off-screen voice of a woman who speaks and instructs the local rebels to resist the United Nations and the Chinese. In her own words, she and her group want African mineral resources. As the film develops, the true identity of Dr. Annie is exposed as her actions and words become suspicious and inconsistent, and lighting on her face and camera shots of her head become dark, sinister, and distorted. She is White Widow, the boss of the African terrorist group.

The portrayal of Annie is reminiscent of a long tradition of female spies (*nü tewu* 女特务) in China's socialist film history, especially in the anti-espionage genre (*fante pian* 反特片). These egregious negative characters make a strong impression on the minds of the Chinese audience who do not have chances

to witness and interact with other types of people and experience alternative lifestyles. The duplicitous female spies look attractive and mysterious. These roles must be cast in such a way early in the film in order to deceive and endear unwary Chinese citizens within the film narrative. Ironically, such negative female characters were the first screen lovers for many young male spectators in the Mao era. The positive female revolutionary heroes on the screen act and talk in predictable manners, wear unisex uniforms, and provoke no sexual excitement. They tend to be flat, one-dimensional, politically correct characters. In contract, the female spies appear to be complex, uncanny, unusual characters. Now that a foreign woman joins the rank of the deceptive woman is an interesting development in Chinese cinema. And this becomes a possibility because of the spatial expansion in a transnational world.

In the episode about White Nile Hotel, which is a turning point toward finding out the real identity of Annie, camera shots of Annie are rather intriguing. Blonde-haired Annie walks down the stairs of the hotel, wearing a white dress and a blue scarf. Frontal views of her movement are captured in slow motion. Her mysterious look, shapely figure, and legs are shot in an enticing way under hazy lighting. She appears simultaneously attractive and dubious, lovely and devious, warm and cool. As the viewers soon discover, the terrorists have planned the bombing of the hotel to kill the UN investigation team. The mastermind behind it all is none other than Annie.

Midway in the film, Annie inadvertently blurts out that she hopes to avenge the death of her late husband in the bombing of London subway. In such a way,

Figure 1.6 *China Peacekeeping Forces (Zhongguo lankui).* Directed by Nie Haiqiang. August First Film Studio. 2018. Annie walks down the stairs of White Nile Hotel.

a white European is ultimately responsible for the carnage in Africa. Violence is displaced from black Africans in East Africa to white Europeans. The greed for Africa's natural resources seems to be a natural manifestation of a continuous neocolonialism. It is then the task of Chinese soldiers to defeat White Widow and all the evil that her group represents.

Soldiers of the Chinese special task force are necessarily all male members. But they interact, banter, cooperate, or fight with these foreign women as the occasion arises. The two erstwhile comrades on a previous assignment in Lebanon, Sophie and Du Feng, work together again this time in East Africa. In the scene of their reunion in Africa right upon Du Feng's arrival, a deeply emotional Sophie sees Du Feng, rushes to him, and embraces him at the brink of tears. Nothing can adequately express her bonding with and gratitude for him. He saved her life in Lebanon. Their mutual affection seems to go beyond an ordinary working relationship. Here is part of an intriguing conversation when they analyze a difficult situation at hand.

Du Feng speaks in Chinese: Your Chinese gets so much better.
Sophie replies in Chinese: That is all for you.

(A pause. Surrounding Chinese soldiers are amazed and gaze at them.)

Du Feng asks in Chinese: Why?
Sophie replies in Chinese: Because your English is so bad.
Du Feng says in English: I am sorry.

As the story develops, members of a special UN coordination team are ambushed and kidnapped by the terrorists. Sophie is among the kidnapped group. She is tied up and being interrogated by Nile Crocodile. She is defiant to the terrorists and remains loyal to the UN and the Chinese soldiers. Being frustrated, the savage and lustful native Nile Crocodile rips open her clothes and is about to assault her sexually. At this crucial moment, as her bosom was partially exposed on the screen for a split second, the Chinese special task force arrives, beats back the rebels, and rescues Sophie.

The scene of action in the film is a fictional East African country, South Cudan (*Nan kudan* 南库旦), echoing the name of a real East African country: South Sudan. The Chinese soldiers are caught in a struggle between world peace and terrorism, between Third World solidarity and European neocolonialism, enacted through transnational dramas between Chinese male soldiers and foreign women. They are idealized as guardians of world peace and the embodiment of self-sacrifice, courage, heroism, and honor. The film pays a

tribute to the contribution that China has made for UN peace missions around the world. At the end of the film, the words on the screen state that China has completed 24 UN peace missions, 35,912 Chinese soldiers have served such peace missions, and 13 of them have died in other countries since 1990.

This genre of military/action film has pointed to a new direction for the growth of China's film industry. It combines elements from the so-called "main-melody films" (*zhu xuanlü* 主旋律) and commercial films into a new type of Chinese blockbuster. The main-melody films are usually state-commissioned propaganda films about the communist revolution, socialist nation-building, model cadres, and national heroes. This new type of military/action film is both didactic and entertaining, nationalistic and popular. Due to its phenomenal box-office success, it boosts the power of the domestic film industry and constitutes a substantial counterweight to imported American blockbusters (*meiguo dapian* 美国大片) in the Chinese film market. In the final analysis, films like *China Peacekeeping Forces* reenvisions and consolidates the place of China and the national identity of its citizens in the contemporary world by resorting to the resources and opportunities that have become available in the time of globalization.

Figure 1.7 *China Peacekeeping Forces (Zhongguo lankui)*. Directed by Nie Haiqiang. August First Film Studio. 2018. Lieutenant Sophie (Irina Kaptelova) among UN peacekeeping soldiers and local Africans.

Notes

1 Sheldon Lu, "Crouching Tiger, Hidden Dragon, Bouncing Angels: Hollywood, Taiwan, Hong Kong, and Transnational Cinema," in *Chinese-Language Film: Historiography, Poetics, Politics*, ed. Sheldon H. Lu and Emilie Yueh-yu Yeh (Honolulu: University of Hawaii Press, 2005), pp. 220–33. See also Whitney Crothers Dilley, *The Cinema of Ang Lee: The Other Side of the Screen* (New York: Wallflower Press, 2014).

2 Naomi Greene, *From Fu Manchu to Kung Fu Panda: Images of China in American Film* (Honolulu: University of Hawaii Pres, 2014), especially chapter 1, "The Pendulum Swings … and Swings Again," pp. 1–16.

3 Christina Klein, *Cold War Orientalism: Asia in the Middlebrow Imagination, 1945–1961* (Berkeley: University of California Press, 2003).

4 Greene, *From Fu Manchu to Kung Fu Panda*, pp. 14, 214.

5 Yiman Wang, *Remaking Chinese Cinema: Through the Prism of Shanghai, Hong Kong, and Hollywood* (Honolulu: University of Hawaii Press, 2013), p. 1.

6 For a vigorous critical analysis of the *Infernal Affairs* film series and its American adaptation, see Gina Marchetti, *Andrew Lau and Alan Mak's* Infernal Affairs—the Trilogy (Hong Kong: Hong Kong University Press, 2007).

7 Arnhilt JohannaHoefle, *China's Stefan Zweig: The Dynamics of Cross-Cultural Reception* (Honolulu: University of Hawaii Press, 2018); Shaohua Guo, "*Wenyi, Wenqing* and Pure Love: The European Imaginary in Xu Jinglei's Films," *Journal of Chinese Cinemas* vol. 12, no. 1 (2018): 41–58.

8 Michael Curtin, *Playing to the World's Biggest Audience: The Globalization of Chinese Film and TV* (Berkeley: University of California Press, 2007).

9 For a relevant insightful study, see Kin-Yan Szeto, *The Martial Arts Cinema of the Chinese Diaspora: Ang Lee, John Woo, and Jackie Chan in Hollywood* (Carbondale: Southern Illinois University Press, 2011).

2

Space, Mobility, Modernity: The Female Prostitute in Chinese-Language Film

This chapter is a study of the figure of the modern Chinese female prostitute by examining a series of Chinese-language films. I describe a pattern of increasing mobility on the part of the Chinese prostitute from the turn of the twentieth century to the turn of the twentieth-first century. The spatial expansion of the female prostitute over a long historical time span has to do with the evolving conceptions and realities of the modern Chinese nation-state within a global capitalist system. Chinese modernity, as literally embodied by the figure of the prostitute, must be necessarily understood in specific gender relations. I gaze at the face and body of the Chinese prostitute as envisioned in several films respectively from China, Taiwan, and Hong Kong: *Flowers of Shanghai* and *Three Times* by Taiwanese director Hou Hsiao-hsien; *Goddess* from Shanghai cinema in the silent era; and finally the prostitution films of Hong Kong director Fruit Chan. The varying representations of the prostitute in the cinematic traditions of these regions bespeak different film aesthetics. Moreover, the changing face and body of the prostitute arises out of specific historical moments of modernity in the Greater China area. To borrow the title of Hou's film *Three Times*, I demarcate successively three times in modern Chinese history and describe the corresponding phases/faces of gender politics as embodied by the figure of the Chinese prostitute. There are numerous Chinese-language films involving female prostitutes, and it is impossible to examine them all. The purpose is to focus on selected films to outline certain general tendencies in film culture and modern China.

What I hope to outline is the evolution and transformation of the figure of the female prostitute from an immobile indoor *house-sitter* (*Shanghai Flowers* and *Three Times*) at the turn of the twentieth century and early twentieth century, to a mobile outdoor *street-walker* (*Goddess*) in 1930s Shanghai, to a long-distance

border-crosser at the turn of the twenty-first century in post-1997 Hong Kong. This is a pattern of accelerated mobility of people over a long historical period.

All the films I discuss below happen to be stories of female prostitutes and heterosexual relationships. And almost all the films that I analyze in regard to issues of Chinese masculinity in the next two chapters of the book revolve around heterosexual relationships. However, my book does not necessarily champion forms of heteronormative, male/female binary relationship to the exclusion and marginalization of other types of sexual relationships. As a diasporic, ethnic, male scholar, I am aware that my research could be ridden with both insight and blindness. Indeed, my ensuing analysis will illustrate the problematic nature of exploitative heterosexual sexuality as represented in Chinese-language cinema. Historical trauma and social oppression occur through the bodies and inside the psyche of female prostitutes and male characters even as they seek liberation from patriarchal bondage.

Static Camera and Immobility on the Eve of Modernity

Hou Hsiao-hsien's film *Flowers of Shanghai* (*Haishang hua* 海上花, 1998) is a film adaptation of an eponymous late-nineteenth-century novel by Han Bangqing 韩邦庆. This is a story of the lives of courtesans in the International Settlement of Shanghai toward the end of the nineteenth century. What is most noticeable is that the prostitutes are decidedly immobile in this film as framed by the director's immobile camera. Although Shanghai is at the cusp of modernity in that historical moment, courtesans/prostitutes do not have the freedom of being streetwalkers. These are not free-roaming modern subjects. They are confined to their respective houses, waiting to be visited and bought out by rich patrons. Their movement is hampered by their own bound feet, which are thought to be indicative of refinement and femininity in late imperial China. The courtesans do not go out to the open aggressively recruiting clients, but only travel out of their houses in carriages when booked by wealthy patrons. In order to be free, they must be bought out by their lovers and would-be husbands. Spatial fixity in the film is heightened by the signature long takes of Hou's cinematography. These slow-paced long takes of the interior of the houses of the courtesans, sometimes lasting for minutes without any cut, graphically signify the claustrophobic atmosphere of the place and the confinement of all these women.

Throughout the film, there is not a single shot of an outside scene. All the actions take place within the interior of a building. There is no establishing

shot of the larger outdoor physical environment. Although the setting of the film is the British Concession in semi-colonial Shanghai, the film describes a completely Chinese world without any reference to the international scene in Shanghai or China at large. Such ellipses, silences, and absences about the immediate geopolitical situation remain intriguing. The self-enclosure of the brothel in Shanghai appears to be metonymic of the Chinese nation itself on the global stage of the modern world at the time.

The courtesans in the film: Crimson, Jasmine, Emerald, and Jade, are in a perpetual state of vigilance, competition, conspiracy, and jealousy as they hope to win and hold the affections of male patrons such as Master Wang and Master Luo. This is a world of love, loyalty, betrayal, and bondage between men and women. Lucky is the one who is bought out of the house/brothel by a sincere patron. For instance, the narrative of the film registers a specific moment in one scene: October 6, 1884, the day when Emerald, an attractive yet feisty courtesan, gained freedom as she and her lover Master Luo bought her out by paying the Madame enough taels of silvers and transferring to her a long list of treasures. These precious objects that Emerald gave to the Madame make up a curious and astonishing list: one blue crystal bracelet; one pair of cloud-pattern earrings; one pair of blue chrysanthemum pearl earrings; one pair of inlaid-gold jade earrings; one jade bat-pattern pendant; one embroidered silk blouse, maroon, with phoenix pattern; one embroidered silk shirt, black, with flower pattern; one embroidered silk blouse, black, with cloud pattern; two large trunks, two medium and two small; cotton items, with or without linings: ten trunks. As clearly spelled out by this exhaustive list of dazzling material objects, the courtesan's freedom rests on her exchange value in an economy of affect and sexuality within a male dominated society in the late Qing period.

Figure 2.1 *Flowers of Shanghai* (*Haishang hua*). Directed by Hou Hsiao-hsien. Producers: Shozo Ichiyama, Yang Teng-kuei. 1998. Emerald in the middle of the frame.

Shifting from the seaport city of Shanghai to the island of Taiwan, Hou Hsiao-hsien's film *Three Times* (*Zuihao de shigang* 最好的时光, literally *Best Times*, 2005) again depicts the figure of the courtesan/prostitute at great length. This is the second story of the film: A Time for Freedom, or a Dream for Freedom (*ziyou meng* 自由梦). Actress Shu Qi wins the Award for Best Actress at Taiwan's Golden Horse Film Festival for her role in the film. This chapter of the film is set in Japan-occupied colonial Taiwan in 1911. The Qing government has ceded Taiwan to Japan in the Treaty of Shimonoseki (in Chinese: Treaty of Maguan, *Maguan tiaoyue* 马关条约) in the aftermath of its defeat in the Sino-Japanese War. A courtesan, performed by Shu Qi 舒淇 but whose name is never given, is often visited by a male patron, a journalist (Chang Chen 张震), whose name is also not revealed. This moment in the film is the time when Liang Qichao 梁启超 visits Taiwan from Japan. Liang is a leader in the failed Reform Movement (*weixin yundong* 维新运动), is wanted by the Qing government, and flees to Japan. The journalist accompanies Liang in his Taiwan tour, and is very much inspired by his ideas. Liang tells his Taiwanese friends that the Chinese government will not be able to regain Taiwan from Japanese rule in the next thirty years. Parallel to the dream of Taiwan's freedom is the plot of the pursuit of freedom on the part of courtesans in the brothel. Shu Qi's character dreams of someone who can be "depended upon for a lifetime" (*zhongshen youtuo* 終身有托). Her hope is that some day her lover-journalist will ransom and buy her out and take her as a concubine, mimicking what happened to A Mei ("Spring" in English subtitles in the film), a fellow courtesan in the brothel. Toward the end of this chapter of the film, the courtesan raises this question of her lifetime freedom/dependence to the journalist. The latter's attitude is nonresponsive. As a result, the freedom of the courtesan and of Taiwan remains an elusive dream as they stay in bondage to an old institution and a foreign ruler. The irony of the historical situation becomes all the more apparent when this section ends with the news of the Wuchang Uprising in China, which leads to the end of the Qing Dynasty, the founding of the Republic of China, and the beginning of a modern nation.

The segment "A Time for Freedom" is also shot in Hou's typical static camera style. What is most extraordinary is that dialogues are projected on the screen as intertitles in the same way as in a silent film. The subdued minimalist acting, elegant speech patterns and real poetry (projected on screen), the setting, costumes, lighting, slow-paced editing, the absence of close-ups, and abundant use of medium and long shots—all these create a sense of historical distance and evoke a bygone era. At that historical juncture, Taiwan cannot count on mainland

Figure 2.2 *Three Times* (*Zuihao de shiguang*). Directed by Hou Hsiao-hsien. Producers: Hua-fu Chang, Wen-Ying Huang, Ching-Sung Liao. 2005. A courtesan (Shu Qi) and her patron/journalist (Chang Chen).

China for liberation from servitude just as the courtesan cannot depend on her male patron for gaining freedom. Hence, the figure of the classical courtesan on the eve of modernity is made to function as an allegory of a large political situation, namely, the uncertain fate of the land of Taiwan. As Liang Qichao rightfully predicts, Taiwan's independence from Japan indeed has to wait for some thirty years from that time (1911). Truly, it is not until 1945, at the end of the Second World War, more than thirty years later, when Taiwan is handed back to Chinese sovereignty.

After all, it should be noted with caution that the static setting of prostitution in Taiwan and possibly the passive state of Taiwanese society as a whole in this historical period are the representation of Hou Hsiao-hisen's film art. Hou is a contemporary filmmaker and possesses an idiosyncratic style of filmmaking. It remains to be seen whether Hou's representation of late Qing society as an enclosed, immobile space risks essentializing what might be an otherwise open and transnational space from a contemporary perspective.

Mobility and Streetwalking in Republican Shanghai

One of the most memorable Chinese prostitution films of all time is undoubtedly Wu Yonggang's 吴永刚 *Goddess* (*Shennü* 神女, 1934) from the silent era. This film has received plenty of scrutiny in scholarship and criticism, and it predates the historical period of my primary focus. Now I choose to revisit the film in order to better frame certain issues such as space, mobility, and modernity, and to make some meaningful comparisons with later films.

The lead actress performing the role of "goddess," namely a prostitute, is none other than the legendary star of the era Ruan Lingyu 阮玲玉. Ruan's character roams the streets of Shanghai in order to pick up customers. Shanghai is the showcase of Chinese modernity in the 1930s, and the nocturnal street-walking goddess is an apt sign of modern mobility.[1] This free-roaming female in the open streets of a city was unseen in premodern China. She is an epiphenomenon of modernizing China in the Republican Era, when China's cultural and political centers are located in Shanghai and Nanjing. The profession of the urban prostitute in 1930s Shanghai is more mobile than many other jobs that women could possibly have in any part of the country. The prostitute and her likes leave the bondage of the traditional village to seek opportunities and freedom in the metropolis. Nonetheless, it should be pointed out that the immodest activities of the mobile streetwalker are under the surveillance of the modern nation-state. She is now and then monitored, harassed, disciplined, and arrested by the police. Furthermore, she does not cross the border and must stay inside China.

Cinematography was effectively deployed to aid characterization in *Goddess*. The frequent close-ups of Ruan Lingyu's face throughout the film testify to her remarkable acting skill. After a long's night work, Ruan's tired body walks back home. The minute she sees her child and picks him up from the crib, she transforms into a different person. Sometimes intercut and cross-edited with the flashing neon lights of Shanghai's night in the background, a single close-up of Ruan's face can simultaneously express a range of feelings: love and hate, hope and despair, pride and shame, as the character herself is the incarnation of both mother and sex worker. In other words, the close-up of the modern woman's face reveals the contradictions of modernity in the metropolis. As Mary Ann Doane aptly puts it, "The face carries a multiplicity of sometimes contradictory significations—modernity, timelessness, clarity, illegibility, objecthood, excessive subjectivity—but its ubiquity and semiotic centrality in modernity are linked specifically to the vicissitudes of female sexuality, its lure and threat."[2]

The close-up of the face is crucial in this film. Also important are shots of other body parts, such as the feet. Finally unbound and let loose after centuries of binding, the feet of Chinese women saunter freely in the public space of a modernizing city. A highly suggestive shot of the film is a shot of the feet of the goddess and that of a male customer walking together in unison. This is an artful allusion to the fact that the prostitute has found a client and they are on their way to the business of flesh transaction. The freedom of movement, or nightly walk, is registered by these kinds of shots.

Figure 2.3 *Goddess* (*Shennü*). Directed by Wu Yonggang. Lianhua Film Company (United Photoplay). 1934. Close-up of the face of Goddess (Ruan Lingyu) expressing mixed, conflicting emotions.

However, the prostitute's servitude to patriarchy and male authority is also unmistakably captured in memorable shots. For instance, there is a rather symbolic shot of the Goddess holding her small son from under the legs and crotch of the Boss, a husky male gambler who has taken control of her life because he "saved" her from a police raid one night. The male domination of the sexuality and livelihood of the female is graphically brought forth to the viewer. The world of Shanghai that she deals with consists of powerful male characters: the school principal, members of the school board, judges in the court, the police, gamblers, and thugs.

In the scene of the trial for her murdering the Boss, the frontal shots of her are rather striking. She stands in the middle of the frame, flanked by two male guards, looks directly in the eyes of the judges, in the direction of the film spectator. It is as if she were asking the general film audience to judge her: "Am I innocent? Am I a criminal?" "You the judges, the court, the film audience, and society in large, you decide what I am doing is right or wrong, moral or immoral." She indicts the entire patriarchal society for the tragedy of her life.

Given the spatial expansion of the terrain of the activities of the prostitute in the twentieth century, her options and social choices are still limited. The film cuts back and forth between the indoor private space of the home of the prostitute and the public outdoor space of the streets of Shanghai. However, as Kristine Harris points out, "The artificiality and alternation of these spaces underscores the highly circumscribed patterns of daily life for this goddess, as she attempts to maintain a separation between her two roles as mother and streetwalker."[3]

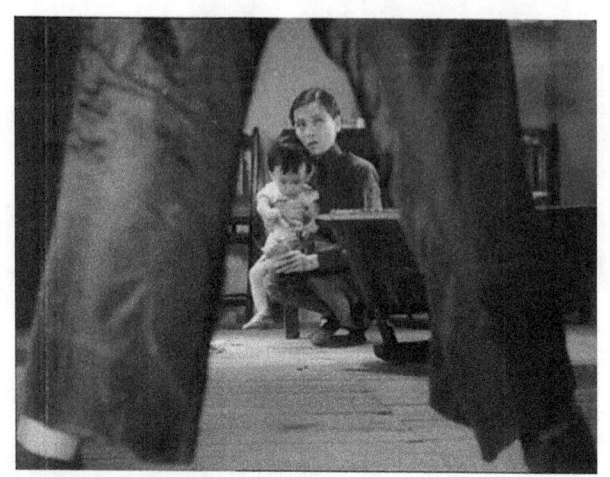

Figure 2.4 *Goddess* (*Shennü*). Directed by Wu Yonggang. Lianhua Film Company (United Photoplay). 1934. Goddess and her small son under the control of a local gangster.

Figure 2.5 *Goddess* (*Shennü*). Directed by Wu Yonggang. Lianhua Film Company (United Photoplay). 1934. The trial of Goddess in a courtroom.

Despite the newly gained mobility in the modern metropolis, Chinese women, streetwalking or otherwise, still could not escape the oppressive power structure of a patriarchal society. At the end of the film, the goddess is locked in a jail, and her only hope pins on the imaginary bright future of her male child.

An extraordinary feature of this film is the depiction of what amounts to the emergence of a public culture in Chinese society at the time. The issue of prostitution is discussed in the setting of a budding public sphere in a Chinese

urban center. Questions of tolerance, intolerance, discrimination, inclusion, exclusion, and stigmatization in regard to prostitution are heatedly debated in a fledging public culture and civil society in Republican China as envisioned in the film. The issue is brought up in the school's board meeting, which is literarily a platform for such a social debate. The school principal and the board members discuss and examine different sides of the issue, the pros and the cons. Although he is the most powerful person in the school, the principal must follow the recommendation of the school board against his own personal opinion. He and his colleague need to take into consideration the attitudes and feelings of children's parents and the community.

The trial scene in the courthouse is also an effective rendition of a public space. What appears to be the defense lawyer argues vigorously for Goddess. The judges listen and evaluate the situation. As mentioned, the frontal camera shots of Goddess directly facing the audience call on the audience and the general public to consider the matter and make their own judgment.

The school itself is a gated community. Only kids with good and clean background can enroll there, so to speak. The neighbors and parents gossip about their environment and suspicious people in the neighborhood. There are powerful camera shots of Goddess looking at the inside of the school from the outside through the bars of the school gate. Toward the end of the film, there are also shots of Goddess inside the prison through the bars of the door of her cell. These "behind-the-bars" shots are an effective framing of the mechanisms of inclusion and exclusion.

Public space, or the public sphere, is a crucial component of a modern civil society. Citizens ought to have the right to participate in debates and deliberations about their society and community through a rational, intersubjective process. However, this essential link in nation-building is short-circuited in the Republican period. Rational public debates are drowned in the loud rhetoric and mass movements of class struggle, social revolution, anti-imperialism. The treatment of the figure of the prostitute in the film *Goddess* appears even more rare and astonishing in comparison to the depiction of prostitution in films released at approximately the same time or later in the so-called Left-wing Film Movement. In such films as *Boatman's Daughter* (*Chuanjia nü* 船家女, dir. Shen Xiling 沈西苓, 1935) and *Street Angel* (*Malu tianshi* 马路天使, dir. Yuan Muzhi 袁牧之, 1937), the possibility of a debate about the phenomenon of prostitution within the framework of a functioning civil society does not exist. Class inequality, social injustice, and foreign invasion are attributed to be the origins of prostitution, social evils, and personal tragedies. In *Street Angel*, the two sisters,

Xiao Hong and Xiao Yun, are refugees and migrants from northeast China, which was controlled by Japan since the September 18 Incident in 1931. While Xiao Hong (actress Zhou Xuan 周旋) becomes a singer, Xiao Yun succumbs to the fate of a prostitute in order to survive. Class inequality in Shanghai is the cause of Xiao Yun's suffering and tragic death at the end of the film. In *Boatman's Daughter*, class is also the key issue. Class division between the rich and the poor caused Ah Ling, the daughter of a poor old boatman, to take on prostitution. In these films, moral indignation, condemnation of the rich, and social protest are the dominant themes. There seems to be a hint that a revolutionary overhaul of a corrupt society might be the only route to social progress. The fine-tuning of a nascent bourgeois public sphere in a young republic is out of the picture.

Fluid Border-Crossing in the Age of Transnational Capitalism

Prostitution as a social phenomenon largely disappears in socialist China in the Mao era (1949–1976). The New Society (*xin shehui* 新社会) aims at sweeping away all the evils of the Old Society (*jiu shehui* 旧社会) such as gambling and prostitution. Gender politics is necessarily of paramount importance in the construction of a socialist modernity, but reveals unique characteristics. Sexuality is often erased, and even romantic love is minimized in artistic works. In the extremist political atmosphere of the Cultural Revolution, an attempt is made to eliminate visible signs of gender difference in everyday life as men and women wear the same unisex Mao uniforms (*zhongshan fu* 中山服). Libidinal drives are sublimated and rechanneled into a single-minded devotion to the Party, the state, and the Great Leader that are embodied by male authorities. Ultimately, Chinese citizens are subjected to a new type of disciplinary regime— socialist patriarchy.[4]

Soon after the founding of the People's Republic, the feature film *Sisters, Stand Up* (*Jiejie meimei zhan qi lai* 姐姐妹妹站起來, 1951, director Chen Xihe 陳西禾) was released. It deals with prostitutes in 1940s Beiping (Beijing), castigates the dehumanizing treatment of individuals in the Old Society, and eulogizes liberation in New China. Unlike the street-walking goddess in *Goddess*, these prostitutes are still confined in a brothel in Beiping. Beiping is a more traditional and less cosmopolitan, less "modern" city in comparison to Shanghai in the Republican period. As prostitution is banned, former prostitutes are reformed to be new citizens in a socialist country at the end of the film.

In general, films about prostitution become increasingly rare in the Mao period. However, with the reappearance of prostitution in real life in the post-Mao period, filmic presentation of prostitutes returns in mainland China. There are two kinds of films involving prostitution in the mainland in the post-Mao era. First, there are films that feature prostitution and prostitute-characters but are set in the pre-1949 era, namely, before the socialist period. These are melodramas and legitimate films shown to the public. Examples include Chen Kaige's 陈凯歌 *Farewell my Concubine* (*Bawang bieji* 霸王别姬 1993), Huang Shuqin's *A Soul Haunted by Painting* (*Hua hun* 画魂, 1994), Li Shaohong's 李少红 *Blush* (*Hongfen* 红粉, 1995), and Zhang Yimou's *Flowers of War* (*Jinling shisan chai* 金陵十三釵, 2012). Second, there are films that involves prostitution in the contemporary period. These films are mostly independent films that were sometimes denied legitimate venues of exhibition. They include fiction films such as *Rain Clouds over Wushan* (*Wushan yunyu* 巫山云雨, Zhang Ming 章明, 1995), *Orphan of Anyang* (*Anyang ying'er* 安阳婴儿, Wang Chao 王超, 2001), *Blind Shaft* (*Mang jing* 盲井, Li Yang 李杨, 2003), and *A Touch of Sin* (*Tian zhuding* 天注定, Jia Zhangke, 2013). There are also independent documentaries such as *Wheat Harvest* (*Mai shou* 麦收, Xu Tong 徐童, 2008), which tell stories of real people. The economic and social reforms have profoundly changed people's lifestyles. The transition from a planned economy to a market economy have forced many people to look for new sources of income. The restructuring of China's state-owned enterprises, especially in China's socialist heartland, such as Northeast, has caused the bankruptcy of countless factories, companies, and shops. Numerous women leave their hometowns to look for work elsewhere. Many become sex workers. A mobile female working force has emerged in China's landscape. Street-walking goddesses, so to speak, resurface in Chinese cities. Many women move to other cities inside China, or cross the national border to go to other places, such as Hong Kong, and beyond. Prostitutes become again mobile subjects who struggle to change their low economic status in contemporary China.

A jarring, ironic moment in Jia Zhangke's film *A Touch of Sin* is a nightclub scene. There is a cameo appearance of Jia himself. He acts as a rich businessman from Shanxi who comes to the nightclub as a male customer to pick a girl, or *xiaojie* 小姐, a euphemism for "prostitute." The film presents a spectacle of many young girls, or prostitutes, dressed in Soviet-style military uniforms. They parade themselves in front of male clients in order to be chosen, under a Soviet revolutionary song. This is a hilarious yet tragic reminder of what has become of a nominally socialist country.

Figure 2.6 *A Touch of Sin* (*Tian zhuding*). Directed by Jia Zhangke. Production companies: Xstream Pictures, Office Kitano, Shanghai Film Group, Shanxi Film and Television Group, Bandai Visual Company, Bitters End. 2013. A nightclub scene where male customers gaze at and pick girls who parade themselves in Soviet-style army uniforms.

Films about prostitutes are abundant and too numerous to fully count in the outlying islands of Greater China: Taiwan and Hong Kong. There is no lack of such representations in films from Hong Kong and about Hong Kong under the British colonial rule. In the era of globalization, the figure of the prostitute has sometimes become a translocal, border-crossing subject shuttling between the mainland and Hong Kong within the Greater China area. Therefore, we may attempt a tentative historicization of the figure in Hong Kong cinema and transnational Chinese cinema.

The character Suzie Wong, an exotic Hong Kong prostitute in the Cold War era in the famous Hollywood film *The World of Suzie Wong* (director Richard Quine, starring William Holden and Nancy Kwan, 1960), is by now an archetypal figure of the Asian woman in East-West cultural dynamics.[5] Although a fallen Asian woman, she has a heart of gold, and is luckily rescued and redeemed at the end by a white knight-artist, performed by William Holden. This film and its male star William Holden are humorously yet touchingly evoked in Peter Chan's film *Comrades, Almost a Love Story* (*Tian mimi* 甜蜜蜜, 1996) as the Aunt Rose dies with an undying memory of her liaison with "William."

Hong Kong has been known as a major nodal point in the translocal and transnational trafficking of bodies, labor, capital, sex, and images. In the post-handover period, with the unification with mainland China and the influx of mainland tourists, this function of the city seems to have further expanded. Although it has to compete with emergent global cities[6] from China such as Beijing, Shanghai, and Shenzhen in the post-1997 period, Hong Kong continues

to serve as a premier site in the global and regional circulation of people, libido, and service, whether in real life or in fictional representation. There exists a vital film tradition on this aspect of Hong Kong, that dates back to the Orientalist example of *The World of Suzie Wong*, through Peter Chan's film *Comrades, Almost a Love Story* from the handover period, to Fruit Chan's 陈果 Prostitution Trilogy: *Durian Durian (Liulian piaopiao* 榴梿飘飘, 2000), *Hollywood Hong Kong (Xianggang you ge Helihuo* 香港有個荷里活, 2001), and *Three Husbands (Sanfu* 三夫, 2018) in the post-handover era. Hong Kong remains a key link in the capitalist, neoliberalist global marketplace of goods and bodies despite recent challenges from other Chinese cities that are poised to replace Hong Kong's preeminent position.

Cut to the pivotal, pregnant moment of 1997. *Chinese Box* directed by the Chinese-American filmmaker Wayne Wang offers an unambiguous dystopian representation of the city on the eve of the city's return to (ominous communist) China. The Chinese whore in the film, Vivian, performed by the famed mainland actress Gong Li, could hardly mumble a word of English or Cantonese. The Hong Kong local, Jean (Maggie Cheung), has a scar on her face. John, the British expatriate in Hong Kong, will die of leukemia soon. The tragedy of the Tiananmen incident in 1989 looms large in the film. Overall, *Chinese Box* presents a heavy-handed allegory of the fate of China, Hong Kong, and Britain.

In contrast, Fruit Chan's famous post-1997 prostitution films such as *Durian Durian* and *Hollywood Hong Kong* are much more nuanced works. What appears to be most remarkable is that these films describe the experience of border-crossing as the quintessential condition of Chinese subjects-cum-prostitutes. In other words, the borderless prostitute epitomizes the dilemma of post-1997 Hong Kong. *Hollywood Hong Kong* is the most extreme example about the ruthless, relentless trafficking of bodies in the contemporary era. The prostitute (Zhou Xun 周迅) in the film, who is called Honghong and goes by a number of other names, comes to Hong Kong from mainland China. Yet, Hong Kong is just a transit point. At the end of the film, she arrives at her final destination—Hollywood, Los Angeles, California, United States. She feels no qualms, anxiety, or uneasiness about assuming multiple identities and being called by different names. She achieves her objectives by any means—lying, extortion, blackmailing. This fluid, smooth shifting and shuffling of identity and citizenship is a guilt-free process by all appearances. In this way, this migrant figure in *Hollywood Hong Kong* is a far cry from the main characters in Peter Chan's classic from and about the handover period: *Comrades, Almost a Love Story*. This latter film is also about mobility, but mobility achieved at every step with a profound sense of loss and

agony. The main characters Li Qiao and Xiaojun leave China, work and reside in Hong Kong, and finally arrive in the United States. It is not easy for them psychologically to be mainlanders one day, and then Hong Kongers another day, and then suddenly transform to American green-card holders. It takes a ten-year span to travel this distance geographically and mentally. Hence, this film is not just about the thrills and euphoria of opportunistic border-crossing; it is really about the trials and tribulations of identity-formation across borders.

1997 is a moment of transition, of crisis. Hong Kong residents struggle over who they are and what Hong Kong might become. Identity matters. In the post-1997 period, the transition is a *fait accompli*. Done. Border-crossing is a taken-for-granted mode of existence. This is especially true after mainland China relaxes border control between the mainland and Hong Kong. Presently Hong Kong is flooded with tourists from China who cross the Hong Kong border to shop, travel, and do business. This precarious sense of existence-in-mobility as people depart from home for an adventure elsewhere is well captured in the words of Hong Kong critics Esther Cheung and Chu Yiu-wai. They write the following:

> [Any] departure from "home" engenders a "crisis"—a threat to our ontological security. What underlines our common concern is how the aesthetics of film corresponds directly and indirectly to the politics of identity in a transitory moment and space, one that is between "home" and "world." The Chinese *xiake* (swordsman) might bear a lot of differences from the contemporary border-crossers but what they share is the need to confront contingencies in a space away from "home"—the *jianghu* where love, hate, hope, despair, victory, and defeat collide. What are more contingent, fluid and mobile, than moments of crisis and spaces of transition?[7]

Honghong in *Hollywood Hong Kong* does not seem to have much *Angst* or psychological hang-up in freely shuttling between home and the world. The other prostitute, Xiaoyan in Fruit Chan's *Durian Durian*, however, is a different case. She is almost a carefree streetwalker in the first half of the film set in fast-paced, post-handover, postcolonial, capitalist Hong Kong. She readily lies to her male customers about where she comes from when asked: local, Xinjiang, Shanghai, and so on. Identity does not matter so long as business flourishes. As we come to learn from David Harvey and Aihwa Ong, "flexible production" and "flexible citizenship" characterize the economy and identity-formation in the post-Fordist, postmodern era.[8] Indeed, Xiaoyan has no problem juggling her real or fake identities on the spot while handling/manhandling the job.

The second half of the film is set in postsocialist slow-paced, northeast China. Xiaoyan returns home in Mudangjiang after a stint as a prostitute in Hong Kong. The prospect of going back to Hong Kong to take up the old trade is tempting as she constantly receives phone calls from her former coworkers. She is torn between returning to Hong Kong and staying in China. The stagnant economic condition in backward Northeast is no comparison to the glamour and wealth of the "Pearl of the Orient," Hong Kong. Yet, at the end of the film, Xiaoyan refuses to resume the job of a prostitute. In the final scene, she is seen singing traditional Chinese opera, aligning herself with virtue and tradition. Hence, what could have been a smooth choice in the pursuit of profit and mobility meets strong resistance at the local level. A local Chinese town does not respond to the alluring call from Hong Kong.

Post-1997 Hong Kong is an unrivalled key site and transit point in the movement of people, bodies, and capital. Therefore, Hong Kong appears to be an obvious choice when people ponder their destination. The city government has proclaimed Hong Kong as "Asia's World City." This glossy shining image of the city is visible to even the most casual tourist as she/he is easily overwhelmed by the dizzying neon lights of skyscrapers at the Victoria Harbor at night. However, it takes an independent director from Hong Kong such as Fruit Chan to redirect the gaze of the accidental tourist as well as the longtime observer to witness the night scene in the underbelly of Hong Kong's prosperity since the handover period. Fruit Chan's films reveal the living condition of the dispossessed, disenfranchised, working class of Hong Kong as well as those immigrants who have no legal rights to live and work in Hong Kong.[9] His films *Made in Hong Kong*, *The Longest Summer*, and *Little Cheung* take a hard look at the plight and hardship of disadvantaged social groups. His two remarkable films about the fairytale of mobility as embodied by two mainland prostitutes debunk the myth of the triumph of global capitalism. The fluid transfer of money, sex, and bodies across national borders stems from the ideology and practice of neoliberalism which favors the primacy of the market of supply and demand above all else and at all costs. As such, the clandestine trade in the human body has taken a toll on all people caught in the transaction.

The relationship between Hong Kong, China, and the rest of the world must be characterized as increasing intimacy and integration since Hong Kong's reversion to China in 1997. This intimate interflow of goods, bodies, sexuality, and money across the Hong Kong-Shenzhen border is a defining feature of the political and libidinal economy in this region.[10] Fruit Chan's remarks are instructive when he talks about his film *Hollywood Hong Kong* in an interview:

> I just wanted to use this character [Zhou Xun] to comment on the realities of
> Hong Kong's current economic, political, and social structures. Anyone who has
> lived in Hong Kong understands why so many people are heading to mainland
> China for business, to marry, look for mistresses, or whatever—this is all a direct
> result of the post-1997 consciousness in Hong Kong. It is a ripple effect.[11]

The material, cultural, monetary, and libidinal exchange in this region is
multidirectional, inter-Chinese, trans-Chinese, and global as both Hong
Kong and China open up to each other and to the capitalist world system. The
trajectory of one particular fictional prostitute, Honghong, from inland China,
via Hong Kong, to the shore on the other side of the Pacific Ocean is a facetious
yet real story of transnationalism in action, with all the delirium and tragedy
embedded in this very process of global movement.

As mentioned, the character Honghong in *Hollywood Hong Kong* is played by
mainland actress Zhou Xun. The multiple roles performed by actress Zhou Xun
as the migrant Chinese (sex) worker at the turn of the twenty-first century are
worth mentioning. Take a look at the ending of Dai Sijie's 戴思杰 Sino-French
coproduction *Balzac and the Little Chinese Seamstress* (*Ba'erzhake yu xiao
caifeng* 巴尔扎克与小裁缝, 2002). Having learned a lesson from Balzac that "a
woman's beauty is a priceless treasure," Little Seamstress (Zhou Xun) decides to
leave the remote mountain village in Sichuan Province for city life. Where does
she go? Within a network of filmic intertexts, there are three possible busy hubs
for her travel: Beijing, Shanghai, and Hong Kong. Actress Zhou Xun also plays
the role of a migrant Chinese female worker from the countryside working in
a city in several other films: a housemaid in Wang Xiaoshuai's 王小帅 feature
Beijing Bicycle (*Shiqisui de danche* 十七岁的单车, 2001); a performer/mermaid
in a seedy bar in Lou Ye's 娄烨 feature *Suzhou River* (*Suzhou he*, 2000); and a
mainland Chinese prostitute in Fruit Chan's film *Hollywood Hong Kong*, who
eventually moves to Hollywood in the United States via Hong Kong. As one of
her former suitors tells us, it is most likely that Little Chinese Seamstress left for
Hong Kong.

Hong Kong has been known as the success story of laissez-faire capitalism in
modern world history. This privileged hub of commerce and business is further
consolidated after it joins hands with the motherland since 1997. Moreover,
the advent of the age of globalization could not be more opportune to the
commercial atmosphere of the city. As a global city, Hong Kong encapsulates
most dramatically the characteristics and contradictions of globalization. The
sense of both exhilaration and shame comes to the surface as people attempt

to move across geographic, moral, institutional borders. The felicity as well as absurdity of such transnational and translocal trafficking of capital, sexuality, and bodies are masterfully distilled in compelling images by independent Hong Kong filmmakers.

The government of the Hong Kong Special Administrative Region has projected itself as such a global city in the official slogan "Hong Kong—Asia's World City." This is a "city of opportunity," a "city at the hub of Asia," a special transit point that is built on an effective communications network and a solid financial system. This self-image of a progressive, forward-looking city is only confirmed by the spectacular, beautiful photographs of the people and cityscape in the publicity booklet entitled *Hong Kong—Asia's World City*, which is made readily available to tourists and businessmen. The history of the Special Administrative Region since its establishment is narrated as a total success story on the surface, and the city is expecting greater success in the future.

However, the inter-Chinese integration between Hong Kong and China as well as the globalization of the Asia Pacific Region are never a one-sided smooth ride for everyone and at every locale. Hong Kong also experiences joys and pains as Asia enters the stage of global postmodernity at the end of the last century.[12] Without exception, Hong Kong has been embroiled in the broad social, economic, political changes in the Pacific region. In regard to the specific characteristics of Hong Kong culture in transition at the turn of the twenty-first century, Gina Marchetti and Tan See Kam write the following words:

> Global economic changes have fuelled migrations of labour and resources to and from Hong Kong, fostering the emergence of new and globally-connected class formations. The speed of information exchange and the flexibility of capital, in turn, have opened up questions of property rights, piracy, and global copyrights. Meanwhile entrenched traditional values give way to new roles for women and men, changing family dynamics, and calls for gay/lesbian/bisexual/trans-gendered rights to public recognition. Other areas of personal identity likewise become hotly contested, from citizenship to "generation-ship." The local/global nexus questions national borders, linguistic barriers, and the putative powers of the state, while unearthing class inequalities, racial prejudices, and ethnic chauvinism.[13]

While this border-crossing global economy might be a liberating force in unleashing people from their bondage to old forms of attachment and territoriality, new patterns of oppression and exploitation have emerged, such as class inequalities and social discrimination. Such is the dialectic of globalization

and its discontents[14] as we zero in on the trajectory of the border-crossing prostitute from inland China to Hong Kong and other parts of the world.

As I have demonstrated, prostitutes are confined to their rooms at the turn of the twentieth century in Shanghai and Taipei in Hou Hsiao-hsien's *Flowers of Shanghai* and *Three Times*. Hou's static cinematographic style is particularly well suited to depict such constricted movement and limited space in early modern China. Fast forward to decades later in modern Chinese history, the 1930s. The Ruan Lingyu character roams the streets of Shanghai in *Goddess*, conveying a sense of increased mobility and modernity in the Republican era, yet ultimately constrained by omnipotent male authority. As we leap ahead by a century from the historical milieu of *Flowers of Shanghai* and *Three Times* to the turn of the twenty-first century, from Shanghai and Taipei to Hong Kong, the figure of the prostitute in Fruit Chan's films turns into a signifier of the flexible, transnational, border-crossing postmodern subject, and becomes a function of mobile global capitalism with all the accompanying exhilarations and horrors.

Although Hong Kong is a popular destiny in films involving Chinese prostitute-characters, there are also films about Chinese prostitutes by directors from other countries. These characters travel to as far as Paris, France in the fiction films. Laid-off women workers from China's Northeast end up being streetwalkers in Paris. This is the subject of the French film *She Walks* (*La Marcheuse*, director Nathanaël Marandin, 2016), as well as the content of the Belgian-Chinese coproduction *Bitter Flowers* (*Xiahai*下海, director Olivier Meys, 2017). Chinese actress and model Candice Zhao (Zhao Xi 赵茜), who appeared for a few seconds in an elevator scene in the Hollywood blockbuster *Transformers 4: Age of Extinction* (2014), performs the lead role, Lily, in *Siji: Driver* (2018, director David Chai), an English-language feature film about human trafficking. The figure of the Chinese prostitute continues to appear in films from Taiwan, China, Hong Kong, and the Chinese diaspora. At their best, they entice the viewer to reflect on the living conditions of humanity and to envision the construction of a just society.

Notes

1 For a study of prostitution in China in the first half of the twentieth century from the perspectives of an anthropologist, see Gail Hershatter, *Dangerous Pleasures: Prostitution and Modernity in Twentieth-Century Shanghai* (Berkeley: University of California Press, 1999).

2 Mary Ann Doane, "The Female Face, the Cityscape, and Modernity in a Transcultural Context," in *Proceedings of the International Conference "Women in Focus: Gender and Chinese-Language Cinema,"* ed. School of Humanities of Nanjing University and the Pembroke Center for Gender Studies of Brown University (Nanjing, China, 2008), p. 8. See also Mary Ann Doane, "The Close-Up: Scale and Detail in the Cinema," *differences: A Journal of Feminist Cultural Studies* vol. 14, no. 3 (2003): 89–111.

3 Kristine Harris, "*The Goddess*: Fallen Woman of Shanghai," in *Chinese Films in Focus: 25 New Takes*, ed. Chris Berry (London: British Film Institute, 2003), p. 114; See also Yingjin Zhang, "Prostitution and Urban Imagination: Negotiating the Public and the Private in Chinese Films of the 1930s," in *Cinema and Urban Culture in Shanghai, 1922–1943*, ed. Yingjin Zhang (Stanford: Stanford University Press, 1999), pp. 160–80. For further study of Ruan Lingyu and the filmic presentation of the modern Chinese woman in this historical period, see also Kristine Harris, "The *New Woman* Incident: Cinema, Scandal, and Spectacle in 1935 Shanghai," in *Transnational Chinese Cinemas: Identity, Nationhood, Gender*, ed. Sheldon H. Lu (Honolulu: University of Hawaii Press, 197), pp. 277–302.

4 I summarized these points in the section on gender politics in Chinese cinema in my "Historical Introduction: Chinese Cinemas (1896–1996) and Transnational Film Studies," in *Transnational Chinese Cinemas: Identity, Nationhood, Gender*, especially pp. 20–5.

5 See Thomas Y. T. Luk and James Price, eds., *Before and After Suzie: Hong Kong in Western Film and Literature* (Hong Kong: The Chinese University of Hong Kong, 2002).

6 Saskia Sassen, *The Global City: New York, London, Tokyo* (Princeton, NJ: Princeton University Press, 1996). Sassen's pioneering study is dated in the sense that she does not get to analyze newer global cities emerging from the pan-Chinese world such as Hong Kong and Shanghai.

7 Esther M. K. Cheung and Chu Yiu-wai, "Introduction," in *Between Home and World: A Reader in Hong Kong Cinema*, ed. Esther M. K. Cheung and Chu Yiu-wai (Hong Kong: Oxford University Press, 2004), p. xv.

8 David Harvey, *The Condition of Postmodernity: An Inquiry in the Origins of Cultural Change* (Oxford, UK: Blackwell, 1989); Aihwa Ong, *Flexible Citizenship: The Cultural Logics of Transnationality* (Durham, NC: Duke University Press, 1999).

9 For an informative essay in this regard, see Wimal Dissanayake, "The Class Imaginary in Fruit Chan's Films," online journal *Jump Cut: A Review of Contemporary Media*, no. 49 (spring 2007), website address: www.ejumpcut.org. See also Wendy Gan, *Fruit Chan's Durian Durian* (Hong Kong: Hong Kong University Press, 2005).

10 I attempt to outline this global libidinal economy in reference to Hong Kong and China in my book *Chinese Modernity and Global Biopolitics: Studies in Literature and Visual Culture* (Honolulu: University of Hawaii Press, 2007).

11 Michael Berry, "Fruit Chan: Hong Kong Independent," in *Speaking in Images: Interviews with Contemporary Chinese Filmmakers* (New York: Columbia University Press, 2005), p. 477.

12 In regard to China's social, economic, and cultural formations in the global postmodern context, see Sheldon Lu, *China, Transnational Visuality, Global Postmodernity* (Stanford, CA: Stanford University Press, 2001).

13 Gina Marchetti and Tan See Kam, "Introduction: Hong Kong Cinema and Global Change," in *Hong Kong Film, Hollywood and the New Global Cinema: No Film is an Island*, ed. Gina Marchetti and Tan See Kam (London and New York: Routledge, 2007), p. 1.

14 Saskia Sassen, *Globalization and Its Discontents* (New York: Free Press, 1998).

Reorientations of Hong Kong Cinema and Transformations of Masculinity

In the perennial envisioning and revisioning of the Chinese nation in filmic discourse in Greater China, gender, sexuality, femininity, and masculinity necessarily remain the crucial ingredients in fiction films. The nexus of nation and gender, or the conjoining of a political economy and a libidinal economy, continues to be a major topic of discussion in this chapter as well. I have analyzed the manifestation of female sexuality as embodied in the figure of the prostitute in Chinese-language films from China, Taiwan, and Hong Kong in the previous chapter. In this chapter, however, I narrow down the focus to the issue of masculinity in one particular film tradition, namely, Hong Kong cinema. To achieve this goal, I also delineate some main tendencies in the development of Hong Kong cinema from the eve of Hong Kong's return to mainland China to the present day. In regard to specific case studies, I analyze the representation of Chinese masculinity in the hands of selected Hong Kong film directors in this time span. The evolving images of masculinity in fact corroborate the general trends of Hong Kong cinema.

Dimensions of Hong Kong Cinema

On the eve of Hong Kong's return to the sovereignty of the People's Republic of China in 1997, I ruminated about the dimensions, types, paradigms, and functions of varieties of Chinese cinemas, especially Hong Kong cinema from 1949 to that historic moment. I wrote the following:

> In the case of the Mainland and Taiwan (Republic of China), we may speak of two competing Chinese "national" cinemas as a function of the Chinese nation-state;

in the case of Hong Kong and Taiwan again (as a Chinese "province"), what we see is the flourishing of local Chinese cinemas, often spoken in dialects (Cantonese, Fukienese); the popularity of Chinese films, especially Hong Kong action films, in Southeast Asia and East Asia also creates a regional Chinese cinema; finally, the spread of Chinese films across the entire world makes Chinese cinema a global cinema. In the late 1980s and the 1990s, at the end of the twentieth century, new patterns of international coproduction and global distribution render the idea of national cinema rather problematic. The study of *national* cinemas must then transform into *transnational* film studies.[1]

I pinpointed several modes of existence for Hong Kong cinema: national cinema, local cinema, regional cinema, and global cinema. Moreover, the various levels of Hong Kong cinema can be fruitfully examined in the critical framework of transnational cinema studies. Many years have passed since Hong Kong's handover to China and the publication of the anthology *Transnational Chinese Cinemas*, both in 1997. Although the general contours of Hong Kong cinema as enumerated at that time still apply to the present condition, the perimeters of our analysis can be broadened and enriched. The critical framework of transnational Chinese cinema studies has also been debated about, reexamined, and supplemented in film studies circles since then. The transnational approach is still one of the most useful and apt ways of describing contemporary Hong Kong cinema, and surely it can be further fine-tuned and expanded.

Based on recent developments in Hong Kong as well as on research done by Hong Kong film scholars, I would propose the following paradigms to describe the nature of Hong Kong cinema since 1997. The basic dimensions are still the same: national, local, regional, and global. But there are reorientations. We could use new terms: mainlandization, or nationalization; localization, indigenization, or Hong Kongization; regionalization, or Asianization; and globalization.

Needless to say, Hong Kong's economy, culture, and society have moved closer to the Mainland in many ways as it has officially become a Special Administrative Region (SAR) of China. Moreover, with the signing of the Close Economic Partnership Arrangement (CEPA) by Hong Kong and China in 2003, it has been more lucrative for the Hong Kong film industry to make coproduced films with the Mainland. China gives preferential treatment to Hong Kong film companies that invest and produce in China. Hence, mainlandization has become an inevitable trend. The film market in China has undergone phenomenal growth and now stands as the second largest market in the world. How could one not take advantage of this vast market? Famed Hong Kong filmmakers have seized on this opportunity to coproduced films with China. Suffice to mention such best-selling

films as *Red Cliff* (*Chibi*, John Woo 吴宇森, 2008), *Ip Man* (*Yewen* 叶问, director Wilson Yip 叶伟信, starring Donnie Yen 甄子丹, 2008), *Confucius* (*Kongzi* 孔子, director Hu Mei 胡玫, starring Chow Yun-fat 周润发, 2010), *American Dreams in China* (*Zhongguo hehuo ren* 中国合伙人, director Peter Chan 陈可辛, 2013), and *Journey to the West: Conquering the Demons* (*Xiyou: xiang mo pian* 西游: 降魔篇, director Stephen Chow 周星驰, 2013). These quintessentially Hong Kong filmmakers have obtained a new lease of life by venturing into the huge mainland market. As the ex-colony rejoins the nation-state, Hong Kong cinema nationalizes itself and participates in Chinese national cinema. World-famous for his casting as the classic Hong Kong gangster hero, Chow Yun-fat portrays in a mainland production the most revered Chinese personality of all time: Confucius. Peter Chan's transformation is equally noteworthy. He is the director of *Comrades, Almost a Love Story* (*Tian mimi* 甜蜜蜜, 1996), by now a classic from the handover period, a film that so touchingly details the drama, love, and aspirations of Chinese-turned-Hong Kongers. Yet, in the second decade of the twenty-first century, he directs mainland films such as *American Dreams in China*, which is set in Beijing. He has transformed from an indigenous Hong Kong director into an adept Chinese director.

If nationalization and mainlandization are the order of the day, Hong Kong cinema's self-identity might be destabilized. Akbar Abbas famously theorized about the culture of "disappearance" on the eve of Hong Kong's handover to China.[2] The anxiety of disappearance still looms large today. In response to this precarious situation, topophilia, namely, a place-bound urban cinema has consolidated itself at the same time against the uniformity and anonymity of postmodern globalized space. It is a cinema of affect, of personal attachment to the place. Fruit Chan's "1997 Trilogy" films are good early examples of this. I would particularly mention Ann Hui's 许鞍华*A Simple Life* (aka *Sister Peach*, *Taojie* 桃姐, 2011) as a further testimony to a sense of the emotional attachment to the local culture, tradition, and history of Hong Kong. The film describes an old-fashioned mode of life that is literally disappearing from Hong Kong. Precisely due to its indigenization or re-Hong Kongization, the film captures the attention and praise of international film communities. Hong Kong cinema stubbornly persists as a *local cinema*.

For a long time, Hong Kong cinema has been a powerful *regional cinema* in East Asia and Southeast Asia. Its genre films (action, martial arts, comedy, period drama, family drama) have been watched and savored by generations of audiences throughout the region. It has offered a steady diet of entertainment that the Chinese-language films from China and Taiwan could not provide.

Figure 3.1 *A Simple Life* (*Taojie*). Directed by Ann Hui. Production companies: Focus Group Holdings Limited, Polybona Films, Sil-Metropole Organization. 2012. Sister Peach (Deanie Ip) and Roger (Andy Lau) discuss what food to cook for him at home.

After failed earlier attempts, Hong Kong cinema finally crossed over to mainstream international film culture beginning in the mid-1990s. Hong Kong cinema also thrives as a *global cinema*. John Woo, Jackie Chan, Jet Li, Johnnie To, Stephen Chow, and other directors have in their own ways transformed Hong Kong's indigenous film genres into global film genres (action, martial arts, comedy). Wong Kar-wai has emerged as a unique art-house director hailing from Hong Kong. A host of actors and actresses such as Chow Yun-fat, Donnie Yen, Tony Leung Chiu-wai, Andy Lau, Maggie Cheung, and Michelle Yeoh are internationally recognized film personages with numerous fans. Hong Kong film styles, themes, and action choreography have in turn influenced and provided inspiration to filmmakers from elsewhere, as evidenced in such mainstream Hollywood films as *The Matrix Trilogy* (Wachowski Brothers, 1999–2003), *Charlie's Angels: Full Throttle* (Joseph McGinty Nichol), *The Departed* (Martin Scorsese, 2006), and *Kill Bill 1 & 2* (Quentin Tarantino, 2003–2004). In the words of one critic: "The start of the twenty-first century has seen the emergence of a new kind of Chinese cinema." "Chinese cinema today is inescapably transnational. Its film-makers pool resources drawn from multiple film industries, cater to the tastes of foreign as well as domestic viewers, and appropriate genres and styles developed by other cultures."[3] This is the phenomenon where a Chinese-language film has become a global film, or a truly global blockbuster. For instance, Hong Kong director and actor Stephen Chow's film *Kung Fu Hustle* (*Gongfu* 功夫, 2004) is an exemplary case. This martial-arts comedy endeared

and attracted audiences in many parts of the world and achieved spectacular international box office success.

The prominence of Hong Kong cinema as at once a national, local, regional, and global cinema has entailed reorientations in cinema studies. As opposed to the model of national cinema, the transnational model and the "Chinese-language film" model have emerged to account for the dynamic interflow within the Greater China area: China, Taiwan, Hong Kong.[4] Coproduction within Greater China has become increasingly widespread since the early 1990s. As mentioned earlier, a group of scholars have theorized the transnational turn in Chinese film studies. The transnational paradigm has been further embellished since its first introduction.[5] Hong Kong itself has never been a nation-state; it is located on the margins of geopolitical entities such as China (PRC), Taiwan (Republic of China), Great Britain, and the United States. The model of national cinema could not adequately explain its modality of existence. Hence, Hong Kong cinema is a transnational cinema *par excellence*. The transnational is not merely a two-way traffic from one nation to another nation. It could be also translocal and polylocal,[6] subnational and supranational. Nor is transnational cinema a handmaid of transnational capitalism; rather, it could be a liberating force breaking out of the narrow confines of the nation-state.

The paradigm of Chinese-language cinema (*huayu dianying*) was proposed by film scholars from Taiwan and Hong Kong in the early 1990s. Fearful of a possible de-Sinification tendency, mainland Chinese scholars were initially hesitant in embracing this paradigm. However, nowadays many mainland-based Chinese film scholars are enthusiastic proponents of the paradigm of Chinese-language cinema in the united front of Greater China film studies. They regularly hold international conferences and edit book series on such a topic. The cultural forms from a borderland—Hong Kong, have in turn exerted a powerful influence on the mainland and have changed the terms of academic discourse.

The Sinophone is another influential discourse to rename and redescribe the cultural politics of Chinese-speaking communities throughout the world. But in one prominent definition of the term, the Sinophone does not include the Mandarin-speaking (*hanyu*) people and regions of China, and ideologically functions as a counter-hegemonic force against China-centrism. Such a standoffish relationship between the Sinophone and China does not accurately demarcate the interactions between Hong Kong and China since 1997. Thus, this particular paradigm defined as such has limited applicability in regard to the cultural productions of Hong Kong. As mentioned, mainlandization in the

post-1997 era is so evident that it is impossible to wish away this trend. Even in a heart-warming film such as *A Simple Life* that celebrates the local life of Hong Kong, the presence of China cannot be elided. The protagonist Roger (Andy Lau) is a film producer and must travel to China frequently. There is a scene set in China where heavyweight Hong Kong filmmakers such as Sammo Hung, Tsui Hark, and Andy Lau sit to discuss issues of film coproduction with a mainland company. Mainland director Ning Hao 宁浩 also makes a cameo appearance in a scene set in Hong Kong. Mainland Chinese actress Qin Hailu 秦海璐, who achieves popularity after debuting in Fruit Chan's Hong Kong film *Durian Durian* (*Liulian piaopiao* 榴梿飘飘, 2000), plays an important role in *A Simple Life*.

The transnational, even understood in the most literal sense of border-crossing between locales, regions, and nations, finds its exemplary articulation in Hong Kong cinema. The productive synergies of Hong Kong cinema are further sped up in a "borderless world" in the age of globalization.[7] It should be also be added that the paradigm of Chinese-language cinema, encompassing film production and circulation beyond the limitation and teleology of the modern Chinese nation-state, is also an apt discourse to speak about the rich and diverse cinematic tradition of Hong Kong.

Evolving Images of Masculinity in Hong Kong Cinema

I would like to further explore the relationship between mainlandization and localization by focusing on the evolving representation of masculinity in Hong Kong cinema. These antithetical tendencies shape the identity formation of film characters. Images of Chinese masculinity do not remain the same. They change over time. Different constructions of masculinity in visual and literary culture emerge at specific historical junctures. They are reflexes and responses to particular social events and historical moments. Hence, I find it important to historicize images of Chinese masculinity in contemporary filmic discourse in the span of a quarter century.

I trace the transformation of Chinese masculinity in selected films directed by Hong Kong directors from the early 1990s to the present time. I discuss a number of relevant films, and focus particularly on three films: *Farewell China* (*Ai zai biexiang de jijie* 爱在别乡的季节, director Clara Law 罗卓瑶, 1990); *Comrades, Almost a Love Story* (director Peter Chan, 1996), and *American Dreams in China* (2013), also directed by Peter Chan. Although the directors

are Hong Kong directors and some of the films are classified as Hong Kong films, the films themselves portray male figures originating from mainland China. All these films tell the stories of Chinese nationals and their attempted journeys overseas. They are tales of mostly heterosexual love between ethnic Chinese men and women, with one exception in *American Dreams in China*. Needless to say, male characters play important roles in the films, and indeed central roles in *American Dreams in China*. The three films involve Chinese male characters' travels to America, and more specifically, New York City. At one time or another, there is an "American dream" in the back of their minds. That dream turns nightmarish at times, as in the case of *Farewell China*; or it transforms into a Chinese dream, as in the case of *American Dreams in China*; or it seems more like a perpetual process of questing and becoming, as in *Comrades, Almost a Love Story*. In fact, the Chinese Dream (*Zhongguo meng* 中国梦) is also the slogan advocated by Chinese President Xi Jinping in the twenty-first century.

The three films correspond to three historical time frames in the last thirty years. They are 1989, the Tiananmen Incident; 1997, Hong Kong's return to mainland China; 2010s, the ascendancy of China as an economic superpower. The social, historical, economic, and political developments in these moments in China and the world impact the formation of subjectivity and masculinity on the part of Chinese males, whether they stay earthbound in China or move airborne around the globe. Altogether, these films reveal the transformations of Chinese masculinity over a quarter century from the late 1980s to the mid-2010s. This is a trajectory from an incapacitated, suffering male figure, to a questing, inquisitive male around 1997, and finally to a figure of empowered, confident male in the twenty-first century. In other words, there is a movement from the pathos of self-exile, to the spirit of expectancy, uncertainty, and searching, and finally to triumphant manhood/nationhood.

My present study is a continuation of my earlier research and writing about masculinity, transnationalism, diaspora, and nationality in Chinese and Hong Kong cinema. Previously, I examined films and TV dramas from the 1980s through the 1990s. I noticed a pattern of change "from homecoming to exile to flexible citizenship." I wrote the following:

> It is common knowledge that three important historical moments have greatly influenced the construction of place, self, and nationality in Hong Kong's filmic discourse: the Joint Sino-British Declaration in 1984, the Tiananmen incident in 1989, and Hong Kong's return to China in 1997. I want to suggest that there seems to be a significant paradigm change in the representation of issues

related to nationality, identity, and citizenship in Hong Kong films depicting the Chinese diaspora. In a nutshell, the change may be characterized as a shift from a "China syndrome" in the mid-1980s to an "exile complex" or "persecution complex" shortly after 1989 and finally to a discourse of flexible citizenship and transnationalism around 1997.[8]

In retrospect, I believe the above observations are still accurate and valid. But I stopped short at the 1990s and did not get to analyze the situation in the twenty-first century. There have been major changes in the representation of masculinity and subjectivity as well as new developments in the Greater China film industry since 1997. Peter Chan's film *American Dreams in China* offers a good case for us to write a new chapter about national and transnational Chinese masculinity in the new century.

Given the fact Hong Kong has been an economic, commercial, and cultural crossroads, and the fact that Hong Kong cinema could not be easily assimilated into the paradigm of a national cinema, I find the transnational approach particularly appropriate for the purpose of this chapter. Moreover, the specific case of Hong Kong cinema could be also fruitfully situated in a broad transnational framework of Chinese-language cinemas, as I first explained many years ago.[9] More recently, in their joint "Introduction" in a new anthology on Hong Kong cinema, Esther Cheung, Gina Marchetti, and Esther Yau further highlight this important feature of Hong Kong cinema. Their statement should be quoted at length:

> Hong Kong cinema poses some particularly thorny questions for a field dominated by studies of Hollywood and European cinema. Given the prominence of "national" cinema research in which language, ethnicity, geographic borders, and cultural identity become paramount in understanding specific films, identifying Hong Kong cinema in relation to a specific "nation" poses some serious problems. Moreover, Hong Kong boasts a global standing and transnational production and distribution network that places it in competition with Hollywood in some regional markets. Hong Kong, like Hollywood, is a cinema that has been shaped by exiles, immigrants, and diasporic migrants throughout its history, and the continuing exchange of technology and talent within Asia as well as with the West needs to be understood theoretically in relation to postcolonial flows, hybrid cultures as well as global capitalism.[10]

Apparently, the border-crossing flow of people, images, and technology between Hong Kong and the world continues to remain a central characteristic of this special island city called Hong Kong, a "Special Administrative Region" as it

is officially named since 1997. Travelers, exiles, immigrants, and migrants constitute the very stuff of transnational masculinity of Hong Kong cinema. In the following sections, I offer brief analyses of the several films that I mentioned at the beginning of this chapter. At the same time, I also bring in and juxtapose some other related materials, such as films and popular songs, in order to better compare, contrast, and contextualize these films.

The Suffering Male Bids Farewell to China

Farewell China (1990) directed by Clara Law seems to be an allegory of national suffering. It echoes a general mood among overseas Chinese after what happened in Tiananmen Square and broadly in China in 1989. The nation is accused of a persecution complex. Characters suffer because of the fault of the Chinese nation-state. The fate of Chinese nationals as well as that of overseas Chinese is directly related to a traumatic event of the motherland.

Farewell China is made in the aftermath of the Tiananmen incident in 1989. Students occupied Tiananmen Square for months, and then were forcefully driven away by the Chinese government. The male and female characters in the film have had enough suffering and sorrows. The film begins with the life of a family in southern China. A young couple desperately wishes to leave China. Li Hong's 李红 (Maggie Cheung 张曼玉) visa application for traveling to America has been rejected several times by American visa officers. She tries one more time, and finally receives an American visa. She leaves her husband Zhou Nansheng 周南生 (Tony Leung Ka-fai 梁家辉) and their young child behind and goes to America. But life in the dreamland is not as easy as it was imagined to be from far distance. Hong experiences a series of hardships in America. She is mentally ill. At the end of the film, she works to swindle money from retirees in a Chinese neighborhood in New York City. She has not communicated with her husband in China.

Having lost contact with his wife Hong, the male protagonist Nansheng sets out to travel to America to find her. He illegally enters the United States. His American trip is equally harrowing and disappointing, full of heartache and setbacks. At one point, he becomes friends with a rebellious teenage Chinese-American girl, an underage prostitute who has run away from home. Eventually Nansheng finds Hong. They are tearfully reunited. They sleep together and recount the difficulties they each have gone through since separation. In the scene of their emotional reunion in the bedroom, the soundtrack plays the

powerful patriotic song *My Motherland* (*Wo de zuguo* 我的祖国). The irony cannot be more apparent here because their beloved motherland has turned into such a hated place that they both feel compelled to go abroad. The next morning, Hong, who has become schizophrenic mentally, does not recognize her husband, and goes out to conduct business as well. Nansheng runs after her. They meet and struggle with each other in a Chinese neighborhood. Hong stabs Nansheng to death in front of a replica of the Statue of Goddess of Democracy, which was designed by Beijing's art students and displayed in Tiananmen Square in June 1989. High up, an American flag flutters at the top of the building. Below, Nanshang's notebook falls on the ground. The red cover of his Chinese notebook is graced with Chairman Mao's saying and calligraphy: "serve the people" (*wei renmin fuwu* 为人民服务).

In this heavy-handed tragic film, the characters prefer to live a life outside China. But living abroad is not a good choice either. The Chinese as a group are masochistic, and are condemned to suffering no matter where they are. Men cannot protect their wives and families, and cannot survive themselves either. Their spouses leave them for greener pastures. *Farewell China* describes perhaps the lowest point in the self-esteem of Chinese people, whether they are in China or in the diaspora. The traveling Chinese male is not truly transnational. He gets nowhere and meets a tragic end. A triumphant return of the prodigal sons and daughters of China is out of the question. How time has changed. A quarter century later, *American Dreams in China* (2013) reverses that tragic view of life and celebrates the newfound success of Chinese masculinity on the native soil.

Mobile Masculinity in Love

Comrades, Almost a Love Story appears more like a heart-warming tale of transnational journeys. It is the story of individual entrepreneurship, namely, the story of transnational capitalism on an individual scale.[11] The characters' sense of themselves changes. They develop a flexible, evolving subjectivity. What Aihwa Ong's calls "flexible citizenship" seems to be an apt description of the formation of subjectivity in this film.[12]

The change of mood between then and now can be measured by comparing the two films directed by Peter Chan: *Comrades, Almost a Love Story* and *American Dreams in China*. *Comrades, Almost a Love Story* is released on the eve of Hong Kong's return to mainland. The film is now hailed as a classic from the so called "handover period." The male protagonist, Xiaojun 小军 (literally "Little

Soldier"), leaves China, works in Hong Kong, and then moves to New York City. His personal journey is the tale of Chinese diaspora. At the end of the film, it is not clear what his national affiliation is. He seems to be forging a pan-Chinese diasporic identity, an identity in perpetual motion. Xiaojun's affiliation with the Chinese nation-state weakens as the film progresses. Recall an early episode of the film, where Xiaojun is a delivery boy for a Chinese restaurant and is happily singing nationalistic mainland Chinese songs *The East Is Red* (*Dongfang hong* 东方紅) and *I Am a Soldier* (*Wo shi yige bing* 我是一个兵). The Chinese national anthem is also played on the soundtrack in this episode. This cocksure Chinese identity begins to dissolve in the next episode when Xiaojun arrives at a McDonald restaurant in Hong Kong, where he meets a Cantonese-turned-Hong Konger, Li Qiao. He falls in love with her, and severs his relationship with his fiancée from mainland China. The film largely depicts an outward journey undertaken by Chinese nationals.

It might be said that he identifies with "Cultural China" because of his liking for the songs of Teresa Tang (Deng Lijun 邓丽君). Tang was born in Taiwan. Her parents came from China. She was arguably the most popular singer in the Chinese-speaking world during her lifetime. In fact, the film's original title, *Tian mimi* (甜蜜蜜, "Sweet Honey"), is the title of a song of Teresa Tang's. The film is also a tribute to the memory of Teresa Tang, who passed away untimely while on vacation in Thailand. She is remembered by Chinese communities throughout the world. The transnational, pan-Chinese love songs of Teresa Tang, rather than the Chinese national anthem and revolutionary songs of mainland China, create an emotional cohesiveness among diasporic Chinese.

The ending of *Comrades, Almost a Love Story* is inconclusive as if the main characters would start a new journey. A sense of expectancy, open-endedness, and searching characterize the films released at the time. This can be also said about Wong Kar-wai's 王家卫 film *Happy Together* (*Chunguang zhaxie* 春光乍洩, 1997), a film about the relationship between two gay men from Hong Kong. The film focuses on their physical journeys in South America as well as their emotional and intellectual search for meaning and stability. Will they be "happy together"? Or allegorically, will Hong Kong and China be happy together after 1997? In fact, nobody knows exactly what will happen to Hong Kong after its return to China. People have yet to live lives in the future. By the time of *American Dreams in China*, what is future in 1997 is already future past. This is the second decade of the twenty-first century when Hong Kong's return to China is a *fait accompli*.

At this juncture, it might be useful to provide a cultural subtext to Hong Kong cinema by revisiting another form of mass culture. One of the most telling indicators of the attitude of China's young men and women toward Hong Kong on the eve of Hong Kong's return to China is Ai Jing's 艾敬MTV *My 1997* (*Wo de 1997*, 我的1997). The MTV and the song are extremely popular at the time. Ai Jing's song expresses the longing of China's young generation for Hong Kong. Hong Kong is the epitome of mobility, prosperity, and fun. Ai Jing tells the autobiographical story of a young woman from mainland China. She was from Shenyang, Northeast China, the industrial heartland of socialist China. Her father worked in a state-owned enterprise, and her mother missed out the good days of life. She left her hometown, drifted to Beijing, Shanghai, and finally Guangzhou. She loved the south, and stayed in Guangzhou because her lover was in Hong Kong. "He can come to Shenyang, but I cannot go to Hong Kong." She eagerly awaits the return of Hong Kong to China so that she can be together with her boyfriend, to "see a midnight show" together.

> I sang my way from Beijing to Shanghai Bund,
> From Shanghai all the way to the south, singing my song.
> I stayed in Guangzhou for a long time,
> Because my man was living in Hong Kong.
> When did Hong Kong come about?
> What's so cool about Hong Kongers?
> He can come to Shenyang, but I can't go to Hong Kong.
> Little Hou said that I should venture out to try my luck.
> Why should Hong Kong be so fragrant?
> I heard it is an important market for Old Cui.
> Take me to that dazzling world.
> Give me a red stamp.
> Come quickly 1997! What's so cool about Yaohan?
> Come quickly 1997! So I can make it to Hong Kong.
> Come quickly 1997! So I can stand at the Hon Hom Coliseum.
> Come quickly 1997! So I can go with him to see the midnight show.
> Come quickly 1997! So I can see how the clothes in Yaohan are actually like.

Hong Kong is described as the place where young men and women can fulfill their dreams and lovers can be united. In contrast, the socialist heartland of China is the place to go away from. Hong Kongers can freely travel to China,

but Chinese citizens cannot go to Hong Kong. The fate of immobile state workers from the interior of socialist China has been described in a number of compelling mainland films. Jia Zhangke's 贾樟柯 film *24 City* (*24 cheng ji*, 24 城记, 2009) chronicles the trials and tribulations of a state-owned enterprise in Chengdu, Sichuan province. The film contains interviews with real and fictional factory workers. The camera's static frontal shots of factory workers portray the lives of ordinary men who seem to be frozen in an era of socialist nation-building. These men live and work in a landlocked area. The origin of this military airplane factory in Chengdu is Northeast China. The factory moved to China's interior from Northeast, and the workers settled in Chengdu. The once proud state factory must face new challenges in the Era of Reform and Opening. The model of the male factory worker has forfeited its coveted central position in Chinese society, and has lost its appeal to a young woman looking for a potential husband! Equally gripping and elegiac is the description of men in Wang Bing's 王兵 9-hour long documentary *West of the Tracks* (*Tiexi qu* 铁西区, 2002). The film tells the story of "Rust," "Remnants," and "Rails." Again, a once proud state factory in Northeast China is going bankrupt. Male workers lose their jobs and have to retool their skills. Their wives and daughters must also struggle to find new work to do.

Where do these women go to then? Hong Kong seems like a promised land of mobility for young men and women. Fruit Chan's 陈果 incomplete *Prostitution Trilogy* points the way. Unemployed young women from struggling Northeast come to Hong Kong for work. A network of legal movement and illegal trafficking of people between China and Hong Kong provides an avenue of new lives beyond the dreary, drab landscape of wintry, snowy Northeast. The lively, busy scene of Hong Kong seems like a favorite destination for many mainlanders. These women range from an aspiring real singer Ai Jing to fictional sex workers in Fruit Chan's films *Durian Durian* (榴莲飘飘, 2000) and *Hollywood Hong Kong* (*Xianggang youge Helihuo* 香港有个荷里活, 2001). The heroine in *Durian Durian*, Yan 燕, is indeed another beautiful young woman from Northeast China. In filmic representation, mainland women seem to be able to make a transition more easily than mainland men. In *Comrades, Almost a Love Story*, Li Qiao comfortably adapts to the pace of capitalist lifestyle in Hong Kong whereas it takes a longer time for hard-boiled masculinity to change, as in the case of Xiaojun. Socialist masculinity seems to be more stubborn than flexible femininity.

The Fulfillment of Men's Dreams on Chinese Soil

American Dreams in China is produced in the time of renationalization and mainlandization. Many Hong Kong filmmakers brace for a realignment with the Chinese film industry. China has become the second largest economy and the second largest film market in the world in the second decade of the twenty-first century. This is a time of growing integration between Hong Kong and China economically and culturally. The Close Economic Partnership Arrangement (CEPA) between Hong Kong and China has brought Hong Kong and Chinese film industries closer to each other. It is more lucrative for the Hong Kong film industry to cooperate and coproduce with the mainland. The Chinese national market is such a large market for the distribution of Hong Kong films. It is unwise not to take advantage of the huge size of the mainland audience.

However, this trend of close partnership between the mainland and Hong Kong film industries is worrisome for some critics. In the words of Mirana May Szeto and Yun-chung Chen, this is a case of the neoliberalization and mainlandization of a once thriving cinema that is now anxiety-ridden for its survival. They write:

> A spectrum of preferential market liberalization measures are extended to the Hong Kong SAR but not to foreign countries under the mainland and Hong Kong Closer Economic Partnership Arrangement (CEPA) in 2004. These privileges coupled with declining local and Asian markets accelerate the restructuring of the Hong Kong film industry towards mainlandization. The seeming rebound of the Hong Kong film industry is often attributed to CEPA policies. But at what cost?[13]

Mainland China's favoritism toward Hong Kong might have a negative consequence—a cinema in disappearance, the fading away of the local flavor of Hong Kong cinema. As Esther Yau has written, "The naming of Hong Kong cinema became detached from the city of Hong Kong in the mid-2000s when its major local film companies, producers, and directors relocated their offices and personnel to the Chinese mainland to redirect their energies into co-producing films."[14] This mismatch between the city of Hong Kong and its cinema is a consequence of mainlandization in pan-Chinese film industries.

However, all this does not bother Peter Chan. He has become a beneficiary as well as a major player in this new trend of mainlandization. His career is a good example of this shift in contemporary Hong Kong film industry. Chan had been working in the Hong Kong film industry and making Hong Kong films for a long

time. But in recent years, he collaborates with the mainland film industry and makes Mandarin-language films about the lives of mainland Chinese people. *American Dreams in China* and *Dearest* (*Qin'ai de* 亲爱的, 2014, starring Zhao Wei 赵薇) are two examples. The stars of these films are mainland actors and actresses.

Chan is also the director of a highly patriotic film about the national women's volleyball team of China, *Leap* (*Duoguan* 夺冠), which is released in fall 2020. The national women's volleyball team has been one of the most revered and beloved group of people in China. In the last forty years, it has won numerous championships in international competitions, including the Olympic Games. *Leap* spans several decades and details the hardship, endurance, glory, and indomitable spirit of Chinese athletes. Legendary mainland actress Gong Li plays the lead role in the film and portrays another legendary mainland Chinese woman, namely, volleyball player and future coach Lang Ping.

The production companies of *American Dreams in China* include China Film Group, Media Asia Films, Edko Films, Stellar Mega Films, and Yunnan Film Group. It is a China-Hong Kong coproduction, a pan-Chinese transnational film. It is also a good example of Chinese-language film (*huayu dianying*). The language of the film is Mandarin as it is catered the vast mainland Chinese audience for distribution. The film has won major awards at Golden Rooster Awards Film Festival of China, the Golden Horse Awards Film Festival of Taiwan, and Hong Kong Film Festival.

American Dreams in China is the story of three male characters: Cheng Dongqing 成东青, Meng Xiaojun 孟晓骏, and Wang Yang 王阳. They were best friends at college and are now "Chinese business partners" (*Zhongguo hehuo ren* 中国合伙人), as the original film title says. Their lives, careers, choices, failures, and successes point to a righteous path of career development guided by a Chinese dream in the age of globalization.

The central character is Cheng Dongqing. He comes from a humble peasant family. He fails national college entrance examination a couple times. His family borrows money from relatives to continue to support his dream of entering a college. He is finally admitted to Yanjing University.

As a young man, Cheng Dongqing harbors a dream of coming to America. However, he is repeatedly denied an American visa by the American Consulate in Beijing. His girlfriend Su Mei 苏梅 (Du Juan 杜鹃) also leaves him for the United States. Without other choice, he has to try to fulfill his American dream on the Chinese soil by becoming an English teacher to Chinese students. Through sheer perseverance and hard work, he eventually founds an English

language school. Toward the end of the film, their school is so successful that it trades at the New York Stock Exchange. However, the school is sued for copyright violation. Having becoming successful businessmen, Cheng and his associates come to America to settle the lawsuit. In their meeting with American lawyers, Cheng lectures them about the Chinese way in a drawn-out speech. Paradoxically, it is the Chinese who teach Americans about how to do business in the world, how to be good capitalists!

In *American Dreams in China*, Chinese men and women, such as the character Meng Xiaojun, come to America in pursuit of their dreams. However, their American dreams turn sour, and they end up returning to China. China is ultimately described as the land of opportunities. What appears to be a film with a transnational ethos turns into a film that affirms a cultural and economic affiliation with the Chinese nation. In such a way, *American Dreams in China* is rather different from Peter Chan's earlier film *Comrades, Almost a Love*. That film is about the perpetual journey of Chinese men and women in search of economic opportunities and cultural identity. The main characters move from China, to Hong Kong, to New York City, and continually forge a sense of self.

Meng Xiaojun arrives in America. But in this bountiful land, he could only find work as a bus boy in a restaurant. He chooses to return to China. The three former classmates: Cheng Dongqing, Wang Yang, and Meng Xiaojun, open a lucrative language school. Toward the end of the film, Cheng Dongqing donates a laboratory in the name of Meng Xiaojun to the research center where Meng Xiaojun worked when he first came to the United States. Ironically, Meng and his friends' success in China have redeemed his early failure in America.

In *American Dreams in China*, in regard to gender formation, the courtship and marriage of the main male characters with Chinese women also help them develop their identity as Chinese nationals. One main character, Wang Yang, dates Lucy (Claire Quirk), an American exchange student while in college, but Lucy eventually dumps him and returns to the United States. That is a traumatic experience for him. Heartbroken by his erstwhile American girlfriend, Wang Yang cancels his plan to come to America. He marries a Chinese woman later in the film. The former "angry youth" (*fenqing* 愤青), the romantic poet with a wild hairstyle, is eventually domesticated, and becomes a loyal partner, a peacemaker among the three good friends in college back then and three business partners nowadays. Wang Yang warns his buddies at his wedding: "Do not marry a woman who has too many ideas." This is a lesson he has learned from dating an inquisitive, independent-minded American girlfriend. In this inward-looking

film, dating the other seems to be a route not to be taken in the establishment of Chinese masculinity.[15]

Cheng Dongqing embodies the spirit of the successful "local turtle" (*tubie* 土鳖). Meng Xiaojun's story is a representative case of the so-called "overseas returnees" (*haigui* 海归, homophone nickname "sea turtle" 海龟). They give up their careers abroad and return to motherland. This is the story of both patriotism and the ascendancy of China as the promised land in the new century. China, not America, nor any other foreign country, is the place for personal and professional development. *American Dreams in China* is about Chinese nationals' rootedness in China and their willful return from overseas.

The ending credits of the film pay tribute to successful Chinese entrepreneurs, including the real-life founders of the Chinese language school New Orient (*Xin Dongfang* 新东方). Also included in this list of extraordinary entrepreneurs is Ma Yun 马云. Ma Yun, a physically small-statured male, has become one of the biggest businessmen in mainland China. His company Ali Baba trades in the New York Stock Exchange. In his early years, Ma Yun failed China's national college examination a couple times. He was eventually admitted to a college and became a major in English. He did not have an opportunity to study abroad. His personal story is also a story of rags to riches. He stays in China rather than going abroad, and has enacted the real-life drama of a Chinese success story. His career mirrors the fate of the main characters in *American Dreams in China*. The fictional characters in the film as well as their real-life prototypes represent a new generation of Chinese males. They are white-collar workers and business leaders. They are well educated, urban, and cosmopolitan. They are globe-trotting jet-setters and are yet at the same time firmly rooted in Chinese reality.

It might be also fruitful to briefly mention and compare the depictions of Chinese men in Chinese-language films and in American films in the early twenty-first century. Two examples of English-language American films are *Shanghai Calling* (directed by Daniel Xia, 2012) and *Shanghai Kiss* (directed by Kern Konwiser and David Ren, 2007). These are dramas about the transnational journeys and diasporic condition of ethnic Chinese living in America. They are American films directed or codirected by Chinese-American directors. In these Asian-American films, ethnic Chinese, who might not be able to speak Chinese, travel to Shanghai to do business as well as search for their cultural roots. While the characters undergone cross-cultural experiences in transnational settings, they enhance their self-understanding as Asian-American males. Interracial romances between these Chinese-American males and Caucasian American

women also help define their sense of cultural identity: "American citizens with Chinese characteristics," so to speak.

In *Shanghai Calling*, the male protagonist is Sam Chao, a young, dashing, well-dressed New York lawyer, performed by Daniel Henney, a Korean-American actor and model. The female protagonist is Amanda Wilson, a relocation specialist, a single mother, a Caucasian American woman, performed by Eliza Coupe. Unlike the failed interracial romance of the character Wang Yang in *American Dreams in China*, Sam Chao and Amanda find each other, fall in love, and forge a life together in *Shanghai Calling*. The film points to the possibility of cross-cultural understanding and interracial heterosexual bliss. It is different from the nationalistic, patriotic, standoffish ethos of *American Dreams in China*. *Shanghai Calling* makes China into a land where expatriates and foreigners can realize their dreams. Men can assert their ability and masculinity in Shanghai, and will be able to fulfill their libidinal drives and professional goals. Sam Chao, as an American expatriate, discovers the wonders of China. Unlike the flow of people from China to New York in those Chinese-language films, this time the direction of traffic is the other way around, from New York to China. The ethnic Chinese male, Sam, establishes his identity in China, the land of his ancestors.

All in all, the resurrection of Chinese masculinity in films goes hand in hand with the so-called "rise of China" in the new century. Chinese nationals as well as ethnic Chinese abroad both seem to have regained confidence in their entrepreneurship in the national arena as well as the international stage. Some of them may even have the good luck of falling in love, and being loved by women from China or elsewhere.

Hong Kong Cinema and the Pursuit of the Chinese Dream

I would like to summarize my above discussions by further looking at the pursuit of the Chinese Dream at the level of the translocal, transnational Hong Kong film industry as well as the level of themes in the films of Hong Kong or ex-Hong Kong directors. As mentioned earlier, since Hong Kong's return to China in 1997, and especially after the signing of the Close Economic Partnership Arrangement (CEPA) between Hong Kong and China, Hong Kong filmmakers have increasingly crossed the border to mainland China to take advantage of the huge mainland market. This phenomenon has been described as "mainlandization" or "re-nationalization." Established Hong Kong directors have made many films with astonishing box office success in mainland China.

Stephen Chow's 周星驰 2016 blockbuster *The Mermaid* (*Meiren yu* 美人鱼) broke the box office record in China at the time. What happens to local identity and indigenous cinema in the pursuit of a grand Chinese Dream then?

At the level of the filmic text, previous Hong Kong films often embody themes of quest, journey, and diaspora, and their characters harbor a "Hong Kong Dream" (Peter Chan's *Comrades, Almost a Love Story*), a "New York Dream" (Stanley Kwan's 关锦鹏 *Full Moon in New York, Ren zai Niuyue* 人在纽约, 1989), or a "California Dream" (the soundtrack of *California Dreamin'* in Wong Kar-wai's *Chungking Express, Chongqing senlin* 重庆森林, 1994). With the rise of China in the twenty-first century, many Hong Kong films hasten to embrace the "Chinese Dream." A noticeable example is Peter Chan's film *American Dreams in China*. Mainland China has become the place where Hong Kong filmmakers as well as fictional characters within Hong Kong films themselves can realize their dreams. As Peter Chan confesses, there is no need for his films to aim at the global film market. The mainland Chinese market is big enough and good enough.

However, the mainland-originated grand Chinese Dream sometimes meets vigorous contestation at the local level. The Hong Kong film *Ten Years* (*Shinian* 十年, 2015) is a good example. It offers a dystopian, ominous vision of what will happen in Hong Kong in year 2025, when Hong Kong society is increasingly ruled by mainland China. In one episode, taxi drivers are forbidden to speak the Cantonese dialect in certain zones of the city. Putonghua (standard Mandarin) is the speech of the town. The Chinese Dream turns into a nightmare in this futuristic film. This small budget film surprisingly won the Best Film Award at the 35th Hong Kong Film Awards. Against the usual practice, mainland media did not broadcast that year's Hong Kong Film Awards.

Another case of "localization," not so boisterous and combative, is veteran Hong Kong filmmaker Ann Hui's 许鞍华 work *A Simple Life* which is a slow-paced, quiet, touching, elegiac tale of an old maid in a traditional Hong Kong family. I have already mentioned this key film a couple of times in this chapter. The film casts a last glimpse at a disappearing lifestyle in Hong Kong. It is love at last sight, the *déjà disparu*, or what Ackbar Abbas describes with prescience as the "culture and the politics of disappearance," the title of his book on Hong Kong published in the fateful year of 1997. The film won four awards at the 68th Venice International Film Festival, including Best Actress for Deanie Ip 叶德娴 in the lead role of Sister Peach.

Veteran director Ann Hui's case is intriguing as she must have felt a double-bind between a deep affection for locality and the allure of the mainland. She goes on to make films that highlight the importance of mainland Chinese

history and politics. She directs a biopic of the female writer Xiao Hong 萧红, *The Golden Era* (*Huangjin shidai* 黄金时代, 2014). She must have felt a strong affinity with Xiao Hong because they were both born in China's Northeast and then settled in Hong Kong. She also directs *Our Time will Come* (*Mingyue jishi you* 明月几时有, 2017), which depicts the resistance movement in Hong Kong and the struggle of Hong Kong people to protect mainland refugees during the Japanese occupation in the Second World War. Hence, Ann Hui embodies the twin forces of localization and mainlandization. It is a great recognition and honor to both her and Hong Kong cinema that she wins the Lifetime Achievement Award at the Venice Film Festival in 2020.

In general, here are two dominant strategies in the reorientations of the contemporary Hong Kong film industry. One is to capitalize on the huge market of mainland China. Commercially successful examples include the films and practices of such directors as Peter Chan and Stephen Chow. They participate in and contribute to the building of the Chinese Dream which promises national unity and prosperity to all Chinese regardless of where they reside. Another tendency is to stubbornly hold onto the local and resist the national, as exhibited by such films as *Ten Years*. In that instance, the local tradition and autonomy of Hong Kong will not be subsumed under a grand national ideology. Last but not least, it should be emphasized that epochal social changes, traumatic political dramas, and intense personal feelings are necessarily played out in the bodies, minds, and psyches of a multitude of male characters in Hong Kong cinema as I have attempted to delineate throughout this chapter. Masculinity figures prominently in the imaging and imagining of the local identity of Hong Kong citizens as well as in the national identity of Chinese people.

Notes

1 Sheldon Lu, ed., *Transnational Chinese Cinemas: Identity, Nationhood, Gender* (Honolulu: University of Hawaii Press), p. 25.

2 Ackbar Abbas, *Hong Kong: Culture and the Politics of Disappearance* (Minneapolis: University of Minnesota Press, 1997).

3 Christina Klein, "*Kung Fu Hustle*: Transnational Production and the Global Chinese-language Film," *Journal of Chinese Cinemas* vol. 1, no 3 (2007): 189.

4 Sheldon Lu, "Notes on Four Major Paradigms in Chinese-Language Film Studies," *Journal of Chinese Cinemas* vol. 6, no. 1 (2012): 15–26.

5 SheldonLu, "Crouching Tiger, Hidden Dragon, Bouncing Angels: Hollywood, Taiwan, Hong Kong, and Transnational Cinema," in *Chinese-Language Film: Historiography, Poetics, Politics*, ed. Sheldon H. Lu and Emilie Yueh-yu Yeh (Honolulu: University of Hawaii Press, 2005); Chris Berry, "Transnational Chinese Cinema Studies," in *The Chinese Cinema Book*, ed. Song Hwee Lim and Julian Ward (London: Palgrave Macmillan), 2011, pp. 9–16.

6 Yingjin Zhang, *Cinema, Space, and Polylocality in a Globalizing China* (Honolulu: University of Hawaii Press, 2010).

7 Esther C. M. Yau, ed., *At Full Speed: Hong Kong Cinema in a Borderless World* (Minneapolis: University of Minnesota Press, 2001).

8 Sheldon Lu, "Hong Kong Diaspora Film and Transnational TV Drama: From Homecoming to Exile to Flexible Citizenship," in *Chinese-Language Film: Historiography, Poetics, Politics*, ed. Sheldon H. Lu and Emilie Yueh-yu Yeh (Honolulu: University of Hawaii Press, 2005), p. 298.

9 Sheldon Lu, ed., *Transnational Chinese Cinemas: Identity, Nationhood, Gender* (Honolulu: University of Hawaii Press, 1997).

10 Esther M. K. Cheung, Gina Marchetti, and Esther C. M. Yau, "Introduction," in *A Companion to Hong Kong Cinema*, ed. Esther M. K. Cheung, Gina Marchetti, and Esther C. M. Yau (Malden, MA: Wiley-Blackwell, 2015), pp. 5–6.

11 I compare Hong Kong films *Farewell China; Comrades, Almost a Love Story; Full Moon in New York* (*Ren zai Niuyue*, by Stanley Kwan), and *Happy Together* (*Chunguang zhaxie*, by Wong Kar-wai) in Sheldon Lu, Chapter 5, "Diaspora, Citizenship, Nationality: Hong Kong and 1997," in *China, Transnational Masculinity, Global Postmodernity* (Stanford, CA: Stanford University Press, 2001), pp. 104–21.

12 See Aihwa Ong, *Flexible Citizenship: The Cultural Logics of Transnationality* (Durham, NC: Duke University Press, 1999). Ong builds her theory in part on the notion of "flexible accumulation" in David Harvey's book *The Condition of Postmodernity: An Inquiry in the Origins of Cultural Change* (Oxford, UK: Blackwell, 1989, 1991.) Flexible accumulation is the mode of operation in the global capitalist economy in the postmodern age. This kind of economic life has an impact on the formation of subjectivity and results in the appearance of flexible and multiple identities.

13 Mirana May Szeto and Yun-chung Chen, "Hong Kong Cinema in the Age of Neoliberalization and Mainlandization: Hong Kong SAR New Wave as a Cinema of Anxiety," in *A Companion to Hong Kong Cinema*, ed. Esther M. K. Cheung, Gina Marchetti, and Esther C. M. Yau (Malden, MA: Wiley-Blackwell, 2015), p. 94.

14 Esther C. M. Yau, "Watchful Partners, Hidden Currents: Hong Kong Cinema Moving into the Mainland of China," in *A Companion to Hong Kong Cinema*, ed.

Esther M. K. Cheung, Gina Marchetti, and Esther C. M. Yau (Malden, MA: Wiley-Blackwell, 2015), p. 17.

15 Interracial romance has been a strategy of establishing a confident, outward-looking masculinity in some Chinese TV dramas and films. See Sheldon Lu, Chapter 10, "Soap Opera in China: The Transnational Politics of Visuality, Sexuality, and Masculinity," in *China, Transnational Masculinity, Global Postmodernity* (Stanford, CA: Stanford University Press, 2001), pp. 213–38.

Masculinity in Crisis: Male Characters in Jia Zhangke's Films

The previous chapter has offered a broad, general, historical analysis of the representation of masculinity in contemporary Hong Kong cinema. This chapter continues to pursue the topic of masculinity by zeroing in on the films of only one important director from mainland China, Jia Zhangke. As the chapter will demonstrate, Hong Kong cinema, Hong Kong popular culture, Cantopop songs, and more specifically the genre of Hong Kong gangster film have had an enduring impact on Jia's film art. Indeed, he has repeatedly and profusely alluded to and paid homage to Hong Kong cinema in many of his films. The imitation and recycling of Hong Kong-style gangster characters in a mainland Chinese setting has been a constant and crucial strategy in Jia's films. The pervasive influence of Hong Kong popular culture has helped Jia create and finesse mood, psychology, and social ambiance characteristic of the people of a country undergoing tremendous social transformations.

Jia Zhangke's films are famous for their portrayal of ordinary Chinese people caught in the historic yet troubled transition of China from a socialist planned economy to a capitalist market economy. Male heroes, or antiheroes, are central characters in his films. The filmic depiction of Chinese masculinity in crisis partakes of a more general description of the losses and discontents of a whole generation of people in socialist China.[1] I focus on male protagonists in the films of Jia Zhangke such as *Xiao Wu* (小武, aka *The Pickpocket*, 1997), *Platform* (*Zhantai* 站台, 2000), *The World* (*Shijie* 世界, 2004), *Still Life* (*Sanxia haoren* 三峡好人, 2006), *24 City* (*24 cheng ji* 二十四城记, 2008), *a Touch of Sin* (*Tian zhuding* 天注定, 2013), and *Ash Is Purest White* (*Jianghu ernü* 江湖儿女, 2018). The characters suffer the trauma of losing their loved ones (girlfriend, wife, or lover), or have difficulty entering into satisfying relationships with

women due to the fundamental social and economic transformations in the period of Reform and Opening.

Jia Zhangke (born 1970) has emerged as one of most well-known independent art-house film directors hailing from the People's Republic of China. His films have persistently focused on the history as well as contemporary reality of socialist China. Many of his films depict the drama and trauma of ordinary Chinese citizens in the throes of economic reforms. Jia's film aesthetics is also striking and intriguing. Sound, music, image, cinematography, editing, pacing, and storytelling are rather idiosyncratic under his direction. The interplay between fact and fiction, between documentary realism and fictional narration is noteworthy.

In the classical socialist era (1949–1976), the available role models for men are the exemplary workers, peasants, and soldiers (*gong, nong, bing* 工农兵), as well as occasionally cadres (*ganbu* 干部), officials, and administrators. In the post-Mao era, especially since the onset of Reform and Opening, Chinese society has unleashed a multitude of heretofore unseen role models, possible careers, and subject-positions. The Chinese economy has moved away from a predominantly planned economy with national ownership to a mixture of a planned economy and a market economy with a variety of forms of ownership: national, collective, and private. Individual entrepreneurs (*getihu* 个体户) and businessmen have appeared as new social classes. These men function, compete, and operate in a society where the line between a legitimate business and an illegitimate transaction is often blurred. Jia Zhangke's films testify to the processes of the formation and deformation of masculinity in a new kind of socialist state—"postsocialism."[2] He is "the cinematic poet of post-socialist China."[3]

Men from the working class populate Jia's films. As mentioned above, the old socialist trio of workers, peasants, and soldiers has become less appealing in Chinese society. Available positive role models are lacking. Men must search for new suitable subject-positions. Jia's films show that men have to borrow role models from elsewhere. They look for inspiration from the film, TV, and popular culture of Hong Kong, East Asia, and the West. For instance, the gangster type in Hong Kong cinema, as exemplified by the charismatic performance of Chow Yun-fat, has been a recurrent image in Jia's films. The diverse influences from outside the People's Republic of China have contributed to mixed masculine models.

Xiao Wu: The Gangster Model

Xiao Wu 小武, the title character of the film, was a pickpocket in Fenyang 汾阳, Jia Zhangke's hometown, in Shanxi Province 山西. One of his ex-friends, Jin Xiaoyong 靳小勇, became rich through the illegal selling of cigarettes, and was inculpated by the local government as a model entrepreneur. He made a donation of 30,000 yuan to the town, and was interviewed and praised by the local television station. He was busy preparing for his wedding, but did not invite his ex-buddy Xiao Wu to the event. He wanted to be clean and be not tainted by association with a questionable character from the past. Xiao Wu was very upset by not being invited by his "friend." Lonely and sad, he wandered in the streets of the city and visited a karaoke bar. He developed a caring relationship with a hostess in the bar, Meimei 梅梅. When she was sick, he came to help her. Usually he could not sing, but in a fascinating episode set in a public bathhouse, naked Xiao Wu unexpectedly and spontaneously started to sing a song. He fell in love. Toward the end of the film, Meimei was transferred to another city to work by her boss, and Xiao Wu could not find her and see her. Xiao Wu felt the pain of losing his lover. Right at the act of stealing a wallet from a person, his cell phone rang. This was a call from Meimei. The ring caught people's attention, and Xiao Wu was arrested on the spot for his action.

The actor for Xiao Wu is Wang Hongwei 王宏伟, who has appeared in many films of Jia. In this film, Wang Hongwei portrays a character who has a small physique and long hair, and wears a huge pair of eyeglasses. Now and then, the soundtrack of the film broadcasts a famous Hong Kong action film: *The Killer* (*Diexue shuangxiong* 喋血双雄, director John Woo, 1989). Xiao Wu is a pale comparison to the statue of the iconic, heroic, romantic gangster performed by Chow Yun-fat. Chow Yun-fat's stellar performances in John Woo's gangster films have been the defining benchmarks of masculinity in Hong Kong, pan-Chinese, and Asian popular culture. The jarring juxtaposition between sound and image, between the romantic soundtrack of *The Killer* and the lackluster appearance of diminutive Xiao Wu in a dusty town in northern China, makes a poignant caricature of the image of the Chinese male in the Era of Reform and Opening. At the same time, the morally ambiguous male person is becoming the order of the day in a fast-changing nation when a large grey area exists between right and wrong, between legitimate work and illegitimate transaction, between law and social transgression.

Martin Scorsese was among the big-name international fans of this low-budget Chinese film. The American director is also well known for the portrayal of gangsters and morally ambiguous characters. He says that *Xiao Wu* could have been one of the ten best films of the year at the time if he were able to help with the promotion of the film. He was "mesmerized" by this underground film from a Sixth-Generation director when he first saw it. Here is his reminiscence of the film:

> The remarkable eye and ear for detail grabbed me immediately: every scene was so rich, so perfectly balanced between storytelling and documentary observation. And as a character study, and a film about a community, *Xiao Wu* is extraordinary. There is nothing sentimental about Wang Hongwei's performance or about Jia's approach to him, and somehow that makes the end of the film, where the protagonist is arrested, chained, and exposed to public ridicule, all the more devastating. This was true guerrilla filmmaking, in 16mm format, and it reminded me of the spirit in which my friends and I had begun, back in the 1960s.[4]

Scorsese points to the attraction and effectiveness of this "guerrilla," experimental mode of filmmaking in a new generation of Chinese filmmakers. It exemplifies the spirit of innovation in world film culture, whether it pertains to cinema in the West in the 1960s or mainland Chinese cinema in the late twentieth century.

As evident in the case of Xiao Wu's former friend Jin Xiaoyong, the big-time gangster-turned-legitimate businessman has become a new role model for men in the post-Mao era. Failing to achieve that prowess and respectability, the Chinese male then struggles to survive as a petty thief ineluctably and may be punished by law eventually, as in the case of Xiao Wu himself. The film *Xiao Wu* vividly describes this particular route of male adventures in contemporary Chinese society.

Still Life: The Migrant Worker and Embodied Masculinity

Still Life (*Sanxia haoren* 三峡好人) also narrates the tale of the trauma of Chinese socialism in transition. The male protagonist Han Sanming 韩三明, a coalminer from Shanxi Province, came to Fengjie 奉节 in the Three Gorges area to search for his lost wife. His wife ran away from him many years ago. Back then, he spent 3000 yuan and "bought" a wife for himself in Shanxi. At Fengjie, he met an intriguing young man, a small-time gangster, who went by "Mark."

There is a striking scene consisting of a single long take and medium shot. It is a conversation between Han Sanming and Mark. Mark's silhouette looked like Chow Yun-fat 周润发. Han Sanming asks him what his name was. He replies: "Mark." It came from "Brother Mark" (*Fa Ge* 发哥, Brother Fat). He reiterates lines from Chow Yun-fat's role Jeff in *The Killer* directed by John Woo: "We are not suited for this modern world. We old-timers are too nostalgic." Again, there is a discrepant juxtaposition between the icon of Chinese masculinity embodied by Chow Yun-fat's film roles and a thug in present-day Fengjie. Throughout the film, the soundtrack plays a number of romantic Cantopop songs. Eventually, this Mark is killed, and his body is found under the debris of a demolished building by Han Sanming. The influence of Hong Kong's cinema and pop culture is strongly present in this film. There is a rich and yet ironic layering of different meanings. The disconnect between sound and mage is equally prevalent. Music and sound from different time periods are mixed to produce a particular affect and feeling.

In *Still Life*, Han Sanming comes to Fengjie to look for his long-lost wife. Finally he finds her and the two meet. But it is uncertain whether she will go back to him and live with him in the future. He needs to return to Shanxi to earn more money in order to win her back. The issue of marriage also looms large at the ending of an earlier film by Jia, *Platform* (*Zhantai* 站台, 2000). The film chronicles the adventures and transformation of a performance troupe in the span of some twenty-odd years from the beginning of the Reform Era to the end of the twentieth century. It is largely a story of thwarted ambitions and failed attempts, a "journey across the ruins of Post-Mao China."[5] However, at the end the film, two protagonists: Cui Mingliang 崔明亮 (Wang Hongwei) and Yin Ruijuan 尹瑞娟 (Zhao Tao 赵涛), get married and even have a child. After years of wandering and searching in vain, they return to their hometown in Shanxi, with a sense of resignation. The ending does not show a picture of marital bliss, but the tired body and dispirited face of the male protagonist Cui Mingliang.

The companion film to *Still Life* is Jia Zhangke's documentary *Dong* 东. Dong refers to the name of the painter Liu Xiaodong 刘小东. The two films are shot at the same time in Fengjie. Liu Xiaodong is a leading contemporary Chinese painter who specializes in the oil painting of human figures. He is friends with many filmmakers of the so-called Sixth Generation, and has appeared in some of their films. The first half of the documentary revolves around Liu Xiaodong's painting of migrant demolition workers in Three Gorges. A group of half-naked, ordinary male workers serve as the models of Liu's painting. Indeed, some of the same workers/models, including the actor for Han Sanming, also appear

in the painting and the documentary. In fact, such lean, muscular, masculine bodies of local and migrant workers are also frequently featured in *Still Life*. And these male workers are not professional actors but real workers. This realist aesthetics, by way of the use of mostly nonprofessional actors, adds to the realism of Jia's films. It should be emphasized that masculinity itself, in the unadorned, original bodily form of half-naked male workers, constitutes the main subject of representation in both the documentary *Dong* and the feature film *Still Life*. Shuqin Cui comments on the representation of the bodies of the migrant workers in this painting and the film with the following words:

> These body images are the primary artistic and discursive modes for the construction of the migrant social identity. Half-naked, dark-skinned, and sweet-soaked, dirty male bodies have been a central mise-en-scène in urban China. The bodies are everywhere, but identities remain invisible. The primary workforce for China's economic development, inferior in socio-political status, this collective entity remains subject to economic exploitation and socio-cultural neglect.[6]

The migrant workers have been the primary laborers in the building of China's shining facades of modernization and globalization in the decades of Reform and Opening. Yet, they barely have an audible voice in Chinese society and politics. They are a disenfranchised and exploited class. Jia's films attempt to visibly represent them on the screen and lend them a voice in soundscapes. He usually avoids depicting the upper echelon of Chinese people but rather focuses on the average person. As one critic rightfully states: "the main characters of Jia's films are individuals whose walks of life are closer approximations of the Chinese 'average': all live in or are from towns of lower rank than provincial capital, none have college educations or the hope of attaining one, and none occupy the extraordinary social position of the professional artist."[7]

Figure 4.1 *Hot Bed No. 1 (Wenchuang zhi yi)*. 2005. 260 × 1000 cm. Oil on canvas. Liu Xiaodong.

24 City: The Fate of the Socialist Worker

24 City is specifically about the socialist legacy. It details the history of a once proud state-owned enterprise and its near bankruptcy in the present time in Chengdu. (The title of the film possibly originates from a line of classical poetry, whose authorship is uncertain: "24 City is full of hibiscus flowers; Jin'guan is known for prosperity in the old days" (*Ershisi cheng furong hua, Jin'guan zixi cheng fanhua* 二十四城芙蓉花，锦官自昔称繁华). The Cheng Fa Group 成发集团and its Factory 420 were a military airplane factory. It was selling its land to a real estate developer China Resources Land (*Huarun zhidi* 华润置地), and was relocating to the suburb of Chengdu.[8] The film begins in December 2007 when the company was finalizing the land sale. The film is a mixture of fictional narrative and documentary.

Demolition of the physical structure of old buildings and symbolically the tearing apart of old personal stories are at the center of the film. This is largely a nostalgic look at a time when honest manual labor (*laodong* 劳动) was appreciated. In one scene, a slightly modified line of a poem by the poet Ouyang Jianghe 欧阳江河 was directly projected onto the screen: "The whole airplane factory is a huge eyeball; labor is its deepest part" (整个造飞机的工厂是一个巨大的眼球，劳动是其中最深的部分). In contemporary China, the big shots are people like real estate developers who take over the old factory site, as if capitalism were taking over socialism. The camera focuses on the lives of model workers in the heyday of socialism and the sorry state of laid-off workers in the present. The film captures the disappearance of the socialist past along with attendant pains and traumas. These aspects of the film are reminiscent of Wang Bing's 王兵 9-hour long documentary *West of the Tracks* (*Tie xi qu* 铁西区, 1999–2001), set in Shenyang, northeastern China.

The film about the everyday life of ordinary people deploys Jia's signature long-take aesthetics. The viewer sees shots of an old factory, empty rooms, dilapidated buildings, and scarred landscape. Such static shots often contain a pastiche of different space-times: awards and banners from olden days of socialism hung on the wall of factory rooms; buildings in ruins and under demolition. The multiple layering of space and time is striking in Jia Zhangke's oeuvre. It is a mixing of past, present, memory, desire, and affect. The soundtrack, songs, music, and ambient noises include bits of different historical moments, slices of past, shattered dreams, and the forgotten past. The stylistic collage creates

both fragmentation and linkage, continuity and discontinuity. There is often a disconnect between sound and image.

There are static, frontal shots of ordinary workers in the factory. These shots linger on the plainness of the faces and bodies of the male workers, who may look shy and hesitant while directly facing the camera. Such unglamorous images in fact lionize these men and transform them into "ordinary heroes." An intriguing scene is about a worker who looks like a security officer in the factory. He rides a bike at night and examines the surrounding with a flashlight. There is a shot of the worker's flashlight as if the cinematographic image were lending an existential weight to an otherwise insignificant object. As this worker rides the bike at night, the soundtrack is the sentimental, romantic melody of a song (*Qianzui yisheng* 淺醉一生, literally "A Life of Mild Intoxication") by Sally Yeh (叶倩文), which is used in the film *The Killer* (*Diexue shuangxiong* 喋血双雄) as Jeff (Chow Yun-fat) is about to shoot a group of gangsters in a nightclub where Jenny (Sally Yeh) is singing this song. Jenny sings: "I wander around every day; my heart flutters each morn and each night, hoping to find a companion so that my heart no longer flutters" (author translation). This ordinary security officer in Chengdu is juxtaposed through soundtrack to the exemplum of masculinity created in Hong Kong popular culture. In fact, Jia Zhangke uses the soundtrack from this same episode in *The Killer* in his earlier film *Xiao Wu* when the character Xiao Wu was doing his line of work in the streets of Fenyang. And this is still not enough for Jia as he uses and recycles this song in yet another film: *Ash is Purest White*.

24 City consists of a series of interviews with workers of the factory. Some interviewees are real workers from this factory, and some interviewees are fictive characters portrayed by film stars such as Lü Liping 吕丽萍 and Chen Chong 陈冲 (star of the film *Xiao Hua* 小花, 1978). The film is a blend of fiction and documentary.

The film begins with an interview of a real worker from the plant. He Xikun 何锡昆, a middle-aged man now, was a young machinist at the plant some twenty years ago. He reminisced about his teacher (*shifu* 师傅) Wang Zhiren 王芝仁 at the time when he was an apprentice. The teacher taught him to be frugal, not to be wasteful, when using precious factory materials. He was a model worker. During the Cultural Revolution when dangerous fighting between different factions was rampant, most workers stopped working, but he still came to the factory to work. At the end of this episode, He Xikun paid a visit to his former teacher, who had long been retired and had partially lost memory. It was an emotional reunion between the teacher and the disciple.

One of the interviewees is Song Weidong 宋卫东, a manager at the factory. He told about his memory of the factory's past as well as the personal story of his first love affair. In his account, the factory was the typical product of a socialist planned economy. It was like a self-sustained island in Chengdu. The children of the factory had little interaction with other children of Chengdu except when it came to fighting. Children of the factory attended the kindergarten, elementary school, and high school run by the factory itself. In summertime, the factory even produced its own cold drink (*qishui* 汽水) for its employees and their families. As a state-owned enterprise (SOE), employees and their families enjoyed privileges that were not given to the locals of Sichuan Province. Being a worker of a SOE was an enviable job. Those were the good old days of socialism. Song Weidong reminisced about this part of the history of the factory with pride and nostalgia. But things started to change since the reforms in the Deng Xiaoping era. The factory began to lose money, especially in time of peace. China was transitioning to a market economy. The factory must be financially accountable by itself. Job security and financial well-being were no longer guaranteed.

The worst blow of it all was when universities and colleges were reopened and national examinations for entry into universities were reinstituted in the late 1970s. Song Weidong's girlfriend was admitted to a university whereas he stayed in the factory. Because of the social disparity between a university student and a factory employee in the new era of reforms, Song's girlfriend decided to break their relationship and left him. There existed a difference in social status between a mental laborer (an intellectual) and a manual laborer (a factory worker) in a putatively egalitarian socialist state.

That was also the time of the influx of foreign culture and soap operas into socialist mainland China. In 1984, China Central Television imported a Japanese TV drama for the first time: *Red Suspicion* (*Akai Giwaku* 赤い疑惑, 1975–1976), which was translated as *Xue Yi* (血疑) in Chinese. The soap opera was especially popular in China at the time. Yamaguchi Momoe 山口百惠, who portrayed the lead role in the TV series, became a pop icon among the Chinese audience. The theme song of the TV series, *Thank You Very Much* 多谢你, was a national hit in China. Chinese girls mimicked the demeanor and hair style of the film protagonist, teenager Oshima Yukiko 大岛幸子. Song Weidong recalled that on the day of their separation, his girlfriend wore a red scarf in the style of Yukiko. Ironically, toward the end of the interview, Song Weidong said that his wife, the current personnel files manager at the factory, was a fan of the Japanese soap opera and still watched its replay now!

At the end of the interview with Song, the film cuts to a scene of Song playing basketball alone on a basketball court of the factory's residential area. The soundtrack of the emotional theme song of the Japanese soap opera is heard. Song Weidong lost his girlfriend due to China's social changes. A socialist SOE was no longer a safe haven for a man. He could lose his loved one, as it happened in the case of Song, in a time when China was gradually transforming to a capitalist-style market economy.

The importance of the multiple international influences on gender formation in Chinese popular culture in the late 1970s and early 1980s cannot be underestimated. Suffice to mention another such example. It is noteworthy that in the early years of Reform and Opening, an extremely influential masculine idol also comes from Japanese popular culture. In 1978, the Japanese film *Manhunt* (Kimi yo Fundo no Kawa o Watare, 1976; original Japanese title: 君よ憤怒の河を渉れ; Chinese translation: *Zhuibu* 追捕) was shown in China. The star of the film was Ken Takakura (高仓健). He immediately became the epitome of the tough guy (*yinghan* 硬汉) in Chinese popular culture. Chinese viewers of that generation do not forget him. About thirty years later, this iconic masculine figure, though much older, starred in Zhang Yimou's film *Riding Alone for Thousands of Miles* (*Qianli zou danqi* 千里走单骑, 2005). Die-hard Chinese fans of Ken Takakura got a chance to see their former icon again.

It might be said that in Jia Zhangke's films the exemplary masculine figure is the factory manual laborer in the socialist Mao era. In the post-Mao, postsocialist era, this erstwhile masculine ideal of the worker has disappeared, and male characters must search for new suitable social roles, often without success. With the disintegration of socialist masculine models, men take on a variety of sometime dubious roles: gangsters in the style of Hong Kong action cinema, seedy entrepreneurs, petty thieves, rebellious youth, migrant workers, and so forth. There is a thin line between a hero and an antihero, between a legitimate male occupation and an illegitimate occupation. There is a lack of clear role models in a confusing and rapidly changing era.

I Wish I Knew: Glimpse of a Strong Woman

Jia Zhangke's film *I Wish I Knew* (*Haishang chuanqi* 海上传奇, 2010) is a documentary about Shanghai. It is made to coincide with the World Expo in Shanghai in 2010. The hosting of the World Expo is a big thing on the agenda of the Chinese government. The World Expo is like retro chic, a catching-up with

the world for a country of belated modernity. It is as if the idea of World Expo were still something important and worthwhile for a nation to organize. The World Expo is a simulacrum of the world, built on miniature models of various countries of the world.

This documentary film consists of a series of interviews with real people. It offers a multi-perspectival representation of Shanghai and endeavors to capture lost moments. These are memories of the socialist legacy as well as other periods of Chinese history. The socialist period is but one important moment in Shanghai's history.

Again, Jia's typical style is at work in the film: the mixing of images, ideas, and sound from various peoples and different historical periods. Together these elements create jarring effects of various dreams, ambitions, emotions, and sentiments about the past and present of the city. The lyricism of the film evokes a tinge of nostalgia for the lost old days of Shanghai. Horizontal panning of the landscape reveals rampant ruins, which are environmental and physical, but could be also psychological and emotional. Jia's film as a whole testifies to the changing modes of production over a long stretch of time, the transition from industrial production in a planned economy of the socialist model to transnational production, flexible accumulation and production in the post-Fordist, post-industrial mode.

One particular character, a female character, is noteworthy in the analysis of Chinese masculinity in the socialist era. This woman constitutes a backdrop to the portrayal of males. Huang Baomei 黄宝妹 was a confident model worker in the 1950s, and had the honor of being received by Chairman Mao. She was a worker at Shanghai No. 17 Cotton Plant 上海国棉17厂. (Interestingly enough, a member of the Gang of Four, Wang Hongwen 王洪文, was also originally from this model factory.) Huang Baomei's personal story is one of national pride. It is the story of the socialist confiscation and transformation of old capitalist and foreign plants in the 1950s. In fact, Shanghai-based director Xie Jin 谢晋 made a film about her, *Huang Baomei* (1958). In the interview in *I Wish I Knew*, she proudly recalled her trip to Europe to attend an international gathering of youth representatives from various countries. She said that foreigners were impressed by how good-looking young people from New China were. She was proud of being a Chinese woman on the world stage. Her assertiveness and confidence is a sharp contrast to the hesitancy and indecisiveness of many Chinese male characters in Jia's films.

The camera cuts to an empty factory in this episode. The jarring discrepancy between an idealist past and an empty present is felt here and there throughout

the documentary. The Huang Baomei episode transitions to the next episode about workers from Changxing Ship-building Factory. The viewers see images of modern industrial male workers. Against the images of male workers, one hears the soundtrack of a famous song from the 1970s: "We Workers are Powerful" (*Zanmen gongren you liliang* 咱们工人有力量). The part of the film offers a glimpse of the heyday of socialist industrialization in Shanghai, a time when men are empowered by Red ideology.

Suffice to mention that Jia's film *The World* (*Shijie*, 2004) richly depicts the predicament of Chinese masculinity in the era of globalization. The setting is a simulacrum of sorts: the World Park on the outskirts of Beijing. The film brings about an ironic juxtaposition of a futuristic globalized world and the harsh reality of a socialist legacy. Young males with a Shanxi accent come to Beijing in search for jobs and a better life. These migrant workers join the vast floating population in China's capital. While Beijing stands as a symbol of globalization and mobility, these earthbound male characters are trapped in the World Park and are unable to advance upward on the social ladder. The "World" turns into a spatial confinement for those who lack career opportunities. Their lives may even come to a tragic end, as seen in the case of Taisheng and his girlfriend Tao. Jia's style of cinematic realism with restraint and understatement rather than high melodrama helps drive home his vision of the harsh reality in China.[9]

The Pains of the Working Class in *A Touch of Sin*

In Jia Zhangke's film A *Touch of Sin* (*Tian zhuding* 天注定, 2013), male characters occupy central positions in the film's narrative once again. The film consists of four separate tales set in different places in China. Coal-miner Dahai 大海 takes matters in his own hands to fight corruption and redress social injustice in his village in Shanxi 山西 Province. San Er 三儿 is a filial son and loving father in his home village in Chongqing, but lives a life of robbery and murder. Xiaohui 小辉 is a migrant worker from Hunan province and works in a factory in Dongguan, Guangdong Province. He jumps off from a building and commits suicide out of desperation. Xiao Yu 小玉, a young woman from Hubei Province, fights back against a rapist and kills him. All these four stories of violence and death are based on real people and events in contemporary China. In a departure from the usual style of constraint and understatement in Jia's previous works, this crime film describes raw emotions and stages physical violence. Desperate characters ultimately resort to extraordinary measures to

fight against a dehumanizing world. This film is a reflection of the escalating tensions and social problems in contemporary China. Main characters in the film are people from the working class, or the underprivileged class. They speak a medley of Chinese dialects: Shanxi dialect, Chongqing dialect, Hunan dialect, Hubei dialect, and Cantonese dialect. In such a manner, this particular *huayu* film (Chinese-language film) speaks to the plight and living condition of all working-class Chinese people regardless where they are.

The English title of this film is *A Touch of Sin*, which is an evocation of King Hu's film *A Touch of Zen* (*Xia nü* 侠女, 1971). Jia Zhangke pays homage to the martial arts films of Hong Kong directors King Hu and Chang Che. When the times are so bad and the authorities are undependable, people must take matters in their own hands. There seems to be a call for the return of the spirit of chivalry in *jianghu*, which is an arena outside law and civil society. Male and female characters in the film are like modern knights-errant who right wrongs and combat evils. In such instances, these Chinese male heroes possess the spirit of courageous, strong-willed warriors (*wu*),[10] and yet they cannot properly vent their outrage and indignation through legitimate social channels. They must act like ancient martial arts heroes who operate outside law and the government, as reenacted in Hong Kong martial arts films again and again. In the first episode about coalminers, as Dahai is pondering his next move in regard to corrupted officials and businessmen, he watches a performance of a famous play in Shanxi opera. The piece is *Lin Chong Flees at Night* (*Lin Chong yeben* 林冲夜奔). The story comes from the great Ming Dynasty novel *Water Margin* (*Shuihu zhuan*). Lin Chong is a law-abiding military officer, but he is unjustly persecuted by corrupt officials in the government. He decides to join the bandits, or more appropriately, the heroes in the *jianghu* who fight for and uphold justice in their own manner. This situation is a familiar scenario in Chinese society: "the government forces the people to rebel" (*guanbi minfan* 官逼民反).

The final sequence of *A Touch of Sin* feels like a magic touch, and is perhaps one of the most powerful moments in Jia Zhangke's oeuvre. Xiao Yu walks toward a city in Shanxi. Outside the city, there is a performance of Shanxi opera. Again, the film invokes the traditional theater to arouse feelings of righteousness. The play is a famous piece: *The Trial of Su San* (*Su San qijie* 苏三起解). Set in Shanxi, the story is about the unjust accusation of an innocent woman for murder. On the screen, the country magistrate cum judge presides over the trial. His face is painted as a villain in accordance with his character in traditional Chinese opera. He asks the tearful, distraught Su San 苏三: "Do you admit your crime?" (*Ni ke zhi zui* 你可知罪)? Next, there is a shot of Xiao Yu's face as she is looking at the

performance. Then comes the final shot, which is a frontal shot of the audience watching the performance. The audience consists of a crowd which stands in for the Chinese people in large. The audience watching the film, namely, the viewing subjects, are also implicated in the indictment.

The crowd has been a persistent trope from the beginning of modern Chinese literature and throughout modern Chinese culture, depicted most famously in Lu Xun's fictional works such as "The True Story of Ah Q" (1921–1922). Lu Xun decides to give up medicine and become a writer in order to awaken the apathetic Chinese crowd, to cure their spiritual disease. While studying medicine in Japan, he saw the image of the reaction, or the lack thereof, of a Chinese crowd witnessing the execution of a fellow Chinese by the Japanese. In *Yellow Earth* (*Huang tudi*, 1984), the foundational Fifth-Generation film, the illiterate, superstitious Chinese peasants, namely the crowd, are unflatteringly represented. The film is filled with numerous frontal shots of the faces of anxious and confused peasants in backward, impoverished northern China. It borders on hopelessness to enlighten them on the part of the Eighth Route Army cultural worker.

"Do you admit your crime?" The question is not only for Su San on the stage, but also for Xiao Yu who killed a customer at the sauna out of self-defense not long ago. And more significantly, the question is for all the audience, and by extension, to all Chinese people. The film thus concludes with the indictment of the stage character Su San, and possibly the pensive, guilt-ridden Xiao Yu, and the crowd which is watching the play, and all Chinese. The powerful, emotional singing of Shanxi opera plays on the sound track as the ending credits roll up on the screen. The film ends loudly by raising questions about the moral dimension of human action.

The logical thing to do for one of Jia's ensuing projects is to make a film on the very topic of *jianghu*. Hence the original title of his next film is, in a straightforward fashion, *Jianghu ernü* (江湖儿女, 2018), which means "sons and daughters of *jianghu*." The English title is *Ash is Purest White*. The film is entirely about the world of gangsters (*jianghu*) in Datong, Shanxi, Jia's home province. It tells the ups and downs of the relationship between the head of a gang, Bin (Liao Fan), and his lover Qiao (Zhao Tao). Bin had his good old days, but was attacked and wounded by a rival gang, disgraced, and left Datong. Toward the end of the film, he was partially paralyzed and reluctantly returned to Datong to live with Qiao. At the very end, the enfeebled former gangster boss left Qiao's

Figure 4.2 *A Touch of Sin* (*Tian zhuding*). Directed by Jia Zhangke. Production companies: Xstream Pictures, Office Kitano, Shanghai Film Group, Shanxi Film and Television Group, Bandai Visual Company, Bitters End. 2013. In the traditional play *The Trial of Su San* near the end of the film, the judge asks Su San: "Do you admit your crime?"

Figure 4.3 *A Touch of Sin* (*Tian zhuding*). Directed by Jia Zhangke. Production companies: Xstream Pictures, Office Kitano, Shanghai Film Group, Shanxi Film and Television Group, Bandai Visual Company, Bitters End. 2013. Penultimate shot of *A Touch of Sin*. Xiao Yu (Zhao Tao) watches a performance onstage and hears the judge's question: "Do you admit your crime?"

home, perhaps with the hope of restarting his career in the *jianghu*. There is a gap between the idealized gangster hero and his actual fate.

The richness and complexity of Jia's portrayal of men in contemporary society is facilitated by a unique film aesthetics, a hybrid aesthetics of sound and image. Shuqin Cui perceptively explores this aspect of Jia's films:

你可知罪？！

Figure 4.4 *A Touch of Sin* (*Tian zhuding*). Directed by Jia Zhangke. Production companies: Xstream Pictures, Office Kitano, Shanghai Film Group, Shanxi Film and Television Group, Bandai Visual Company, Bitters End. 2013. Final shot of the film. The audience watches a play and hears the judge's question: "Do you admit your crime?"

> Trends from Mao's mass culture to contemporary pop genres provide temporal illustrations of the shifting social scene. Pop forms such as music, songs, KTV, media, fashion, and hairstyle all function as indices of socio-cultural change. A single performance brings the audience back to Mao's era, and a multi-sound installation suggests the confluence and divergence of the local and the global. As the long take rejects the audience's engagement, the soundtrack becomes the primary mode for comprehension.[11]

As such, the male character is an overdetermined being that embodies the contradictions, hopes, frustrations, uncertainty, and anxiety of people in the historical transformation of Chinese socialism. He is befuddled by an array of models and ideals of masculinity: the old-style socialist worker, the gangster in Hong Kong popular culture, and the capitalist ideology of individual entrepreneurship. He may fail to live up to any of these new models and end up being a petty thief or an unlucky migrant worker. It might not be feasible to judge whether a male character is a macho hero or a pathetic weakling in Jia's films. A male character is an ordinary hero of some sort because he carries the burden of gender formation and enacts the multifaceted nature of life in postsocialist China.

Chinese masculinity has undergone tremendous changes in modern times. Jia's films are explorations of such profound transformations. The time-honored, traditional masculine dichotomy of *wen/wu* (intellectual/warrior) inevitably evolves in postsocialist China. The old masculine images and ideals from the

Chinese tradition are no longer the sole cultural and spiritual resources for men to deal with reality. Myriad influences from the pan-Chinese world, East Asia, and other places have all played a role in the shaping of masculinity in contemporary China.

Notes

1 The question of masculinity in crisis has been an important topic in the study of Chinese literature, film, and culture in the post-Mao era. See, for example, Xueping Zhong, *Masculinity Besieged? Issues of Modernity and Male Subjectivity in Chinese Literature of the Late Twentieth Century* (Durham and London: Duke University Press, 2000); Shuqin Cui, "The Return of the Repressed: Masculinity and Sexuality Reconsidered," in *A Companion to Chinese Cinema*, ed. Yingjin Zhang (West Sussex: Wiley-Blackwell, 2012), pp. 499–517. However, these studies do not specifically address questions of masculinity in the films of Jia Zhangke.

2 I attempt to clarify the notion of "postsocialism" in my book *Chinese Modernity and Global Biopolitics: Studies in Literature and Visual Culture*, especially "Postscript: Answering the Question: What Is Chinese Postsocialism?" (Honolulu: University of Hawaii Press, 2007), pp. 204–10.

3 Chris Berry, "*Xiao Wu*: Watching Time Go By," in *Chinese Films in Focus II*, ed. Chris Berry (London: Palgrave Macmillan, 2008), p. 250.

4 Martin Scorsese, "Foreword," in *Speaking in Images: Interviews with Contemporary Chinese Filmmakers*, Michael Berry (New York: Columbia University Press, 2005), p. viii.

5 See Xiaoping Lin, "Jia Zhangke's Cinematic Trilogy: A Journey Across the Ruins of Post-Mao China," in *Chinese-Language Film: Historiography, Poetics, Politics*, ed. Sheldon H. Lu and Emilie Yueh-yu Yeh (Honolulu: University of Hawaii Press, 2005), pp. 186–209.

6 Shuqin Cui, "Boundary Shifting: New Generation Filmmaking and Jia Zhangke's Films," in *Art, Politics and Commerce in Chinese Cinema*, ed. Ying Zhu and Stanley Rosen (Hong Kong: Hong Kong University Press, 2010), pp. 189–90.

7 Valerie Jaffee, "'Every Man a Star': The Ambivalent Cult of Amateur Art in New Chinese Documentaries," in *From Underground to Independent: Alternative Film Culture in Contemporary China*, ed. Paul G. Pickowicz and Yingjin Zhang (Lanham, MD: Roman & Littlefield, 2006), p. 79.

8 Hai Ren gives an account of this land sale between China Resources Land and Factory 420 and analyzes Jia Zhangke's film *24 City* in his chapter "Redistribution of the Sensible in Neoliberal China: Real Estate, Cinema, and Aesthetics," in *China*

and New Left Visions: Political and Cultural Interventions*, ed. Ban Wang and Jie Lu (Lanham, MD: Lexington Books, 2012), pp. 225–45.

9 On this point as well as the tension between global fantasy and unfulfilled hope in the film *The World*, see Jerome Silbergeld, "Façades: The New Beijing and the Unsettled Ecology of Jia Zhangke's *The World*," in *Chinese Ecocinema in the Age of Environmental Challenge*, ed. Sheldon Lu and Jiayan Mi (Hong Kong: Hong Kong University Press, 2009), pp. 113–27.

10 The dichotomy between *wu* (warrior) and *wen* (scholar) as the twin embodiment of Chinese masculinity is discussed in Kam Louie's groundbreaking work *Theorizing Chinese Masculinity: Society and Gender in China* (Cambridge: Cambridge University Press, 2002). Kam Louie updates his theory of Chinese masculinities in a broad context in his new book *Chinese Masculinities in a Globalizing World* (London: Routledge, 2014). The paradigm of *wu* seems to be more relevant to the working-class male characters in *A Touch of Sin* as well as other films by Jia Zhangke.

11 Shuqin Cui, "Boundary Shifting: New Generation Filmmaking and Jia Zhangke's Films," in *Art, Politics and Commerce in Chinese Cinema*, ed. Ying Zhu and Stanley Rosen (Hong Kong: Hong Kong University Press, 2010), pp. 176–7.

Part 2

Multimedia Engagements with the Local, National, and Global

Peripheral, Underground, and Independent Cinema

In the previous chapter, I analyzed the film art of one director from China, Jia Zhangke. He has been navigating the boundary between independent cinema and mainstream cinema for more than two decades in his directorial career. In this chapter, I broaden the scope of investigation and expands on the topic of peripheral, independent, and underground filmmaking. I look at a wide range of such films in contemporary China with a sense of historical development. While I revisit the exemplary case of Jia Zhangke at some point, I review a large number of other film directors from China. The chapter will illustrate the ways in which independent cinema has maintained a relationship of negotiation and contestation with established official institutions of filmmaking and distribution in a nominally socialist state.

The concept of "cinema at the periphery" seems to designate film practices remotely located from the centers of power. For instance, we can talk about the situation of "small national cinemas" such as Scottish cinema and Danish cinema in such a framework. These are small nations relative to their immediate neighbors (England, Germany), or the huge European Union, or the biggest of it all, United States/Hollywood. The small-nation paradigm works perfectly well in analyzing such cinematic traditions at the periphery of major powers.

But the cinematic tradition that I write about is China, the most populous nation in the world. Obviously, China does not fit in the paradigm of small national cinemas. However, the question of a cinema at the periphery is still a valid and important issue in the Chinese case. In fact, there does exist a cinema at the periphery, or there exist multiple cinemas at the periphery in mainland China. The center of power is officially sanctioned mainstream cinema. Due to the mechanism of domestic censorship, Chinese cinema at the periphery is what has been known as "independent film" and "underground film." Moreover, due

to a peculiar turn of logic, marginal Chinese film under the guise of "art film" transforms into mainstream cinema in the circuits of international film festivals.

There have been several phases and periods in the evolution of mainland China's independent film and underground film since the 1990s. There exist two lines of development: feature film and documentary. In the beginning, feature film is in the limelight and caught much of the attention. As I will explain later, the phenomenon has to do with the works of the so-called "Sixth Generation" directors. The beginning of underground and independent documentary is modest. The most famous case was Wu Wenguang 吴文光. His documentary film *Bumming in Beijing* (*Liulang Beijing* 流浪北京, 1990) is the most well-known example. The life of a group of aspiring, struggling, rootless artists in the suburbs of Beijing captures the mood of such documentary. However, as the world enters the twenty-first century, China's independent cinema is increasingly associated with documentary. This is partially the result of a technological development, namely, the digital camera, as well as due to changes in the mechanisms of funding, production, circulation, and reception of films. The digital turn creates the condition for the emergence of a digital public sphere, an online culture, a DVD culture, and finally a streaming platform. In the end, independent digital cinema opens up new possibilities for configuring the interface between private space and public space, between individual autonomy and participatory intervention. In this chapter, I begin by discussing the case of feature film first. Toward the end, I move to the situation of documentary film.

Setting the Terms: Underground, Independent, Peripheral

For a long time, the category of independent or underground cinema has been a convenient and conventional way of labeling films from the People's Republic of China. Defiant, independently financed films are banned by the censors of the regime but circulate and are applauded at international film festivals. These films may be suppressed in the national market, yet they are supported by benign transnational networks of film culture.

Many formerly "underground" film directors have emerged to the surface, and their films are openly screened in public theaters across China, with uneven box-office sales. Independent films and their film makers are no longer at the periphery but move to the public domain, if not outright to the mainstream. The films of such celebrated underground figures as Jia Zhangke and Wang

Xiaoshuai are available not just in bootlegged DVD copies sold at the street corner, but meet the eye in a legitimate theater.

The new film policies and film practices in China in the early twenty-first century call for a reexamination of old dichotomies in film studies and geo-aesthetics: periphery and center, marginal and mainstream, independent and studio, national and transnational, opposition and co-optation. This chapter attempts to chart patterns of production and exhibition of independent film in contemporary China. I examine the specific style and textuality that mark such films as distinct from mainstream Chinese cinema.

Peripheral cinema, independent cinema, or underground cinema in the Chinese case can be defined at several levels: subject matter and theme, source of funding, networks of production and distribution, venue of screening, and film aesthetics. Paul Pickowicz offers to clarify the ambiguities in using the two terms "underground" (*dixia* 地下) and "independent" (*duli* 独立). He writes:

> In general, "underground" is a term preferred by overseas media and embodies expectations of the subversive function of this alternative film culture in contemporary China. A majority of young filmmakers themselves, however, favor "independent," a term that has gained more currency in Chinese media and scholarship, not necessarily due to censorship pressures. More often than not, "independent" means a cinematic project's independence from the state system of production, distribution, and exhibition, rather than to its sources of financial support, for filmmakers increasingly depend on the private (*minying*) sector and foreign investment, thereby revealing their status of "in dependence" as joint or coproducers, or even contracted media workers.[1]

While agreeing with Pickowicz's broad description, I emphasize the fact that to obtain independence from the state system of production the filmmakers must seek funding from sources external to the state. Collaboration with sources from outside China, namely transnational coproduction, is a major way of making films for independently minded directors in the early phase, the 1990s, a time when the country was not wealthy and awash with funds. Independent filmmaking is to a large extent part and parcel of the development of transnational Chinese cinema since the early 1990s. More recently, as Pickowicz points out, funding from the private sector inside China has begun to play an increasingly important role in getting film projects off the ground.

As mentioned, a basic characteristic in the formation and evolution of Chinese independent cinema is its marginal status within China and its high profile in global film festival culture. This has a great deal to do with the perceived position

of China as one of the last strongholds of communist states. Like the Chinese nation-state itself, its cinema is also politicized in international media. The fate of being "banned in China" often warrants entry to major Western film festivals, such as the "Big Three" in Europe (Cannes, Venice, Berlin) and many others around the world. Here we are dealing with old binary oppositions that had been established throughout the Cold War years—East vs. West, communism vs. capitalism, political oppression vs. freedom.

We owe the rise of the New Chinese Cinema in a large measure to the groundbreaking works of the so called Fifth-Generation directors such as Chen Kaige, Zhang Yimou, and Tian Zhuangzhuang. Zhang Yimou is arguably the best-known director hailing from mainland China. His martial arts features *Hero* (*Yingxiong* 英雄, 2002), *House of Flying Daggers* (*Shimian maifu*, 十面埋伏, 2004) and *Curse of the Golden Flower* (*Mancheng jindai huangjin jia* 满城尽带黄金甲, 2006) are global blockbusters. These films tend to be politically conformist with high entertainment values. People inside China jokingly call him the "official director" (*guanfang* 官方) of China. Indeed, he is handpicked by Chinese officials to direct and choreograph a section of the closing ceremony of the Athens Olympic Games in 2004 and the entire opening ceremony of the Beijing Olympic Games in 2008. Zhang Yimou's complicity with the state notwithstanding, many of his early films are prime examples of what we call independent cinema at the periphery inside China and arthouse spectacles outside China. His films *Ju Dou* (*Ju Dou* 菊豆, 1990), *Raise the Red Lantern* (*Dahong denglong gaogao gua* 大红灯楼高高挂, 1991) and *To Live* (*Houzhe* 活着,1994) were banned in China but were award winners at major international film festivals such as Cannes. Hence, Zhang's career over the last thirty years is a good example of the transformation of independent cinema to mainstream cinema as embodied in the works of one single director.

It is the generation of filmmakers after the Fifth Generation, namely the so called "Sixth Generation" that has been most closely associated with the phenomenon of independent and underground cinema. They graduated from the Beijing Film Academy in the late 1980s and early 1990s. This new generation could not compete with their elder schoolmates—the giants of the Fifth Generation—in obtaining funding. They usually start their career with low-budget films. Their style often departs from the glossy spectacles and the melodramatic mode associated with the Fifth-Generation filmmakers, conveying a gritty, rough, documentary quality.[2] Their subject matter and interests are contemporary China—especially the urban China that they see, witness, and live in. The unglamorous underbelly of China in the era of Deng

Xiaoping's "Reform and Opening" (*gaige kaifang*) becomes the focus of their lens: marginal social groups, gay sexuality (which was not tolerated in socialist China for a long time), migrant workers, petty thieves, prostitutes, drug addicts, criminals, underground rock culture, and so forth. Due to the predilection for representing urban malaise in terms of subject matter and the directors' lack of rural experience in their personal upbringing, the Sixth Generation is also labeled the "urban generation."[3] There are several prominent elements that "characterize the world of vision of independent film practice: the portrait of the artist-self in film, the non-allegorical depiction of sexuality, and the construction of the coming-of-age narrative."[4] The leading directors of the Sixth Generation include figures such as Zhang Yuan, Guan Hu, Lu Xuechang, Ning Ying, Lou Ye, Zhang Ming, Wang Xiaoshuai, and Jia Zhangke. Notable films that exemplify the underground spirit and unconventional behavior are such films as *Beijing Bastards* (*Beijing zazhong* 北京杂种, Zhang Yuan 张元, 1993), *East Palace, West Palace* (*Donggong Xigong* 东宫西宫, Zhang Yuan, 1996), *Dirt* (*Toufa luanle* 头发乱了, Guan Hu 管虎, 1994), and *Suzhou River* (*Suzhou he* 苏州河, Lou Ye娄烨, 2000).

This new generation attempts to differentiate itself from the older generation in another important way. Their point of departure is the present moment rather than some mythical past that is exoticized for the gaze of the international audience. The nitty-gritty and the here and now with all the undisguised horrors constitute the focal point of their lens. Nevertheless, the frank unflattering portrayal of the socialist present can equally lead to a politicized reading of the East in international reception.

The wind of relaxation and tightening shifts from time to time. In the beginning of the twenty-first century, censorship is more lenient toward the erstwhile "underground" filmmakers, perhaps due to the inauguration of a new generation of Party leadership in the era of Hu Jintao. Their films begin to openly circulate in legitimate markets and are even screened in public theaters. The Chinese censors seem to have got smart and finally come to their senses: there is no need to regulate the film market in an old-style, heavy-handed manner, since audiences for these art films are few anyway. The big box-office draws are the commercial blockbusters from Hollywood, Feng Xiaogang's comedic "new-year-pictures" (*hesui pian* 贺岁片), and the films by the self-censored, self-reformed Zhang Yimou.

But in the second decade of the twenty-first century, control over artists has been tightened. For instance, the Annual Chinese Independent Film Festival (*Zhongguo duli yingxiang niandu zhan* 中国独立影像年度展) had been

running in the city of Nanjing since 2003. Although independent cinema had not been institutionalized to the extent of losing its edge and meaning, this phenomenon indicated that Chinese independent cinema was emerging from the underground into the public arena. But that did not last long. Such a festival could not continue under the current severe political atmosphere, and was terminated in 2019, after 14 successful years.

Many formerly underground directors have experienced a change of heart and are no longer so obstinate about the cherished themes and aesthetics of art cinema. They move with the times. For instance, Wang Xiaoshuai's early films *The Days* (*Dongchun de rizi* 冬春的日子, 1994) and *Frozen* (*Jidu hanleng* 极度寒冷, 1999) are quintessential experimental underground films in terms of subject matter (estranged marginal avant-garde artists) and style (low-budget features lacking in dramatic flourishes). But his later productions *Beijing Bicycle* (*Shiqisui de danche* 十七岁的单车, 2001) and *Shanghai Dreams* (*Qinghong* 青红, 2005) have been screened in theaters, becoming available to Chinese viewers not just as pirated DVDs but also in legitimate venues. He seems to have found a combination or compromise between arthouse aspirations and economic necessity.

There have been forbidden zones for independent cinema all these years. Examples abound. For instance, Li Yang's film *Blind Shaft* (*Mangjing* 盲井, 2003) startled the international film community by its unsparing depiction of the tragic condition and the darkness of human nature in Chinese coalmines. For that precise reason, the film was not allowed to be released in Chinese public theaters.

When Sixth-Generation director Lou Ye touched on the still politically sensitive subject of the events of June 4th 1989 in Tiananmen Square, he crossed the line and invited himself to troubled water. His feature *Summer Palace* (*Yiheyuan* 颐和园, 2006) falls perfectly into the perceived image of underground/independent cinema from unsmiling communist China. In a review of film, for *Variety*, film critic Derek Elley states that "there's an unmistakable feeling throughout *Summer Palace* that Lou is deliberately pressing hot buttons to cater to Western auds. If the pic does end up banned in China, that will only add to its prestige in some Western critical circles—despite the fact that the pic is at least half an hour too long and poorly organized on a dramatic level."[5] Elley's sarcastic yet perceptive remarks describe the precise geopolitics of a Chinese independent film. We see the repetition of a familiar scenario in East-West cultural relations. Due to the inclusion of sex (display of immodest frontal nudity) and politics (specifically, one of the remaining untouchables of China: the Tiananmen

incident in June 1989) the film was banned in communist China. Moreover, the director also violated the domestic politics of film regulation, since he did not obtain prior approval from the authorities to submit this film for competition at the Cannes Film Festival in 2006. As Elley observed, Lou pushed all the "hot buttons" for a film from communist China to succeed in a Western film festival. However, despite the fact that a fellow Chinese director from Hong Kong, none other than the legendary Wong Kar-wai, sat on the jury of that year's Cannes festival, Lou Ye did not bag any award to take home. And trouble was waiting for him at home nevertheless. He was censured, blacklisted, and banned from making film in China for the next five years.

The Chinese authorities took action to discipline a maverick domestic filmmaker because he transgressed the political bottom line. They could be also over-sensitive to imports from Hollywood. In summer 2006, as *The Da Vinci Code* (Ron Howard, USA 2006) was screened in Chinese theaters across the nation and created impressive box office figures, the film was suddenly pulled out of the market on the order of the authorities. This was a knee-jerk reaction to complaints of Chinese Catholics about the film's alleged negative portrayal of the Vatican. Some Catholics warned that "the film threatened social stability."[6]

Another interesting turn of events is likewise indicative of the nature of China's level of tolerance. When Ang Lee's film *Brokeback Mountain* (2005) received major prizes from the Academy Awards, the official Chinese media equally basked in a moment of glory and pride. It praised the outstanding achievement of a diasporic Chinese. However, *Brokeback Mountain* was not released in China due to its patent gay theme. In China's slow march to a civil society, such paranoid reactions to public opinion are typical of the Chinese bureaucracy that is guarded and afraid of assuming responsibility. In a severely limited "public sphere," China's film censors appear immature and do not know how to handle problems and complaints. Of course, the easiest and rudest way is to shut something down as soon as someone whispers something not in line with the official Party line. There exists caution against foreign import as well as discipline against unruly indigenous production on the part of Chinese censors. It seems that we cannot completely detach ourselves from political considerations in the Chinese case. And for this reason alone, the category of the peripheral, independent, or underground, will stay for a long time when film observers turn their gaze to the East.

Jia Zhangke's Film Aesthetics and *Still Life*

In the previous chapter, I have already discussed Jia Zhangke's films at great lengths, including *Still Life* (*Sanxia haoren* 三峡好人, 2006). But my focus was more on the subject of masculinity in his films. In this chapter, I revisit this exemplary film and related issues pertaining to Jia's life and works in order to illustrate the aesthetics and ethos of Chinese independent cinema as a whole.

The filmmaker who has persistently stood by the tenets of an austere independent art cinema is Jia Zhangke, the Wunderkind of the Sixth Generation. He has not bent to the allure of commercial cinema so far, and continues the pursuit of a rarefied aesthetics of art cinema. Jia's early career was a typical case of independent filmmaking. His first films were not permitted to be openly screened in legitimate venues due to their satirical social commentary, political subversiveness, and failure to get cleared by the proper channels of censorship. These films are *Xiao Shan Going Home* (*Xiaoshan huijia* 小山回家, 1995), *Xiao Wu*, aka *Pickpocket* (*Xiaowu* 小武, 1997), *Platform* (*Zhantai* 站台, 2000), and *Unknown Pleasures* (*Ren xiaoyao* 任逍遥, 2002). Such works were released abroad to high acclaim. Inside China, they only circulated via pirated DVD copies available in the black market. However, beginning with *The World* (*Shijie* 世界2004), his films start to emerge from the underground and are screened in Chinese theaters, with relatively low audience attendance.

Jia is officially banned from filmmaking by the Chinese Film Bureau in January 1999 for alleged violations of the regulations concerning filmmaking in China. The ban is not lifted until January 2004. His relationship with Zhang Yimou is strained at times, perhaps due to misunderstandings or different philosophies about filmmaking.[7] The feud between Jia and arthouse director-turned commercial director Zhang Yimou flares up now and then. Zhang Weiping, the powerful producer of Zhang Yimou's films such as *Curse of the Golden Flower*, accuses Jia and the Italian producers of *Still Life* of buying off the jury to win the Golden Lion Award at the 2006 Venice Film Festival. Jia has also lampooned Zhang Yimou for abandoning art cinema in favor of shallow but profitable commercial cinema. In the eyes of many observers and film viewers, Zhang Yimou, the once respected leader of Chinese art cinema, has lost his principles and has caved in to the pressure and allure of the regime and the market.

In all fairness, as a versatile veteran director, Zhang Yimou has also directed other types of films and has taken up sensitive subject matters in recent years besides marital arts films that avoid overt political content and cater to mass consumption. His films *Coming Home* (*Guilai* 归来, 2014) and *One Second* (*Yi miao zhong* 一秒钟, 2020) are intensely political films by exploring the devastation on ordinary citizens brought by the Cultural Revolution. They describe the sufferings and traumas of the people in that dark period of socialist history. Renowned actor Chen Daoming and actress Gong Li star in *Coming Home*. Upon being released from a labor camp and returning to home, the male protagonist Lu Yanshi (Chen Daoming) discovers that his once loving and responsive wife, Feng Wanyu (Gong Li), suffers from amnesia and does not recognize him. Indeed, "amnesia" speaks to the general mental state of the entire Chinese population. This film confronts the question of collective forgetfulness about the horrors of the past. The making of the film testifies to the fact that Zhang Yimou has not forgotten history and possesses the courage to address the past.

One Second tackles the political sensitive subject of the Cultural Revolution once again. The film tells the story of a man who escaped from a labor camp in order to watch a screening of a documentary and catch a glimpse of his deceased daughter. She appears in the documentary for one second. While it is scheduled to be screened in the 69th Berlin International Film Festival in 2020, the film is withdrawn from competition in the film festival at the last minute for "technical reasons." The boundary between independent cinema and mainstream cinema in Chinese and global public culture is blurred again even in the case of such a high-profile filmmaker as Zhang Yimou, who launched his directorial career by winning a Golden Bear Award at the Berlin Film Festival in the 1980s.

However, it is Jia Zhangke who has emerged as an unwavering champion of serious art film in China throughout his career. Moreover, he has also spoken out for Chinese national cinema at large. In May 2007, Hollywood blockbuster *Spider-Man 3* (Sam Raimi, USA 2007) is the rage in Chinese cinemas across the country. Cinema managers rush to screen *Spider-Man 3* time and again in primetime slots. This foreign film outperforms local Chinese films in box-office sales and screening time. Jia offers his take on this trend of globalization as Hollywoodization: "Cinema managers always say the market and audience decide what they show, but it is not true … The truth is cinema managers speculate on which films might be profitable and which are not. They make feature lists based on their assumptions and let audiences follow, which results in domestic small-budget films always being shown at the worst

times."[8] He calls for the establishment of a mechanism that would guarantee the screening of Chinese films in cinemas for a certain number of days during a year, as has been done in some other countries such as South Korea. The invasion and conquest of the Chinese film market by foreign films is the direct result of China's accession to the World Trade Organization. To be a member of the WTO, China has signed an agreement with the United States to allow a growing number of Hollywood blockbusters to be shown in China annually. Needless to say, globalization comes at a price for the native.

Jia is an *auteur* director in the old sense. His idiosyncratic film style stands out: few close-ups; frequent use of medium shots, long shots, and long takes; slow pace, and minimal use of professional actors. Dramatic scenes of tension (fighting, intimacy, death) are not directly staged onscreen but indirectly suggested. Most extraordinary of all, there is not one single shot/reverse-shot pattern in all of his films. When two people are in conversation, a static camera is placed at ninety degrees to the characters or at a slightly oblique angle. Very often the viewer cannot see the face of the character due to the absence of a frontal shot. The effect that Jia is aiming at is a sense of objective distance as if the camera (or the viewer) were a detached observer of a real-life situation. Moreover, Jia's characters often speak a dialect of Shanxi Province, his home province. Even native Chinese-language speakers must put in some effort in understanding the characters' speech, hopefully with the help of Chinese subtitles. Their "quaint" provincial dialect further conveys the marginal status of Jia's characters.[9] This is a film world populated by migrant workers from the countryside, petty thieves, delinquent adolescents, and misfits at the periphery of Chinese society. For all these qualities, Jia's persistently uncompromising style is not the usual dish for the taste of most domestic viewers who want to relax and have a good time with friends or loved ones in cinemas. Fast-paced, star-studded, and spectacle-ridden films from Hollywood prove more popular for the average Chinese spectator. Likewise, the handsome faces of superstars from Hong Kong and Taiwan, such as Andy Lau, Takeshi Kaneshiro (Jin Chengwu), or Chow Yun-fat; or the sexy appeal of Zhang Ziyi and busty middle-aged Gong Li, along with the scantily dressed palace maids in Tang-Dynasty China in Zhang Yimou's martial arts features *House of Flying Daggers* and *Curse of the Golden Flower* are meant to be more palatable and enjoyable for mass audiences than the slow-paced social realism which starkly confronts the viewer with ugliness rather than beauty.

All the above factors make Jia Zhangke a darling of prestigious international film festivals. His award-winning feature *Still Life* repeats and typifies all the

stylistic characteristics of his previous films as mentioned above. A new element is the more extensive use of horizontal pans because of the scenery at hand—sprawling Three Gorges (*sanxia* 三峡) along the mighty Yangtze River. The story of the film unfolds against the background of the controversial Three Gorges Dam project. The dam boasts of being the largest hydraulic project in the world. But this great achievement is not without disastrous side effects. Countless residents along the Yangtze River are dislocated, numerous towns and villages are flooded, archeological sites are irretrievably buried under water, and ecological equilibrium is destroyed forever.

Still Life focuses on the human dimension of this impersonal national mega-project. Two Shanxi natives come to the city of Fengjie near Three Gorges to look for their loved ones. Coal miner Han Sanming wants to find his former wife, and nurse Shen Hong hopes for a reunion with her husband Guo Bin. The viewer then follows their steps and actions in Fengjie as they are entangled in an unfamiliar territory searching for their wife and husband. The viewer and the two main characters together embark on an ethnographic and social tour of the area. This is a place that is already partially flooded to the extent that Han Sanming cannot find the old address of his wife, which is under water now. Buildings are in the process of being demolished as the risk of total flooding increases by the day. People are told to leave their homes. Gangsters and thugs freely conduct their business in the area, where there is a very thin line between legitimate business and illegal transaction. The viewer sees the anger, discontent, frustration, and resignation of many local residents who must face up to dislocation. The two-thousand years-old town, Fengjie, will be completely inundated soon.

While Han Sanming is stranded in the city and must wait for the arrival of his wife, he finds a temporary job as a demolition worker. The viewer is then presented with a double vision of the landscape. The pre-deluge original scenery at Three Gorges unfolds like a beautiful Chinese landscape painting. Indeed, the very Chinese characters standing for landscape—*shanshui* (山水) mean literally "mountains and water." The mountains and water along the Yangtze River, especially at Three Gorges, have come to signify the essence of landscape in the Chinese tradition. The camera slowly pans horizontally to reveal the wonder and magnitude of the natural surrounding. At the same time, the demolition team goes on with its usual business. They must completely tear down all remaining buildings in the area. This is an ugly sight of ruins, rubble and filth. Through mise-en-scène and camerawork, Jia drives home a feeling of horror in the jarring juxtaposition of man-made destruction on the one hand, and the serenity of nature on the other.

The sense of ruins and destruction is pervasive in Jia's oeuvre. In his first three films, a lonely young man (performed by amateur actor Wang Hongwei) experiences and lives through the spiritual emptiness and physical decay of post-Mao China. In his discussion of the first three films by Jia Zhangke, Xiaoping Lin perceptively points out: "this one man's journey starts from the capital city Beijing in *Xiaoshan Going Home*, continues in a small town called Fenyang in *Xiao Wu*, and finishes in an unknown, barren land in *Platform*."[10] While continuing to depict human beings' alienation from society in contemporary China, *Still Life* carries a deeper and broader meaning of alienation in that this is humanity's alienation from nature itself. Ruins are portrayed in the most literal and graphic way in *Still Life* as viewers' senses are pounded with the sight and sound of demolition. The vast expanse of nature (Three Gorges) as well as the colossal man-made destruction *cum* construction (the dam) reveal a catastrophe of a staggering magnitude.

A rather interesting character in the film is a young small-time gangster, nicknamed "Mark," in homage to the character Mark in the Hong Kong film *A Better Tomorrow* (*Yingxiong bense* 英雄本色, John Woo, 1986) starring Chow Yun-fat. Mark attempts to exhort money from the outsider Han Sanming in the early part of the film, but later on they become friends. Mark's is a dangerous, deadly profession. In one scene, he is seen sitting alone at the riverbank with his face covered in blood. He is eventually killed as the story unravels.

In Chapter 4, I briefly mentioned and analyzed an intriguing scene in the film where Mark and Han Sanming are drinking and chatting together at a table. Now I focus on this episode in greater details in order to explore the ethos and aesthetics of Jia's film art more fully. The entire scene is rendered in one continuous long take with a stationary medium shot, without any cuts or shot/reverse-shot. There is no close-up as the two characters speak to each other. The viewer cannot see their faces clearly. Below are some excerpts of their fascinating conversation. Han Sanming shows Mark his wife's address in Fengjie, written on a piece of paper torn from a cigarette box.

Mark: Okay, show me. "Mango?" What cigarettes are these?

Han Sanming: They were the best brand sixteen years ago.

Mark: You are nostalgic!

Han Sanming: We remember our own pasts.

Mark: You know what? Present-day society doesn't suit us because we're too nostalgic.

Han Sanming: Who taught you that?

Mark: Chow Yun-fat! Brother Fat! Brother Fat!

Han Sanming: If something comes up, please help me.

Mark: No problem. Tell you what, I will give you my mobile number. Call me if you need me. We're buddies. I will be there for you.

Han Sanming: Call my mobile.

(Mark dials Han's cell phone number. Han's phone rings, with the ringtone of a song)

Mark: What's that song?

Han Sanming: "Bless Good-Hearted People."

Mark: Fuck, "Good-hearted People"! None of those in Fengjie these days. Okay, call my mobile. Listen to mine.

Han dials Mark's cell phone number. The phone rings, with the ringtone of the theme song of a Hong Kong TV series, *The Bund* (*Shanghai tan* 上海灘, 1980), starring Chow Yun-fat, that was wildly popular in Hong Kong and China in the 1980s. At the same time, the film cuts to televisual images of sorrowful immigrants on a boat leaving the Sanxia area. There is a close-up of the face of a crying, tearful old woman. A huge board on a mountain reads: THIRD PHASE WATER LEVEL: 156.3 METERS. A man in the mountain waves to the departing boat.

Figure 5.1 *Still Life* (*Sanxia haoren*). Directed by Jia Zhangke. Producers: Keung Chow, Tianyun Wang, Pengle Xu, Wang Yu, Jioing Zhu. Distributor: Xstream Pictures. 2006. A static long take of Mark and Sanming in a conversation that pays homage to Hong Kong gangster film star Chow Yun-fat.

This is the instance when the coalminer Han Sanming gives a full account of the reason for his coming to Fengjie, to his stranger-turned-friend "Mark," and to the film audience in large. He comes to look for his estranged wife whom he purchased with 3000 yuan many years ago. The conversation between two "old-timers" captures the mood and subject of much of Jia Zhangke's film world. "Criminals," gangsters, thieves are the heroes or anti-heroes of his films such as *Xiaoshan Going Home*, *Xiao Wu*, and *Unknown Pleasures*. The line between good guys and bad boys is blurred. In fact, what is legitimate and illegitimate are indistinguishable. "Mark" in *Still Life* worships the original "Mark" and the characters performed by charismatic Chow Yun-fat in John Woo's "heroic gangster" classics *A Better Tomorrow* and *The Killer*. He mimics Chow's hand gesture as he repeats Chow's line: "We are not suited for this modern world. We old-timers are too nostalgic." As the immobile camera is positioned sideways to his body and face, his silhouette does resemble Chow's body and posture. This is a film that takes up characters at the periphery of Chinese society as its focal attention. The film also clearly reveals the extent of the influence of classical Hong Kong gangster films from the 1980s in mainland Chinese popular culture.

The original Chinese title of the film is plain and yet provocative. A literal translation of *Sanxia haoren* should be "Good People of Three Gorges." It is reminiscent of Bertolt Brecht's play *The Good Person of Setzuan* (*Der Gute Mensch von Setzuan*). Evidently, there is a moral dimension in being a "good person." However, Brecht also reveals the untenable position of abstract morality and hollow idealism in the context of Chinese society in the early twentieth century or in any society at any time. Both good and bad are faces of the same individual. Brecht's materialist critique calls for more attention to the concrete condition of life rather the imposition of unrealistic moral demands on people. Likewise, Jia's *Still Life*, or better still, *Good People of Three Gorges*, instills an ethical imperative as well as provokes the viewer to make efforts in understanding the real material conditions of life in the Three Gorges area. "There exist no more good people these days," as Mark exclaims. Yet, in this big batch of shady gray area that is China, ordinary people, whether from the underworld and out in the open, bond and help each other.

Later in the film, Mark goes on to a job with several youngsters to "get even" (*baiping*) with somebody in another city. They are all hired and paid by "Brother Bin," who is none other than the man that Shen Hong comes to look for as husband. Guo Bin has become a head of a large "legitimate" business in the area. Eventually he and Shen Hong decide to settle for a divorce, and she returns to Shanxi. One day Han Sanming is looking for his friend Mark, and

dials his cell phone number. The song/ringtone of Mark's cell phone rings from under a pile of rubble. Mark's dead body is discovered under the pile. Characters such as Mark the thug, or the coalminer Han Sanming who illegally bought a wife sixteen years back, make up the spectrum of "good people" in Jia's film. This is a properly independent cinema about characters at the periphery of Chinese society. It is noteworthy that *Still Life* passed the censors and were screened in public theaters in China.

From Fiction Film to Documentary in the Digital Age

So far, I have only discussed feature film. However, peripheral, underground, and independent cinema has spawned a variety of formats and media: feature, documentary, video, and digital camera. In fact, the latter categories have played an increasing role in the formation of China's independent film culture. Numerous independent documentary filmmakers have emerged, and some of them have attracted notice from domestic audience and international critics. Quite a few illuminating book-length studies on Chinese independent cinema have been published in English-language academia in recent years.[11] They have advanced our understanding of the subject.

Here I highlight the differences between independent feature film and independent documentary film. That is to say, the documentary pushes the ethical impulse to a higher level by way of its privileged direct style of recording reality. Certain feature films do have a raw "documentary" quality. They may employ a *cinéma vérité* style and aspire toward a realist aesthetics. But they are fictional films after all. In contrast, a documentary is supposedly in the business of directly documenting reality and truth. It is situated in a specific locale at a particular moment, casts real-life people, and induces activism from the viewer.

In order to understand the unique characteristics of the documentary mode, we may compare a fiction film, *Orphan of Anyang* (*Anyang ying'er* 安阳婴儿, Wang Chao 王超, 2001), and the documentary films of Xu Tong 徐童 on the same subjects of migrants, female prostitutes, and individuals living on the margins of society in contemporary China. Both directors have received much scrutiny and acclaim for these remarkable works from domestic and international film critics.

Orphan of Anyang is the story about the relationship between a laid-off factory worker and a female migrant in a northern city, Anyang. The background of such a story is all too familiar to viewers of this type of Chinese films by now: China's transition from a socialist planned economy to a *laissez-faire* capitalist market

economy has resulted in tens of millions of ordinary people losing their jobs, especially in Northeast China. Yanli, a statuesque good-looking woman comes to Anyang from Northeast to work as a prostitute. Being a single mother, she abandons her infant. The infant is picked up and adopted by a middle-aged man, a former factory worker, Dagang. He is willing to take care of the infant as long as he is paid by her for child support. The three of them live together and make up a temporary, makeshift family.

The alternative vision of a noncommercial independent art film that *Orphan of Anyang* participates in constructing has become a stylistic convention now: avoidance of overly melodramatic scenes, acting with restraint, minimal dialogues, frequent long takes, slow pace, dark lighting, a noir quality, a bleak postindustrial cityscape, and noises and ambient sound from the streets of a dirty, dusty city. An overall brooding atmosphere permeates the film as it portrays the daily struggles of a drifting population in a time of unrelenting social and economic changes.

Yet, despite its quasi-neorealist style, *Orphan of Anyang* is a well-crafted narrative film. There are gaps and suspenseful moments in the plot for the viewer to ponder and think through. The young lead actress Zhu Jie 祝捷 is a professionally trained actress and has a blossoming career. Occasional close-ups of her face and body contribute to the special allure and appeal of the filmic image. On the whole, the film narrates a compelling fiction about the fate of ordinary men and women trapped in traumatic social transformations.

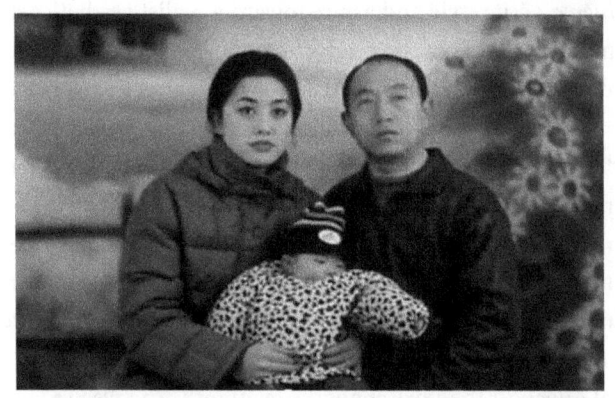

Figure 5.2 *Orphan of Anyang (Anyang ying'er)*. Directed by Wang Chao. Producers: Wang Chao, Wang Yu. 2001. Laid-off worker Dagang, prostitute Yanli, and her abandoned infant take a "family" picture at a photo studio in Anyang.

Now I turn to the documentary mode for comparison. Xu Tong's *Drifters Trilogy* (*Youmin sanbu qu* 游民三部曲, 2008–2011) consists of *Wheat Harvest* (*Maishou* 麦收, 2008), *Fortune Teller* (*Suanming* 算命, 2009), and *Shattered* (*Lao Tang tou* 老唐头, 2011). *Wheat Harvest* is the first installment in the trilogy. Xu Tong shoots the lives of several prostitutes working in the outskirts of Beijing. The lead character in the film, Miao Miao, is a young woman from a village in Hebei Province; she comes to Beijing to work as a prostitute in order to earn enough money to cure her ill father. Throughout the film, there are numerous frontal shots and long takes of the prostitutes chatting together. The women tend to speak loudly and profusely about their male customers, fellow coworkers, and their experiences as sex workers. At the end of the film, the camera eye looks directly at Miao Miao, who serves as the main narrative thread of the film. She looks back at the camera and speaks to the filmmaker/interviewer. Kuei-fen Chiu and Yingjin Zhang describe the final scene of the film in the following words:

> At the ending of *Wheat Harvest*, the prostitute, sitting on her bed, is done with her narration and awaits Xu Tong's further questions. A moment of silence ensures, in which she represses her emotions, wipes off her tears, and finally returns the gaze to the off-screen filmmaker, asking impatiently, "Are you shooting?" The camera captures her face in a frontal portrait, directly challenging not only the filmmaker but the viewer as well.[12]

The character in the film addresses the spectator as a real person and calls attention to the process of shooting her in a film. Needless to say, the documentary mode is also artifice. The framing of the shot and the staging of the character are the artistic decision of the filmmaker. However, the direct shooting of a young woman in real time does seem to constitute an ontologically real world. The documentary creates the feeling of an unmediated interview with a real person.

The second installment of the trilogy, *Fortune Teller*, casts another former female prostitute in addition to the main character of the film, Fortune Teller, who is an old male character. Tang Xiaoyan 唐小雁, also known as Tang Caifeng 唐彩凤, or Xiaofeng 小凤, a divorced woman in her mid-30s. She comes from Heilongjiang Province in Northeast. She is separated from her husband due to his infidelity, and leaves home to search for opportunities and new jobs in Hebei Province and the outskirts of Beijing. Many things have happened to her in Hebei. She is raped by a man, works as a prostitute for some time, and serves as a madam of a brothel disguised as a "massage parlor." She is arrested for running a brothel by the police; it is none other than director Xu Tong who bails her out of detention with cash by selling his own car. Due to this incident, a strong

bond develops between the documentary director and a real-life character. Grateful for what the director has done for her, Tang Xiaoyan agrees to Xu Tong's request that she appears in the documentary without facial masking unafraid of exposing her true personal identity as someone with a seedy past. Xu Tong is so fascinated by Tang's life that he visits her real home in Northeast and meets her family. Consequently, her father becomes the subject of the third installment of the trilogy, *Shattered*, literally "Mr. Old Tang" in the original Chinese title (*Lao Tang tou*). The film focuses on a working-class family and reveals generational differences between the father and the children in their perceptions of the past and the present of socialist China. This is still not all for the film director; Xu Tong makes films about other members of Tang Xiaoyan's family.

In Xu Tong's subsequent films, Tang Xiaoyan joins the production team. She functions as a camera person, and even serves a producer. Moreover, she becomes a public figure in Chinese and international film circuits. She appears on TV talk shows to share with the audience her real life offscreen and film roles onscreen. She has travelled abroad to many international film festivals outside China with Xu Tong. Interestingly enough, she is the winner of the Annual Real-Person Award of China Independent Film and Video Festival (*Zhongguo duli yingxiang niandu zhenshi renwu jiang*) 中国独立影像年度展真实人物奖 in 2010. The appearance and testimony of a real-life person from a documentary creates the impression of an unadorned, authentic, indexical relationship to reality that a fiction film cannot claim to do. There appears to be zero distance between people and film, between life and screen in such a documentary practice. The documentary mode makes a truth claim to the world that a fiction film cannot despite its avowed realist aesthetics. As she talks and travels in China and around the world, Tang Xiaoyan herself is literarily a living embodiment of China's independent documentary and a persuasive advocate for its *raison d'être*.

The drifting subjects in China's postsocialist, postindustrial landscape in feature films as well as documentary films have turned into "digital subjects" as digital video has become the primary mode of shooting films in the twenty-first century. This is the contention of Zhang Zhen, Angela Zito, and their collaborators in an anthology titled *DV-Made China: Digital Subjects and Social Transformations after Independent Film*. It is debatable as to the extent in which the digital moment is a development "after independent film" as Zhang and Zito claim; it may well be a continuation of a long existing practice with new characteristics in some way. The digital turn has opened doors for fresh possibilities of social intervention and aesthetic experimentation. Zhang and Zito write the following words:

你一定要听话，知道吧
you should obey me, get it?

Figure 5.3 Tang Xiaoyan speaks to a new staff member in her illicit massage parlor in *Fortune Teller*. Directed by Xu Tong.

Indeed, at every turn we confront the irony that the digital, on the one hand, facilitates forms of radically *private* film production and audience habits of small-screen consumption while simultaneously linking up makers and consumers, curators and censors even more swiftly into wider *publics*. These publics allow for speedier circulation of films made in digital video, more discussion, and quicker formation of public and aesthetic discourses. While the personalization may provide a *sense of independence* (which, to be sure, has profound creative results), the spreading and tightening of networking surely bespeaks a growing *actual interdependence* among writers, directors, producers, distribution entrepreneurs, and audiences.[13]

The digital camera entails a more expedient mode of production and a faster channel for circulation. It can enter and shape the public sphere in a new way. The ethical and political stakes are high in the digital media.

The digital camera allows for formal innovations that did not exist with previous models of shooting. For Bérénice Reynaud, "Digital modes of production render the distinction between 'art cinema' and 'cinema with a documentary impulse' somehow obsolete …" The old kind of editing and montage is not necessary. "The quintessential digital possibility to extremely long takes fulfills an old cinema dream hitherto foreclosed by the limited size of film magazines." "For documentary, archival, as well as surveillance purposes, the camera can be kept on for hours and record while being held by an untrained hand or even without being monitored."[14] The digital media thus provides the condition for a more direct and fuller participation in social processes. It could potentially help widen the public sphere.

The mobile, portable, personal, and flexible mode of digital production along with an expanded technological capacity allows the filmmaker, or the videographer, more freedom and leeway in making documentaries. Armed with this technology, a new wave of documentaries is able to participate in social activism and artistic experiments by directly recording contemporary social events and getting their messages across. Zhao Liang赵亮 is a particularly noteworthy example in this respect. One of his documentary films is emphatically called *Crime and Punishment* (*Zui yu fa* 罪与罚, 2007), which exactly echoes the title of a novel, *Crime and Punishment*, by the anguished and spiritually tormented Russian writer Dostoyevsky. In another instance, it takes Zhao Liang twelve years to observe Chinese citizens' petitions to the Chinese government and to make a documentary out of the accumulated footage, thanks to the availability of a digital camera. This is his film *Petition* (*Shangfang* 上访, 2009). Countless Chinese citizens travel to Beijing from the provinces seeking to redress injustices. They gather at the South Railway Station in Beijing and plead their cases there. These petitions look like an impossible Sisyphean struggle for justice by a multitude of disenfranchised, powerless, poor people at the periphery of Chinese society. As expected, there was nearly no legitimate venue to exhibit this film, but it was well received in international film circuits. Such films by Zhao Liang accomplish a lot for the audience, in the words of Jie Li: "by rendering visible those who are un(der)represented; by exposing and critiquing the deception of official media images; and by showing various complex ways power is connected to surveillance and visibility."[15]

These so-called onetime independent filmmakers need to change course once in a while, to make compromises with commercial film culture, political orthodoxy, and censorship. They move from the periphery to the mainstream now and then. Whether they are makers of feature films like Jia Zhangke, who often utilizes a documentary aesthetics, or documentaries like Zhao Liang, who attempts to tell good stories, they cross the boundary between resistance and collaboration, between independent artists and conventional cultural workers. This give-and-take is a matter of survival, a manner to test the water, and a way to push the limits of art and society in postsocialist China.

Notes

1 Paul G. Pickowicz and Yingjin Zhang, "Preface," in *From Underground to Independent: Alternative Film Culture in Contemporary China*, ed. Pickowicz and Zhang (Lanham, MD: Rowman & Littlefield, 2006), pp. viii–ix.

2 On the question of melodrama in Chinese cinema, especially in reference to Fifth Generation classics such as *Yellow Earth* (*Huang tudi*黄土地, Chen Kaige, 1984), see Chris Berry and Mary Farquhar, "Realist Modes: Melodrama, Modernity and Home," in *China on Screen: Cinema and Nation* (New York: Columbia University Press, 2006), pp. 75–107. For a delineation of the distinctive features of the Sixth Generation in contrast to previous generations, see Zhen Zhang, "Introduction: Bearing Witness: Chinese Urban Cinema in the Era of "Transformation," in *The Urban Generation: Chinese Cinema and Society at the Turn of the Twenty-first Century*, ed. Zhen Zhang (Durham, NC: Duke University Press, 2007), pp. 1–45.

3 See the anthology *The Urban Generation: Chinese Cinema and Society at the Turn of the Twenty-First Century*, ed. Zhen Zhang (Durham, NC: Duke University Press, 2007).

4 Shuqin Cui, "Working from the Margins: Urban Cinema and Independent Directors in Contemporary China," in *Chinese-Language Film: Historiography, Poetics, Politics*, ed. Sheldon H. Lu and Emilie Yueh-yu Yeh (Honolulu: University of Hawaii Press, 2005), p. 100.

5 Derek Elley, review of *Summer Palace* (*Yiheyuan*), *Variety* (May 18, 2006), http://www.variety.com/review/VE1117930547.html?categoryid=31&cs=1&query=derek+elley+summer+palace+lou+ye (accessed May 15, 2007).

6 Joseph Kahn, "How China Banished 'Da Vinci,'" *The Sacramento Bee* (June 10, 2006), A15.

7 In a casual yet troubling story that he wrote in a privately published newsletter, Jia revealed how he was banned by the government. He was summoned to the Film Bureau of the State Administration of Radio, Film and Television in January 1999. Upon arrival at the Film Bureau, he saw a revered master of the Fifth Generation schmoozing with officials. He had a more shocking discovery at the place. It was the screenwriter of that master of the Fifth Generation who reported on him to the authorities for spoiling "normal foreign cultural exchange" with his film *Xiao Wu*. Jia felt devastated by being betrayed by fellow film artists. He did not give the names of the "master" of the Fifth Generation and his screenwriter, but many people speculated that this had to be Zhang Yimou and his screenwriter Wang Bin. Wang Bin had denied this speculation. See Jia Zhangke, "A Record of Confusion," Danwei.org (January 6, 2007), http://www.danwei.org/film/jia_zhangke_vs_zhang_yimou.php (accessed June 14, 2007).

8 Anon., "China's Film Industry Rankles as Spiderman's Web Snares Cinemas," English. eastday.com (May 17, 2007). http://english.eastday.com/eastday/englishedition/features/userobject1ai2837715.html (accessed June 15, 2007).

9 I outline the politics of dialect in Jia Zhangke's film and contemporary Greater Chinese cinema in general in my essay "Dialect and Modernity in 21st Century Sinophone Cinema," *Jump Cut* no. 49 (Spring 2007), http://www.ejumpcut.org.

10 Xiaoping Lin, "Jia Zhangke's Cinematic Trilogy: A Journey across the Ruins of Post-Mao China," in *Chinese-Language Film: Historiography, Poetics, Politics*, ed. Sheldon H. Lu and Emilie Yueh-yu Yeh (Honolulu: University of Hawaii Press, 2005), p. 187.

11 Paul G. Pickowicz and Yingjin Zhang, eds., *From Underground to Independent: Alternative Film Culture in Contemporary China* (Lanham, MD: Rowman and Littlefield, 2006); Zhen Zhang, ed., *The Urban Generation: Chinese Cinema and Society at the Turn of the Twenty-First Century* (Durham, NC: Duke University Press, 2007); Xiaoping Lin, *Children of Marx and Coca-Cola: Chinese Avant-garde Art and Independent Cinema* (Honolulu: University of Hawaii Press, 2010); Chris Berry, Lu Xinyu, and Lisa Rofel, eds., *The New Chinese Documentary Film Movement: For the Public Record* (Hong Kong: Hong Kong University Press, 2010); Paolo Voci, *China on Video: Small-Screen Realities* (New York: Routledge, 2010); Luke Robinson, *Independent Chinese Documentary: From the Studio to the Street* (New York: Palgrave Macmillan, 2012); Kuei-fen Chiu and Yingjin Zhang, *New Chinese-Language Documentaries: Ethics, Subject and Place* (London and New York: Routledge, 2015); Zhang Zhen and Angela Zito, eds., *DV-Made China: Digital Subjects and Social Transformations after Independent Film* (Honolulu: University of Hawaii Press, 2015); Paul G. Pickowicz and Yingjin Zhang, eds., *Filming the Everyday: Independent Documentaries in Twenty-First Century China* (Lanham, MD: Rowman & Littlefield, 2016). Dan Edwards, *Chinese Independent Documentary: Alternative Visions, Alternative Publics* (Edinburgh: Edinburgh University Press, 2015).

12 Kuei-fen Chiu and Yingjin Zhang, *New Chinese-language Documentaries*, pp. 189–90.

13 Zhang Zhen and Angela Zito, "Introduction," in *DV-Made China, Digital Subjects and Social Transformations after Independent Film*, ed. Zhang Zhen and Angela Zito (Honolulu: University of Hawaii Press, 2015), p. 21.

14 Bérénice Reynaud, "Chinese Digital Shadows: Hybrid Forms, Bodily Archives, and Transnational Visions," in *DV-Made China*, ed. Zhang and Zito, p. 189.

15 Jie Li, "Filming Power and the Powerless: Zhao Liang's *Crime and Punishment* (2007) and *Petition* (2009)," in *DV-Made China*, ed. Zhang and Zito, p. 77.

Performing and Romancing the Other in Film, Television Drama, and Ballet

In this chapter, I examine the representation of Sino-Russian romantic encounters in film and television drama as yet another way of envisioning the self, the other, and the nation in contemporary China. Russia and China share one of the longest borders in the world and have been entangled in an unending love-and-hate relationship. At times they are friendly ideological bedfellows of communism and socialism; other times they are bitter geopolitical rivals. For the most part of the twentieth century, China is the weaker state at the receiving end of technology, ideology, revolution, industry, and knowledge between the two giant neighbors. Related cultural productions narrate love stories of ordinary people and yet at the same time reimagine and reconfigure the ups and downs in the changing relationship between the two countries. An important theme of this chapter is the exoticization, objectification, and fetishization of the figure of the foreign female for the gaze of the Chinese male spectator and by extension for the positioning of the state in contemporary film and television drama.

In order to set up the analytic framework and better comprehend the historical context of international socialist politics, we may begin by briefly taking a look at another art form, the ballet. The changes in cross-cultural mutual perceptions and interracial gender relationship between the Soviet Union and China can be seen in the history of a Soviet ballet. Such an early foundational work might be taken as the baseline that subsequent Sino-Soviet cross-cultural art forms need to respond to. This is the case of the ballet *The Red Poppy* (Russian: *Красный мак*) or *The Red Flower* (Russian: *Красный цветок*). The ballet is created and first performed in the Bolshoi Theater in Moscow in 1927. It has been hailed as the first revolutionary ballet in the Soviet Union.

The ballet has gone through several revisions over time to adapt to evolving political situations in world history. Nonetheless, the basic plot is a romantic international encounter between a Russian male sailor and a Chinese young

woman. A Soviet ship docks at a Chinese seaport. The Russian sailors witness the suffering of Chinese laborers. The captain of the ship meets a Chinese girl, Taohua, and the two develop feelings toward each other. Taohua gives a red poppy flower to him as token of love. The roles of Taohua and other Chinese characters are performed by white Russian dancers. The anachronistic, outlandish details about Asian manners and lifestyles may look like an amusing Orientalist spectacle to Soviet and European audiences but could appear demeaning and absurd to Chinese spectators who are knowledgeable about Chinese history and culture.

Soviet sailors arrive in China and see the misery of Asian people. They are the harbinger of truth and knowledge and the agent of change and salvation. They rescue a damsel in distress, so to speak. At the end of the ballet, Russian men dance to musical phrases of "The Internationale." The song "The Internationale" serves as the national anthem of the Soviet Union for a long time. In fact, the Third Communist International (Comintern) was headquartered in Moscow until the dissolution of the organization in 1943. The ballet may well be the right kind of work of art for that moment in Soviet and international socialist history when the Soviet Union is positioned as the leader of a broad worldwide communist movement.

Audiences have different perceptions of the various versions and performances of the ballet as well as the exact profession of Taohua as they follow the unfolding of the story. Red China's new leaders are among the ballet's potential viewers. Right after the founding of the People's Republic of China (PRC) in 1949, Mao Zedong and Zhou Enlai visit Moscow and enter difficult negotiations with Joseph Stalin for the signing of a friendship treaty between the two giant communist states. Stalin is mindful of the remaining Russian interests and privileges in China left behind by czarist Russian Empire, such as the naval port of Lüshun, the Manchurian railway, and businesses in Xinjiang. He wishes to keep them even though the newly founded socialist China hopes to uphold sovereignty and national autonomy after so many of years of subjection to imperial foreign powers. Stalin is the Big Brother, the elder statesman and leader of the communist world looking down on the junior comrades from China. The ballet *The Red Poppy* is performed in town at the time. Members of the Chinese delegation have the impression that the story is about a romance between a Russian sailor and a Chinese prostitute. A Russian man enlightens a Chinese woman and passes Marxism and revolution to China through her. Upon hearing this account of the ballet, Mao Zedong refuses to go to watch it. The Sino-Soviet revolutionary relationship portrayed as a lop-sided interracial love story in

the ballet is unacceptable to the leaders of a newly victorious socialist country. Nor are the ballet's exotic stage production and performance palatable to the audience of a new China.[1]

In January 1950, Zhou Enlai takes a train to join Mao Zedong in Moscow to negotiate with Soviet leadership for the future partnership between the two countries. In this long journey, he begins to read a Soviet novel *Port Arthur* (Russian: Порт-Артур; Chinese translation: *Lüshun kou* 旅順口), written by Aleksandr Stepanov. The author lived in Port Arthur as a child and his father was a commander fighting on the side of the Russian Empire during the Russo-Japanese War in 1904–5. The novel is a winner of the Stalin Prize for Literature in 1946 and is translated into Chinese. The novel describes the horrors of the war and the heroism of Russian officers and soldiers in the Russo-Japanese War in Northeast China, which was fought on Chinese soil.[2] Port Arthur, part of the Chinese city of Dalian, is the base of a Russian fleet in the Far East. Japan is determined to take it over from Russia and launches an attack. Russia and Japan, two empires, fight a bloody war against each other for the control of Northeast China. Zhou Enlai is surprised by the content of this award-winning book from a socialist neighbor and is angry at how Chinese people are described by the author. Chinese people are described as spies, traitors, wicked businessmen, and prostitutes. This is the image of China in the literature of Stalin's Russia, the shining beacon of the socialist bloc. In retrospect, it is no coincidence that Zhou Enlai travels to Indonesia a few years later and becomes a key player at the Bandung Conference. The latter offers a new vision of the international order and advocates solidarity among the Third World beyond the domination of the two superpowers, the United States and the USSR. Socialist China makes a move toward independence from the Soviet Union.

The history and practice of dance in the socialist period is complicated and fascinating.[3] Ballet dancers in Red China are trained by Soviet dance teachers at first. But when China is in a position to create its own indigenous ballet, it makes sure to grant agency and subjectivity to Chinese men and women as active players in a revolution. The most prominent examples of China's own ballet are two so-called "revolutionary model ballets" during the Cultural Revolution: *The Red Detachment of Women* (*Hongse niangzi jun* 红色娘子军) and *The White-Haired Girl* (*Bai mao nü* 白毛女). Chinese women are no longer being looked at, enlightened, and rescued by foreigners. They become soldiers and self-conscious progressive members of the society through revolutionary processes. However, it should be noted that male characters, now surely Chinese men, still occupy

the position of leaders and enlighteners. They teach Chinese women about liberation and lead them to the path on revolutionary struggles.

The White-Haired Girl has been masqueraded as an indisputable red classic of China's own indigenous ballet. However, in yet another fascinating twist and turn of cross-cultural relationships, it is in fact a Japanese dance troupe, Matsuyama Ballet, that first creates *The White-Haired Girl* as ballet in the 1950s. The company's lead ballerina, Mikiko Matsuyama, and its director, Masao Shimizu, wife and husband, watched the Chinese film *The White-Haired Girl* (1950) and were deeply touched by an empowering tale of the liberation of suffering Chinese peasants. They adapted the film into a ballet. With the help of Premier Zhou Enlai, Matsuyama Ballet visited China and performed *The White-Haired Girl* for the Chinese audience in 1958. This dance company and its leaders have repeatedly visited China ever since. They served as a cultural bridge between Japan and China during those Cold War years when the two countries did not have an official diplomatic relation. Matsuyama Ballet's rendition of a Chinese story must also be acknowledged as the pioneer in the indigenization of ballet, which is originally a Western art form. In addition to performing European and Russian classics such as *Swan Lake* and *Sleeping Beauty*, Matsuyama Ballet breaks new ground in choreographing such a new ballet based on the life story of modern Asia. Evidently, Chinese dancers are inspired by the example of Japan and consequently launch their own version of *The White-Haired Girl*.

In the later years of the Cultural Revolution, the mid-1970s, China produces more revolutionary dances and ballets in an effort to enlarge its repertoire. They include such works as *Women Militia on the Grassland* (*Caoyuan nü minbing* 草原女民兵) and *A Hymn to Yimeng* (*Yimeng song* 沂蒙颂). *Women Militia on the Grassland* tells the story of heroic female Mongolian militia. These gun-toting, horse-trotting females patrol the grassland of Inner Mongolia to defend the motherland. It is a time period when China and the Soviet Union have a very tense relationship, and China fears an invasion from the Soviet Union from the north. In the event of a Soviet attack, the armed female horse riders of Inner Mongolia would be at the very front line of the battlefield.

Set in the Yimeng mountain area in Shandong, *A Hymn to Yimeng* is a ballet that tells the close relationship between the people and the People's Liberation Army during the civil war in the late 1940s. One day, a guerrilla soldier's wife finds and saves a starving, parched, wounded solider by feeding him with her own milk. Then she brings him home, cooks chicken soup for him, and nurses him back to health. The ballet is made into a film, which is screened all over the country. In fact, Feng Xiaogang's 冯小刚 nostalgic and commercially successful

film *Youth* (*Fanghua* 芳华, 2017) is precisely a film about the life of a cultural troupe in the Chinese army during the Cultural Revolution. The members of this troupe are dancers, and these above two dances are the routine numbers in their repertoire. There are enticing scenes of rehearsals and on-stage performances of these dances throughout the film. The filmic representation of a bygone age, through youthful, graceful dancers, resonates with a generation of people who grow up in the heyday of the socialist period.

Now I turn to cultural productions from contemporary China and examine a series of works in a chronological sequence from the 1990s to the present time. It may well be the case that these Chinese works react against and rectify the kind of male–female, Sino-Soviet, cross-cultural relationship as presented in the early Soviet ballet. In portraying the interactions between the people of two countries, these works reposition the Chinese self and the foreign other and reimagine the place of China and its citizens in the world.

A telling example is a TV drama with seventeen episodes, *Russian Girls in Harbin* (*Eluosi guniang zai Haerbin* 俄罗斯姑娘在哈尔滨), released and aired in China in 1993, two years after the collapse of the Soviet Union. Young Russian women cross the border city of Suifenhe and enter China. Destitute and desperate as they are, yet beautiful and attractive, they come to Harbin to look for jobs and improve their lives. The city of Harbin was first built by imperial Russia at the time of the late Qing Dynasty as it stood at the far eastern end of the Trans-Siberian railroad. It is the capital of Heilongjiang Province and one of the biggest cities in Dongbei. Historically, a large émigré Russian population lived in Harbin as many people fled the Bolshevik Revolution in the first half of the twentieth century.

The two protagonists of this TV series are a Russian girl, Olga (or Olia, Aolijia 奥丽佳 in Chinese), and a Chinese youth, Fan Tiancheng 方天成 (starring Jiang Wu 姜武, Jiang Wen's 姜文 younger brother), who delivers bread for a bakery in the city. Olga leaves a problematic family in the Russian Far East and comes to China for a change in life. As the story develops, she falls in love with a local Chinese boy, Fang Tiancheng, who happens to be the nameless brave young man who saved her from an attack by bad Chinese boys in Suifenhe when she first entered China. With his help, she finds a job, an apartment, a home in Harbin. As lovers, Tiancheng and Olga also become business partners selling clothes in the marketplace at one point in the development of their relationship.

There is necessarily a fetishization and exoticization of the body of the foreign female for the gaze of the domestic spectator. Early on in the story, in the third episode, there is a revealing shower scene in a hotel room. Olga takes off her

Figure 6.1 *Russian Girls in Harbin* (*Eluosi guniang zai Haerbin*). Directed by Sun Sha. Producer: Lü Zifeng. 1993. In the third episode, Olga takes a shower in a hotel.

pajama to wash herself. The camera caresses her back, upper body, shoulders, neck, and head. The screen offers a fleeting moment of voyeuristic pleasure for the cross-cultural male spectator.

The TV drama revolves around a triangular love relationship among Fang Tiancheng, his erstwhile Chinese girlfriend Liu Ying 刘莹, and the Russian newcomer Olga. Liu Ying is a successful, attractive young businesswoman. Her

Figure 6.2 *Russian Girls in Harbin* (*Eluosi guniang zai Haerbin*). Directed by Sun Sha. Producer: Lü Zifeng. 1993. Tiancheng and Olga celebrate their successful business at home as Olga utters, "Today we made a lot of money."

role is performed by Harbin-born actress Wang Luyao 王璐瑶. Both women desire the same man, and all three of them must wrestle with love, jealousy, competition, and change of heart in their evolving relationship. The positioning of a Chinese man at the center amidst women of different ethnic backgrounds has become a predictable, standard narrative pattern in similar TV dramas and films. Such a wishful foregrounding of Chinese masculinity in romantic relationships is a return and assertion of a repressed political unconscious in a symbolic form. The TV drama tells a reversal in the fortune and relative positions of China and Russia as embodied in the love story of two ordinary people. Now the Russian girl is at the receiving end of food, bread, job, help, generosity, and love. It is the Chinese man who is the provider of all things. In this instance, a transnational, interracial libidinal economy comes handy in support of China's national political economy.

Now I move fast forward in time to a feature film about a Sino-Russian encounter. Mainland director Feng Xiaoning 冯小宁 completed and released the last part of his "War and Peace Trilogy," *Purple Sunset* (*Ziri* 紫日, 2001), at the turn of the twenty-first century. The film is also set in China's Northeast or Manchuria in the last days of the Second World War in 1945. A young male Chinese peasant, a Japanese schoolgirl, and a female Soviet soldier are each lost in a deep forest in the confusion of a battle between the Soviet Red Army and the Japanese Imperial Army. Without any other choice, they meet and band together to make their way out of danger. Yang Yufu 杨玉福 is a kind yet inexperienced peasant; Akiyoko 秋叶子 is a smart, alert, yet frightened girl; Nadja (娜佳 in Chinese, actress Anna Dzenilalova) is a disciplined yet nervous young female soldier. Nevertheless, Nadja, among the three, stands tall, possesses a model-like figure, wears a Soviet military uniform, and carries a gun. The three people do not understand each other's languages, have divergent temperaments and habits, and come from different national backgrounds. But these real or potential enemies must work as a group in order to survive and make their way to safety. At the end of the film, after overcoming difficulties and misunderstandings, this company of three is able to get out of the forest and arrive at a safe place. The film's clear message is a call for peace that transcends nationalities.

A climactic moment of the film is when the news of the surrender of Japan is broadcast on radio. Emperor Hirohito's address of surrender as well as the sound of celebration in the streets of Moscow are heard by the three. Nadja is so elated to the extent that she takes off all her clothes and throws them up to a clear blue sky as captured in low-angle shots and slow motion by the camera. Then, entirely naked, she runs toward a pristine river and jump into it for a

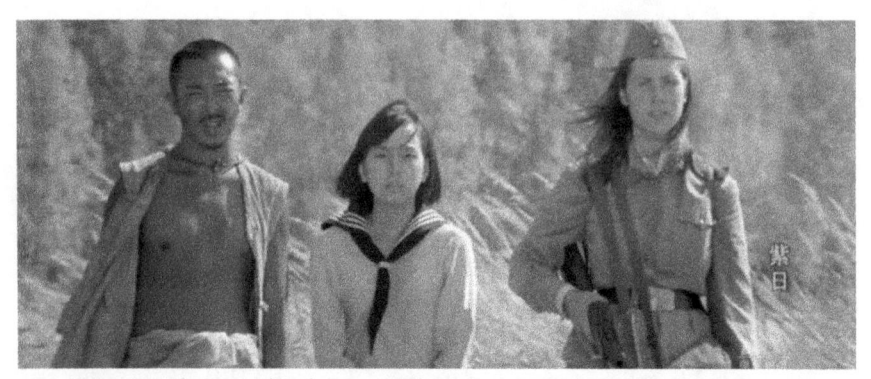

Figure 6.3 *Purple Sunset (Ziri)*. Directed by Feng Xiaoning. Producers: Feng Xiaoning, Zhang Xiaoning. 2001. A company of three strangers: Chinese peasant Yang Yufu, Japanese schoolgirl Akiyoko, Russian soldier Nadja.

swim in nature under the soundtrack of the famous Russian folksong "Kalinka" (Russian: Калинка, "Little Red Berry"). The scene is rendered in an extreme long shot. The spectator is denied a clear frontal view of the female nude at close range. This handling of the character borders on a fetishistic objectification of the white female body and grants the male voyeur a partial visual pleasure. The timid, small-minded Chinese peasant and the statuesque female Russian soldier make no sexual connection in this particular film. The female body is held at arm's length from the native male's reach, so to speak, as shots of her nude body are handled in a specific way by the camera.

Figure 6.4 *Purple Sunset (Ziri)*. Directed by Feng Xiaoning. Producers: Feng Xiaoning, Zhang Xiaoning. 2001. Ecstatic Nadja throws off her clothes upon hearing the news of the end of the war.

Although the focus of my study is not literature, I move forward in time and turn to a literary work in order to flesh out the context of these cultural and romantic encounters between China and Russia. In 2006, celebrated Chinese writer Wang Meng 王蒙 publishes his autobiographical work, *In Memory of the Soviet Union* (*Sulian ji* 苏联祭). The book consists of essays about the legacy of the former Soviet Union and his personal emotional entanglements with the Soviet Union and contemporary Russia. The book is filled with nostalgia for a vanished country and a bygone socialist era. The last part of the book is a description of his unrequited love for a Russian woman in China in the 1950s.[4]

Shortly before the founding of the PRC in 1949, a Soviet ballet troupe visited Beijing and gave performances. Wang Meng attended a performance and was awestruck by the grace and beauty of Russian ballerinas. Already a dedicated Russophile with a profound affection for Russian literature, music, songs, art, and culture, the young Wang Meng fantasied, and in fact was determined, to marry a Russian woman in the future. But it was not until several years later when he had close contact with a Russian female colleague. While he worked in a large Chinese textile factory as the head of its Communist Youth League, Katya arrived in the factory as a so-called "Soviet expert" (*Sulian zhuanjia* 苏联专家) sent by the Soviet Union. (Wang Meng's Chinese transliteration of her full name is 卡杰琳娜·斯密尔诺娃, Katarina Smirnova?) When they first met in 1955, Wang Meng was a young man in his early twenties, and Katya was already in the mid-thirties. Wang Meng lavishly describes the demeanor, look, physique, body, and smell of Katya. For the impressionable young man and a Russophile, Katya was the embodiment of culture, beauty, grace, and femininity. Young Wang Meng also made free associations in his mind between her and other women from Russian literature, music, songs, dance, and ballet.

In the book, Wang Meng vividly describes their first and only dance together in a ball organized by their factory. As Wang Meng recollects the event in old age, dancing with Katya was one of the most exciting and memorable experiences in his life. A later encounter with Katya in 1960 proved to be even more fatal in Wang Meng's emotional journey. Sino-Soviet relationship was already deteriorating at that time, and all Soviet experts were about to leave China. Wang Meng, Katya, and several other Soviet experts in their factory had a chance to go boating together in spring. Katya and Wang Meng had a boat to themselves. The two sat next to each other in the same boat. She took off most of her clothes and wore only a swimsuit for a sunbath in a warm spring day. In the autobiography, the author depicts in the minutest details the physique of the Russian lady, the object of his admiration. He describes just about every single

part of the foreign female body that is visible to him with profuse admiration and endless commentary: hair, hairstyle, body hair, skin, skin color, face, neck, eyes, ears, legs, and edge of buttocks. "Fetishization" is a mild word to use in characterizing the writing of the author at this point. The ecstatic young man was beside himself sitting next to half-naked Katya. He must control his emotion and dared not express himself due to propriety. He tried to look away from Katya by concentrating on rowing the boat. As Wang Meng recalls in the book, the time spent with Katya in the boat was the happiest moment of his life. Never again would he experience that kind of intense love and emotional ripples. He even wrote, "You cannot get this kind of experience just by 'fucking.'"[5]

Katya left China in the end as the relationship between the two communist giants turned sour. The "revisionist" Soviet Union became an enemy of China and a target of criticism. Wang Meng's coworkers in the factory turned against him. They possessed a photograph of Wang Meng with Katya in the boat as an evidence of his corruption. It was a picture taken by another Soviet expert during that boating trip. His colleagues accused him of being with a "naked" Soviet woman, a possible foreign spy. Ironically, what was the tenderest, most loving experience in his life became a stain and a liability against him for his future career in China's vicious political environment.

Wang Meng remained single and did not get married until the end of the Cultural Revolution. When the two countries repaired their relationship in the late twentieth century, Wang Meng led a Chinese delegation and visited the Soviet Union in 1983 during the Gorbachev years. He was reunited with Katya in Moscow briefly. Katya also visited Wang Meng's home as a member of a Soviet delegation to China in the 1991, right before the collapse of the Soviet Union.

The ups and downs of Wang Meng's career are a remarkable story in itself. He rises to the prominent position of the Minister of Culture of the PRC, which is a high-ranking government official with abundant privileges. Although he could not fulfill his wish to be Katya's lover in real time, their reunions in old age, his autobiographical writing, and his standing at the central cultural stage of China may have vindicated his youthful longings in some measure. Psychoanalytically, he has survived personal trauma in the "afterwardsness" (Nachträglichkeit) of his ill-fated relationship with Katya, the secret object of his love. He has emerged intact from broken dreams and a traumatic past by sublimating his unchanneled libidinal energy into writing, into a deferred remembrance of a youthful encounter with a foreign person. "Long live youth" (*Qingchun wansui* 青春万岁)! This is the title of Wang Meng's first novel, which is drafted at the age of nineteen and is later adapted into a film. Wang Meng's remembrance of youth

is a fitting tribute, a "Bolshevik salute" (*Bu li* 布礼), to a legacy, using the title of his novella. The author's ebullient celebration of the past through the love object of a female Soviet expert is an act of resistance to Western-led globalization, be it "Americanization" or "McDonaldization."

I move further forward to the second decade of the twenty-first century. Chinese TV stations air a highly publicized TV drama with forty-one episodes: *My Natasha* (*Wo de Natasha* 我的娜塔莎, 2012). The Ukrainian actress Irina Kaptelova plays the lead female role, Natasha, in this historical drama. For her performance of that role, she wins the Best Foreign Actress Award at the China TV Drama Award in 2012. The drama spans fifty years and tells the historical entanglements and transnational romances in China's Northeast from the Second World Word to the Era of Reform and Opening.

In the beginning of the story, the early 1940s, Pang Tiande 庞天德 is a Chinese resistance fighter in Japanese-occupied Northeast. As he is pursued by the Japanese army, he retreats into the territory of the Soviet Union. The Soviets assign a young female intelligence officer, Natasha, to train him. They enter Dongbei together, successfully collaborate on various assignments, and fall in love with each other in the meantime. As they are thinking of getting married, Natasha is recalled to return to the Soviet Union for a new job assignment. In the peculiar, unforeseeable twists and turns of personal matters, familial pressure, and grand impersonal historical processes, Tiande marries a Japanese nurse, Jizi 纪子 (Noriko), at the end of the Second World War as Japan is defeated and its immigrants in Northeast China are hopelessly stranded.

After the founding of the PRC, China and the Soviet Union become socialist allies. The two countries warmly brace each other and enter a period of honeymoon in the 1950s. Natasha is sent to China again, this time as a "foreign expert" to help with China's socialist construction. As their old passion is rekindled, the relationship between China and Russia deteriorates. It is time for her to leave China and go back to the Soviet Union. Their love for each other is crushed again by fate. They both need to wait for many years before they can meet again. History turns another page, and China is in the post-Mao era and enters a phase of social and economic reforms. The relationship between the two countries thaws and gradually turns friendly. In the 1980s, Natasha can visit China again and be united with Tiande. In their old age, they can fulfill a fifty-year-long wish and consummate their unrequited love. They marry as a bride and a groom in China at last.

The narrative structure of the TV drama is set up as an all too familiar love triangle. A Chinese male, Tiande, stands at the center of the tale, caught

in-between a Russian army officer-turned-lover, Natasha, and Jizi, a Japanese nurse. The drama describes the ups and downs, happy unions, and heart-wrenching separations between Tiande and these two foreign women in the tumultuous twentieth century. This TV drama is a decidedly Chinese male story despite its transnational trappings. Natasha is after all "my" Natasha. The foreign is ultimately internalized and domesticated in a saga about the fate of a struggling modern nation. The subject position of this Chinese-language TV drama is unmistakably the Chinese nation even though the details of the drama are enacted in the minds and on the bodies of individual characters who belong to different nationalities.

In both *My Natasha* and the aforementioned feature film *Purple Sunset*, the setting is Northeast, a meeting point of three countries: China, Russia, and Japan. There are parallels between the film and the TV drama in narrative structure. They both involve a Chinese male, a Russian female, and a Japanese female. In *Purple Sunset*, the three strangers from different countries encounter each other by chance in the final days of the Second World War. They must cooperate for survival, and there is nothing romantic or sexual in their relationship. However, in *My Natasha*, the triangular relationship between a Chinese man and two foreign females, once again a Russian and a Japanese, is nothing but intensely romantic, sexual, and marital. In a drawn-out romantic saga that lasts for half a century from the 1940s to the 1980s, the two foreign females, Natasha from the Soviet Union and Noriko from Japan, both deeply love the same Chinese male, Pang Tiande. They compete for marriage with him. The central position of the Chinese male in this cross-cultural relationship is securely established in this TV series. In much of the twentieth century, Russia and Japan were the stronger and more advanced countries while China was the weakling in comparison. However, this story places China at the geographic center of action and the Chinese male as the emotional linchpin with foreign females from two neighboring countries.

As we may have noticed, Wang's memoir and the TV drama *My Natasha* share many similarities about Chinese men's encounters with Soviet female others. Historical circumstances, geographic proximity, political winds, and international relations are all factors impacting the lives of real people in a memoir or fictional characters in a TV series. As individuals, they all need to weather heartbreaking dramatic reversals of fate and bear the cruel effects of momentous historical changes. Yet, there are things that are unforgettable, and they dearly cherish them. They hold onto that soft spot in the heart until the end.

但是你要知道 狙击只有一次机会

Figure 6.5 *My Natasha* (*Wo de Natasha*). Directed by Guo Jingyu. Producer: Liu Feng. 2010. Transnational comrades-turned-lovers: Natasha and Tiande.

Now I turn to another film genre, namely lowbrow comedy, about Chinese citizens' encounters with foreign others. In the second decade of the twenty-first century, apart from military/action blockbusters about grand national actions to rescue the rest of the world in danger, as I have discussed in Chapter 1, there are lighthearted comedies about the global travels of ordinary citizens. Chinese tourists, shoppers, and vacationers are the protagonists of these films. One noticeable example is a film series that has spawned several sequels. The first one, *Lost on Journey* (*Ren zai jiongtu* 人在囧途, 2010), is about domestic travel. But the sequels describe international journeys as more and more Chinese citizens visit other countries in real historical time. The three sequels are *Lost in Thailand* (*Ren zai jiongtu zhi Tai jiong* 人再囧途之泰囧, 2012), *Lost in Hong Kong* (*Gang jiong* 港囧, 2015), and *Lost in Russia* (*Jiong ma* 囧妈, 2020).

A funny, facetious episode in *Lost in Russia* is an encounter on a train between the male protagonist Ivan Xu, or Xu Yiwan (Xu Zheng 徐峥), and a Russian girl, Natasha (Olga Magnytskao), who claims to be a student of classical Chinese language. The young actress herself, a Ukrainian native, studied acting at the Shanghai Drama Academy. Natasha's command of difficult and obscure Chinese idioms astonishes the native Ivan. They meet, chat, and commiserate with each other on the train. In such a film, the protagonist is usually a Chinese male tourist. The male gaze occupies the central field of vision. He is a voyeur, unabashedly ogling at the foreign woman as the camera provides plenty of subjective point-of-view shots. This story revolves around the fantasy and subject position of a

Chinese male tourist. His field of vision broadens as he encounters foreigners. He is the agent and initiator of action, adventure, and cooperation with the foreigner. The foregrounding of Chinese masculinity in these films, albeit in a facetious and self-deprecatory fashion, is allegorically the resurrection of China in the international arena in the contemporary world.[6]

As they first meet in the train, Ivan Xu is sitting on a bed and Natasha is standing right in front of him trying to put her luggage on the overhead compartment with raised arms. As she is doing so, her clothes are raised about the waist, and her belly is exposed. There are camera shots of a mischievous, puerile Ivan looking intently at the belly of the Russian girl in amazement. Such shots, acting, and storytelling may be funny and hilarious, and they may be required elements for a comedy. But the objectification of the female body calls for a critique of the masculinist, sexist representation of cross-cultural, male–female relationship in contemporary Chinese media.

More can be said about this little detail. White feminist film scholar Laura Mulvey famously theorizes about patterns of the visual pleasure of the male gaze in the representation of heterosexual relationships in classical American narrative cinema. Her critique also applies to non-Western commercial and popular cinema such as contemporary Chinese narrative cinema. However, the difference lies at who is looking and who is being looked at. Who is the voyeur and who is the object of voyeuristic pleasure? What are their nationalities and ethnicities? The Chinese male national is the active spectator and the foreign female body is being looked at and objectified.

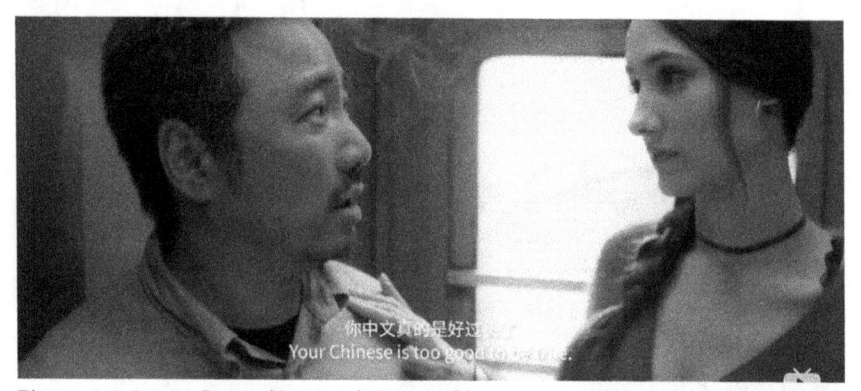

Figure 6.6 *Lost in Russia* (*Jiong ma*). Directed by Xu Zheng. Producer: Huanxi Media. 2020. Ivan Xu banters with Natasha on a train to Russia: "Your Chinese is too good to be true."

Moreover, psychoanalysis may be conjoined with international politics at this instance. The private and the libidinal are somehow linked to the public and the social. There seems to be a Hegelian dialectical reversal between the Big Brother and the little brother in the phenomenology of the defunct international communist movement. The latecomer, namely socialist China, has achieved more self-consciousness and hence arrives at a higher position than the former Soviet Union-turned-Russia. The tale of this world-historical transformation of epic proportion is told in a lighthearted film comedy. Yet in another turn of the perpetual dialectical spiral movement of the Spirit, as it were, many things from the former Big Brother are not to be jettisoned and forgotten. The recurrence of the figure of the Russian female with such names as Olga, Katya, Nadja, and Natasha in Chinese cultural production in the post–Cold War era is an indication of the persistence of the socialist legacy in the Chinese national imaginary.

It appears that the nation is not necessarily diminished in a transnational setting. In fact, it strengthens itself by taking advantage of the new resources made available by globalization. Be it the Chinese nation, or a Chinese soldier fighting on behalf of the United Nations, or an ordinary Chinese citizen, or a Chinese traveler, popular films and TV series have fashioned new ways of consolidating the subjectivity and centrality of Chinese characters in the world.

Notes

1 For an interesting article on this, see Evelyne Chao, "The Ballet That Caused an International Row," *BBC Culture* (June 28, 2017). https://www.bbc.com/culture/ article/20170628-the-ballet-that-caused-an-international-row (accessed September 26, 2020).

2 For an engaging analysis of this novel and related cultural politics, see Zhen Zhang, chapter 8, "Heroism or Colonialism: China and the Soviet Imagination of Manchuria in *Port Arthur*," in *Russia in Asia: Imaginations, Interactions, and Realities*, ed. Jane F. Hacking, Jeffrey S. Hardy, and Matthew P. Romaniello (London: Routledge, 2020), pp. 140–62.

3 See Emily Wilcox, *Revolutionary Bodies: Chinese Dance and the Socialist Legacy* (Berkeley: University of California Press, 2018).

4 Wang Meng王蒙, *Sulian ji* 苏联祭 (In Memory of the Soviet Union) (Beijing: Zuojia chubanshe, 2006), pp. 226–77. For a discussion of this work by Wang Meng and nostalgia for the Soviet Union in Chinese literature, see Zhen Zhang, "Reimagining the Soviet Union in Contemporary Chinese Literature: Soviet *Ji* in Wang Meng's

Remembrance of the Soviet Union and Feng Jicai's *Listening to Russia*," *Frontiers of Literary Studies in China* vol. 8, no. 4 (2014): 598–616.

5 Wang, *Sulian ji* 苏联祭 (In Memory of the Soviet Union), p. 246.

6 Transnational masculinity has been a subfield in masculinity studies and Chinese visual studies. See Sheldon Lu, "Soap Opera in China: The Transnational Politics of Visuality, Masculinity, and Sexuality," *Cinema Journal* vol. 40, no. 1 (2000): 25–47; Geng Song, "Imagining the Other: Foreigners on the Chinese TV Screen," in *Chinese Television in the Twenty-First Century: Entertaining the Nation*, ed. Ruoyun Bai and Geng Song (London: Routledge, 2015), pp. 107–20; Geng Song, "Cosmopolitanism with Chinese Characteristics: Transnational Male Images in Chinese TV Dramas," in *The Cosmopolitan Dream: Transnational Chinese Masculinities in a Global Age*, ed. Derek Hird and Geng Song (Hong Kong: Hong Kong University Press, 2018), pp. 27–39.

Reshaping Beijing's Space: Architecture, Art, Photography, Film

This chapter explores the symbolic and material configurations of the nation in various modes of artistic representations in moments leading to the pivotal national and global event of the 2008 Beijing Olympic Games. Beijing undergoes a round of massive urban construction and destruction in the preparation for the Olympic Games. More specifically, the chapter focuses on two interrelated facets of this process of urban restructuring—the erection of public monuments as symbols of China's globalization, modernization, and progress on the one hand, and the interrogation of such a developmental teleology on the other hand. I examine the city's spatial transformation in the following areas: public monuments, avant-garde art, photography, and local documentary practice.

First, I take a look at the most noticeable architectural symbols in Beijing's new skyline, which are in a large measure designed by foreign architects. Such buildings, with their mocking nicknames, include National Stadium ("Bird's Nest," *niaochao* 鸟巢), National Grand Theater ("Giant Egg", *judan* 巨蛋), and CCTV Tower ("Big Pants-Crotch," *da kucha* 大裤裆; "Big Shorts," *da kucha* 大裤衩). They rival the splendor and scale of the "Ten Great Buildings" (*shida jianzhu* 十大建筑) completed in 1959 at the tenth anniversary of the People's Republic of China in the Mao era. Then, I examine the envisioning of Beijing's new urban space in a collaborative art project between the Chinese diasporic artist Qin Yufen 秦玉芬 and British carmaker Aston Martin. Qin was commissioned to create a specific work as a direct response to the Beijing Olympic Games. Finally, I look at the impact of Beijing's urban restructuring and city planning upon the lives of ordinary people through the lens of local documentary practice. The documentary film, *Zhang's Stir-Fried Tripe and Old Ji's Family* (*Baodu Zhang he Lao Ji jia* 爆肚张和老吉家，dir. Shi Runjiu 施润玖, 2006) narrates how ordinary citizens of Beijing must relocate to other parts of

Figure 7.1 National Stadium ("Bird's Nest"). Beijing. Photo by Sheldon Lu. Circa 2008.

the city by the order of the municipal government for the beautification of the city in anticipation of the Beijing Olympic Games. I follow the documentary's portrayal of the fate, fear, struggle, and uncertain future of two families facing the imminent "tearing down and relocation" (*chaiqian* 拆迁)of their old homes and the interruption of their normal life and business. Meantime, I analyze relevant works of photography, fiction film, and literature in order to flesh out the importance of personal and collective memory of socialist history amid China's march toward globalization.

Globalization has intensified the international division of labor across national borders in the capitalist world-system. As the globe is reduced to a gigantic marketplace, people from different corners of the world share the same fate of functioning in a vast network of global capitalism. Citizens of the world are drawn into an international chain of finance, manufacture, distribution, and consumption. In this sense, we are all internationals. Correspondingly, a renewed solidarity among workers in the world, whether manual or intellectual if we use an old distinction, has emerged. Cosmopolitics, or the politics of cosmopolitanism, is called for to redress this new condition of existence in the beginning of the twenty-first century.[1]

Given its broad global vision, cosmopolitics must be at the same time site-specific and local. Such politics is globally informed in the age of information technology, but must be locally enacted. Here I use the analogy of "site-specific installation art," and demonstrate that cosmopolitics must also be site-specific.

Figure 7.2 National Grand Theater ("Giant Egg") in the foreground and Great Hall of the People in the background, in a dialogue between modernist and neoclassical architecture. Photo by Sheldon Lu. Circa 2008.

Cultural, political, or artistic intervention must originate from individual agency set in a specific location at a specific time. Cosmopolitanism is necessarily built on the concrete practices of individual artists, architects, workers, and so forth.

I investigate the visual and spatial reconfigurations of Beijing in the works of contemporary Chinese and diasporic Chinese artists. These examples of art are reactions to global events but happen in local settings. I regard installation artist Qin Yufen and photographer Wang Guofeng, among others, as cosmopolitan artists who engage in cosmopolitics. The specific site and object of their artistic works is very often the city of Beijing. But while contemplating at Beijing, they have double or multiple frames of reference. They look at China and the world outside China at the same time. Their works invoke different periods of local, national, and world history. Historical memory and the present condition are entwined. There is a spatial coexistence of past and present. Transnational world-space and local specificity are sometimes present in one piece of art. In the case of Wang Guofeng 王国峰, international socialist architecture is repeatedly photographed. Qin Yufen herself is a diasporic Chinese artist. She brings in different modalities of life in her works. While often funded by

foreign sponsors and even transnational corporations, her projects reconfigure the varied landscapes of pristine nature (Beijing suburbs), traditional Beijing (Yinding Bridge in Houhai Lake), and contemporary downtown Beijing.

Monumental Style

The aforementioned iconic new buildings are all designed by prestigious transnational architectural firms, and are erected as symbols of China's globalization and joining the rest of the world. The Giant Egg is the brainchild of French architect Paul Andreu, the new CCTV Tower is conceived by Dutch architect Rem Koolhaas, and Bird's Nest is designed by the Swiss architecture film Herzog and de Meuron. While such *monumentalization of national space* continues, the *commercialization of living space* also proceeds unabated. Old buildings, hutongs, and neighborhoods are torn down to make room for the construction of shopping malls (*shangcheng* 商城), commercial districts (*shangye qu* 商业区), commercial streets (*shangye jie* 商业街), pedestrian walkways (*buxing jie* 步行街), and plazas. For instance, renovated Nanjing Road in Shanghai, Wangfujing in Beijing, and Fuzimiao in Nanjing, are well-known examples of such shopper-friendly, touristy "commercial pedestrian streets."

Traditional buildings and neighborhoods are therefore fated to be either torn down, or remodeled and repackaged. A prominent case in 2008 is the transformation of the Qianmen 前门 area in south Beijing. The Qianmen area was a symbol of old Beijing. Here lies Dashala'er (*Dashanlan* 大栅栏), the famous commercial district. It is also a short walk to Tianqiao 天桥, the boisterous old entertainment quarter known for acrobatic performances, *xiangsheng* comedy (相声 cross-talk), and Beijing opera. Now the main street is converted to a *buxing jie* (walkway). Old trolley bus tracks were laid down to simulate streets of the Republican period. Old-style, gray-tiled shop fronts line up the streets. This is a twenty-first century recreation of late Qing and Republican Beijing. A retro chic is manufactured for the sake of tourism, consumerism, and so-called "cultural preservation."

The monumentalization of space in the early twenty-first century is at the same time the *globalization of space*, projecting an image of China's openness to the outside world. This is unlike the monumentalization of *political* space in the Mao era. The most famous case is the completion of the "Ten Great Buildings" in Beijing in 1959 to commemorate the tenth anniversary of the founding of the People's Republic of China. Those buildings—Great Hall of the People, Museum

Figure 7.3 The old Qianmen area is remodeled into a new commercial area. Photo by Sheldon Lu. Circa 2008.

of Chinese History, Agriculture Exhibition Hall, Museum of Art, Beijing Railroad Station, Palace of Nationalities, and so on, are monuments of socialist modernity and markers of national solidarity. Wu Hung has pointed out the political significance of such "exhibition architecture," and more specifically, "the Ten Great Buildings" project.

> Carried out from 1958 to 1959, this project was the second major effort in Beijing to legitimize the new state by constructing monumental architecture. It was a logical extension of the Monument to the People's Heroes; unveiled in 1958, this earlier monument honoured the past—the martyrs who had dedicated their lives to liberating the Chinese people. The Ten Great Buildings, on the other hand, honoured the present by demonstrating the achievement that a spirited people had made in merely a decade since their liberation.[2]

Wu Hung was analyzing the creation of a "political space" in Beijing in the Mao era. The new buildings at the turn of the twenty-first century are not ostensibly the kind of old political space although they do have political implications and can indeed perform political functions. The Bird's Nest, the Giant Egg, and the Big Crotch constitute first and foremost a *national* space, as they are

titled "National Stadium," "National Theater," and "China Central Television Tower." However, these new mega-projects of construction can be also seen as legitimation projects. Such outlandish-looking architectures create an image of the state that is whole-heartedly committed to the making of a globalized China. The difference is that this time the Chinese socialist state is eager to enlist the help and prestige of capitalist transnational corporations (TNCs) to promote its national agenda of modernization in the age of globalization. The foreign is used to legitimize and showcase the authority and achievements of the nation.

In the rush to project a global-friendly face of China, the local environment is often ignored in urban planning. Call them avant-garde, futuristic, or outright grotesque, such architectures squeeze out traditional urban space and may not mesh with the immediate surroundings. There seems to exist a tension between the local and the global. While discussing the architecture of contemporary Shanghai, Arif Dirlik writes the following:

> But the local here is highly problematic, because global architectural practices (actualized in global architectural firms that are themselves transnational corporations of sorts) seem to derive their aesthetic legitimation not from some commitment to the local but from their ability to represent global capitalism and the consumer clientele it is in the process of creating. The local itself is commodified, in other words, in a dialogue that is not between the global and the local but between the global and the global talking about the local. That dialogue is blessed by a national leadership committed to goals of globalization, a leadership that is much better at suppressing local opposition to globalization ...[3]

Admittedly, Beijing is not Shanghai, and a neat analogy between the two cities does not exist. Shanghai has a colonial or semi-colonial past whereas Beijing was an imperial city and is the capital of socialist China. But it is also true that the state is able to legitimize its aspirations to modernization and globalization by inviting and hiring transnational architectural films to repackage Chinese cities, whether Shanghai or Beijing. Obviously, the socialist state and capitalist global corporations are complicit willing partners in the transformation and manufacture of China's national space. These new buildings do look rather unusual and out-of-place for many local residents. Is globalization in Chinese style, or "socialism with Chinese characteristics," with the help of French, Swiss, and Dutch architects, achieved at the expense of the local?

To many observers, the new jarring skyline designed by foreign architects do not blend in with existing architectural styles, and appears incongruent with the

local environment. Beijing's urban planners deliberately seek out these TNCs to manufacture a new modern face of Beijing. Is this a welcome move in the eyes of local residents? The spirited caricatures and satires of these buildings by Beijing citizens is one indication of people's attitude toward these architectures. While the Bird's Nest seems to be more accepted for its architectural ingenuity, the design, shape, and functionality of the Giant Egg and the Big Crotch remain controversial among the Chinese. Perhaps only time can tell whether these new foreign additions to Beijing's cityscape are monstrous by-products of globalization, or are organic ingredients of a harmoniously expanding metropolis.

The CCTV Tower has been especially the target of ridicule and satire on the Internet. Chinese commentators have pointed out the blatant sexual connotations embedded in the main tower ("Big Crotch") as well as in the relationship between the tower and its surrounding buildings. China has become the playground for international architects to experiment with all sorts of new ideas at the expense of local sensibilities. Foreign defenders of the building call it a "built organism." As one critic explains, "The CCTV Tower's gross shape is the physical expression of a set of interlocking ideas (and broadly, of the idea of interlocking); counterpoise, complementarity, reciprocality. Its rhetorical trope is chiasmus, the reversal of an initial form in the next iteration by an inversion of that form."[4] In the words of a Japanese commentator, "In today's China, the demand is for size, expressions of immensity."[5]

Rem Koolhaas himself relishes the importance of this project, in fact, the most ambitious project his firm has taken on. This kind of opportunity to construct something audacious on such an immense scale is rarely available in the West nowadays. In his own words:

> CCTV is an ambitious building. It was conceived at the same time that the competition of Ground Zero—what should replace WTC—took place, not in the backward-looking USA, but in the parallel universe of China.
>
> In communism, engineering has a very high status, its laws resonating with Marxian wheels of history. To prove the stability of a structure that violated some of the most sincerely held convictions about logic and beauty, ARUP had to dissect every issue in extreme degrees of detail. The effort to reassure only reveals the scary aliveness of every structure—its continuous elasticity, creep, shrinkage, sagging, bending, buckling, the shocking vividness of the mineral world, to which the computer is a hypnotic window, each member analyzed and exposed in all its behaviors with the tenacity of a pervert.[6]

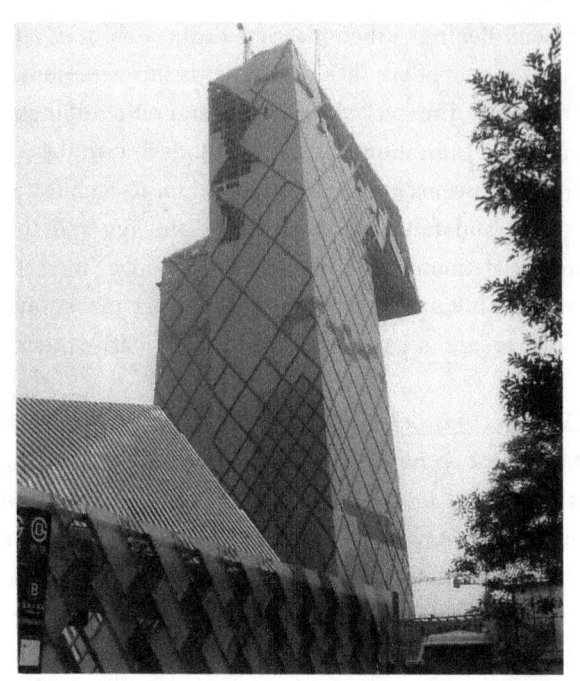

Figure 7.4 China Central TV Tower ("Big Crotch") under construction. Photo by Sheldon Lu. Circa 2008.

The new skyline of Beijing overwhelms and squeezes out the old socialist cityscape. However, traditional socialist space does not totally disappear from people's collective memory. In fact, Beijing's socialist architecture, i.e., the "Ten Great Buildings," and their original models and parallels in the Soviet Union and other countries, are the subject matter of the photographer Wang Guofeng 王国锋. Beijing's socialist public monuments are not only physical structures, but also carry a symbolic meaning in people's minds and hearts. Wang Guofeng talks about his photography for the 2008 Nanijing Triennial with such words:

> The motif of the series of my photography work is those most monumental public buildings that were built in China in 1950s. The meaning that they imply has exceeded their functions. The design combined the architectural styles of both Chinese and the European Classicism with Soviet touch. It speaks of the very political ideals of that specific time. [What] is incredible is that, the entire construction of them all took merely ten months, which was quite a miracle in the world's history for architecture. In this sense, the significance lies no longer solely aesthetically, but also in the construction process itself. It has demonstrated the power of collective ideology in 1950s and the strength of

national will. It expresses the socialist ideals of the time. More precisely speaking, these architectures are the products and practices of the Chinese imagination of [utopia] during a special time. They carry and witness a significant part of Chinese history.[7]

Wang Guofeng's immense photographs of the iconic buildings of Beijing, Moscow, and Pyongyang hence monumentalize and immortalize traces of culture from a different period of world history. Those traces and buildings are in the processes of being forgotten or being wiped off the map. The utopian socialist collective unconscious surfaces now and then in the artistic representation of a new generation of artists.[8]

Wang Goufeng not only works in China. He also obtains permission to take pictures of landmarks in current and former socialist countries such as North Korea and Russia. The scale of Wang Guofeng's photographs is extremely large. For instance, the size of *Ideal No. 1: Great Hall of the People* is 524 cm × 120 cm. The large size of such photographs is proportionate to the monumentality of the buildings. He has to take pictures of the objects section by section. He renders the details of the buildings rather clear and visible. On the one hand, these pictures have almost no people in them. On the other hand, the spirit and the will of the large collectivity can be felt in the monumental buildings in spite of, or because of, the lack of individuals in the pictures. In fact, the emptiness of the buildings and their surroundings emanate an absent presence, a socialist mentality. He attempts to reveal a collective ideology on the national level as well as the international level.

Apart from the Ten Great Buildings completed in 1959, there is also an early Soviet-style building completed in 1954, the Beijing Exhibition Center which is *Ideal No. 9* in Wang Guofeng's photographic series. It was at first called Soviet Exhibition Center, but was later renamed "Beijing Exhibition Center." It also includes a theater and a restaurant. The restaurant is called Moscow Restaurant (*Mosike canting* 莫斯科餐厅). In the Mao era, it was one of a few western restaurants in Beijing. The restaurant is affectionately nicknamed

Figure 7.5 *Ideal No. 1: Great Hall of the People*. Photography. Wang Guofeng. Size: 524 cm × 120 cm. 2006. Courtesy of Wang Guofeng.

"Lao Mo" (Old Moscow) by Beijingers. When the restaurant first opened in the mid-1950s, Russian waitresses worked and served food there. Having an opportunity to dine at the restaurant was an immensely pleasant experience for many Chinese residents. This experience was recounted by writer Wang Meng 王蒙 (born 1934) in his autobiographical work *In Memory of the Soviet Union* (*Sulian ji* 苏联祭). The book was written at the beginning of the twenty-first century. Wang Meng described his past and present emotional entanglements with what was the Soviet Union. Sitting in that legendary restaurant, young Wang Meng tasted Russian food, marveled at the architectural details of the building, enjoyed the service of Russian waitresses, and was nearly moved to tears. If photographer Wang Guofeng's large pictures of imposing socialist edifices may appear impersonal and devoid of feelings at first glance, writer Wang Meng's book is rich in private sentiments and personal details. They both approach the socialist legacy, but employ different methods that are unique to their respective mediums. Since this book has not been translated into English and has not been published in English-speaking countries, I translate and quote a long passage from the book where Wang Meng pours out his feelings:

> In the last several years of the past millennium, a new Russian-style western restaurant opened near the Russian Consulate in our city. I do not want to say much about its cuisine; no matter how I eat, I don't feel it has the yummy taste of a set meal of two yuan five dimes at Moscow Restaurant in the newly built Soviet Exhibition Center in Beijing in the 1950s. At that time, the cheapest Soviet meal was one yuan five dimes; the most expensive was five yuan. At five yuan, there were red caviar salad or crab salad, Moscow borsch or Ukrainian borsch, Kievan butter egg rolls or fried chum salmon. There was pancake with jam, or cream egg cake, or fruit salad. Lastly, there were also ice cream and coffee. And ice cream and coffee were all placed on embroidered silver tableware. The silver looked grayish or whitish, bright yet dark, with a bearing of confidence and nobility. The waitresses were Russian girls wearing ethnic hats and dresses. Every one of them was plumb and well built, with clear facial features. They made you feel that life became so full and solid by having them! ... Perhaps I should be a bit wordy. The pillars of Moscow Restaurant had patterns of hexagon-shaped snowflakes and long tails of squirrels. I did not know why I felt like crying when I entered the dining hall. Actually, getting into this hall was not so easy. Service did not catch up with demand for almost every meal. People needed to take a number, and then waited for being called by staying at the luxuriantly carpeted waiting hall, at the 17th-century-style big sofas with hard backs and purple velvet. I felt that sitting there while waiting for being called was a heavenly enjoyment. Apart from this restaurant whose name and Moscow melt into one, apart from this

restaurant that made Soviet food, there was no other place more worth waiting for! And receiving the service of young Russian women after sitting down—no, I must say the service of Russian girls, I felt that I was the happiest person in the world. I felt that the blood of the revolutionary martyrs was not shed in vain; I felt that paradise on earth already belonged to my generation. [9]

This is the account of dining at Moscow Restaurant by an impressionable young man in his early 20s. Such buildings and sites have become the material embodiments of a "Soviet syndrome" for generations of Chinese people who grew up in that historical period. The blissful experience of spending time at Moscow Restaurant is a token of a more general utopian, optimistic sentiment among many people in a time shortly after the founding of a new republic.

In Jiang Wen's 姜文 film *In the Heat of the Sun* (*Yangguang canlan de rizi* 阳光灿烂的日子, 1994), which could be more accurately translated as *Sunny Days*, the setting of a couple of big gatherings of the youngsters is none but Moscow Restaurant. This famous place is a favorite and coveted location for people to get together. The teenagers eat, drink, and chat at the place under the enchanting violin music of "Gold-colored Furnace" (*Jinse de lutai* 金色的炉台), also known as "The Glory of Chairman Mao Lights Up the Furnace" (*Mao zhuxi de guanghui ba lutai zhaoliang* 毛主席的光辉把炉台照亮). This musical piece was created by composer Chen Gang 陈钢 in the 1970s, the last years of the Mao era, in praise of socialist steel workers. It was one of the most memorable and beautiful musical compositions for the violin from China's socialist period. The scene in the film creates a nostalgic mood for bygone socialist history. Jiang's film offers a revisionist representation of the Mao era, especially the notorious Cultural Revolution, which has been negatively portrayed in a number of internationally renowned films by the masters of the fifth-generation directors, such as *Farewell My Concubine* (*Bawang bieji* 霸王别姬, 1993), *Blue Kite* (*Lan fengzheng* 蓝风筝, 1994), *To Live* (*Huo zhe* 活着, 1994). All these films are released in the same time period, the early 1990s. In the eyes of the younger sixth-generation director, Jiang Wen, the Cultural Revolution is a time of fun and play in bright sunny days, a come-of-age for youngsters with raging hormones and intense longing for love and sexuality.

Collaboration between Transnational Corporation and Art

The internationally renowned Chinese diasporic woman artist, Qin Yufen, was commissioned by the British luxury car producer Aston Martin to create a series

of projects involving its car during 2005–2008. The project culminates in the exhibition *Beijing 008* held at Today Art Museum in Beijing in 2008. Her work is an artistic intervention into the changing spatial configurations of Beijing. It offers a unique view on the complexities and contradictions of an old city that is increasingly submerged under a new car culture. Here is an interesting case of the collaboration among the avant-garde artist, the institution of art museum, and a transnational corporation. It is provocative to compare the different points of departure for launching such a joint venture between an art institution and a business.

Zhang Zikang 张子康, Director of Today Art Museum, writes the following words in "Preface I" of the bilingual exhibition catalogue:

> We hope that the cooperation of art and fashion could make the spiritual value of fashion gradually appear from daily consumption value through fashion's culture and composing fashion's image by art. Beijing 008 aims at bringing an abundant and distinct experience to the visitors, as well as influencing a wider art audience by the splendid combination of art and fashion.[10]

The English translation is a bit awkward, but it is clear that the museum hopes to reclaim certain "spiritual value" as opposed to "consumption value" in China's historic transformation into a consumer-oriented materialistic society. Such is the function of an art museum at the present time.

Immediately following "Preface I" is naturally "Preface II," on the next page. "Preface" II is written by Ulrich Bez, CEO of Aston Martin. However, the head of this world-famous TNC (transnational corporation) has a rather different agenda in mind. He says:

> We are delighted that our collaboration with Qin Yu Fen and the Today Art Museum combines so many of the elements that go into making up Aston Martin; collaboration, individuality, history and the bold spirit of the Olympic games themselves.

> "Beijing 008" encapsulates the strong affinity we have with the fast-changing and dynamic world of modern art, a world that synthesizes our core values of power, beauty and soul. "Beijing 008" is a challenging and invigorating piece of work that marks Aston Martin's entry into this exciting new market at such a critical time in history.[11]

The motivation of the car company is to open the vast Chinese market for its product. And the location and the time, Beijing in 2008, are the most opportune moment for breaking into China. Beijing would receive unprecedented world

attention in 2008 for hosting the Olympic Games. Art would serve the interest of business. Moreover, isn't the sleek, artsy design of an Aston Martin model a work of art? It embodies the company's "core values of power, beauty and soul." The collusion of divergent interests between an art establishment and a TNC at this exhibition brings in sharp relief the ironic nature of Chinese art caught in the vortex of globalization.

Qin's *Beijing 008* is a bold, massive, extraordinary installation. An Aston Martin car is squarely placed on a map of Beijing. Standing next to it is a tape measure blown up 100 times from its original size. A sculpture of the British astrophysicist Stephen Hawking, seated in a wheelchair, was suspended above the car in midair. Beijing's flourishing car culture represents the material pursuits of the upper and middle class who seek upward mobility, consumption, commodities, and new car models. Highways and cars have permanently altered the physical landscape of the city. Yet, from the bird's eye view of the immobile astrophysicist, does everything make sense on the ground? The scientist looks down on the map of Beijing and up at the sky, perhaps contemplating stars, physics, metaphysics, laws of nature, and the universe, "as if to suggest a new understanding of space and time,"[12] in the words of Huang Du, curator of the exhibition. On the wall, there is a quotation from Hawking: "Disorder increases with time because we measure time in the direction in which disorder increases." The vastly oversized tape measure significantly looms large in the space of the exhibition hall. The fundamental question being raised seems to be: what is the measure of life?

Qin has also created striking powerful installments in this multiyear project with the British carmaker in her earlier works. The setting of Qin's *Nomad* (*Youmu* 游牧, in Fangshan, Beijing, 2005) is in the suburb of Beijing. The work is part of her "2005/Art Project." The scene consists of green mountains in the background, rocks on the floor, colorful silk drapery hung on bamboo sticks, and an Aston Martin car. The drapery comes in colors of red, orange, yellow, green, blue, and purple. It could be a symbol of private space, domestic life, and women's labor. Qin Yufen stands tall as a veteran woman artist in China and the Chinese diaspora.[13] Once again, as in some other works by her, the evocation of a perceived traditional oriental feminine touch permeates this work as a way of contrast, contestation, and critical reflection. Bright multicolored silk drapery has been a recurrent material and motif in Qin Yufen's works. The installation dramatizes the tension between technology and the environment. What the viewer witnesses is the invasion of both nature and domestic space by an automobile, or seen in a positive manner, the cohabitation and equilibrium

Figure 7.6 *Beijing 008: Blueprint of the Art Project*. Reshaped tape measure, carpet, Aston Martin V8, and reshaped kites. Qin Yufen. Today Art Museum, Beijing. 2008.

between nature and technology. An Aston Martin car roams the rural landscape and becomes the new motorized "nomad." Pastoral space has been mechanized, and nature has been incorporated into industrial production. As such, the work is also a meditation on ecology.

The Revolving Shanghai (*Xuanzhuan de Shanghai* 旋转的上海, 2006) is an installation created for the 2006 Shanghai Biennial. An Aston Martin vehicle sits on a model of interconnected, spiraling highways built with metal bars. Shanghai's new landmarks such as the Orient TV Tower and Jinmao Tower loom in the background. The work recalls to the mind Shanghai's overpass highways (*gaojia qiao* 高架桥) that enable cars to go quickly to different parts of the city. An Aston Martin automobile intrudes Shanghai's urbanization design.

Car culture has been present in Qin's works that predate the Aston Martin project. In the performance/installation *Chinese Dream* (*Zhongguo meng* 中国梦, 1999), Volkswagen car hubs, draped in colorful silk, are placed on Yinding Bridge 银锭桥, in Houhai Lake 后海, Beijing. The is an old area in Beijing, mostly populated by ordinary citizens. The possession of a car has been the dream of many citizens. Becoming a great car country is also part of the national dream of industrialization and urbanization. A transnational corporation, Volkswagen, is invited to play a role in changing Beijing's landscape and people's lives.

Figure 7.7 *Nomad.* Bamboo, Silk, Aston Martin vehicle. Qin Yufen. Fangshan, Beijing. 2005.

A Documentary of Disappearance

From the 1990s to the twenty-first century, massive waves of urban demolition and destruction have radically and irreversibly changed traditional Chinese cityscape. Beijing's signature traditional courtyard, *sihe yuan* 四合院, formerly populated by the vast majority of residents of the city, is steadily disappearing, and is becoming a luxury home that only the most deep-pocketed can afford to own. Ordinary residents have been driven out of their old, dilapidated, cramped courtyards for the sake of the beautification of Beijing in expectation for the Olympic Games.

Shi Runjiu's documentary *Zhang's Stir-Fried Tripe and Old Ji's Family (Baodu Zhang he Lao Ji Jia,* 2006, 50 minutes) is such a tale about the immanent demolition of their homes as part of the city's campaign to clean up for the Games.[14] The Zhang family and Ji family are located in the scenic Shichahai 什刹海 and Qianhai 前海 area. They are told to relocate to other parts of Beijing so that this place can be turned into a beautiful lawn. Set against the public, official, state-sponsored gigantic projects of urban development, Shi's documentary lens lingers on the life dramas of ordinary citizens in small private settings. For generations these residents have lived in their old courtyards, which they call "home." The film's narrative follows the characters' fears, discussions, and negotiations about where to build their future home and how to conduct

business in an unfamiliar new location. They face an uncertain future as they need to move out of an intimate place to an impersonal space.

The film begins with a long shot of the scenic lake of Shichaihai in summer 2004. The narrative voice-over states that the area along Dongyan Street in Qianhai will be converted to a green lawn for the 2008 Beijing Olympic Games by the order of the local government of the Western District (*Xicheng qu* 西城区). To do this, houses in the area will be demolished and residents must move out by May 2005. As people know, the Shichaihai and Houhai area has been already developed into a hot tourist spot. There exist numerous bars and restaurants along the beautiful lake catering to the taste of both international and domestic visitors.

On February 8, 2005, the New Year Eve in the traditional lunar calendar, the camera zeroes in on two families caught in the situation: the Zhang family and the Ji family. The Zhang family restaurant: Baodu Zhang (Zhang's Stir-fried Tripe) is more than a century old. Located at Donyan Street no. 17, Qianhai (前海东沿17号), it was founded in 1883 in the late Qing. Zhao Yaoxing, 71 years old at the time of filming, is the third-generation owner of the restaurant. He, his wife, son, and daughter-in-law together run the family business. His son would be the fourth- generation owner of the restaurant. The whole family's livelihood depends on this family business. The imminent destruction of the restaurant and the dislocation of the family ominously hang over the minds of the family members. The family is reluctant to leave a place they call home. Nor would they know how to run a family business far away from the inner city. Mr. Zhang has lived at this place for 71 years, his entire life. As the family sits around a table to enjoy their New Year Eve meal, they are unsure about where they will have their next New Year meal. This might be their last one in Qianhai.

In much of the film, the camera follows Li Shuqin, wife of Zhang Yaoxing, in her anxious trips to various units of the local government of the Western District of Beijing to petition for leasing them a place in the Shichaihai area. She attempts to negotiate with the local government. She is also well aware of the rule that if three rounds of negotiations (*tiaojie* 调解) between her and the government fail, her family would be forcefully relocated.

Baodu Zhang is an old, well-established name in Beijing (*Beijing lao zihao*). *Baodu* (stir-fried tripe) is a traditional Beijing snack. Not many people know how to prepare this dish these days. As the Zhang family maintains, what is also at stake is the disappearance of a traditional culinary art and a slice of authentic old Beijing culture (*zhengzong lao Beijing wenhua* 正宗老北京文化). This sentiment is surely shared by many Beijing'ers. It is none other than the

famous Beijing writer Lao She who wrote an essay (*sanwen* 散文) on Beijing's staple snack: stir-fried tripe (*baodu* 爆肚). In this essay, "Discussion on Food at Elegant Home" (*yashe tanchi* 雅舍谈吃), Lao She talked about different ways of cooking stir-fried tripe. With the benefit of hindsight in the twenty-first century, Baodu Zhang appears to be a rare cultural relic that has survived the ravages of time and destruction.

The Ji family is also located along this street, facing the same fate of imminent relocation. This is an extended family of several siblings, their spouses, and their children, living together in the same one-story house (*pingfang* 平房). In old times, the Ji family was an affluent proprietor of a large teahouse in Beijing. Their private family business was seized and nationalized by the Chinese government in 1958. Since then, they have lived the lifestyle of ordinary plebeians (*pingmin* 平民) in a cramped, dilapidated old house. The government has given them relocation money this time. The camera tracks their house-hunting trips and records their discussions of what kind of place they would like to live in: a multistory high-rise (*loufang*), or a traditional one-story house (*pingfang*). The Ji brothers would like to live in a *pingfang* again because they are attached to this kind of dwelling. Most of the Ji family members were actually born and delivered by midwives in their present home. But the wives, namely the women who married into the Ji family, wish to move to a more modern *loufang*. As the family members light up fireworks outside their home to celebrate the New Year Eve, they are uncertain about where they would call "home" the next year.

The ending date of the film is May 2005. This is supposed to be the time when demolition and relocation should have been completed. But the narrative voice-over explains that concerned specialists and scholars from society have voiced a wish for the preservation of people's lifestyle and architectural characteristics of Houhai. Therefore, the destruction of this area is temporarily suspended. "But the pace of urban reforms will not stop," as the narrator reminds everybody. The Zhang family and Ji family are temporarily spared from relocation, but their future remains uncertain.

There is nothing extraordinary about the documentary's cinematography, visual style, and narrative flow. There are no flashy special effects, sensational details, or high-toned arousing commentary. It feels like a rather plain, subdued, straightforward story of the fate of two Beijing families in a specific time frame (from February/Chinese New Year Eve in 2005 to May 2005). And this unadorned simple style fits the subject of the documentary—the lives of ordinary Beijing citizens. Hence the truthfulness of the documentary comes out naturally from a purportedly truthful style.

It seems that documentary as such plays a unique role in the establishment of a potential public sphere in socialist or postsocialist China. Documentary practices range from state-owned and state-sponsored, independent, underground, to semi-independent. TV programs sometimes air documentaries that address topical social issues in Chinese society today. As this particular documentary shows, individual residents, the local government, and concerned citizens can engage in some kind of negotiation and settlement. The habitat and livelihood of ordinary people are indeed endangered by China's sweeping, top-down, often autocratic modernization drives and callous urban planning. Yet, ordinary citizens, filmmakers, documentarians, scholars, and the media can also affect and change the decision of the local government. The "Chinese government" is not a monolithic entity. It consists of many administrative levels, some of which are rooted in specific local communities and municipal districts.

Commenting on the function of documentaries in postsocialist China, Chris Berry raises several important questions:

> What is the relation of these documentaries to the state? Are they a challenge or are they complicit? If the relation is not to be considered in such a binary way, do they function as a supplement that changes the system or as a co-opted token that props it up? The questions are impossible to answer in an absolute and generally applicable way. It is even difficult to give a simple answer in regard to any individual film.[15]

Although Berry's framing of the question sounds also "binary," there seems to be an awareness of the complexity of the issue at hand. It appears that a door is open, or half-open for self-conscious cultural workers to intervene in deliberation processes for the kind of communities that people wish to live in. Film artists, urban planners, architects, cultural critics, proprietors, and citizens might all possibly play a role in the widening of the narrow space of a Chinese public sphere.

Because of the Beijing Olympic Games in 2008, Beijing TV launched a series, *Enter Beijing* (*Zoujin Beijing* 走进北京), in order to introduce the customs, tradition, and history of Beijing. The first installment of the series is the "Series on Old Beijing Culture" (*lao Beijing wenhua xilie* 老北京文化系列). It aired an episode on Baodu Zhang in January 2008. At the time of the broadcast of this TV series, Baodu Zhang was still located at the old address: Qianhai Dongyan no. 17.

Baodu Zhang moved to another location in Qianhai, and reopened on November 23, 2008. Now situated at the northeast corner of Qianhai, the restaurant is much bigger and nicer than the old place at Dongyan Street no. 17.

The plaque (*paibian* 牌匾) for the restaurant's name is graced by the calligraphy of Ma Ji 马季, a famous *xiangsheng* (cross-talk) comedian.

The restaurant is able to stay in Qianhai and Shichahai areas thanks to the publicity generated by the documentary and other sources. But does the restaurant's improvement in comfort at the new place justify the relocation? Some anthropological "fieldwork" and interviews with involved parties (the restaurant owner, local officials, regular clients) would help us understand the situation and people's attitudes. Relocation, demolition, and voluntary and involuntary migration of people have become the order of the day in social engineering, urban planning, and the relentless teleological pursuit of progress. However, the fact that a documentary could be made about this subject and that it had an impact on the result is already an indication of the operation of a fluid, fraught, and fragile public sphere-in-the-making in a Beijing community.

Notes

1 On the topic of cosmopolitics, see Pheng Cheah and Bruce Robbins, eds., *Cosmopoltiics: Thinking and Feeling beyond the Nation* (Minneapolis: University of Minnesota Press, 1998).

2 Wu Hung, *Remaking Beijing: Tiananmen Square and the Creation of a Political Space* (London: Reaktion Books, 2005), p. 108.

3 Arif Dirlik, "Architectures of Global Modernity, Colonialism, and Places," *Modern Chinese Literature and Culture* vol. 17, no. 1 (Spring 2005): 37.

4 William B. Millard, "Dissecting the Iconic Exosymbiont: The CCTV Headquarters, Beijing, as Built Organism," in Rem Koolhaas et al., *Content: Perverted Architecture* (Koln: Taschen, 2004), p. 490.

5 Toyo Ito, "Big Time Dilemmas: Interview by Kayoko Ota," in *Content*, p. 448.

6 Rem Koolhaas, "Post-modern engineering?" in *Content*, p. 515.

7 Wang Guofeng, quoted in *Third Nanjing Triennial: Reflective Asia* 第三届南京双年展——亚洲方位，ed. School of Visual Arts of Nanjing University 南京视觉艺术学院（Nanjing: Nanjing chubanshe, 2008），no page number.

8 K. Sizheng Fan offers an informative account of the influence of Soviet classicist architecture in China in the 1950s in his chapter: "A Classicist Architecture for Utopia: The Soviet Contacts," in *Chinese Architecture and the Beaux-Arts*, ed. Jeffrey W. Cody, Nancy S. Steinhardt, and Tony Atkin (Honolulu: University of Hawai'i Press/Hong Kong: Hong Kong University Press, 2011), pp. 91–126.

9 Wang Meng 王蒙，*Sulian ji* 苏联祭 (In Memory of the Soviet Union) (Beijing: Zuojia chubanshe, 2006), p. 216.

10 Zhang Zikang, "Preface I," *Beijing 008—Art Project of Qin Yufen*,北京008—
 秦玉芬艺术计划，bilingual exhibition catalogue, Curator Huang Du黄笃, ed.
 Chen Ai'er 陈爱儿and An Su安夙 (Beijing: Today Art Museum, 2008), p. 5.

11 Ulrich Bez, "Preface II," *Beijing 008—Art Project of Qin Yufen*, p. 7.

12 Huang Du, "Beijing Sky," *Beijing 008—Art Project of Qin Yufen*, p. 11.

13 For up-to-date discussions of gender and China's women artists in Beijing, see
 Shuqin Cui, *Gendered Bodies: Toward a Women's Visual Art in Contemporary China*
 (Honolulu: University of Hawaii Press, 2016); Sasha Su-ling Welland, *Experimental
 Beijing: Gender and Globalization in Chinese Contemporary Art* (Durham, NC: Duke
 University Press, 2018).

14 Shi Runjiu is usually considered a sixth-generation director. His feature films
 and documentaries are concerned with the lives and plight of ordinary urbanites
 in contemporary China. His documentaries have been classified as belonging to
 China's New Documentary Movement (Zhongguo xin jilupian 中国新纪录片),
 which is dedicated to truthful recording. One of Shi's best-known feature films is *A
 Beautiful New World* (*Meili xin shijie*美丽新世界, 1998). Set in Shanghai, the film
 describes the longing of ordinary Chinese for having an apartment of their own.
 For studies of this film and contemporary Chinese urban film culture, see Augusta
 Palmer, "Scaling the Skyscraper: Images of Cosmopolitan Consumption in *Street
 Angel* (1937) and *Beautiful New World* (1998)," in *The Urban Generation: Chinese
 Cinema and Society at the Turn of the Twenty-first Century*, ed. Zhang Zhen
 (Durham, NC: Duke University Press, 2007), pp. 181–204; Sheldon Lu, *Chinese
 Modernity and Global Biopolitics: Studies in Literature and Visual Culture*, Chapter 9,
 "Tear Down the City: Reconstructing Urban Space in Cinema, Photography, Video,"
 pp. 167–90.

15 Chris Berry, "Getting Real: Chinese Documentary, Chinese Postsocialism," in *The
 Urban Generation: Chinese Cinema and Society at the Turn of the Twenty-First
 Century*, ed. Zhang Zhen (Durham, NC: Duke University Press, 2007), p. 131.

8

Artistic and Multimedia Interventions

This last chapter purports to synthesize the various strands of thought and arguments, different forms of art, and multifarious types of media. By way of thematic continuity and at times intermedia affinity, I offer a comprehensive, kaleidoscopic examination of the many facets of human expressions in contemporary China from the 1990s to the present moment. A wide range of forms and media are under examination: film, photography, billboard, propaganda poster, graffiti, installation, and performance, and poetry. The practitioners include veteran avant-garde artists, emerging talents, amateurs, and even ordinary workers. The various social phenomena brought about by China's neoliberalist[1] developmentalism are carefully scrutinized by the artists: urban design, environmental degradation, government propaganda, grassroots social movements, urban migration, and so on. The Chinese cultural workers particularly tackle the processes of urbanization, modernization, and globalization with all the attendant exhilaration as well as destruction. They forge ingenious ways to configure, represent, and imagine China through their unique media.

The chapter delves into a series of interrelated topics, proceeds in a largely historical, chronological order from the last quarter of the twentieth century to the present time, and makes cross-references among the materials as needed. I begin with a delineation of the changing meaning of art and more specifically of "avant-garde art" in contemporary China. Then this leads to a discussion of an important phenomenon: the transformation of the ubiquitous socialist propaganda poster into "political pop" since the early 1990s. After that, I look at the common invocation of a symbol of American culture, Coca-Cola, in the political pop art of Wang Guangyi, a film by director Zhang Yimou: *Not one Less*, and a poem by Yan Li at the turn of the twenty-first century. The section is followed by a discussion of what might be called "socially engaged art" that has flourished in the twenty-first century, in part as a response to massive

urbanization and as a result of the embryonic, precarious growth of a civil society. The final section is an exploration of the state of intermedia social engagement at the current moment, well into the second decade of the twenty-first century. This is a time when different types of media, for instance, documentary film and poetry, converge to comment on and protest against common problems confronted by people in Greater China and elsewhere, such as environmental crisis, the plight of migrants, and the exploitation of workers in transnational capitalism.

Overall, several important themes seem to be evident in Chinese art, as "art" is understood and used here in the broadest sense to stand for all: visual arts, performance, film, and to a lesser degree poetry. First, the artists navigate and negotiate the complex relationship between art and society, namely the tension between the individual aspirations of artists on the one hand and the limits of tolerance in Chinese public culture on the other hand. Second, the artists need to make sense of the Janus-faced reality of China: the rosy images of a forward-looking society as painted by official media, and the condition of marginal social groups who have not been able to benefit from China's march to prosperity. Third, the artists attempt to find the right ratio in artistic expression between localism and globalization, namely, between the indigenous roots of their art and the pressures and opportunities afforded by the global capitalist economy and the international art market.

The Changing Meaning of Art

It is quite remarkable to notice how the meaning of art has changed and expanded in China since the beginning of Reform and Opening in the late 1970s. Decades ago, these kinds of art forms: installation, performance, body, video, and graffiti, would have been called "avant-garde" (*xianfeng* 先锋, *qianwei* 前卫), "modernist," "postmodernist," "independent," "underground," "new," or "experimental." It is even hard to find proper venues to exhibit such art. At that time, legitimate art forms are traditional-style Chinese painting (*guohua* 国画), European oil painting, Chinese peasant painting (for instance, Hu County peasant painting 户县农民画), and propaganda poster. Avant-garde art is perceived as Western, decadent, and bourgeois. A new art movement emerges in 1985 (85 美术新潮), and the China Avant-Garde Exhibition (中国现代艺术展) is held in the National Art Museum (美术馆) in Beijing in 1989. The status of such movements and exhibitions is tenuous;

the exhibitions have to be approved by the authorities, and could be shut down easily for some reason.

How time has changed. Such adjectives as "avant-garde" have been dropped when referring to these art forms. They have become so ordinary and widespread that the epithet "avant-garde" seems less meaningful. This indicates that they have been legitimized and institutionalized in socialist China.[2] Museums and galleries have been built to host exhibitions of such art. A good example is the spacious Today Art Museum (今日美术馆) in Beijing. Entire art districts such as 798 in Beijing have emerged. Biennial or triennial exhibitions are held regularly to showcase new artworks inside China. The funding of such art market and exhibition comes from a variety of sources: government, private, domestic, and foreign. The works of Chinese artists are exhibited both domestically and internationally, including high-profile museums outside China. Chinese artists participate in international art exhibitions regularly. The collection of such art is also a rising phenomenon. The collectors are no longer exclusively foreigners; local Chinese art connoisseurs have also gradually developed a taste for such art and have begun to purchase it. In short, the Chinese art scene has changed tremendously in the last several decades. It seems that China has entered the postmodern phase of culture where a sharp distinction between highbrow and lowbrow, between elitist and popular is blurred.

However, it is also premature to hail the advent of an era of free expression in the artistic arena. Government censorship is still omnipresent. There are enough examples of artistic exhibitions being censored or forcefully closed. For instance, the Independent Film Exhibition in Songzhuang Village, organized by Li Xianting 栗宪庭, was shut down by the local authority periodically. This is the result of the fraught relationship between art and the state in contemporary China. In this sense, the struggle for artistic autonomy and a truly open public culture is still an "incomplete project" of modernity in mainland China.[3] Artists try to extend the boundary of art and widen the domain of public culture. Sometimes they need to negotiate with the authorities and engage in a tug-of-war with the censors, as it were.

From Propaganda Poster to Political Pop

In this section, I would like to take up the transformation of the propaganda poster into "political pop" as a way to track the evolution of Chinese art. Then, I will comment on the cross-media relationship among Chinese artists in

the various fields of oil painting, film, and poetry. I will particularly examine their joint efforts in representing and satirizing widespread materialism and consumerism in Chinese society. The crucial link between the political pop and urbanization should be pointed out. Urbanization provides the occasion for the emergent middle class to realize its Chinese dream—the right to a modern lifestyle. The possession of desirable commodities and famous brand names is a driving ambition of upward mobile urbanites. The political pop is right on the target in depicting this commodity-fetishism in the country's march toward urbanization and modernization.

The propaganda poster has been very important in the art history of the People's Republic of China. It is one of the most significant art forms in revolutionary times.[4] The use of billboard advertisements by the government at the present time testifies to the longevity of this art form. As it has been pointed out, the propaganda poster is of paramount significance in various totalitarian regimes such as the Soviet Union, the Third Reich, Fascist Italy, and the People's Republic of China, according to Igor Golomstock. "The totalitarian ideal was the language of the propagandist poster, tending toward color photography."[5] The direct, simple, forceful, and dynamic form of the poster is an effective tool for mass mobilization. Indeed, because of its mass appeal, the political poster is arguably the most visible and widely used art form of revolutionary China.

One prominent motif of poster art is "castigation," or "smashing." The heroes of such posters are the revolutionary progressive masses, especially the holy trinity of workers, peasants, and soldiers (*gong, nong, bing* 工农兵). These human figures are invariably healthy-looking, glowing, and round-faced protagonists of revolutionary China. Their fists, pens, brushes, and weapons smash and wipe out the caricatured enemies that are usually positioned at a lower corner of the poster frame.

As social and economic reforms deepen in Deng's China, the genre of castigation/smashing gradually dies out. However, beginning in the 1990s, Maoist propaganda art was picked up and transformed by avant-garde artists to different aesthetic, political, and commercial ends just as "great castigation" fades/phases out as a public theme in daily life as well as in official political sloganeering. Such an emergent form of politically engaged avant-garde art has been called "political pop."

The concept of "political pop" was defined and introduced in the exhibition "China's New Art, Post-1989," organized by the Hanart T Z Gallery in Hong Kong in 1993. The early 1990s were a time when China was still recovering from the dark shadow of the Tiananmen Incident of 1989. Like many other things,

artistic experiments were put on hold in mainland China. This exhibition held outside mainland China in Hong Kong was a major event that helped revive China's avant-garde art movement.

The term "political pop" (*zhengzhi bopu* 政治波普) was coined by senior art critic and curator Li Xianting. He highlighted the urgent social relevance of the term in the following words:

> Like the so-call "Mao fever" that emerged in Chinese society in early 1990, Political Pop art reflects a complex social psychology which is rooted in the difficulty Chinese people have had in releasing themselves from a deep-seated "Mao complex." In a sense, "Mao fever" and Political Pop are linked in that there is inherent in both the use of past icons or "gods" to criticize, or in the case of the latter, to satirize, current reality.[6]

By "current reality," Li was referring to the cultural, economic, and political atmosphere of China at that historical juncture. Although political activism was suppressed, China's paramount leader Deng Xiaoping opened the other door for China, namely, accelerated capitalistic economic development throughout the country. People's political frustration was then transformed into an all-out national embrace of consumerism and commercialization. This is also precisely the point that the co-curator of the exhibition Chang Tsong-zung makes in the exhibition catalogue. Chang writes:

> In the contemporary context, the significance of such an art lies in its re-appropriation of the language of mass culture, hopefully as a means by which to tame the reifying and oppressive nature of culture in the mass-communication age. As China gradually turns itself over to the monster of capitalist consumerism, the message of Political Pop as exemplified in the works of representative painter Wang Guangyi becomes even more poignant in its explication of the subtle fusion of totalitarian and capitalist-consumer cultures. The overt political references in Political Pop works are also slowly changing over to general cultural issues as China's new market economy develops.[7]

In other words, the revolutionary past is used as a resource to launch a criticism of rampant capitalism in the present.

"Political pop" is derived from the political propaganda poster. The themes, icons, and art form of revolutionary China have been turned into a double-edged sword that pokes fun at past propagandist naiveté on the one hand and rebels against present capitalist commodity-fetishism on the other. Bygone revolutionary art has been rendered into a vehicle for the critique of present

consumer culture. At the same time, contemporary avant-garde art from socialist China has been sold at exorbitant prices at the international art market, breaking one record after another. Ironically, the purported critical avant-garde has become a highly sought-after commodity. It sells itself out to the omnipresent capitalist market for cash and prestige. Also sold out at the same moment is the revolutionary legacy that such art draws upon as resource and inspiration.

Many names are associated with this group of avant-garde artists, including Wang Guangyi 王广义, Yu Youhan余友涵, Li Shan 李善, Wang Ziwei 王子卫, Feng Mengbo 冯梦波, and so on. However, Wang Guangyi's *Great Criticism* series (*Da pipan* 大批判) is particularly striking and has captured a great deal of international attention. He substitutes consumer products for counterrevolutionary figures in his paintings. The targets of criticism are no longer disgraced politicians and historical figures such as Liu Shaoqi, Deng Xiaoping, Lin Biao, and Confucius. They are now famous brand-names: Nikon, Canon, Rolex, Band-Aid, and above all, Coca-Cola.

The heroes of Wang's *Great Criticism* series are the revolutionary masses: workers, peasants, and soldiers. Such stock characters come from all sorts of sources in the Mao period: posters, films, ballet, and illustrated books (*lianhuan hua* 连环画). Sometimes these figures smash and attack logos of commodity-products, and sometimes they coexist with the latter on a flat surface. This flat yet provocative postmodern pastiche of socialism and capitalism captures the reality of contemporary China in a forceful way. However, this representational strategy, namely, the marriage of socialism and capitalism on a flat surface, does not originate with the imagination of Chinese avant-garde artists. In fact, this was first done by Soviet Sots artists since the late 1970s. Alexander Kosolapov's *Lenin and Coca-Cola* was one of the most famous examples. From the late 1970s, through the 1980s, into the early 1990s, in the condition of what might be called "late socialism" or "postsocialism," avant-garde artists throughout former socialist countries utilize the symbols and icons of official socialist art to articulate the changing reality that they are facing, be it in the Soviet Union, the Balkan States, East Europe, Cuba, or China.[8] But the Chinese avant-garde arrives at the scene at the most opportune, lucrative moment as some of its members have become the darlings of the capitalist art market place in the post-Cold War era. The practitioners of such political pop art have been facetiously nicknamed "pop masters" (*bopu dashi* 波普大师) inside China, and the worth of their paintings has grown dramatically over the years outside China.

The complicit relationship between the self-styled avant-garde and global capitalism is pointed out by Gao Minglu as "double kitsch" on the occasion of the exhibition "Inside Out: New Chinese Art" in the Unites States in the late 1990s. Gao writes,

> The aesthetic allegory of both propagandist art and consumer mass culture that functions in Political Pop led me to label it "double kitsch"; the Political Pop artists are producers, and their trademark works are real commodities. In other words, they themselves become the "double kitsch." Consequently, the "presence" of the avant-garde in the international exhibitions and markets overseas might reflect an "absence" of the avant-garde inside China.[9]

In the early twenty-first century, the kind of art that Gao Minglu described as kitsch gathers more momentum. As the Chinese economy enters the central stage of the world economy, Chinese art is eagerly sought after by deep-pocketed international art dealers and collectors. The price of Chinese avant-garde works has grown exponentially in the world market. Wang Guangyi's work *Great Criticism: Coca-Cola* (oil and acrylic on canvas, 1993, 200 cm × 200 cm) was bought by a collector at the price of $25,000 in 1996. However, a decade later, at an art fair in London in 2007, the same work was purchased by New York art dealer Larry Warsh, at the price of 780,000 pounds. Warsh said, "Wang Guangyi is the Warhol of China. This is one of the most famous samples of his work and one of the earliest."[10] Wang's fellow Chinese avant-garde painter, Yue Minjun 岳敏君, in the tradition of "cynical realism," set another sales record for contemporary Chinese art at the same Sotheby's auction in October 2007. His piece *Execution* (Oil on canvas, 1995) was sold at 2.9 million pounds. Apparently, this work by Yue is intensely political and touches on an untouchable subject: what happened in Tiananmen Square in Beijing in June 4, 1989. The list of successful Chinese artists keeps growing. China is now "the hottest art market in the world." It is reported that in 2007 "three Chinese artists—Zhang Xiaogang, Yue Minjun, and Zeng Fanzhi—made the global top 10 bestsellers at auction houses. ... $3.3bn worth of Chinese art was sold at public auction worldwide in 2007."[11]

Coca-Cola in Painting, Film, and Poetry

Chinese pop artists like Wang Guangyi has truly mastered the essence of the method of factory mass production in the fashion of Andy Warhol. Wang is able to churn out an endless combination of revolutionary motifs coupled with

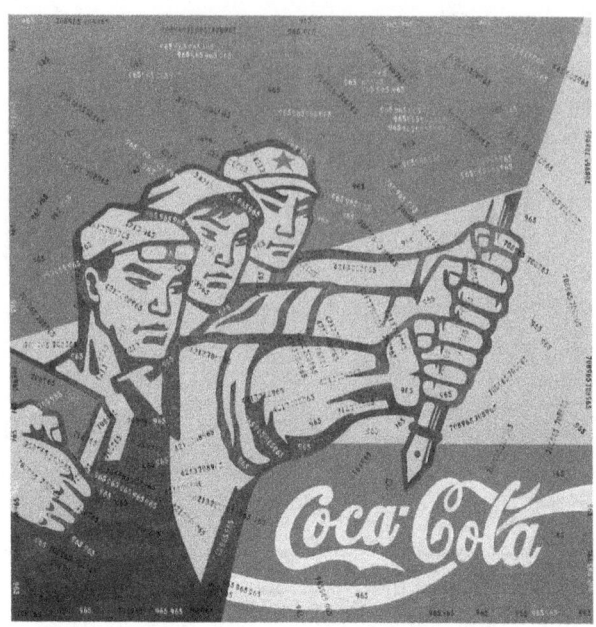

Figure 8.1 *Great Criticism: Coca-Cola.* Wang Guangyi. Oil and acrylic on canvas. 200 cm × 200 cm. 1993.

consumer products. The steady stream of products caters to the appetite of art collectors as well as brings an overflow of hard currency to his coffer. The revolutionary poster, an art form that was meant to be utilized as a criticism of capitalism, has been turned into a cash cow by ingenious Chinese painters in the capitalist market place that nonetheless has a yearning for the exotic political other, for traces of revolutionary history.

Given what Coca-Cola stands for, it is not surprising that Wang's *Great Criticism: Coca-Cola* is regarded as his most poignant piece by some international art collectors. Coca-Cola is very much an icon of America. It is not just an ordinary American drink; it is often taken to stand for American lifestyle, American liberty, and ultimately, triumphant American consumerism. That Wang is the "Warhol of China" might be an overstatement in view of the evidence of other commercially successful Chinese artists, but the Wang phenomenon—both the content of his work and his co-optation in the transnational art market, does encapsulate the uncanny relationship between a rarefied avant-garde artwork and the materialism of the market.

Wang's Coca-Cola piece cannot but remind us of an unforgettable scene in a film by an equally or even more famous Chinese artist in the international arena, namely, the film director Zhang Yimou张艺谋. In his film, *Not One Less* (*Yige*

dou buneng shao 一个都不能少, 1999), there is a heartbreaking scene of Chinese children drinking Coca-Cola. The substitute teacher Wei Minzhi and her pupils are determined to find and bring back to school the dropout pupil Zhang Huike. After a long-day work, they visit a store. Thirsty and tired as they are, the group of students could only afford two cans of Coca-Cola. They pass these two cans of Coca-Cola from one to another, and each is only able to have one sip of the magic potion. It is such a heart-wrenching spectacle to witness how a horde of poor Third-World children thirsting for an American drink. They sip and pass Cola-Cola from one to another with such piety and joy, as if passing the torch of liberty and light.

Another emotionally powerful scene comes toward the end of the film, when Wei Minzhi is invited to the city's TV station as a guest to talk about the plight of school children in her village. The guileless child-teacher could not speak the official adult language of educational policies while facing a Canon camera. She looks into the camera with tears in eyes, and calls out the name of the dropout student, Zhang Huike, begging him to come back to school.

When reading the ending credits, the film viewer might feel more convinced than ever that the film is a compelling masterpiece of documentary neorealism. The names of all the fictional characters in the film are the same as the real names of the amateur actors-children. There is not a single professional actor. For example, such film characters as Wei Minzhi and Zhang Huike are the names of the children who act out these roles. So far, the viewer might be led

Figure 8.2 *Not One Less* (*Yige dou buneng shao*). Directed by Zhang Yimou. Columbia Pictures, Films Production Asia, Guangxi Film Studio, Beijing New Picture. 1999. Poor school children and substitute teacher Wei drink Coca-Cola.

to believe that he/she is watching a credible Jamsonian national allegory of the embattled situation of poverty-stricken Third-World children. But seconds later, as the ending credits continue to roll down, the viewer discovers Coca-Cola and Canon being listed among the sponsors of the film! In hindsight, those two aforementioned emotionally charged scenes are nothing but extended commercials and lengthy product placements. The esteemed Third World artist Zhang Yimou turns out to be entertaining his countrymen and the global audience in order to advertise the products of transnational corporations. Whoever has the patience to watch the film to the very end, namely the end of the ending credits, must feel being duped by the magic of a cunning artist. In the final analysis, both the film director Zhang Yimou and the avant-garde artist Wang Guangyi have succumbed to and have benefited from the grand neoliberalist market symbolized by the Coca-Cola can.

Indeed, it is precisely the fear of the psyche being taken over by Coca-Cola that constitutes the substance of a poem by the Beijinger-turned-diasporic poet/artist Yan Li严力. That omnipotent force called "consumption" has colonized and penetrated the individual's unconscious, the realm of dreams under the impact of globalization. Yan's poem "Untitled" serves as a fitting coda to Wang Guangyi's endless recycling of Coca-Cola in his paintings and lithographs as well as Zhang Yimou's melodramatic commercials of commodity-brands in his film. The poem reads as follows:

> I took a picture with Coca-Cola.
> Friends say they don't see much compatibility between us
> They all say she is too old, too dark, and full of material arrogance
> Though her marketed image is globally recognizable
> They also say, for the quality of the next generation
> I shouldn't just rate a spouse economically
> With body and soul, I ferment affection once again
> Till I lost my direction in measuring various factors
> Till I lost my advantage of being young to compete with the others
> Till there is only chill and loneliness left in my heart
> Till my repentant cries echo thunderously
> Till I feel like an ice-cube, bobbing about in cola
> Talking about no dream but consumption[12]

> 无题
> 我与可口可乐合拍了一张影像
> 但朋友们都说看不出有甚麼夫妻相
> 都说他太老太黑太多物质的狂妄

虽然百年来他有全球共识的卖相
朋友们还说为了我那下一代的质量
绝不能光从经济上考虑配偶的优良
于是我一次次地把全身心的情感酝酿
直到我在各种条件的衡量中乱了方向
直到我再也没有青春的优势与他人较量
直到我内心只剩下一片天寒地冻的凄凉
直到我最终把忏悔词喊得山响
直到如冰块沉浮在可乐中的我
不再谈论除消费之外的任何理想

2001.7.21

The global financial and economic crisis that started in late 2008 temporarily dampens the over-heated art market in the China as well as the rest of the world. Sales of art objects have slowed down and prices have fallen. However, perhaps as a sign of the comeback of the Chinese economy and its art market, the sale of a Mao-era painting of none other than Mao himself at an exorbitant price once again shocks and energizes China's domestic art market. An oil painting by renowned veteran painter Jin Shangyi 靳尚谊, *Full-Body Portrait of Chairman Mao* (*Mao Zhuxi quanshen xiang* 毛主席全身像, 262 × 137 cm, 1966), is auctioned off at the price of RMB $20.16 million (about US$3 million at exchange rate) on June 25, 2009, at the Guangzhou Jiade (Christie's) Auction Fair in summer 2009. [13] This is the highest sales figure in South China's art market at that time. The buyer is reportedly a certain Chinese financial institution. This particular oil painting, whose dimensions are 262 × 137 cm, is reputedly the biggest Mao portrait in Chinese art history. This sale far excels the auction price of a famous oil painting from the Cultural Revolution era, *Chairman Mao Goes to Anyuan* (*Mao Zhuxi qu Anyuan* 毛主席去安源, painter Liu Chunhua 刘春华, 1967), at RMB$6.05 million at Jiade Auction in China in 1995.

Mao's legacy, especially the Cultural Revolution, has been largely denounced and criticized from both outside and within China. However, the memory of the past, in the precise literal sense of recollection of past art objects, does not easily go away. In fact, nostalgia for the socialist past has been both an emotional state as well as a cultural trend in contemporary China as the country wrestles with the dramatic arrival of global capitalism at its doorsteps.

The cultural contradictions of postsocialist/capitalist China are baffling. In his book *Children of Marx and Coca-Cola: Chinese Avant-garde Art and Independent Cinema*, Xiaoping Lin aptly defines the duplicitous role of the Chinese avant-garde artist as at once a "subcontractor" and an "antagonist." Lin finds striking

similarities between the cultural markets of capitalist West and postsocialist China. In his words, "Chinese avant-garde artists and independent filmmakers are obliged to assume a dual identity of 'subcontractor' and 'antagonist,' especially in their relationship with global institutions and Chinese authorities."[14] Hence, the former rebel artist is now fully integrated into the new art establishment on the fertile soil of the global capitalist art market. The Chinese avant-garde itself has been institutionalized in due time. Such is the ironic historical transformation of art in "socialism with Chinese characteristics."

At this point, Wang Guangyi's painting *Materialist's Art* (2006) deserves some special comment. If this piece were created in the Mao era, for instance, during the Cultural Revolution, it would be a most ordinary kind of art coming out of China given its format, style and political message. However, this is a "work of art," so to speak, that Wang has created in the twenty-first century for the gaze of potential Western art collectors. It is this ironic historical distance between bygone revolutionary China and contemporary global capitalism that forces the reader to think about the changing meaning of "materialism." Materialism has been the official philosophy of Marxism, as it has been fervently propagated by party officials in Mao's China, especially during the Cultural Revolution. Materialist art rejects idealist and bourgeois notions of art. Art is rooted in the socioeconomic base, and should serve the masses, the working class, and revolution. Such was the meaning of materialism back then. However, in contemporary China, just like anywhere in the capitalist world, materialism is understood in the most commonsensical way—the acquisition of materials, commodities, and consumer brands. Hence, Wang's piece is a timely reminder of what materialism used to be and what it means today. It is simultaneously a critique of Marxist orthodoxy and a mock-up of capitalist consumption.

Urbanization, Urban Design, and Socially Engaged Art

China is in the midst of massive urbanization on a nearly unimaginable scale. Given the enormity of the landmass and the size of the population, the magnitude of China's urbanization is perhaps unparalleled in human history. Tens of millions of farmers leave the countryside and enter the cities each year. Urbanization has unleashed cycles of hopeful construction as well as painful destruction both physically and psychologically. Indeed, *chai-na* (拆呢, demolition) has become the proper name for China as the character *chai* (拆) is painted on buildings that are marked for demolition everywhere in the country.[15] Naturally, Chinese

Figure 8.3 *Materialist's Art*. Wang Guangyi. Oil on canvas. 300 × 400 cm. 2006.

artists and cultural workers hasten to make attempts to capture, depict, and decipher this huge process unfolding before their eyes.

What is striking about contemporary Chinese artists as a whole is a strong desire to intervene in China's social development. Facing the staggering side effects of China's modernization and urban development, the artists feel an urge to comment on, reflect upon, or directly intervene in social processes. This is socially engaged art.[16] They need to create an artistic space to express themselves. This space comes in various forms: street art, graffiti art, photography, film, interactive video, poster, and so forth. At their best, these artworks contain an ethical imperative to act in an aesthetic experimentation.

The upwardly mobile middles class and the *nouveau riches* hope to build their own dream homes. An interesting phenomenon is the construction of European-style towns and villas in China. Entire new towns and apartment complexes are built in the fashion of European villas and communities.[17] French, English, Dutch, and Italian towns are being built throughout China. Citizens move into these homes to vicariously experience the amenities and pleasures of a globalizing world.

Given the sheer size of the country, the scale of China's urbanization is unrivalled in world history. China is in the midst of building the largest number of skyscrapers in the world. Grandiose, outlandish transnational architecture has dotted the skyline of China's major cities.[18] Beijing itself is the home of many such buildings designed by international architectural firms. As I have discussed in the preceding chapter, the most noticeable or notorious such buildings have

been given humorous nicknames: National Grand Theater ("Giant Egg"), CCTV Tower ("Big Crotch"), and National Olympic Stadium ("Bird's Nest"). The size and foreignness of these huge buildings bespeak of the national ambition of joining an international club of advanced countries.

The builders of those gigantic national monuments, gleaming skyscrapers of glass and steel, and foreign-style luxury homes, are none other than migrant construction workers. Yet, these people have no chance to be part of the brave new world that they build with their own hands. This kind of social inequality is vividly staged in Jia Zhangke's film *The World* (*Shijie* 世界, 2004). I have already analyzed this work and other films directed by Jia in Chapter 4. I briefly mention it again because of its thematic affinity to the issues in this chapter. As we recall, the "world" refers to the World Park in the outskirts of Beijing. The park consists of miniscule models of famous landmarks from around the world: London Bridge, Eiffel Tower, World Trade Center Towers, and so on. The park fulfills the Chinese dream of catching up with the developed countries of the world. Visitors get to see and "travel" to the world within the park without leaving China. Yet, the people who work inside the park such as security guards and dancers are themselves migrants who come to Beijing in search of jobs. They are earthbound, dispossessed, impoverished, and marginalized individuals who are a far cry from the images of suave globe-trotting citizens.

Swerving away from the glossy, futuristic, bright images of propaganda billboards, some artworks directly confront the unsightly, dystopian underbelly of China's development. Artists look the other way: the horror stories of exclusion, dispossession, violence, destruction, and ruins. They are concerned with the predicament of marginalized social groups, migrant workers, and common people in China's urban centers.

Ou Ning 欧宁 and Cao Fei's 曹斐 documentary *Sanyuanli* (三元里, 2003), in the tradition of city symphony films, has garnered much critical attention from scholars and commentators. Sanyuanli is a city within the sprawling city of Guangzhou, which has expanded to the former suburbs in the heady process of urbanization. Such gestural cinema is an attempt to re-enchant the urban environment that has been denuded of charm, magic, and beauty due to rapid urbanization.[19] Their films envision "magical metropolises" and alternative cityscapes in the midst of a headlong rush to modernization. For some commentators, the filmmakers' documentary practice belongs more broadly to the New Documentary Movement in mainland China. Such documentary films are rather different from mainstreams commercial films. For this reason,

Lu Xinyu insists on the avant-garde ethos of independent documentaries. She writes:

> The New Documentary Movement in China, especially in its second phase, is a thoroughly avant-garde form of art, which totally goes against the commercialization or Hollywoodization of the Chinese film industry. Millions of dollars have been invested in the latter to create ahistorical, apolitical, delocalized works that are proclaimed as representative examples of "national cinema." In contrast to these empty and expensive visual spectacles in commercial cinema, the significance of the New Documentary Movement becomes more obvious. In the booklet publication that bears the same title as the film *Sanyuanli*, director Ou Ning uses the line "the debt of history" in the preface.[20]

Lu Xinyu emphasizes the historical, political, local, and situated character of independent art forms. She is mindful of the aspirations of the "avant-garde" at a moment when the meaning of this poignant term is becoming banal, ordinary, and flattened in a postmodern consumer society.

In contemporary China, the poster art form has been retooled and reused for official propaganda purposes in recent times. Various levels of Chinese propaganda organizations resort to this time-honored socialist art form for contemporary events: the 2008 Beijing Olympic Games, the building of a Harmonious Society during the reign of President Hu Jintao, and the projection of a Chinese Dream under the leadership of Xi Jinping. These pleasing posters create healthy, optimistic images of China's present and future. The ubiquity and continuing usage of propaganda art throughout China is even evident in the poster-style murals painted on walls in one of the remotest corners of China: Kashgar (Kashi), Xinjiang. [21] These murals exhort ethnic harmony and castigate violence in a region that has suffered from ethnic strife in recent years.

Independent artists also utilize the art form of the propaganda billboard. A Shanghai-based artist, Ni Weihua 倪卫华, observes and documents public billboards from a detached, critical perspective. His photographic series such as *Keywords-Development and Harmony* (*Guanjian ci: fazhan yu hexie* 关键词：发展与和谐, 2008) and *Landscape Wall* (*Fengjing qiang* 风景墙, 2009) interrogate official ideology and tease out the ramifications of official slogans. One such slogan is Deng Xiaoping's famous saying: "Development is a hard imperative" (*Fazhan shi ying daoli* 发展是硬道理). It is then the duty of these artists to reflect upon the consequences of such a developmentalist mentality and practice in China. Ni Weihua has abandoned installation and performance, which are art forms that normally do not reach a wide audience;

nowadays he chooses a more public form, photography, in order to have a broader appeal.[22] At any rate, many Chinese artists seem to be thirsting for expanding and changing China's public culture.

Another art form, graffiti, or street art, has also emerged in China. The street artists are creating a niche in China's public space to articulate their feelings. These grassroots graffiti artists come and go, and this art form is rather fluid in China's changing art scene. Street art blurs the line between legitimate (legible) art and illegitimate (illegible) art in the socialist public sphere. Such artists negotiate the terms of the existential status of their special art with city planners.

One of the earliest graffiti artists is the by now veteran artist Zhang Dali张大力. In the 1990s, he painted and carved his head on numerous walls and buildings marked for demolition (*chai* 拆). He inserted his subjectivity and personal stamp, in the form of silhouettes of his bald head, in an otherwise massive impersonal process of urban development. It is as if a real Beijing resident were engaging in a dialogue with the past and present of the city.[23] More recently, Zhang Dali have created one hundred life-size sculptures of migrant workers in various postures. They are hung upside down, indicating the uncertainty and plight of these people in Chinese cities. This work, *Chinese Offspring* (*Zhongguo zisun* 中国子孙, 2003–2005), is a vivid group portrait of the fate of the migrant construction workers who build China's shiny cities but must struggle hard to make a living in the cities they themselves build.

We may take another look at an example of the tricky process in which some curators and artists test the boundary of acceptable art in a country where artistic experiments are often monitored and controlled. In 2014, the Shanghai Rockbund Art Museum (上海外滩美术馆) held the Exhibition "Advance Through Retreat" (*yitui weijin* 以退为进). It is about the "Li Yi Zhe Manifesto" (*Li Yizhe dazibao* 李一哲大字报).[24] Li Yi Zhe is the pen name of several young men from Guangdong Province who collectively wrote and published a big-character poster essay on "socialist democracy and legality" (*Shehui zhuyi de minzhu yu fazhi* 社会主义的民主与法制) in 1974. It was the pregnant moment in socialist history when Chinese citizens were disillusioned with the cult of Mao in the aftermath of the Lin Biao incident. People woke up to the failure of the Cultural Revolution and began to reflect on the root cause of the absurdities of fascism (a code word) in socialist China. The Li Yi Zhe big-character poster in fact expressed people's longing for democracy and the rule of law. The Li Yi Zhe event was a highly political event at the time. The real authors behind it: Li Zhengtian, Chen Yiyang, Wang Xizhe, and others, were investigated and persecuted by the regime. In the early years of the post-Mao era, the late

1970s, Xi Zhongxun, father of the present Chinese President Xi Jinping, was the Governor of Guangdong Province. He personally looked into the Li Yi Zhe case, rehabilitated their innocence, and freed them from persecution. At any rate, the mounting of this exhibition directly touches a sensitive topic of socialist history, namely, grassroots, spontaneous struggles for democracy and the rule of law in a socialist society.

Mediated Environment across Oceans and Countries

Now I turn my attention to a symbiotic phenomenon traversing various types of media, namely, "intermedia," that has become increasingly widespread due to technological developments as the twenty-first century enters its second decade. Intermedia (poetry-film-computer-video-smartphone) involves people living in a mediated world. We perceive and process the world through e-products. Some of these are assembled and produced by the manual labor of Chinese workers on the other side of the Pacific Ocean, consumed by customers everywhere in the world, and the resultant e-wastes are often shipped across the ocean back to China. In a world of socio-ecological crises, many people have taken up the intermedia as a form to expose the horrors of the global chain of manufacture and consumption, the dehumanizing aspect of the assembly line, the brutality of animal products, and globally manufactured waste. Film, videos, and poems tell stories about the reification of the everyday and the exploitative nature of transnational capitalism.

Our daily existence is in a state of indefinite mediation via various media. We may sit in an office in California on one side of the Pacific Ocean, and receive information and write messages through an Apple computer, an iPhone, and an iPad. Apple Company's headquarter is located in Cupertino, California. And yet, the platforms and stuffs that we use are the result of an international network of manufacture and consumption across oceans and countries. Much of Apple products are assembled by a transnational corporation, a Taiwanese-owned company, Foxconn, which has set up factories in parts of China, such as the city of Shenzhen, a port city close to Hong Kong. The countless young people working in such a transnational corporation come from relatively poor rural areas in the interior of China. A glimpse of the overwhelming scale of such assembly lines in China's factories is vividly captured in the opening shot of the documentary *Manufactured Landscapes* (by director Jennifer Baichwal and

photographer Edward Burtynsky, 2006), as a film example from the early part of the new century.

It is all too easy for the individual stories of these workers to be buried under the massive, impersonal scale of such a vast global chain of production. Yet, a remarkable phenomenon is the emergence of "migrant worker poetry" in contemporary China. These otherwise nameless, poor workers whose menial labor has fueled the Chinese and global economy have voiced their feelings, emotions, suffering, and experiences in media—poetry and film intertwined. A documentary, *The Verse of Us* (*Wo de shipian*我的诗篇, directed by Feiyue Wu and Xiaoyu Qin, 2015), is made out of several such migrant-worker poets. It follows the lives and poetry of six workers of different age groups and from different parts of China. These workers are also diverse in the nature of their jobs, including a blaster and a coalminer in the mining industry, a forklift driver, a female dressmaker in the clothing industry, a down filling worker of Yi ethnic origin, and finally a Foxconn assembly line worker. The film touches upon pressing issues such as the nature of production and consumption, complex relationship between human labor and machinery, conflicting feelings between individual labor and collective labor, disciplining and punishment of the worker's body, and most importantly social justice. Staging these poets as well as their poems on screen gives expression to their sentiments and humanistic aspirations. The documentary functions as a form of activism and constitutes a call for social change in the age of globalization.

One of these poets in the documentary, Xu Lizhi 许立志 (1990–2014), is the most famous of them all. He worked at the assembly line of Foxconn in Shenzhen, and wrote poignant poetry about environmental degradation, unemployment, alienation, dehumanization, despair, and hope.[25] He was one of the young workers who committed suicide in Foxconn factories. Ever since his highly personal and equally disturbing poems were published and widely circulated in social media after his tragic death, many issues have been raised and numerous debates have been generated on the very nature of being a manufacturing worker in contemporary China, not only in the intellectual community but also in the general public. Chinese netizens followed, shared, and commented on these poems with ardor and anger. Even in the last episode of his film *A Touch of Sin* (*Tian zhuding*, 2013), Chinese director Jia Zhangke makes a reference to these recurring instances of suicide inside the Foxconn factory. In the film, Xiao Hui, a young factory worker from China's interior, Hunan Province, is disillusioned with the monotonous, dreary life of working at an assembly line in a Foxconn-style factory. He leaps to his death from a prison-like dormitory. Unlike the

migrant poet Xu Lizhi who leaves behind a collection of poems waiting to be deciphered, Xiao Hui leaves no traces in this world—the camera quickly shifts back to the assembly line as if implying that human life in the factory were as trivial and lifeless as the inanimate products on the assembly line.

Xu Lizhi's case is exemplary due to his poetry and tragic fate. He worked at Foxconn in Shenzhen, wrote poetry, and committed suicide at a young age. The poetry anthology *Iron Moon* takes its title from his poem: "I swallowed an Iron Moon."[26]

> I swallowed an iron moon they called it a screw
> I swallowed industrial wastewater and unemployment forms bent over machines,
> our youth died young
> I swallowed labor, I swallowed poverty, swallowed pedestrian bridges, swallowed
> this rusted-out life
> I can't swallow anymore, everything I've swallowed roils up in my throat
> I spread across my country a poem of shame[27]

The moon imagery has been one of the most enduring and endearing imageries in Chinese and world poetry. It normally evokes romantic sentiments. But here, the moon has become of an "iron moon," a symbol of cold dehumanization and ruthless industrialization that have entered the interiority of the soul.

The poetic persona, "I" in Xu's poem, swallowed the moon. The poet decries the bitterness of swallowing industrial waste, of suffering horrendous alienation.

Figure 8.4 Factory worker and young poet Xu Lizhi in the documentary *The Verse of Us.*

The labor and the product of the individual worker is turned against himself/herself. Nature, or the universe, as represented in the image of the moon, is made of iron, mechanized and rusted. Post-industrialization in the form of assembling computers, iPhones, and iPads, engulfs the entire ecological system. Xu's suicide is the result of a disequilibrium between humanity and the environment.

Xu's poem *A Screw Plunges to the Ground* prophesies his own suicide by jumping off a building.

> A screw plunges to the ground
> Working overtime at night
> It drops straight down, with a faint sound
> That draws no one's attention
> Just like before
> On the same kind of night
> A person plunged to the ground[28]

Xu's poetry, and migrant worker poetry in general, speak of the hardship and tragedy of the working class in the era of globalization. These workers might be situated in a specific locale, such as Shenzhen, China, but they are also part of an immense network of production, distribution, and consumption in the world economy. In this sense, Chinese migrant-worker poetry resonates with the feeling and plight of the laboring class in all places under the moon, under the sun, and "all under heaven" (*tianxia*).

Another good example of the global chain of production and consumption is the documentary *My Fancy High Heels* (*Wo ai gaogenxie* 我爱高跟鞋, 2010) by Taiwanese filmmaker Chao-ti Ho. It narrates the stories, cruelty, suffering, and profits generated from the transnational production of high-end commodities such as famous-brand shoes. Impoverished young women from the interior of China come to southern China to make high-heel shoes for wealthy customers from the rest of the world. The leather is taken from young cows in China's northeast, processed in a shoe factory owned and managed by Taiwanese businessmen, and ultimately transformed to brand-name high-heel shoes for global consumption by people living in metropolises such as New York, Seattle, and Taipei.

The visualization of the global chain of production and consumption not only encompasses the manufactured goods that first enter the circle of consumption but also includes the afterlife of these goods, or, more precisely, the distribution of trash. Indeed, globally manufactured and circulated waste is the subject of the Chinese documentary *Plastic China* (*Suliao wangguo* 塑料王国, 2016),

directed by Wang Jiuliang 王久良. In this documentary the director surprisingly discovers imported plastic waste from everywhere in the developed world (Germany, Australia, United States, Denmark, etc.) in several unknown Chinese villages, and Chinese children are hired to sort out these plastic products for further consumption. The film traces the waste to its very origin and uncovers a somewhat untold story of the global circulation of waste.

Such intermedia practice, in the form of socio-ecologically concerned poetry and documentary, visualizes and at the same time challenges the chain of production and consumption that has long been normalized and naturalized. It may contribute to a public culture that enhances people's awareness of the environment, the living condition of workers, and the everyday production of waste.

Notes

1 David Harvey counts China's Deng Xiaopeng as a key figure in launching a global neoliberalist revolution. See David Harvey, *A Brief History of Neoliberalism* (Oxford: Oxford University Press, 2007).

2 At that time, I also wrote to plea for tolerance toward Chinese avant-garde art, for the establishment of art galleries, museums, biennials to host such art. See my pieces: Lu Xiaopeng 鲁晓鹏, "Xianfeng yishu de hanyi" 先锋艺术的含义 (The Implications of Avant-Garde Art), *Shanhua* 山花 (Mountain Flower) no. 2 (2001): 83–5; "Gouzao 'Zhongguo' de celüe: xianfeng yishu yu hou dongfang zhuyi" 构造'中国'的策略：先锋艺术与后东方主义 (Strategies of Constructing "China": Avant-Garde Art and Post-Orientalism), *Jinri xianfeng* 今日先锋 (Avant-Garde Today) no. 10 (Jan. 2001): 148–61.

3 Jürgen Habermas, "Modernity: An Incomplete Project," in *The Anti-Aesthetic*, ed. Hal Foster (Port Townsend, WA: Bay Press, 1983), pp. 3–15.

4 For a set of insightful essays on the political poster in the Cultural Revolution, see Harriet Evans and Stephanie Donald, eds., *Picturing Power in the People's Republic of China: Posters of the Cultural Revolution* (Lanham, MD: Rowman and Littlefield, 1999).

5 Igor Golomstock, *Totalitarian Art: In the Soviet Union, the Third Reich, Fascist Italy and the People's Republic of China*, translated from Russian by Robert Chandler (London: Collins Harvill, 1990), p. 179.

6 Li Xianting, "Major Trends in the Development of Contemporary Chinese Art," *China's New Art, Post-1989*, exhibition catalogue, ed. Valerie C. Doran (Hong Kong: Hanart T Z Gallery, 1993), p. XXI.

7 Chang Tsong-zung, "Into the Nineties," *China's New Art, Post-1989*, p. II. I also discuss these issues in regard to Chinese avant-garde art in my books *China, Transnational Visuality, Global Postmodernity* (Stanford: Stanford University, 2001) and *Chinese Modernity and Global Biopolitics: Studies in Literature and Visual Culture* (Honolulu: University of Hawaii Press, 2007).

8 See Ales Erjavec, ed., *Postmodernism and the Postsocialist Condition: Politicized Art under Late Socialism* (Berkeley: University of California Press, 2003).

9 Gao Minglu, "Toward a Transnational Modernity: An Overview of *Inside Out: New Chinese Art*," in *Inside Out: New Chinese Art*, ed. Gao Minglu (Berkeley: University of California Press, 1998), p. 30.

10 Quoted in Colin Gleadell, "Art Sales: Asian Tigers Roar to Auction Records," *Telegraph.co.uk* (October 16, 2007), at http://www.telegraph.co.uk/arts/main. jhtml?xml=/arts/2007/10/16/basales116.xml (accessed Feb. 26, 2008).

11 Jonathan Watts, "Buy! Buy! Buy!" *The Guardian* (March 13, 2008) at http://arts. guardian.co.uk/art/visualart/story/0,,2264539,00.html (accessed March 14, 2008).

12 This translation is by Jing Nie in her dissertation, p. 87. She offers an insightful analysis of Yan Li's poetry and particularly this poem in her dissertation *Beijing in the Shadow of Globalization: Production of Spatial Poetics in Chinese Cinema, Literature, and Drama* (University of California at Davis, 2009).

13 "Jin Shangyi youhua 'Mao Zhuxi quanshen xiang' 2016 wan chengjiao" 靳尚谊油画" 毛主席全身像"2016 万成交 (Jin Shangyi's Oil Painting Full-Body Portrait of Chairman Mao Sold at RMB 20.16 Million) (October 24, 2013.). http:// jinshangyi.artron.net/news/detail/112 (accessed June 11, 2015).

14 Xiaoping Lin, *Children of Marx and Coca-Cola: Chinese Avant-Garde Art and Independent Cinema* (Honolulu: University of Hawaii Press, 2010), p. 14.

15 See Sheldon Lu, Chapter 9, "Tear Down the City: Reconstructing Urban Space in Cinema, Photography, and Video," in *Chinese Modernity and Global Biopolitics: Studies in Literature and Visual Culture* (Honolulu: University of Hawaii Press, 2007), pp. 167–90, especially pp. 179–81.

16 On the topic of urbanization and socially engaged art in contemporary China, see Meiqin Wang, *Socially Engaged Art in Contemporary China: Voices from Below* (New York: Routledge, 2019); Meiqin Wang, *Urbanization and Contemporary Chinese Art* (New York: Routledge, 2016); Minna Valjakka and Meiqin Wang, eds., *Visual Arts, Representations and Interventions in Contemporary China: Urbanized Interface* (Amsterdam: Amsterdam University Press, 2018).

17 Bianca Bosker, *Original Copies: Architectural Mimicry in Contemporary China* (Honolulu: University of Hawaii Press, 2013).

18 See Xuefei Ren, *Building Globalization: Transnational Architecture Production in Urban China* (Chicago and London: University of Chicago Press, 2011).

19 Chris Berry, "Cai Fei's 'Magical Metropolises," in *Visual Arts, Representations and Interventions in Contemporary China: Urbanized Interface*, ed. Minna Valjakka and Meiqin Wang (Amsterdam: Amsterdam University Press, 2018), pp. 209–36; Ling Zhang, "Digitizing City Symphony, Stabilizing the Shadow of Time: Montage and Temporal-Spatial Construction in *San Yuan Li*," in *China's iGeneration: Cinema and Moving Image Culture for the Twenty-First Century*, ed. Matthew D. Johnson, Keith B. Wagner, Kiki Tianwi Yu, and Luke Vulpiani (London: Bloomsbury, 2014), pp. 105–24.

20 Lu Xinyu, "Rethinking China's New Documentary Movement: Engagement with the Social," in *The New Chinese Documentary Film Movement: For the Public Record*, ed. Chris Berry, Lu Xinyu, and Lisa Rofel (Hong Kong: Hong Kong University Press, 2010), pp. 39–40. In the related field of contemporary Chinese theater, the relationship between avant-garde art and popular culture is also debated. See Rossella Ferrari, *Pop Goes the Avant-Garde: Experimental Theater in Contemporary China* (Kolkata: Seagull Books, distributed by the University of Chicago Press, 2012.)

21 BBC News, China blog staff, "The Colorful Propaganda of Xinjiang," January 12, 2015, at the link www.bbc.com/news/world-asia-china-30722268 (accessed January 14, 2015).

22 Meiqin Wang, "Shadow of the Spectacular: Photographing Social Control and Inequality in Urban China," in *Visual Arts, Representations and Interventions in Contemporary China: Urbanized Interface*, ed. Minna Valjakka and Meiqin Wang (Amsterdam: Amsterdam University Press, 2018), pp. 115–46.

23 Wu Hung, "Zhang Dali's *Dialogue*: Conversation with a City," *Public Culture* vol. 12, no. 3 (2000): 749–68.

24 Anne McLaren, "Advance through Retreat: The Li Yi Zhe Manifesto," MCLC Resource Center, February 2015. http://u.osu.edu/mclc/pubs/mclaren/ (accessed February 15, 2015).

25 For a study of Xu Lizhi's poetry, see Maghiel van Crevel, "Misfit: Xu Lizhi and Battlers Poetry (*Dagong shige*)," *Prism: Theory and Modern Chinese Literature* vol. 16, no. 1 (March 2019): 85–114.

26 Qin Xiaoyu, ed., *Iron Moon: An Anthology of Chinese Worker Poetry*, trans. Eleanor Goodman (Buffalo, NY: White Pine Press, 2017).

27 Ibid., p. 198.

28 Ibid., p. 197.

Conclusion: Globalization at Bay

A central irony in the realm of culture in mainland China has been the country's double-handed strategy toward globalization. I have called this "internal globalization" and "walling" at the beginning of the book. The country makes use of the abundant resources and opportunities provided by globalization in order to fortify the solidarity of a singular nation-state. The tactics is to recruit talents and obtain technology from Greater China as well as from the world with the ultimate aim of creating images of a strong state and a unified national culture. This is particularly evident in the production of mainstream commercial blockbuster films as commissioned by the state and made by China's major film conglomerates.

In the first two decades of the twenty-first century, China has made three blockbuster films to commemorate three foundational moments in the history of the Chinese Communist Party (CCP) and the People's Republic of China (PRC). They form a "Trilogy of the Republic." All of them were commissioned by the state and made by a state film company: China Film Group. *The Founding of a Republic* (*Jianguo daye*建国大业, dir. Han Sanping 韩三平 and Huang Jianxin 黄建新, 2009) was made to commemorate the sixtieth anniversary of the PRC, which was established in 1949. Mao Zedong declared the founding of a new republic in Tiananmen Square on October 1, 1949, and ruled the country permanently until his death in 1976. *The Founding of a Party* (*Jiandang weiye*建党伟业, dir. Han Sanping and Huang Jianxin, 2011) was made to celebrate the ninetieth anniversary of the CCP, which was founded in Shanghai in 1921. *The Founding of an Army* (*Jianjun daye* 建军大业, dir. Andrew Lau Wai-keung 刘伟强, 2017) marked the ninetieth anniversary of the People's Liberation Army (PLA), which was founded in 1927 in the so-called Nanchang Uprising and Autumn Harvest Uprising. These films are historical dramas based on real events and real people.

The usual, constant, self-congratulatory celebration of the party and the state is nothing new in the PRC. What is new in filmmaking this time is the co-optation of filmmakers, stars, and celebrities from inside and outside mainland China and throughout Greater China for national, political projects. Numerous stars perform historical characters in these films. Most noticeably, the huge cast includes Hong Kong megastars like Jackie Chan, Jet Li, Andy Lau, and Chow Yun-fat. They participate in these national projects and appear in the films. *The Founding of an Army* was even directed by a Hong Kong director, Andrew Lau. The entire collective of performers in Greater China, especially the most well-known ones, is called upon to serve and perform for the socialist state, the Communist Party, and the PLA. Such regional coproductions in effect contribute to legitimizing the claims of a nation-state. The seemingly transnational, transregional movement of people and images is appropriated for the sole purpose of nationalist propaganda. These Chinese-language films solidify and glorify the politics and power of the mainland.

In an uncanny way, such cultural "internal circulation" or "internal globalization" is a prelude and corollary to an official economic policy adopted in China in 2020. The Chinese government has announced a new model of economic development and international trade: a "two-way circulation" (*shuang xunhuan* 双循环), with primary "internal circulation" (*nei xunhuan* 内循环) and supplementary "external circulation" (*wai xunhuan* 外循环). This is a response to the shrinking international market due to the coronavirus pandemic as well as to the foreign policy of the Trump administration toward China. The United States under President Trump takes steps to decouple itself from the Chinese economy and the Chinese nation as a whole. It imposes heavy tariffs on Chinese commodities, forbids the export of certain technologies, and blacklists some Chinese companies. A point in fact is the proposed banning of Chinese ownership of TikTok and the use of WeChat, a Chinese app, on American soil. China feels that it is cornered by the United States on a number of fronts: politics, economy, diplomacy, and trade, and therefore adjusts its policy by taking an inward turn.

It is a tall order to delink a country such as China from the American economy and the global economy. Some financial analysts have predicted and announced an end to globalization as we have known it.[1] The world has witnessed rising geopolitical tensions, imposition of trade barriers, and the closing of national borders in recent years, especially since the election of Donald Trump as the American president in 2016. In his speech delivered at the Richard Nixon Library in California in 2020, US Secretary of State Michael Pompeo calls on the

free world to band together in combating the authoritarian regime of the CCP. This sounds like the coming of a new Cold War.

An example from popular culture could be a case in point about the political and cultural atmosphere at the time. In 2020, Walt Disney releases an action/drama film *Mulan* to further capitalize on a Chinese legend. The film employs a cast with some of the most visible stars in Chinese-language cinema: Liu Yifei (刘亦菲, aka Crystal Liu, the Mulan character), Donnie Yen, Gong Li, and Jet Li, as well as Asian American actor Jason Scott Lee, the lead actor in the American film *Dragon: The Bruce Lee Story* (1993). However, despite the participation of a big cast of bankable superstars and what promises to be an spectacular martial arts film in a time of unfettered transnational flows of images, *Mulan* has met mixed reviews, outright anger, and a call for boycott. Such negative responses to film are not about the artistic quality of the film per se but have to do with political and ideological factors.

At the closing credits, the film acknowledges and thanks the support of the Public Security Bureau and the Publicity Department of the Communist Party of the city of Turpan, which is a region of Xinjiang where the film is shot on location. The policies adopted in Xinjiang in recent years have drawn criticism from the West. While the Chinese government claims that it has established "vocational training centers" for ethnic Uighurs in Xinjiang, the West perceives those as being equivalent to concentration camps. This practice is seen as an act of cleansing the culture, religion, and tradition of ethnic minorities. Many viewers in the United States and the West are displeased with the film for kowtowing to political oppression. Yet, on the other side of the Pacific, plenty of viewers in Hong Kong are also not happy about the film, again for political reasons. The actress Liu Yifei once voiced support for the Hong Kong police force in handling street protests against the Extradition Law proposed by the Hong Kong government. Some protesters and their sympathizers call for a boycott of the film for her siding with the Hong Kong government and the mainland authorities.

The matter gets more complicated, if not worse, when Zhao Lijian, a spokesperson of the Foreign Ministry of China, comes to Liu Yifei's defense by calling her a "true Chinese descendent" (*zhenzheng de zhonghua ernü* 真正的中华儿女). Zhao Lijian is known for his hawkish tone at the routine briefings of the Foreign Ministry. He is considered a representative of a new style of Chinese diplomacy by commentators and netizens: "wolf-warrior diplomacy" (*zhanlang waijiao* 战狼外交), which is a hard-line, aggressive, overly confident approach in foreign affairs. Indeed, the phrase "wolf-warrior diplomacy" comes from the Chinese film series *Wolf Warrior*, which is known for its high-flying

nationalistic spirit. Yet in another twist and turn, the actress is discovered to be a naturalized American citizen even though she was born in Wuhan, China. Legally speaking, she is not a Chinese. Hence, the audience from mainland China has a further grievance to express. The question is: why should a foreigner perform the role of a traditional Chinese character in this film? Apparently, in these various reactions toward the film, political attitudes and ideological convictions have outweighed the entertainment value and artistic merit of a film.

At this juncture, it is fruitful to turn our attention to the scene of independent film and art for a comparison of the different types and functions of film and art in the national and global arenas. In 2009, which is coincidentally the sixtieth anniversary of the founding of the People's Republic, China's famous dissident artist Ai Weiwei艾未未 released a photographic work, entitled "Grass Mud Horse Covering the Center" (*Caonima dang zhongyang* 草泥马挡中央). It is a picture of himself naked with a stuffed grass mud horse covering his genitals. The so-called "grass mud horse" *Caonima*) is a mythical miniature horse, resembling alpaca, created by China's netizens around 2009. Other than tonal differences, *caonima* in Mandarin Chinese is a homophone and a euphemism for a blasphemy: "f*** you" or "f*** your mother" (*cao ni ma* 肏你妈). *Dang zhongyang* (literary meaning: "cover the center") is a homophone for "Party's Central Committee" (党中央 *dang zhongyang*). Therefore, the title of this work could read as "Fuck Party's Central Committee." Later on, in 2012, Ai further developed this photographic work into a music video: "Grass Mud Horse Style" (草泥马 Style). The video is a parody of the K-pop music video "Gangnam Style" by South Korean singer Psy. Ai and the staff members of his studio dance together and horse-trot to the tune of Gangnam Style and mimic the moves of the original music video. What is not in the Gangnam Style video but present in this new video is that some characters, including Ai himself, are handcuffed sometimes.

"Grass mud horse," in both the photographic version and the video version, may appear witty and humorous, and even obscene and vulgar. It expresses outrage at the treatment of independent artists by the state. This is a way for them to protest against the lack of artistic freedom. Since artists are often silenced, no words can describe their frustration and anger except by resorting to straightforward blasphemy.

Ai has had a long career inside China and on the international arena. His art compasses many forms and modes: installation, photography, video, documentary, performance. He has also been one of the most vocal social critics of China. He stands at the rebellious, independent, extreme end of a wide

spectrum of artists and artistic activities in China. In 2011, he was arrested and detained by the police for eighty-one days and was eventually released due to the concern of international communities. As his personal and artistic freedom was curtailed in China, he has left the country and lives and works in Europe now.

The web page of Ai Weiwei Films (https://www.aiweiwei.com, accessed September 2020) posts the following statement: "Expressing oneself is a part of being human. To be deprived of a voice is to be told you are not a participant in society; ultimately it is a denial of humanity." Being a citizen means being an active participant in a civil society. When citizens, filmmakers, and artists are deprived of the right to speak their minds in a public space, they risk their safety and freedom in raising their voices and telling what they regard as the truth. As mentioned above, Ai himself was arrested for unorthodox thinking and subversive art.

Ai's documentary film *Coronation* (2020) is a film about the lockdown of the city of Wuhan in the heyday of the pandemic in 2020 in China. It offers an alternative narrative about the coronavirus pandemic from the official account given by the state. It decries an old-fashioned model of crisis management, which is characterized by the brainwashing and surveillance of citizens and the concealment of information. The film calls for an open society, transparency, and accountability.

The title of the documentary, "coronation," is intriguing and polysemous. It puns on the word "coronavirus." "Coronation" is the crowning of a sovereign, a king, an emperor. The wordplay may be read as a veiled reference to a system that is responsible for the missteps in the beginning of the crisis but claims victory and legitimacy in battling the coronavirus in the end. The ability to effectively stem the spread of the coronavirus in China is seen as another crowning moment in the official rhetoric of the state. The film title is sometimes spelled as "CoroNation" in publicity. Coronavirus, nation, and coronation are all linked together in a wordplay as well as in reality. This independent documentary is a journalistic interrogation of a major public event with a camera lens. It investigates the handling of a crisis that is credited as a major achievement and implies that the destructive virus lurking in the nation is a secretive, opaque system that withholds information and builds walls between its people and the outside world.

These examples in film and art that I have mentioned are at the extreme opposite ends of a wide range of films and artworks in contemporary China. The state-commissioned "founding" films verge on political propaganda on the one hand; The f***ing art and the "crowning" documentary come from the heart and

mind of an exiled dissident artist on the other hand. As such, these two cases seem to give the impression that there exists a binary, black-and-white, bipolar structure in contemporary Chinese culture. This situation would confirm a long-standing model of criticism in the West in regard to cultural expressions from a totalitarian regime.[2]

First, it is an indisputable fact that such extreme cases do exist. This is the structure of propaganda versus dissidence. Second, there is also a broad spectrum of artworks and individual voices expressing varying degrees of conformity, contestation, negotiation, and negation vis-à-vis the establishment. The realm of art is a vast, fluid, gray area that constantly tests the boundary of tolerance and intolerance in a postsocialist state. Most of the filmic and artistic texts that I have examined in the book fall into the immense middle ground between the two polarities. The cultural terrain consists of porous, sedimented, multichanneled zones of creation, communication, and circulation rather than one single, top-down, uniform platform.[3] Chinese filmmakers and artists envision the world, engage society, create artworks, and make incremental changes in specifically situated locations within permissible ideological perimeters.

As I have used it in the beginning of the book, a term that has appeared as an apt description of the current state of living in the world is "surveillance." In fact, the phrase "surveillance capitalism" has been coined to define a new state of development in world capitalism.[4] People's behavioral patterns, personal choices, likes, dislikes, and spending habits are gathered and stored in the data systems of big companies like Google and Facebook. These companies use the gathered information to target account users, anticipate their needs, and advertise appropriate products for potential purchase and consumption. Twitter and Facebook monitor users' messages and statements, approve, censor, and flag them as needed. Apple phones pry into customers' private photos, create short video "memories" out of collages of photos with background music, and periodically select "featured photos" for them. The autonomous, private citizen lives in an inescapable, constant state of surveillance in a new stage of capitalism.

In its own supreme implementation of surveillance, China bans Western search engines and networking platforms such as Google and Facebook. The Chinese firewall blocks such sites and tools on the internet. In monitoring the country's own internet platforms such as WeChat, the state gathers, filters, allows, and disallows the type of information to be posted. A sensitive piece of information, a message, a song, a video, or a work of art can appear briefly on a platform and then is deleted for the "violation of regulations." In China's mixed mode of economy and unique political structure, what might be called

"surveillance socialism" works in conjunction with surveillance capitalism. The state has effectively adapted to new technological developments as well as has adopted ingenious ways of tracing people's activities and monitoring cultural affairs.

As to the direction in which the pendulum of control and relaxation will swing to, it may well depend on the future development of China's civil society. At a meeting of the People's National Congress in Beijing in 2020, Premier Li Keqiang makes a startling admission about the level of China's socioeconomic development when he answers journalists' questions at the press conference. He states that six hundred million Chinese people earn about one thousand yuan in a month out of a population of 1.4 billion. That is a monthly income of less than two hundred US dollars. As such, China is a poor, developing country, and many people struggle to obtain the basic necessities of life and survival. However, China also has a large, growing middle class, numbering several hundred million people. It seems natural that an ever-growing, well-educated middle class not only defends their private property and consumer rights but also wishes to have a say in social development and nation-building as citizens. A widening civil society, buttressed by an expanding middle class, may push toward more tolerance in artistic expression.

The late twentieth century and the early twenty-first century are an unprecedented time of globalization for China and the world, and therefore constitutes a special interesting conjunction for observation and analysis. In the case of mainland China, this period coincides with the moment of postsocialism. There is an additional layer of engagement for both the filmmaker and the critic, namely how to sort out the lingering socialist, revolutionary legacy within the post–Cold War, neoliberalist, global marketplace. People exist in an increasingly interconnected network of labor, production, consumption, and leisure. The flow of images, ideas, commodities, capital, population, and diseases across previously closed national borders has brought about opportunities of liberation and upward mobility as well as new forms of oppression and exploitation. Like cultural workers elsewhere, Chinese filmmakers and artists hasten to tackle the contractions and dilemmas of a world situation that is at times deceptively borderless but other times relentlessly walled. They depict the tragedies and comedies of the individuals caught in the swirl of Janus-faced globalization. They have indeed created astonishing works to address the new world that they witness and experience.

Part of the book examines multimedia and intermedia configurations of reality through the multicolored lenses of art, architecture, photography, poetry, feature

film, and documentary. Filmmakers, artists, and writers all have a stake in the building of a functional, transparent, accountable public culture. They actively envision the kind of world, community, and planet that they wish to inhabit through their compelling works and specific media. Given the technological innovations in modes of image production and platforms of screening, we might well begin to live and work in a post-cinema age, namely the time of intermedia and multimedia. Again, a case in point is Ai Weiwei's documentary *Coronation*. Ai made and produced the film in Europe by assembling and editing original footages from China. During the pandemic, such a film cannot be watched by an audience in a public theater, nor participate in an international film festival. But it can be viewed as a video on demand on a streaming platform. From the movie theater to cyberspace, the film medium continues to reinvent itself and create new niches in order to be relevant to the contemporary world.

Notes

1 See Michael O'Sullivan, *The Levelling: What's Next after Globalization* (New York: PublicAffairs, 2019).

2 Xiaobing Tang takes issue with the "dissident art" paradigm in the reception of Chinese art in the West. See his book *Visual Culture in Contemporary China: Paradigms and Shifts* (Cambridge: Cambridge University Press, 2015). For a critique of Tang's book from a different position, see Wendy Larson's review of his book at the MCLC Resource Center (August 2016, accessed October 1, 2020). https://u.osu.edu/mclc/book-reviews/larson3/.

3 For instance, online video has been less heavily regulated than broadcast television has been by the Chinese state. The private realm of video provides a space for alternative ways of thinking about the nation and the world. See Luzhou Li, *Zoning China: Online Video, Popular Culture, and the State* (Cambridge, MA: MIT Press, 2019).

4 See Shoshana Zuboff, *The Age of Surveillance Capitalism: The Fight for a Human Future at the New Frontier of Power* (New York: Hachette, 2019).

Filmography

The filmography includes the films mentioned in the book. The listings are alphabetized by English title and include director, country or region of origin, and year. All films are fictional feature films unless otherwise noted as documentary, video, animation, or TV drama.

24 City (24 cheng ji 二十四城记). Jia Zhangke 贾樟柯. China, 2008.

American Dreams in China (中国合伙人). Peter Ho-sun Chan 陈可辛. China, 2013.

Ash Is Purest White (Jianghu ernü 江湖儿女). Jia Zhangke 贾樟柯. China, 2018.

Balzac and the Little Chinese Seamstress (Ba'erzhake yu xiao caifeng 巴尔扎克与小裁缝). Dai Sijie's 戴思杰. China/France, 2002.

Beautiful New World, A (Meili xin shijie 美丽新世界). Shi Runjiu 施润久. China, 1998.

Behemoth (Bei xi moshou 悲兮魔兽). Documentary. Zhao Liang 赵亮. China, 2015.

Beijing Bastards (Beijing zazhong 北京杂种). Zhang Yuan 张元. China, 1993.

Beijing Besieged by Waste (Laji weicheng 垃圾围城). Documentary. Wang Jiuliang 王久良. China, 2011.

Beijing Bicycle (Shiqisui de danche 十七岁的单车). Wang Xiaoshuai 王小帅. China, 2001.

Berlin: Symphony of a Great City (*Berlin: Die Sinfonie der Großstadt*). Walter Ruttmann. Documentary. Germany, 1927.

Better Tomorrow, A (Yingxiong bense 英雄本色). John Woo 吴宇森. Hong Kong, 1986.

Bitter Flowers (Xiahai 下海). Olivier Meys. Belgium/China, 2017.

Blind Shaft (Mangjin g盲井). Li Yang 李杨. China, 2003.

Blue Kite (Lan fengzheng 蓝风筝). Tian Zhuangzhuang 田壮壮. China, 1993.

Blush (Hongfen 红粉). Li Shaohong 李少红. China, 1995.

Boatman's Daughter (Chuanjia nü 船家女). Shen Xiling 沈西苓. China, 1935.

Brokeback Mountain. Ang Lee. United States, 2005.

Bumming in Beijing (Liulang Beijing 流浪北京). Documentary. Wu Wenguang 吴文光. China, 1990.

Cave of the Silken Web, The (Pansi dong 盘丝洞). Dan Duyu 但杜宇. China, 1927.

Charlie's Angels: Full Throttle. Joseph McGinty Nichol. United States, 2003.

China Nights (之那之夜; Japanese: *Shina no yoru*). Osamu Fushimizu. Japan, 1940.

China Peacekeeping Forces, aka *Peacekeeping Force* (Zhongguo lankui 中国蓝盔). Ning Haiqiang 宁海强. China, 2018.

Chinese Box. Wayne Wang. United States, 1997.

Chungking Express (Chongqing senlin 重庆森林). Wong Kar-wai 王家卫. Hong Kong, 1994.

Coming Home (Guilai 归来). Zhang Yimou. China, 2014.

Comrades, Almost a Love Story (Tian mimi 甜蜜蜜). Peter Ho-sun Chan 陈可辛. Hong Kong, 1996.

Confucius (Kongzi 孔子). Hu Mei 胡玫, China, 2010.

Contagion. Steven Soderbergh. United States, 2011.

Coronation. Documentary. Ai Weiwei. 艾未未. China, 2020.

Crime and Punishment (Zui yu fa 罪与罚). Documentary. Zhao Liang 赵亮. China, 2007.

Crouching Tiger, Hidden Dragon (Wohu canglong 卧虎藏龙). Ang Lee 李安. China/Taiwan/United States, 2000.

Curse of the Golden Flower (Mancheng jindai huangjin jia满城尽带黄金甲). Zhang Yimou 张艺谋. China, 2006.

Da Vinci Code, The. Ron Howard. United States, 2006.

Days, The (Dongchun de rizi 冬春的日子). Wang Xiaoshuai 王小帅. China, 1994.

Dearest (Qin ai de 亲爱的). Peter Ho-sun Chan 陈可辛. Hong Kong/China, 2014.

Departed, The. Martin Scorsese. United States, 2006.

Dirt (Toufa luanle 头发乱了). Guan Hu 管虎. China, 1994.

Dong (Dong 东). Documentary. Jia Zhangke 贾樟柯. China, 2006.

Dragon: The Bruce Lee Story. Rob Cohen. United States, 1993.

Drifters Trilogy (Youmin sanbu qu 游民三部曲). Documentaries. Xu Tong 徐童. China，2008–11.

Durian Durian (Liulian piaopiao 榴莲飘飘). Fruit Chan 陈果. Hong Kong, 2000.

East Palace West Palace (Donggong Xigong 东宫西宫). Zhang Yuan 张元. China, 1996.

Farewell China (Ai zai biexiang de jijie 爱在别乡的季节). Clara Law 罗卓瑶. Hong Kong, 1990.

Farewell My Concubine (Bawang bieji 霸王别姬). Chen Kaige 陈凯歌. China/Hong Kong, 1993.

Flowers of Shanghai (Haishang hua 海上花). Hou Hsiao-hsien 侯孝贤. Taiwan, 1998.

Fortune Teller (Suanming 算命). Documentary. Xu Tong 徐童. China, 2009.

Founding of a Party, The (Jiandang weiye 建党伟业). Han Sanping 韩三平, Huang Jianxin 黄建新. China, 2011.

Founding of a Republic, The (Jianguo daye 建国大业). Han Sanping 韩三平, Huang Jianxin 黄建新. China, 2009.

Founding of an Army, The (Jianjun daye 建军大业). Andrew Lau Wai-keung 刘伟强. China, 2017.

Frozen (Jidu hanleng 极度寒冷). Wang Xiaoshuai 王小帅. China, 1999.

Full Moon in New York (Ren zai Niuyue 人在紐約). Stanley Kwan 关锦鹏. Hong Kong, 1989.

Gangs of New York. Martin Scorsese. United States, 2002.

Goddess (Shennü 神女). Wu Yonggang 吴永刚. China, 1934.

Gold Underground (Biandi wujin 遍地乌金). Documentary. Li Xiaofeng 黎小峰. China, 2012.

Golden Era, The (Huangjin shidai 黄金时代). Ann Hui 许鞍华. Hong Kong/China, 2014.

Golden Gate Girls (Jinmen yinguang meng 金门银光梦). Documentary. Louisa Wei 魏时煜. Hong Kong, 2014.

Grass Mud Horse Style (草泥马Style). Music video. Ai Weiwei. China, 2012.

Great Wall, The (Changcheng 长城). Zhang Yimou 张艺谋. China/United States, 2017.

Happy Together (*Chunguang zhaxie* 春光乍洩). Wong Kar-wai 王家卫. Hong Kong, 1997.

Hero (Yingxiong 英雄). Zhang Yimou 张艺谋. China, 2002.

Heroic Trio, The (Dongfang sanxia 东方三侠). Johnnie To 杜琪峰. Hong Kong, 1993.

Hollywood Hong Kong (Xianggang youge Helihuo 香港有個荷里活). Fruit Chan 陈果. Hong Kong, 2001.

House of Flying Daggers (Shimian maifu 十面埋伏). Zhang Yimou 张艺谋. China, 2004.

Huang Baomei (Huang Baomei 黄宝妹). Xie Jin 谢晋. China, 1958.

I Wish I Knew (Haishang chuanqi 海上传奇). Documentary. Jia Zhangke 贾樟柯. China, 2010.

In the Heat of the Sun (Yangguang canlan de rizi 阳光灿烂的日子) Jiang Wen 姜文. China, 1994.

Infernal Affairs (Wu jian dao 无间道). Andrew Lau刘伟强 and Alan Mak麦兆辉. Hong Kong, 2002.

Ip Man (Yewen 叶问). Wilson Yip 叶伟信. Hong Kong, 2008.

Iron Men 3. Shane Black. United States, 2013.

Journey to the West: Conquering the Demons (西游: 降魔篇). Stephen Chow 周星驰. Hong Kong/China/Taiwan, 2013.

Ju Dou (Ju Dou 菊豆). Zhang Yimou 张艺谋. China, 1990.

Kill Bill 1 & 2. Quentin Tarantino. United States, 2003–4.

Killer, The (Diexue shuangxiong 喋血双雄). John Woo 吴宇森. Hong Kong, 1989.

Kung Fu Hustle (Gongfu 功夫). Stephen Chow 周星驰. Hong Kong/China, 2004.

Kung Fu Panda. Animation. Mark Osborne and John Stevenson. United States, 2008.

Leap (Duoguan 夺冠). Peter Ho-sun Chan 陈可辛. China, 2020.

Legend of the Silk Road (Sichou zhi lu chuanqi 丝绸之路传奇). TV drama. Wang Wenjie 王文杰 and Zhao Lijun 赵立军. China, 2015.

Letter from an Unknown Woman Max Ophül. United States, 1948.

Letter from an Unknown Woman (Yige mosheng nüren de laixin 一个陌生女人的来信). Xu Jingle 徐静蕾. China, 2005.

Little Cheung (Xi lu xiang 细路祥). Fruit Chan 陈果. Hong Kong, 1999.

Longest Summer, The (Qunian yanhua tebie duo 去年烟花特别多). Fruit Chan 陈果. Hong Kong, 1998.

Lost in Hong Kong (Gang jiong 港囧). Xu Zheng 徐峥. China, 2015.

Lost in Russia (Jiong ma 囧妈). Xu Zheng 徐峥. China, 2020.

Lost in Thailand (Ren zai jiongtu zhi Tai jiong 人再囧途之泰囧). Xu Zheng 徐峥. China, 2012.

Lost on Journey (Ren zai jiongtu 人在囧途). Ye Weimin 叶伟民. China, 2010.

Made in Hong Kong (Xianggang zhizao 香港制造). Fruit Chan 陈果. Hong Kong, 1997.

Man Who Has a Camera, The (*Chi sheyingji de ren* 持摄影机的人).
Documentary. Liu Na'ou 刘呐鸥. China, 1933.

Man with a Movie Camera (*Chelovek s kino-apparatom*). Dziga Vertov.
Documentary. Soviet Union, 1929.

Manhunt (Japanese title: Kimi yo Fundo no Kawa o Watare
君ょ憤怒の河を渉れ; Chinese translation: *Zhuibu* 追捕). *Satō Jun'ya*.
Japan, 1976.

Manufactured Landscapes. Documentary. Director Jennifer Baichwal.
Canada, 2006.

Matrix Trilogy, The. Wachowski Brothers. United States, 1999–2003.

Mermaid, The (Meiren yu 美人鱼). Stephen Chow 周星驰. Hong Kong/
China, 2016.

Mulan. Animation. Tony Bancroft and Barry Cook. United States, 1998.

Mulan. Niki Caro. United States, 2020.

My Fancy High Heels (Wo ai gaogenxie 我爱高跟鞋). Documentary. Chao-ti
Ho 贺照缇. Taiwan, 2010.

My Natasha (Wo de Natasha 我的娜塔莎). TV drama. Guo Jingyu 郭靖宇
and Bo Shan 柏衫. China, 2012.

New Immigrant (Xin ke 新客). Liu Bei-jin 刘贝锦. Malaya/Singapore, ca.
1926–7.

Not One Less (Yige dou bu neng shao 一个都不能少). Zhang Yimou
张艺谋. China, 1999.

One Second (Yi miao zhong 一秒钟). Zhang Yimou. China, 2020.

Operation Mekong (Meigonghe xingdong 湄公河行动). Dante Lam 林超贤.
China, 2016.

Operation Red Sea (Honghai xingdong 红海行动). Dante Lam 林超贤.
China, 2018.

Orphan of Anyang (Anyang ying'er 安阳婴儿). Wang Chao 王超.
China, 2001.

Our Time Will Come (Mingyue jishi you 明月几时有). Ann Hui 许鞍华.
Hong Kong/China, 2017.

Petition (Shangfang 上访). Documentary. Zhao Liang 赵亮. China, 2009.

Phurbu and Tenzin (Xizang tiankong 西藏天空). Fu Dongyu 傅东育.
China, 2014.

Plastic China (Suliao wangguo 塑料王国). Documentary. Wang Jiuliang
王久良. China, 2016.

Platform (Zhantai 站台). Jia Zhangke 贾樟柯. China, 2000.

Purple Sunset (Ziri 紫日). Feng Xiaoning 冯小宁. China, 2001.

Rain Clouds over Wushan (Wushan yunyu 巫山云雨). Zhang Ming 章明. China, 1995.

Raise the Red Lantern (Dahong denglong gaogao gua 大红灯楼高高挂). Zhang Yimou 张艺谋. China, 1991.

Red Cliff (Chibi 赤壁). John Woo 吴宇森. Hong Kong, 2008.

Red Suspicion (Japanese title: *Akai Giwaku* 赤い疑惑; Chinese translation: *Xue Yi* 血疑). TV drama. Yasuo Furuhata, Toshiaki Kunihara, Masaharu Segawa. Japan, 1975.

Riding Alone for Thousands of Miles (Qianli zou danqi 千里走单骑). Zhang Yimou张艺谋. China/Japan, 2005.

Romance of the Western Chamber (Xixiang ji 西厢记). Hou Yao 侯曜. China, 1927.

Russian Girls in Harbin (Eluosi guniang zia Haerbin 俄罗斯姑娘在哈尔滨). TV drama. Sun Sha 孙沙. China, 1993.

Sanyuanli (Sanyuanli 三元里). Documentary. Ou Ning 欧宁 and Cao Fei 曹斐. China, 2003.

São Paulo: A Metropolitan Symphony (*São Paulo: sinfonia da metropole*). Documentary. Adalberto Kemeny and Rudolf Rex Lustig. Brazil, 1929.

Searching for Brodsky. (Xunzhao Buluosiji 尋找布洛斯基). Documentary. Hsieh Chia-kuen 謝嘉錕. Taiwan, 2009.

Shanghai Calling. Daniel Xia. United States, 2012.

Shanghai Dreams (Qinghong 青红). Wang Xiaoshuai 王小帅. China, 2005.

Shanghai Kiss. Kern Konwiser and David Ren. United States, 2007.

Shattered (Lao Tang tou 老唐头). Documentary. Xu Tong 徐童. China, 2011.

She Walks (*La Marcheuse*). Nathanaël Marandin. France, 2016.

Siji: Driver. David Chai. United States, 2018.

Simple Life, A (Tao Jie 桃姐). Ann Hui 许鞍华. Hong Kong/China, 2011.

Sisters, Stand Up (Jiejie meimei zhan qilai 姊姊妹妹站起來). Chen Xihe 陈西禾. China, 1951.

Sky Hunter (Kongtian lie空天猎). Li Chen李晨. China, 2017.

Song of China (Tianlun 天伦). Fei Mu 菲穆. China, 1935.

Soul Haunted by Painting, A (Hua hun 画魂). Huang Shuqin 黄蜀芹. China, 1994.

Spider-Man 3. Sam Raimi. United States, 2007.

Still Life (Sanxia haoren 三峡好人). Jia Zhangke 贾樟柯. China, 2006.

Street Angel (Malu tianshi 马路天使). Yuan Muzhi 袁牧之. China, 1937.

Summer Palace (Yiheyuan 颐和园). Lou Ye 娄烨. China, 2006.

Suzhou River (Suzhou he 苏州河). Lou Ye 娄烨. China, 2000.

Ten Years (Shi nian 十年). Jevons Au 欧文杰, Kiwi Chow 周冠威, Ng Ka-Leung 伍嘉良, Wong Fee-Pang 黄飞鹏, Kwok Zune 郭臻. Hong Kong, 2015.

Three Husbands (Sanfu 三夫). Fruit Chan 陈果. Hong Kong, 2018.

Three Times (Zuihao de shigang 最好的时光). Hou Hsiao-hsien 侯孝贤. Taiwan, 2005.

To Live (Houzhe 活着). Zhang Yimou 张艺谋. China,1994.

Tomorrow Never Dies. Roger Spottiswoode. United States/United Kingdom, 1997.

Touch of Sin, A (Tian zhuding 天注定). Jia Zhangke 贾樟柯. China, 2013.

Touch of Zen, A (Xia nü 侠女). King Hu 胡金铨. Hong Kong, 1971.

Transformers 4: Age of Extinction. Michael Bay. United States, 2014.

Treason by Birth (Shiji xuan'an: Liu Na'ou chuanqi 世紀懸案: 劉吶鷗傳奇). Documentary. Liao Ching-Yao 廖敬堯. Taiwan, no year.

Trip through China, A. Documentary. Benjamin Brodsky. United States, 1916.

Unknown Pleasures (Ren xiaoyao 任逍遥). Jia Zhangke 贾樟柯. China, 2002.

Verse of Us, The (Wo de shipian 我的诗篇). Documentary. Feiyue Wu 吴飞跃 and Xiaoyu Qin 秦晓宇. China, 2015.

Wandering Earth, The (Liulang diqiu 流浪地球). Frant Gwo 郭帆. China, 2019.

Wheat Harvest (Mai shou 麦收). Documentary. Xu Tong 徐童. China, 2008.

West of the Tracks (Tie xi qu 铁西区). Documentary. Wang Bing 王兵. China, 2003.

White-Haired Girl, The (Baimao nü 白毛女). Wang Bin 王滨, Shui Hua 水华. China, 1950.

Wolf Totem (Lang tuteng 狼图腾). Jean-Jacques Annaud. China/France, 2015.

Wolf Warrior (Zhanlang 战狼). Wu Jing 吴京. China, 2015.

Wolf Warrior 2 (Zhanlang 战狼 2). Wu Jing 吴京. China, 2017.

World, The (Shijie 世界). Jia Zhangke 贾樟柯. China, 2004.

World of Suzie Wong, The. Richard Quine. United States, 1960.

X-Men: Days of Future Past. Brian Singer. United States, 2014.

Xiao Hua (Xiao Hua 小花). Zhang Zheng 张铮. China, 1978.

Xiao Shan Going Home (Xiaoshan huijia 小山回家). Jia Zhangke 贾樟柯. China, 1995.

Xiao Wu, aka *Pickpocket* (Xiao Wu 小武). Jia ZHanke 贾樟柯. China, 1997.

Yellow Earth (Huang tudi 黄土地). Chen Kaige 陈凯歌. China, 1984.

Youth (Fanghua 芳华). Feng Xiaogang 冯小刚. China, 2017.

Zhang's Stir-Fried Tripe and Old Ji's Family (Baodu Zhang he Lao Ji jia 爆肚张和老吉家). Documentary. Shi Runjiu 施润玖. China, 2006.

Bibliography

Abbas, Ackbar. *Hong Kong: Culture and the Politics of Disappearance.* Minneapolis: University of Minnesota Press, 1997.

Anderson, Benedict. *Imagined Communities: Reflections on the Origin and Spread of Nationalism.* London: Verso, 1983.

Andrew, Dudley. "Time Zones and Jet Lag: The Flows and Phases of World Cinema." In *World Cinemas, Transnational Perspectives*, ed. Nataša Durovičová and Kathleen Newman, pp. 59–89. London: Routledge, 2010.

Appadurai, Arjun. *Modernity at Large: Cultural Dimensions of Globalization.* Minneapolis: University of Minnesota Press, 1996.

Bao, Weihong. *Fiery Cinema: The Emergence of an Affective Medium in China: 1915–1945.* Minneapolis: University of Minnesota Press, 2015.

Baskett, Michael. *The Attractive Empire: Transnational Film Culture in Imperial Japan.* Honolulu: University of Hawai'i Press, 2008.

Bergen-Aurand, Brian, Mary Mazzilli, and Hee Wai-Siam, eds. *Transnational Chinese Cinema: Corporality, Desire, and the Ethics of Failure.* Piscataway, NJ: Bridge21 Publishers, LLC, 2014.

Berry, Chris. "Getting Real: Chinese Documentary, Chinese Postsocialism." In *The Urban Generation: Chinese Cinema and Society at the Turn of the Twenty-First Century*, ed. Zhang Zhen, pp. 115–136. Durham, NC: Duke University Press, 2007.

Berry, Chris. "*Xiao Wu*: Watching Time Go By." In *Chinese Films in Focus II*, ed. Chris Berry, pp. 250–7. London: Palgrave Macmillan, 2008.

Berry, Chris. "Transnational Chinese Cinema Studies." In *The Chinese Cinema Book*, ed. Song Hwee Lim and Julian Ward, pp. 9–16. London: Palgrave Macmillan, 2011.

Berry, Chris. "Pema Tseden and the Tibetan Road Movie: Space and Identity beyond the 'Minority Nationality Film.'" *Journal of Chinese Cinemas* vol. 10, no. 2 (2016): 89–105.

Berry, Chris. "Cai Fei's 'Magical Metropolises.'" In *Visual Arts, Representations and Interventions in Contemporary China: Urbanized Interface*, ed. Minna Valjakka and Meiqin Wang, pp. 209–36. Amsterdam: Amsterdam University Press, 2018.

Berry, Chris, and Mary Farquhar. *China on Screen: Cinema and Nation.* New York: Columbia University Press, 2006.

Berry, Chris, and Laikwan Pang, eds. "Special Issue: Transnational Chinese Cinemas." *Journal of Chinese Cinemas* vol. 2, no. 1 (2008): 3–79.

Berry, Chris, Lu Xinyu, and Lisa Rofel, eds. *The New Chinese Documentary Film Movement: For the Public Record.* Hong Kong: Hong Kong University Press, 2010.

Berry, Michael. "Fruit Chan: Hong Kong Independent." In *Speaking in Images: Interviews with Contemporary Chinese Filmmakers*, Michael Berry, pp. 458–82. New York: Columbia University Press, 2006.

Bez, Ulrich. "Preface II." In *Beijing 008—Art Project of Qin Yufen*, 北京008— 秦玉芬艺术计划，bilingual exhibition catalogue, curator Huang Du 黄笃, ed. Chen Ai'er 陈爱儿and An Su 安夙, pp. 6–7. Beijing: Today Art Museum, 2008.

Bloom, Michelle. *Contemporary Sino-French Cinemas: Absent Fathers, Banned Books, and Red Balloons*. Honolulu: University of Hawai'i Press, 2016.

Bosker, Bianca. *Original Copies: Architectural Mimicry in Contemporary China*. Honolulu: University of Hawai'i Press, 2013.

Brown, Wendy. *Walled States, Waning Sovereignty*. Cambridge, MA: Zone Books, 2010.

Chan, Kenneth. *Remade in Hollywood: The Global Chinese Presence in Transnational Cinemas*. Hong Kong: Hong Kong University Press, 2009.

Chang, Chia-ning. "Introduction: Yamaguchi Yoshiko in Wartime East Asia: Transnational Stardom and Its Predicaments." In Yamaguchi Yoshiko and Fujiwari Sakuya, *Fragrant Orchid: The Story of My Early Life*, translated with an introduction by Chia-ning Chang, pp. xvii–li. Honolulu: University of Hawai'i Press, 2015.

Chang, Tsong-zung. "Into the Nineties." In *China's New Art, Post-1989*, exhibition catalogue, ed. Valerie C. Doran, pp. i–vii. Hong Kong: Hanart TZ Gallery, 1993.

Chao, Evelyne. "The Ballet That Caused an International Row." *BBC Culture*, June 28, 2017. https://www.bbc.com/culture/article/20170628-the-ballet-that-caused-an-international-row (accessed September 26, 2020).

Cheah, Pheng. *What Is a World? On Postcolonial Literature as World Literature*. Durham, NC: Duke University Press, 2016.

Cheah, Pheng, and Bruce Robbins, eds. *Cosmopolitics: Thinking and Feeling Beyond the Nation*. Minneapolis: University of Minnesota Press, 1998.

Chen, Jianhua. "D. W. Griffith and the Rise of Chinese Cinema in the Early 1920s Shanghai." In *Oxford Handbook of Chinese Cinemas*, ed. Carlos Rogers and Eileen Cheng-yin Chow, pp. 23–38. London: Oxford University Press, 2013.

Cheng, Jihua 程季华, Li Shaobai 李少白, and Xing Zuwen 邢祖文. *Zhongguo dianying fazhanshi* 中国电影发展史 (History of the Development of Chinese Film). Beijing: Zhongguo dianying chubanshe, 1963.

Cheung, Esther M. K., and Chu, Yiu-wai, eds. *Between Home and World: A Reader in Hong Kong Cinema*. Hong Kong: Oxford University Press, 2004.

Cheung, Esther M. K., Gina Marchetti, and Esther C. M. Yau. "Introduction." In *A Companion to Hong Kong Cinema*, ed. Esther M. K. Cheung, Gina Marchetti, and Esther C. M. Yau, pp. 1–13. Malden, MA: Wiley-Blackwell, 2015.

"China's Film Industry Rankles as Spiderman's Web Snares Cinemas." http://english.eastday.com (May 17, 2007). Available at http://english.eastday.com/eastday/englishedition/features/userobject1ai2837715.html (accessed June 15, 2007).

Chiu, Kuei-fen, and Yingjin Zhang. *New Chinese-Language Documentaries: Ethics, Subject and Place*. London: Routledge, 2015.

Cui, Shuqin. "Working from the Margins: Urban Cinema and Independent Directors in Contemporary China." In *Chinese-Language Film: Historiography, Poetics, Politics*, ed. Sheldon H. Lu and Emilie Yueh-Yu Yeh, pp. 96–119. Honolulu: University of Hawai'i Press, 2005.

Cui, Shuqin. "Boundary Shifting: New Generation Filmmaking and Jia Zhangke's Films." In *Art, Politics and Commerce in Chinese Cinema*, ed. Ying Zhu and Stanley Rosen, pp. 189–90. Hong Kong: Hong Kong University Press, 2010.

Cui, Shuqin. "The Return of the Repressed: Masculinity and Sexuality Reconsidered." In *A Companion to Chinese Cinema*, ed. Yingjin Zhang, pp. 499–517. West Sussex: Wiley-Blackwell, 2012.

Cui, Shuqin. *Gendered Bodies: Toward a Women's Visual Art in Contemporary China*. Honolulu: University of Hawai'i Press, 2016.

Curtin, Michael. *Playing to the World's Biggest Audience: The Globalization of Chinese Film and TV*. Berkeley: University of California Press, 2007.

Desai, Vishakha N., and David A. Ross. "Foreword." In *Inside Out: New Chinese Art*, ed. Gao Minglu, pp. 7–10. Berkeley: University of California Press, 1998.

Dilley, Whitney Crothers. *The Cinema of Ang Lee: The Other Side of the Screen*. New York: Wallflower Press, 2014.

Ding Yaping 丁亚平. *Zhongguo dianying tongshi* 中国电影通史 (A General History of Chinese Film), 2 vols. Beijing: Zhongguo dianying chubanshe, Wenhua yishu chubanshe, 2016.

Dirlik, Arif. "Architectures of Global Modernity, Colonialism, and Places." *Modern Chinese Literature and Culture* vol. 17, no. 1 (Spring 2005): 33–61.

Dissanayake, Wimal. "The Class Imaginary in Fruit Chan's Films." Online journal *Jump Cut: A Review of Contemporary Media* no. 49 (Spring 2007). www.ejumpcut.org (accessed May 1, 2016).

Doane, Mary Ann. "The Close-Up: Scale and Detail in the Cinema." *differences: A Journal of Feminist Cultural Studies* vol. 14, no. 3 (2003): 89–111.

Doane, Mary Ann. "The Female Face, the Cityscape, and Modernity in a Transcultural Context." In *Proceedings of the International Conference "Women in Focus: Gender and Chinese-Language Cinema,"* pp. 3–13. Nanjing: Nanjing University and the Pembroke Center for Gender Studies of Brown University, 2008.

Du, Daisy Yan. *Animated Encounters: Transnational Movements of Chinese Animation, 1940s–1970s*. Honolulu: University of Hawai'i Press, 2019.

Du, Weijia. "Exchanging Faces, Matching Voices: Dubbing Foreign Films in China." *Journal of Chinese Cinemas* vol. 12, no. 3 (2018): 285–99.

Durovičová, Nataša, and Kathleen Newman, eds. *World Cinemas, Transnational Perspectives*. London: Routledge, 2010.

Edwards, Dan. *Chinese Independent Documentary: Alternative Visions, Alternative Publics*. Edinburgh: Edinburgh University Press, 2015.

Elley, Derek. "Review of *Summer Palace* (Yiheyuan)." *Variety* (May 18, 2006). http://www.variety.com/review/VE1117930547.html?categoryid=31&cs=1&query=derek+elley+summer+palace+lou+ye (accessed May 15, 2007).

Erjavec, Ales, ed. *Postmodernism and the Postsocialist Condition: Politicized Art under Late Socialism*. Berkeley: University of California Press, 2003.

Evans, Harriet, and Stephanie Donald, eds. *Picturing Power in the People's Republic of China: Posters of the Cultural Revolution*. Lanham, MD: Rowman and Littlefield, 1999.

Ezra, Elizabeth, and Terry Rowden, eds. *Transnational Cinema: The Film Reader*. London: Routledge, 2006.

Fan, K. Sizheng. "A Classicist Architecture for Utopia: The Soviet Contacts." In *Chinese Architecture and the Beaux-Arts*, ed. Jeffrey W. Cody, Nancy S. Steinhardt, and Tony Atkin, pp. 91–126. Honolulu: University of Hawai'i Press/Hong Kong: Hong Kong University Press, 2011.

Fan, Victor. *Cinema Approaching Reality: Locating Chinese Film Theory*. Minneapolis: University of Minnesota Press, 2015.

Farquhar, Mary, and Chris Berry. "Shadow Opera: Toward a New Archaeology of the Chinese Cinema." In *Chinese-Language Film: Historiography, Poetics, Politics*, ed. Sheldon H. Lu and Emilie Yue-yu Yeh, pp. 27–51. Honolulu: University of Hawai'i Press, 2005.

Ferrari, Rossella. *Pop Goes the Avant-Garde: Experimental Theater in Contemporary China*. Kolkata: Seagull Books, distributed by the University of Chicago Press, 2012.

Fisher, Jaimey, and Marco Abel, eds. *The Berlin School and Its Global Contexts: A Transnational Art Cinema*. Detroit: Wayne State University Press, 2018.

Frangville, Vanessa. "Pema Tseden's *The Search*: The Making of a Minor Cinema." *Journal of Chinese Cinemas* vol. 10, no. 2 (2016): 106–19.

Fu, Poshek. *Between Shanghai and Hong Kong: The Politics of Chinese Cinemas*. Stanford, CA: Stanford University Press, 2003.

Fu, Yongchun. *The Early Transnational Chinese Cinema Industry*. London: Routledge, 2019.

Gan, Wendy. *Fruit Chan's Durian*. Hong Kong: Hong Kong University Press, 2005.

Gao, Minglu. "Toward a Transnational Modernity: An Overview of *Inside Out: New Chinese Art*." In *Inside Out: New Chinese Art*, ed. Gao Minglu, pp. 15–40. Berkeley: University of California Press, 1998.

Gleadell, Colin. "Art Sales: Asian Tigers Roar to Auction Records." *Telegraph.co.uk* (October 16, 2007), at http://www.telegraph.co.uk/arts/main.jhtml?xml=/arts/2007/10/16/basales116.xml (accessed Feb 26, 2008).

Golomstock, Igor. *Totalitarian Art: In the Soviet Union, the Third Reich, Fascist Italy and the People's Republic of China*, translated from Russian by Robert Chandler. London: Collins Harvill, 1990.

Greene, Naomi. *From Fu Manchu to Kung Fu Panda: Images of China in American Film*. Honolulu: University of Hawai'i Press, 2014.

Guo, Shaohua. "*Wenyi, Wenqing* and Pure Love: The European Imaginary in Xu Jinglei's Films." *Journal of Chinese Cinemas* vol. 12, no. 1 (2018): 41–58.

Habermas, Jürgen. "Modernity: An Incomplete Project." In *The Anti-Aesthetic*, ed. Hal Foster, pp. 3–15. Port Townsend, WA: Bay Press, 1983.

Hansen, Miriam. "Fallen Women, Rising Stars, New Horizons: Shanghai Silent Film as Vernacular Modernism." *Film Quarterly* vol. 54, no. 1 (Autumn 2000): 10–22.

Harding, Harry. "The Concept of 'Greater China': Themes, Variations and Reservations." *The China Quarterly* no. 136 (December 1993): 660–86.

Harris, Kristine. "The *New Woman* Incident: Cinema, Scandal, and Spectacle in 1935 Shanghai." In *Transnational Chinese Cinemas: Identity, Nationhood, Gender*, ed. Sheldon H. Lu, pp. 277–302. Honolulu: University of Hawai'i Press, 1997.

Harris, Kristine. "*The Romance of the Western Chamber* and the Classical Subject Film in 1920s Shanghai." In *Cinema and Urban Culture in Shanghai, 1922–1943*, ed. Yingjin Zhang, pp. 51–73. Palo Alto, CA: Stanford University Press, 1999.

Harris, Kristine. "*The Goddess*: Fallen Woman of Shanghai." In *Chinese Films in Focus: 25 New Takes*, ed. Chris Berry, pp. 111–19. London: British Film Institute, 2003.

Harvey, David. *The Condition of Postmodernity: An Inquiry in the Origins of Cultural Change*. Oxford, UK: Blackwell, 1989.

Harvey, David. *A Brief History of Neoliberalism*. Oxford: Oxford University Press, 2007.

Hee, Wai Siam. "*New Immigrant*: On the First Locally Produced Film in Singapore and Malaya." *Journal of Chinese Cinemas* vol. 8, no. 2 (2014): 244–58.

Hee, Wai Siam 徐維賢 (Xu Weixian). *Huayu dianying zai hou Malaixiya: tuqiang fengge, huayifeng yu zuozhe lun* 華語電影在後馬來西亞：土腔風格、華夷風與作者論 (Post-Malaysian Chinese-Language Film: Accented Style, Sinophone and Auteur Theory). Xinbeishi: Lianjing, 2018.

Heidegger, Martin. "The Age of the World Picture." In *The Question Concerning Technology and Other Essays*, ed. and trans. William Lovitt, pp. 115–54. New York: Harper Torchbooks, 1977.

Hershatter, Gail. *Dangerous Pleasures: Prostitution and Modernity in Twentieth-Century Shanghai*. Berkeley: University of California Press, 1999.

Hoefle, Arnhilt Johanna. *China's Stefan Zweig: The Dynamics of Cross-Cultural Reception*. Honolulu: University of Hawai'i Press, 2018.

Huang, Du. "Beijing Sky." In *Beijing 008—Art Project of Qin Yufen*, 北京008—秦玉芬艺术计 划，bilingual exhibition catalogue, curator Huang Du黄笃, ed. Chen Ai'er 陈爱儿and An Su安夙, pp. 8–11. Beijing: Today Art Museum, 2008.

Hunt, Leon, and Wing-Fai Leung, eds. *East Asian Cinemas: Exploring Transnational Connections on Film*. London: I.B. Tauris, 2008.

Ito, Toyo. "Big Time Dilemmas: Interview by Kayoko Ota." In *Content: Perverted Architecture*, ed. Rem Koolhaas et al., pp. 448–9. Koln: Taschen, 2004.

Jaffee, Valerie. "'Every Man a Star': The Ambivalent Cult of Amateur Art in New Chinese Documentaries." In *From Underground to Independent: Alternative Film*

Culture in Contemporary China, ed. Paul G. Pickowicz and Yingjin Zhang, pp. 77–108. Lanham, MD: Roman & Littlefield, 2006.

Jameson, Fredric. *Postmodernism, or, the Cultural Logic of Late Capitalism*. Durham, NC: Duke University Press, 1991.

Jia, Leilei 贾磊磊. "Zhongguo dianying xuepai jiangou de fanxiang mingti" 中国电影学派建构的反向命题 (The Antithetical Hypothesis of the Construction of a Chinese Film School). *Dianying yishu* 电影艺术 (Film Art) no. 2 (2018): 22–5.

Jia, Zhangke. "A Record of Confusion." *Danwei* (June 1, 2007). http://www.danwei.org/film/jia_zhangke_vs_zhang_yimou.php (accessed June 14, 2007).

Jin, Hainan. "Introduction: The Translation and Dissemination of Chinese Cinemas." *Journal of Chinese Cinemas* vol. 12, no. 3 (2018): 197–202.

"Jin Shangyi youhua 'Mao Zhuxi quanshen xiang' 2016 wan chengjiao" 靳尚谊油画"毛主席全 身像"2016万成交 (Jin Shangyi's Oil Painting *Full-Body Portrait of Chairman Mao* Sold at RMB 20.16 Million) (October 24, 2013). http://jinshangyi.artron.net/news/detail/112 (accessed June 11, 2015).

Johnson, Matthew D., Keith B. Wagner, Kiki Tianwi Yu, and Luke Vulpiani, eds. *China's iGeneration: Cinema and Moving Image Culture for the Twenty-First Century*. London: Bloomsbury, 2014.

Kääpä, Pietari, and Tommy Gustafsson, eds. *Transnational Ecocinema: Film Culture in an Era of Ecological Transformation*. Bristol: Intellect, 2013.

Kahn, Joseph. "How China Banished 'Da Vinci.'" *The Sacramento Bee* (June 10, 2006), A15.

Kauer, Raminder, and Ajay Sinha, eds. *Bollywood: Popular Indian Cinema through a Transnational Lens*. New Delhi: Sage, 2005.

Klein, Christina. *Cold War Orientalism: Asia in the Middlebrow Imagination, 1945–1961*. Berkeley: University of California Press, 2003.

Klein, Christina. "*Kung Fu Hustle*: Transnational Production and the Global Chinese-Language Film." *Journal of Chinese Cinemas* vol. 1, no 3 (2007): 189–208.

Koolhaas, Rem. "Post-Modern Engineering?" In Rem Koolhaas et al., *Content: Perverted Architecture*, pp. 513–14. Koln: Taschen, 2004.

Krings, Matthias, and Onookome Okome, eds. *Global Nollywood: The Transnational Dimensions of an African Video Film Industry*. Bloomington: Indiana University Press, 2013.

Larson, Wendy. Review of Xiaobing Tang, *Visual Culture in Contemporary China: Paradigms and Shifts* (Cambridge: Cambridge University Press, 2015), at MCLC Resource Center (August 2020). https://u.osu.edu/mclc/book-reviews/larson3/ (accessed October 1, 2020).

Li Daoxin 李道新. "Chongjian zhutixing yu chongxie dianyingshi: yi Lu Xiaopeng de kuaguo dianying yanjiu yu huayu dianying lunshu wei zhongxin de fansi yu pipan" 重建主体性与重写电影史:以鲁晓鹏的跨国电影研究与华语电影论述为中心 的反思与批判 (Re-building Chinese Subjectivity and Re-writing Chinese Film History: Reflections on and Critique of Sheldon Lu's Transnational Film Studies and

Chinese-Language Film Discourse) *Dangdai dianying* 当代电影 (Contemporary Film) no. 8 (2014): 53–8.

Li, Jie. "National Cinema for a Puppet State: The Manchurian Motion Picture Association." In *Oxford Handbook Chinese Cinemas*, ed. Carolos Rojas and Eileen Cheng-yin Chow, pp. 79–97. Oxford: Oxford University Press, 2013.

Li, Jie. "Filming Power and the Powerless: Zhao Liang's *Crime and Punishment* (2007) and *Petition* (2009)." In *DV-Made China: Digital Subjects and Social Transformations after Independent Film*, ed. Zhang Zhen and Angela Zito, pp. 76–96. Honolulu: University of Hawai'i Press, 2015.

Li, Jie. "Gained in Translation: The Reception of Foreign Cinema in Mao's China." *Journal of Chinese Cinemas* vol. 13, no. 1 (2019): 61–75.

Li, Luzhou. *Zoning China: Online Video, Popular Culture, and the State*. Cambridge, MA: MIT Press, 2019.

Li, Xianting. "Major Trends in the Development of Contemporary Chinese Art." In *China's New Art, Post-1989*, exhibition catalogue, ed. Valerie C. Doran, pp. x–xxii. Hong Kong: Hanart TZ Gallery, 1993.

Liao, Gene-Fon 廖金鳳, producer; Hsieh Chia-kuen 謝嘉錕, director. *Searching for Brodsky* 尋找布洛斯基. Documentary. DVD. Taipei: 48ers Production, 2009.

Liao, Gene-fon 廖金鳳, producer; Liao Ching-Yao 廖敬堯, director. *Treason by Birth* 世紀懸案: 劉吶鷗傳奇. Documentary. DVD. New Taipei City: Ishine Creative Presents, no date.

Lim, Song Hwee. *Tsai Ming-Liang and a Cinema of Slowness*. Honolulu: University of Hawai'i Press, 2014.

Lin, Xiaoping. "Jia Zhangke's Cinematic Trilogy: A Journey across the Ruins of Post-Mao China." In *Chinese-Language Film: Historiography, Poetics, Politics*, ed. Sheldon H. Lu and Emilie Yueh-yu Yeh, pp. 186–209. Honolulu: University of Hawai'i Press, 2005.

Lin, Xiaoping. *Children of Marx and Coca-Cola: Chinese Avant-Garde Art and Independent Cinema*. Honolulu: University of Hawai'i Press, 2010.

Lo, Kwai-Cheung Lo, and Jessica Wai Yee Yeung, eds. Special issue on the Tibetan Cinema of Pema Tseden. *Journal of Chinese Cinemas* vol. 10, no. 2 (2016): 87–165.

Louie, Kam. *Theorizing Chinese Masculinity: Society and Gender in China*. Cambridge: Cambridge University Press, 2002.

Louie, Kam. *Chinese Masculinities in a Globalizing World*. London: Routledge, 2014.

Lu, Sheldon H. "Historical Introduction: Chinese Cinemas (1896–1996) and Transnational Film Studies." In *Transnational Chinese Cinemas: Identity, Nationhood, Gender*, ed. Sheldon H. Lu, pp. 1–31. Honolulu: University of Hawai'i Press, 1997.

Lu, Sheldon H, ed. *Transnational Chinese Cinemas: Identity, Nationhood, Gender*. Honolulu: University of Hawai'i Press, 1997.

Lu, Sheldon H. "Soap Opera in China: The Transnational Politics of Visuality, Masculinity, and Sexuality." *Cinema Journal* vol. 40, no. 1 (2000): 25–47.

Lu, Sheldon H. *China, Transnational Visuality, Global Postmodernity*, Stanford: Stanford University Press, 2001.

Lu, Sheldon H. "Crouching Tiger, Hidden Dragon, Bouncing Angels: Hollywood, Taiwan, Hong Kong, and Transnational Cinema." In *Chinese-Language Film: Historiography, Poetics, Politics*, ed. Sheldon H. Lu and Emilie Yueh-yu Yeh, pp. 220–33. Honolulu: University of Hawai'i Press, 2005.

Lu, Sheldon H. "Hong Kong Diaspora Film and Transnational TV Drama: From Homecoming to Exile to Flexible Citizenship." In *Chinese-Language Film: Historiography, Poetics, Politics*, ed. Sheldon H. Lu and Emilie Yueh-yu Yeh, pp. 298–311. Honolulu: University of Hawai'i Press, 2005.

Lu, Sheldon H. *Chinese Modernity and Global Biopolitics: Studies in Literature and Visual Culture*. Honolulu: University of Hawai'i Press, 2007.

Lu, Sheldon H. "Dialect and Modernity in 21st Century Sinophone Cinema." *Jump Cut* no. 49 (Spring 2007). http://www.ejumpcut.org.

Lu, Sheldon H. "Gorgeous Three Gorges at Last Sight: Cinematic Remembrance and the Dialectic of Modernization." In *Chinese Ecocinema in the Age of Environmental Challenge*, ed. Sheldon Lu and Jiayan Mi, pp. 39–55. Hong Kong: Hong Kong University Press, 2009.

Lu, Sheldon H. "Notes on Four Major Paradigms in Chinese-Language Film Studies." *Journal of Chinese Cinemas* vol. 6, no. 1 (2012): 15–26.

Lu, Sheldon H. "Genealogies of Four Critical Paradigms in Chinese-Language Film Studies." In *Sinophone Cinemas*, ed. Audrey Yue and Olivia Khoo, pp. 13–25. London: Palgrave Macmillan, 2014.

Lu, Sheldon H. "Re-visioning Global Modernity through the Prism of China." *European Review* vol. 23, no. 2 (May 2015): 210–26.

Lu, Sheldon H. "Agitation or Deep Focus? Early Chinese Film History and Theory." A review essay. *Harvard Journal of Asiatic Studies* vol. 76, no. 1 (June 2016): 197–207.

Lu, Sheldon H. "The First Screenings of Lumière Films in China: Conjectures and New Findings." *Asian Cinema* vol. 30, no. 1 (2019): 129–35.

Lu, Sheldon H., and Emilie Yueh-yu Yeh, eds. *Chinese-Language Film: Historiography, Poetics, Politics*. Honolulu: University of Hawai'i Press, 2005.

Lu, Sheldon H., and Emilie Yueh-yu Yeh. "Introduction: Mapping the Field of Chinese Language-Cinema." In *Chinese-Language Film: Historiography, Poetics, Politics*, ed. Sheldon H. Lu and Emilie Yueh-yu Yeh, pp. 1–24. Honolulu: University of Hawai'i Press, 2005.

Lu, Sheldon H., and Haomin Gong, eds. *Ecology and Chinese-Language Cinema: Reimagining a Field*. London: Routledge, 2020.

Lu, Sheldon H., and Jiayan Mi, eds. *Chinese Ecocinema in the Age of Environmental Challenge*. Hong Kong: Hong Kong University Press, 2009; Seattle: University of Washington Press, 2010.

Lu Xiaopeng (Sheldon Lu) 鲁晓鹏. "Gouzao 'Zhongguo' de celüe: xianfeng yishu yu hou dongfang zhuyi" 构造'中国'的策略：先锋艺术与后东方主义 (Strategies

of Constructing "China": Avant-Garde Art and Post-Orientalism). *Jinri xianfeng* 今日先锋 (Avant-Garde Today) no. 10 (January 2001): 148–61.

Lu Xiaopeng (Sheldon Lu) 鲁晓鹏. "Xianfeng yishu de hanyi" 先锋艺术的含义 (The Implications of Avant-Garde Art). *Shanhua* 山花 (Mountain Flower) no. 2 (2001): 83–5.

Lu, Xinyu. "Rethinking China's New Documentary Movement: Engagement with the Social." In *The New Chinese Documentary Film Movement: For the Public Record*, ed. Chris Berry, Lu Xinyu, and Lisa Rofel, pp. 15–48. Hong Kong: Hong Kong University Press, 2010.

Lü Xinyu 吕新雨. "Xin Zhongguo shaoshu minzu yingxiang shuxie: lishi yu zhengzhi" 新中国少数民族影像书写: 历史与政治 (Writing Images of Ethnic Minorities in New China: History and Politics). *Shanghai daxue xuebao* 上海大学学报 (Journal of Shanghai University) vol. 32, no. 5 (2015): 13–51.

Luk, Thomas Y. T., and James Price, eds. *Before and after Suzie: Hong Kong in Western Film and Literature*. New Asia Academic Bulletin, no. 18. Hong Kong: Chinese University of Hong Kong, 2002.

Lupke, Christopher. *The Sinophone Cinema of Hou Hsiao-Hsien: Culture, Style, Voice, and Motion*. Amherst, NY: Cambria Press, 2016.

Ma, Jean. *Melancholy Drift: Marking Time in Chinese Cinema*. Hong Kong: Hong Kong University Press, 2010.

Marchetti, Gina. "Introduction: Plural and Transnational." *Jump Cut* 42 (1998): 68–72.

Marchetti, Gina. *From Tian'anmen to Times Square: Transnational China and the Chinese Diaspora on Global Screen, 1989–1997*. Philadelphia, PA: Temple University Press, 2006.

Marchetti, Gina. *Andrew Lau and Alan Mak's* Infernal Affairs — the Trilogy. Hong Kong: Hong Kong University Press, 2007.

Marchetti, Gina. *Citing China: Politics, Postmodernism, and World Cinema*. Honolulu: University of Hawai'i Press, 2018.

Marchetti, Gina, and Tan See Kam. "Introduction: Hong Kong Cinema and Global Change." In *Hong Kong Film, Hollywood and the New Global Cinema: No Film Is an Island*, ed. Gina Marchetti and Tan See Kam, pp. 1–9. London: Routledge, 2007.

Marciniak, Katarzyna, and Bruce Bennett, eds. *Teaching Transnational Cinema: Politics and Pedagogy*. London: Routledge, 2017.

McIlroy, Brian, ed. *Genre and Cinema: Ireland and Transnationalism*. London: Routledge, 2007.

McLaren, Ann. "Advance through Retreat: The Li Yi Zhe Manifesto." MCLC Resource Center, February 2015. http://u.osu.edu/mclc/pubs/mclaren/ (accessed February 15, 2015).

Mendes, Ana Cristina, and John Sundholm, eds. *Transnational Cinema at the Borders: Borderscapes and the Cinematic Imaginary*. London: Routledge, 2018.

Millard, William B. "Dissecting the Iconic Exosymbiont: The CCTV Headquarters, Beijing, as Built Organism." In Rem Koolhaas et al., *Content: Perverted Architecture*, pp. 490–1. Koln: Taschen, 2004.

Morris, Meaghan, Siu Leung Li, and Stephen Chan Ching-kiu, eds. *Hong Kong Connections: Transnational Imagination in Action Cinema*. Hong Kong: Hong Kong University Press, 2005.

Nestingen, Andrew, and Trevor G. Elkington, eds. *Transnational Cinema in a Global North: Nordic Cinema in Transition*. Detroit: Wayne State University Press, 2005.

Nie, Jing. *Beijing in the Shadow of Globalization: Production of Spatial Poetics in Chinese Cinema, Literature, and Drama*. Doctoral dissertation. University of California at Davis, 2009.

Nochimson, Martha P., ed. *A Companion to Wong Kar-wai*. West Sussex, UK: Wiley-Blackwell, 2016.

Ong, Aihwa. *Flexible Citizenship: The Cultural Logics of Transnationality*. Durham, NC: Duke University Press, 1999.

Ong, Aihwa. "Introduction: Worlding Cities, or the Art of Being Global." In *Worlding Cities: Asian Experiments and the Art of Being Global*, ed. Ananya Roy and Aihwa Ong, pp. 1–26. West Sussex, UK: Wiley-Blackwell, 2011.

O'Sullivan, Michael. *The Levelling: What's Next after Globalization*. New York: PublicAffairs, 2019.

Palacio, Manuel, and Jörg Türschmann, eds. *Transnational Cinema in Europe*. Vienna: LIT, 2013.

Palmer, Augusta. "Scaling the Skyscraper: Images of Cosmopolitan Consumption in *Street Angel* (1937) and *Beautiful New World* (1998)." In *The Urban Generation: Chinese Cinema and Society at the Turn of the Twenty-First Century*, ed. Zhang Zhen, pp. 181–204. Durham, NC: Duke University Press, 2007.

Pickowicz, Paul G. "Preface." In *From Underground to Independent: Alternative Film Culture in Contemporary China*, ed. Paul G. Pickowicz and Yingjin Zhang, pp. vii–xii. Lanham, MD: Rowman & Littlefield, 2006.

Pickowicz, Paul G., and Yingjin Zhang, eds. *From Underground to Independent: Alternative Film Culture in Contemporary China*. Lanham, MD: Rowman & Littlefield, 2006.

Pickowicz, Paul G., and Yingjin Zhang, eds. *Filming the Everyday: Independent Documentaries in Twenty-First Century China*. Lanham, MD: Rowman & Littlefield, 2016.

Qin, Xiaoyu, ed. *Iron Moon: An Anthology of Chinese Worker Poetry*, trans. Eleanor Goodman. Buffalo, NY: White Pine Press, 2017.

Raju, Zakir Hossain. "Filmic Imaginations of the Malaysian Chinese: '*Mahua* Cinema' as a Transnational Chinese Cinema." *Journal of Chinese Cinemas* vol. 2, no. 1 (2008): 67–79.

Rawle, Steven. *Transnational Cinema: An Introduction*. New York: Palgrave, 2018.

Ren, Hai. "Redistribution of the Sensible in Neoliberal China: Real Estate, Cinema, and Aesthetics." In *China and New Left Visions: Political and Cultural Interventions*, ed. Ban Wang and Jie Lu, pp. 225–45. Lanham, MD: Lexington Books, 2012.

Ren, Xuefei. *Building Globalization: Transnational Architecture Production in Urban China*. Chicago: University of Chicago Press, 2011.

Reynaud, Bérénice. "Chinese Digital Shadows: *Hybrid Forms, Bodily Archives, and Transnational Visions.*" In *DV-Made China, Digital Subjects and Social Transformations after Independent Film*, ed. Zhang Zhen and Angela Zito, pp. 187–214. Honolulu: University of Hawai'i Press, 2015.

Robinson, Luke. *Independent Chinese Documentary: From the Studio to the Street*. New York: Palgrave Macmillan, 2012.

Said, Edward. *The World, the Text, and the Critic*. Cambridge, MA: Harvard University Press, 1983.

Sassen, Saskia. *The Global City: New York, London, Tokyo*. Princeton, NJ: Princeton University Press, 1996.

Sassen, Saskia. *Globalization and Its Discontents*. New York: Free Press, 1998.

School of Visual Arts of Nanjing University 南京视觉艺术学院, ed. "Wang Guofeng王国峰." In *Third Nanjing Triennial: Reflective Asia* 第三届南京双年展--亚洲方位, bilingual edition, n.p. Nanjing: Nanjing chubanshe, 2008.

Scorsese, Martin. "Foreword." In Michael Berry, *Speaking in Images: Interviews with Contemporary Chinese Filmmakers*, pp. vii–viii. New York: Columbia University Press, 2005.

Shih, Shu-mei. *Visuality and Identity: Sinophone Articulations across the Pacific*. Berkeley: University of California Press, 2007.

Silbergeld, Jerome. "Façades: The New Beijing and the Unsettled Ecology of Jia Zhangke's *The World*." In *Chinese Ecocinema in the Age of Environmental Challenge*, ed. Sheldon Lu and Jiayan Mi, pp. 113–27. Hong Kong: Hong Kong University Press, 2009.

Song, Geng. "Imagining the Other: Foreigners on the Chinese TV Screen." In *Chinese Television in the Twenty-First Century: Entertaining the Nation*, ed. Ruoyun Bai and Geng Song, pp. 107–20. London: Routledge, 2015.

Song, Geng. "Cosmopolitanism with Chinese Characteristics: Transnational Male Images in Chinese TV Dramas." In *The Cosmopolitan Dream: Transnational Chinese Masculinities in a Global Age*, ed. Derrek Hird and Geng Song, pp. 27–39. Hong Kong: Hong Kong University Press, 2018.

Spivak, Gayatri Chakravorty. "The Rani of Sirmur: An Essay in Reading the Archives." *History and Theory* vol. 24, no. 3 (October 1985): 247–72.

Sun, Shaoyi. "Chinese-Language Film or Chinese Cinema: Review of an Ongoing Debate in the Chinese Mainland." *Journal of Chinese Cinemas* vol. 10, no. 1 (2016): 61–6.

Szeto, Kin-Yan. *The Martial Arts Cinema of the Chinese Diaspora: Ang Lee, John Woo, and Jackie Chan in Hollywood*. Carbondale: Southern Illinois University Press, 2011.

Szeto, Mirana May, and Yun-chung Chen. "Hong Kong Cinema in the Age of Neoliberalization and Mainlandization: Hong Kong SAR New Wave as a Cinema of Anxiety." In *A Companion to Hong Kong Cinema*, ed. Esther M. K. Cheung, Gina Marchetti, and Esther C. M. Yau, pp. 89–115. Malden, MA: Wiley-Blackwell, 2015.

Tang, Xiaobing. *Visual Culture in Contemporary China: Paradigms and Shifts*. Cambridge: Cambridge University Press, 2015.

Taylor, Jeremy E. *Rethinking Transnational Chinese Cinemas: The Amoy-Dialect Film Industry in Cold War Asia*. London: Routledge, 2011.

"The Colorful Propaganda of Xinjiang." *BBC News, China blog staff*. January 12, 2015. www.bbc.com/news/world-asia-china-30722268 (accessed January 14, 2015).

Valjakka, Minna, and Meiqin Wang, eds. *Visual Arts, Representations and Interventions in Contemporary China: Urbanized Interface*. Amsterdam: Amsterdam University Press, 2018.

van Crevel, Maghiel. "Misfit: Xu Lizhi and Battlers Poetry (*Dagong shige*)." *Prism: Theory and Modern Chinese Literature* vol. 16., no. 1 (March 2019): 85–114.

Voci, Paola. *China on Video: Smaller-Screen Realities*. New York: Routledge, 2010.

Wang, Lingzhen, ed. *Chinese Women's Cinema: Transnational Contexts*. New York: Columbia University, 2011.

Wang, Meiqin. *Urbanization and Contemporary Chinese Art*. New York: Routledge, 2016.

Wang, Meiqin. "Shadow of the Spectacular: Photographing Social Control and Inequality in Urban China." In *Visual Arts, Representations and Interventions in Contemporary China: Urbanized Interface*, ed. Minna Valjakka and Meiqin Wang, pp. 115–46. Amsterdam: Amsterdam University Press, 2018.

Wang, Meiqin. *Socially Engaged Art in Contemporary China: Voices from Below*. New York: Routledge, 2019.

Wang, Meng 王蒙. *Sulian ji* 苏联祭 (In Memory of the Soviet Union). Beijing: Zuojia chubanshe, 2006.

Wang, Yiman. *Remaking Chinese Cinema: Through the Prism of Shanghai, Hong Kong, and Hollywood*. Honolulu: University of Hawai'i Press, 2013.

Watts, Jonathan. "Buy! Buy! Buy!" *The Guardian* (March 13, 2008). http://arts.guardian. co.uk/art/visualart/story/0,,2264539,00.html (accessed March 14, 2008).

Wei, Louisa, producer and director. *Golden Gate Girls*. Feature documentary. DVD. 2014.

Welland, Sasha Su-ling. *Experimental Beijing: Gender and Globalization in Chinese Contemporary Art*. Durham, NC: Duke University Press, 2018.

Wilcox, Emily. *Revolutionary Bodies: Chinese Dance and the Socialist Legacy*. Berkeley: University of California Press, 2018.

Wu, Hung. *Remaking Beijing: Tiananmen Square and the Creation of a Political Space*. London: Reaktion Books, 2005.

Wu, Hung. "Zhang Dali's *Dialogue*: Conversation with a City." *Public Culture* vol. 12, no. 3 (2000): 749–68.

Yau, Esther C. M., ed. *At Full Speed: Hong Kong Cinema in a Borderless World*. Minneapolis: University of Minnesota Press, 2001.

Yau, Esther C. M. "Watchful Partners, Hidden Currents: Hong Kong Cinema Moving into the Mainland of China." In *A Companion to Hong Kong Cinema*, ed. Esther M. K. Cheung, Gina Marchetti, and Esther C. M. Yau, pp. 17–50. Malden, MA: Wiley-Blackwell, 2015.

Ye Yueyu (Yeh, Emilie Yueh-yu) 叶月瑜，Feng Youcai 冯莜才，and Liu Hui 刘辉, eds. *Zouchu Shanghai: zaoqi dianying de linglei jingguan* 走出上海：早期电影的另类景观 (Get Out of Shanghai: Alternative Views of Early Cinema). Beijing: Beijing daxue chubanshe, 2016.

Yeh, Emilie Yueh-yu, ed. *Early Film Culture in Hong Kong, Taiwan, and Republican China: Kaleidoscopic Histories*. Ann Arbor: University of Michigan Press, 2018.

Yeh, Emilie Yueh-yu. "Introduction." In *Early Film Culture in Hong Kong, Taiwan, and Republican China: Kaleidoscopic Histories*, ed. Emlie Yueh-yu Yeh, pp. 1–16. Ann Arbor: University of Michigan Press, 2018.

Yeh, Emilie Yueh-yu, and Darrell William Davis. "Re-nationalizing China's Film Industry: Case Study on the China Film Group and Film Marketization." *Journal of Chinese Cinemas* vol. 2, no. 1 (2008): 37–51.

Yi Shui 易水. *Malaiya hua huayu dianying wenti* 馬來亞化華語電影問題 (Issues of Chinese-Language Film in Malaya). Singapore: Nanyang, 1959.

Zhang Ali 张阿利. *Shanpai dianshi ju: diyu wenhua lun* 陕派电视剧：地域文化论 (Television Drama of the Shanxi School: On Regional Culture). Beijing: Zhongguo dianying chubanshe, 2008.

Zhang, Ling. "Digitizing City Symphony, Stabilizing the Shadow of Time: Montage and Temporal-Spatial Construction in *San Yuan Li*." In *China's iGeneration: Cinema and Moving Image Culture for the Twenty-First Century*, ed. Matthew D. Johnson, Keith B. Wagner, Kiki Tianwi Yu, and Luke Vulpiani, pp. 105–24. London: Bloomsbury, 2014.

Zhang, Ling. "Rhythmic Movement, Metaphoric Sound, and Transcultural Transmediality: Liu Na'ou and *The Man Who Has a Camera* (1933)." In *Early Film Culture in Hong Kong, Taiwan, and Republican China: Kaleidoscopic Histories*, ed. Emlie Yueh-yu Yeh, pp. 277–301. Ann Arbor: University of Michigan Press, 2018.

Zhang, Yingjin, ed. *Cinema and Urban Culture in Shanghai, 1922–1943*. Stanford: Stanford University Press, 1999.

Zhang, Yingjin. "Prostitution and Urban Imagination: Negotiating the Public and the Private in Chinese Films of the 1930s." In *Cinema and Urban Culture in Shanghai*, 1922–1943, ed. Yingjin Zhang, pp. 160–80. Stanford: Stanford University Press, 1999.

Zhang, Yingjin. *Screening China: Critical Interventions, Cinematic Reconfigurations, and the Transnational Imaginary in Contemporary Chinese Cinema Studies*. Ann Arbor: Center for Chinese Studies, University of Michigan, 2002.

Zhang, Yingjin. *Cinema, Space, and Polylocality in a Globalizing China*. Honolulu: University of Hawai'i Press, 2010.

Zhang, Zhen. *An Amorous History of the Silver Screen: Shanghai Cinema, 1896–1937.* Chicago: University of Chicago Press, 2006.

Zhang, Zhen. "Introduction: Bearing Witness: Chinese Urban Cinema in the Era of 'Transformation.'" In *The Urban Generation: Chinese Cinema and Society at the Turn of the Twenty-First Century*, ed. Zhen Zhang, pp. 1–45. Durham, NC: Duke University Press, 2007.

Zhang, Zhen, ed. *The Urban Generation: Chinese Cinema and Society at the Turn of the Twenty-First Century.* Durham, NC: Duke University Press, 2007.

Zhang, Zhen, and Angela Zito, eds. *DV-Made China: Digital Subjects and Social Transformations after Independent Film.* Honolulu: University of Hawai'i Press, 2015.

Zhang, Zhen, and Angela Zito. "Introduction." In *DV-Made China, Digital Subjects and Social Transformations after Independent Film*, ed. Zhang Zhen and Angela Zito, pp. 1–25. Honolulu: University of Hawai'i Press, 2015.

Zhang, Zhen (different author with same name). "Reimagining the Soviet Union in Contemporary Chinese Literature: Soviet *Ji* in Wang Meng's *Remembrance of the Soviet Union* and Feng Jicai's *Listening to Russia*." *Frontiers of Literary Studies in China* vol. 8, no. 4 (2014): 598–616.

Zhang, Zhen (different author with same name). "Heroism or Colonialism: China and the Soviet Imagination of Manchuria in *Port Arthur*." Chapter 8, in *Russia in Asia: Imaginations, Interactions, and Realities*, ed. Jane F. Hacking, Jeffrey S. Hardy, and Matthew P. Romaniello, pp. 140–62. London: Routledge, 2020.

Zhang Zhongnian 张仲年, ed. *Menggu zu yingshi yanjiu* 蒙古族影视研究 (Studies in the Film and TV of Mongolian People). Beijing: Zhongguo dianying chubanshe, 2015.

Zhang, Zikang 张子康. "Preface I." In *Beijing 008—Art Project of Qin Yufen*, 北京008—秦玉芬 艺术计划, bilingual exhibition catalogue, curator Huang Du黄笃, ed. Chen Ai'er 陈爱儿 and An Su 安夙, pp. 4–5. Beijing: Today Art Museum, 2008.

Zhong, Xueping. *Masculinity Besieged? Issues of Modernity and Male Subjectivity in Chinese Literature of the Late Twentieth Century.* Durham, NC: Duke University Press, 2000.

Zuboff, Shoshana. *The Age of Surveillance Capitalism: The Fight for a Human Future at the New Frontier of Power.* New York: Hachette, 2019.

Index

Beijing Bastards (Beijing zazhong) (Zhang Yuan) 121
Beijing Besieged by Waste (Laji weicheng) (Wang Jiuliang) 23
Beijing Bicycle (Shiqisui de danche) (Wang Xiaoshuai) 70, 122
Beijing Exhibition Center 163
Beijing Film Academy 120
Beijing Olympic Games (2008) 120, 155–6, 170, 172, 189
Berlin Film Festival (1980) 125
Berlin: Symphony of a Great City (Berlin: Die Sinfonie der Großstadt) (Ruttmann) 8
Berry, Chris 18, 172
Best Times 58
Better Tomorrow, A (Yingxiong bense) (Woo) 128
Bez, Ulrich 166
biopolitics 13
Bitter Flowers (Xiahai) (Meys) 72
bizhen (zeroing in on reality) 21
Blind Shaft (Mang jing) (Li Yang) 65, 122
Bloom, Michelle 4
Blue Kite (Lan fengzheng) 165
Blush (Hongfen) (Li Shaohong) 65
Boatman's Daughter (Chuanjia nü) (Shen Xiling) 63
Bolshevik Revolution 143
Bolshoi Theater in Moscow 139
box-office 9–10, 26, 41, 45, 47–8, 52, 118, 121, 125
Brecht, Bertolt 130
British Concession 57
Brodsky, Benjamin 4
Brokeback Mountain (Ang Lee) 123
Brosnan, Pierce 43
Buddhism 42
Bumming in Beijing (Liulang Beijing) (Wu Wenguang) 118
Bund, The (Shanghai tan) (Chow Yun-fat) 129
Burtynsky, Edward 192

cadres *(ganbu)* 52, 98
California 67
Cannes Film Festival (2006) 123
Cantonese-dialect films 16
Cao Fei 188

capitalism 103
business and 10
criticism 182
global 69, 72, 82, 156, 160, 181, 185–6
laissez-faire 70
print 12
socialism and 180
surveillance 204–5
transnational 64–72, 79, 176, 191
Casablanca 45
Catholicism 42
Cave of the Silken Web, The (Pansi dong) (Dan Duyu) 5
CCTV Tower ("Big Pants-Crotch," *da kucha*) 155, 159–62, 188
censorship
domestic 117
government 177
independent filmmakers and artists 2
tolerance and 23
underground filmmakers 121, 122–4
Chai, David 72
Chairman Mao Goes to Anyuan (Mao Zhuxi qu Anyuan) (Liu Chunhua) 185
Chan, Fruit 55, 67–70, 72, 77, 80, 87
Chan, Jackie 78, 200
Chan, Peter 10, 66–7, 77, 80–2, 84–5, 87–94
Chang Che 109
Chang Chen 58–9
Chang Tsong-zung 179
changing meaning of art 176–7
Charlie's Angels: Full Throttle (Nichol) 78
Cheah, Pheng 22
Chen Chong 104
Chen Daoming 125
Chen Gang 165
Chen Kaige 120
Chen Xihe 64
Chen Yiyang 190
Chengdu, Sichuan province 87, 103–5
Cheng Jihua 3
Cheung, Esther 68
Cheung, Maggie 43, 67, 78, 83
China 1, 55, 68, 72, 75, 77–9, 81, 83, 86, 88, 90, 92–3, 105, 110, 128, 139–40, 142, 147–8, 150
accession to WTO 126